SWEET DREAMS

SWEET DREAMS

contemporary art and complicity JOHANNA DRUCKER

THE
UNIVERSITY
OF CHICAGO
PRESS
CHICAGO
AND LONDON

The University of Chicago Press, Chicago 60637
The University of Chicago Press, Ltd., London
© 2005 by The University of Chicago
All rights reserved. Published 2005
Paperback edition 2006
Printed in the United States of America

14 13 12 11 10 09 08 07 3 4 5

ISBN-10: 0-226-16505-1 (paper)
ISBN-13: 978-0-226-16505-9 (paper)

Library of Congress Cataloging-in-Publication Data

Drucker, Johanna, 1952–
 Sweet dreams : contemporary art and complicity / Johanna Drucker.
 p. cm.
 Includes bibliographical references and index.
 ISBN 0-226-16504-3 (cloth : alk. paper)
 1. Postmodernism. 2. Art and society. 3. Art criticism—Philosophy.
4. Art, Modern—20th century. 5. Art, Modern—21st century. I. Title
N6494.P66D78 2005
709'.049—dc22

 2005004164

♾ The paper used in this publication meets the minimum
requirements of the American National Standard for Information
Sciences—Permanence of Paper for Printed Library Materials,
ANSI Z39.48-1992.

THIS BOOK IS DEDICATED TO LINDA DAITZ,

WHO GAVE ME THE OPPORTUNITY

TO SPEAK IN THIS VOICE.

CONTENTS

ILLUSTRATIONS

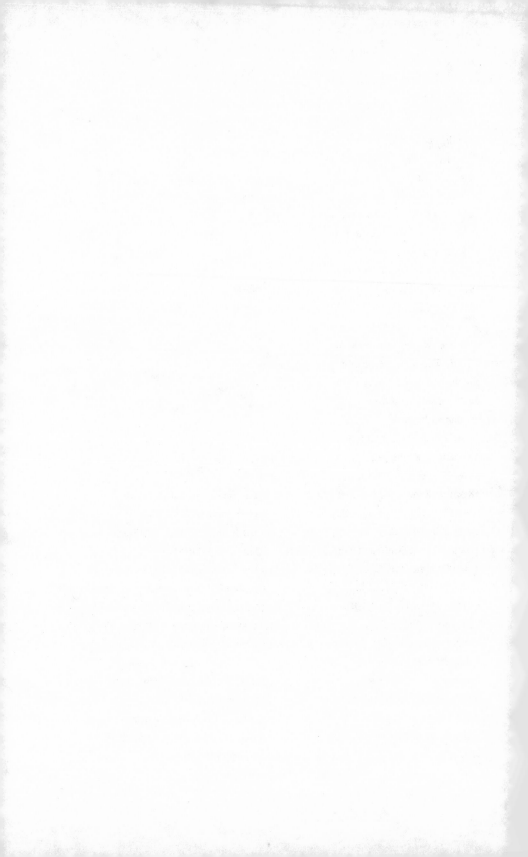

PREFACE: STARTING NOW

In the 1990s, an abundant range of works of art exhibited in mainstream
venues called out for a new critical vocabulary. This fresh sensibility was ill-
served by the remnants of modernism's legacy of avant-garde terms. The
critical suppositions underlying artists' works were clearly changing. These
shifts have now outstripped even the formulations we identify as the ortho-
doxy of 1980s postmodernism. They mark a turn away from autonomy, op-
position, or radical negativity and toward attitudes of affirmation and com-
plicity.

Current fine art sensibility vibrates with enthusiasms: an uninhibited
engagement with material pleasure drawn from across the widest spectrum
of contemporary experience exists alongside an impulse to mine the ar-
chival riches of our diverse pasts. A renewed studio culture is flourishing.
Making objects with evident appreciation of process has pushed traditional

techniques into a highly charged exchange with new media capabilities. Materials and structures of expression have never been more varied. Nor has the license to use them ever been so broad. Any effort to synthesize a dominant aesthetic sensibility from such heterogeneity meets an impasse—especially if it is based on the modern and postmodern attachment to oppositional critique.[1] This new art doesn't fit the old criticism.

An anthropologist could supply a detailed study of ritual practices that sustain current art institutions or provide a description of fine art as a sphere of esoteric activity where specialized knowledge is power. The boundaries between populist and elite zones are marked by obscure codes. This highly rulebound culture is known as the art world. Ritualized structures and meanings abound within its domains. A sociologist could add a nuanced insight into the stratified class relations in which fine art functions. These conspicuous status signs read very clearly to the communities of upwardly mobile or politically ambitious participants. Other social scientists could discuss the addictive power of celebrity culture in which complex forces glorify an individual through the inflated mechanisms of fame. Still others could point out the roles of money and media, of educational networks, the fashion trends and personality cults that create elite cliques for a season or a decade or more. These phenomena constitute the realm of fine art at the turn of the millennium. Most have long historical legacies. All are significant underpinnings to the project I have at hand. But though these approaches would describe the systems of social relations in which fine art functions, they would miss the point. Which is? The art.

Contemporary art embodies more than just its social circumstances or its anthropological operation. The highly refined system of artistic practices has its own codes. No matter how diverse the object—lint sculpture, snapshot, painted wood, or artist's body—every work that passes for "art" is operating within that system. The works of this moment in time engage cultural and art historical perspectives through specific materials, concepts, references, themes. Getting a purchase on what constitutes art in the last decade or so, and within the critical frames emerging for its comprehension, is the task of the contemporary critic. Trying to understand the theoretical precepts to which new work gives rise also requires a historian's perspective.

What pervades current art as a set of concerns? What are its framing principles? How can we speak metacritically about the current circumstances of art production? The critical contours of what's happening should be de-

duced from the works, not projected onto them. Jennifer Pastor's imaginatively suggestive sculptures assembled from store-bought items, Jim Campbell's digital displays of everyday streets, Orlan's remaking of her face and body as images through surgery, Warren Neidich's photographs of media events, Robert Colescott's paintings combining historical precedents and African American vernacular, and Jason Rhoades's maxed-out assembly-of-stuff installations: do they have anything to do with each other? Is the work of this period to be distinguished from that of the 1980s? The 1960s? Can we rethink our understanding of historical modernism by seeing new manifestations of artistic production as part of a continuity of ideas from earlier movements like romanticism, realism and symbolism rather than as an innovative break? My examination of contemporary art acknowledges the critical reality of a recognizably distinct set of concerns. But these link the current scene to historical considerations long present in modernism, many of which have been eclipsed by dominant strains of interpretation. What's happening? And how does our coming to terms with current work provide insight into the historical lineage on which we still draw for many of the premises and practices that underpin ongoing activity?

My approach is grounded in an admittedly partisan feeling about works of imagination and their value as cultural work. The function of art is essential to human understanding—now as much as ever. But this book is not about beauty, that too-popular term of recent work. Instead, my focus is on the value of artifice. The reflective self-consciousness by which art performs the task of insight, and then of memory, provides a crucial means by which the apparently seamless, "natural" condition of our existence is called to attention. See this? Look at that! Take note and rethink what you think you know—again. And again. By such basic rhetorical principles fine art objects provide the cracks in the surface of appearance. Without these insights, we have no capacity at all to think critically—by which I mean, to think imaginatively—about our condition as specific cultural beings enmeshed in highly particular historical circumstances. Through an aesthetic appeal to the eye and senses, fine art achieves its effect. Through its artifice, it shows the constructed-ness of its condition—and ours.

I love the art of the 1990s and 2000s because it seems fresh, exuberant, vibrant, and eclectic in its capacity to imagine ways of producing meaning through formal invention. Unifying principles do exist that give many apparently dissimilar practices common theoretical and critical ground. These

principles rely on a historically informed understanding of the specific discourses of aesthetic objects. By using the term "aesthetic," I mean to suggest images and artifacts made for no apparent or utilitarian purpose beyond the processing of subjective experience into form. Such objects, by their mannered quality, their "wrought-ness," or display of artifice, demonstrate the highly self-conscious process by which an object identifies as art. The "uselessness" that Oscar Wilde insisted upon as key to the anti-instrumental, nondirected character of art provides an important foundational touchstone for my thinking about the role and identity of contemporary work. His art-for-art's sake approach, while it may have given rise to a particular notion of autonomy in formalist and critical terms, can also be read as bearing within it a sophisticated acknowledgment of complicity. The term "aesthetic" underscores the productive creation and reception of art as artifice, free of any other directed purpose or obligation.

Contemporary artists are at least as conspicuously self-conscious about the history of art and theory as are the critics whose writings arise in response. Artists working today are also keenly influenced by mass media and material culture as much as by the rich traditions of fine art. They are also likely to draw freely from both traditional visual arts and the canonical histories of major movements, epochs, cultures. But critical theory, in particular, the theoretical apparatus of what we could term the "new academicism," has failed to keep pace by attending to its own renewal. Sclerotic and decrepit, most contemporary academic work about late twentieth-century art is based on a doddering scaffold of outmoded thought. Modernism is not what the academy made of it. And contemporary art marks that distance in its remarkable escape from many habits of academic thought. The critical realm is as ready for an overhaul as poor Miss Haversham's parlor was due for a Mighty-Maid to purge its pathetic contents and throw them on the ash heap. Time to start over.

Why? Because the bulk of critical writing, particularly that produced within the Ph.D. mills of the high academy, is still premised on oppositional models that are the legacy of the avant-garde. Keepers of that dim flame are loyal to the notion of negative aesthetics and its rejection of mass culture and media. Artists and critics under sway of this legacy cultivate a self-styled radical chic supposedly pure of crass motives like careerism or material gain. They pretend to hold aloof from the supposedly polluting pleasures of the consumer culture in which they participate. Hypocrisy aside, the

stance nets little insight into our current condition. Academic theory tends to impose its requirements top down (most contemporary art criticism has its roots in the university graduate programs that feed the institutions that exhibit, promote, publicize, review, canonize, and collect contemporary work). Subscribers to this belief system are often unable, or unwilling, to be taken by surprise by artists' work, seeking instead those works that fulfill formulaic expectations according to the letter of the critical law. A bad faith premised on presumption of moral superiority has come to prevail.

Theory has rigidified into predictable categories of thought, each identifiable by their characteristic vocabulary of the "abject," the "subversive," the "transgressive," the "resistant," or other negative keyword. Some artistic work has suffered as a consequence, hidebound by the same theoretical precepts it comes to illustrate. But fortunately, the wellsprings of imaginative life are not so readily corked. New work by a whole range of creative artists offers a variety of responses to the world and to the complicit condition we inhabit in our new millennial culture. A broad cross-section of that work exhibits a fantastic array of ways of thinking and making. A critical response needs to be called forth on similarly fresh premises. Contemporary art transforms lived experience into symbolic form.

Close readings of individual works are the touchstone of interpretation. I'm not advocating a retroformalism grounded in the idea of self-identical work or visually self-evident meaning. Complicit formalism is not a neoconservative move. I'm not interested in repressing attention to "politics" under the banner of "beauty." Quite the contrary. The lessons of formalist method, processed through poststructuralist Marxism and deconstruction in many modes, all contribute to the appreciation of material visual artifacts as *works*, that is, dynamic nodal points in complex systems of the cultural and symbolic order.[2] But art performs its work through its specific material construction, its forms of expression. I am, however, making an aggressive attempt to counter certain tendencies of recent decades to lead with critical discourse first, or to sort works of art into "good" and "bad" objects according to their degree of conformity to critical expectations. Criticism's prescriptive effect paralyzes the inventive impulse of making and locks artists into an impoverished "poststudio" position in which art making is conceived largely as a conceptual or symbolic act. But this simply isn't true. For all the crucial significance of conceptualism, art is never only an idea.

The phrase "complicit formalism" suggests entangled and embedded

associative possibilities of critical method. Form making, facture, the structure and iconography of images, means of production, circumstances of making and reception, critical and technical training, as well as underlying assumptions—all of these are facets of complicity, of the embedded condition of meaning and effect accessed through response to formal properties. The term "complicit" is deliberately provocative, since it implies a knowing compromise between motives of opportunism and circumstantial conditions—whether on the plane of production, or reference, or within institutional and social situations. Complicit formalism counters the very basis on which autonomy could be assumed, while returning respect for the aesthetic properties of works of art—material and visual considerations— to a central place within our understanding of the ways art works through constructed artifice. Complicity is closer to contingency, that critical term on which postmodernism based one understanding of the way works of art had to be situated within conditions of production and reception.[3] Complicity underscores an acknowledged participation by artists, critics, and academics that contingency sometimes overlooked in its preservation of a separate critical space.

This book is my contribution to a fresh approach. Chapter 1, "Sweet Dreams," focuses on a work that is emblematic of the twilight of resistant aesthetics and sketches the need for a reawakening of affirmative sensibilities. Chapter 2, "Current Conditions," articulates basic, critical principles arising from new art and describes them through recent examples. Chapter 3, "Critical Histories," briefly surveys a history of critical thought and conceptions of artistic practice within which contemporary art has derived its various impulses. Readers eager to engage with contemporary work could skip those essays. Chapter 4, "Forms of Complicity," consists of readings of works whose themes cut across lines of media: hybridity, identity manipulation, eclectic materialism, flirtations with mass media culture, historicist dialogues, and so on. Woven in among these are other issues— formalist sleights, slacker aesthetics, mutant creativity, gender ennui, branding, impurity of media, thing-ness, incidental resonance, mini- and macro-monumentality, recycling sensibilities, interactive conditions, and docu-fictional impulses. Clearly the list could go on. These boxcar terms are meant to suggest a radical shift in conceptual attitude. Ways of reading contemporary works are as rich and numerous as those of interpreting con-

stellations in the night sky. Many works could be added and the arguments extended.

The topics sketched in chapter 4 are neither exhaustive nor definitive. Any semblance of a fixed taxonomy emerging from my choices should be treated lightly. I've picked works for which I feel a particular sympathy, and thus the issues they elicit come to the fore. Other works and other issues deserve attention, and get it, in other quarters, since the inventory of interesting topics is constantly renewed by artistic invention. Each encounter with stimulating work calls forth another set of critical, descriptive terms (a new and complex historicism, for example, or concern with absorption and ornament, or modes of mediated subjectivity). But the term *complicit* supplies the specific rubric under which I identify these current sensibilities, distinguishing them from modern and postmodern works by the critical premises they seem to embody in their production and elicit in their reception. The shift I'm making in critical method is called forth by a change in prevailing attitudes within production.

Starting now—my opening phrase—suggests that we are far from done with the possibilities of fine art. We are always beginning again in that process of rethinking that is the crucial function of artistic practices. The need for alternative thought has never been more compelling than it is in the current phase of our collective life. I believe in the power of imaginative work as fundamental to the processes of change, but only if we don't shackle art to the task of serving as the social conscience of the culture, or serving any other formulaic agenda—clipping the spirit and straitjacketing artistic potential. Creative works abound. The challenge is to speak as powerfully in a critical frame as new artists are doing through material, visual forms of expression.

SOME PORTIONS OF THIS manuscript were shaped in papers written over the last decade, but with few exceptions, this material has not appeared in print elsewhere. Only two sections have a direct relation to previously published work. "Thingness and Objecthood" was published in *Sculpture*, vol. 16, no.4 (April 1997). Its companion piece, "Affectivity and Entropy," was prompted by a response I was invited to give to the *Blunt Object* exhibition curated by Courtney Smith at the Smart Museum. The core of that argument appears in the 2003 Scarecrow Press publication *Objects and Meaning*, edited

by Anna Fariello and Paula Owen. Both are reprinted with permission. Some parts of "Techno-bodies and Art Culture" had their first formulation in "Le Corps d'a Côté," in *Les Cahiers du Musée National d'Art Moderne* (spring 1995), but with a very different emphasis in the argument. Throughout this text, ideas and arguments appear that were forged in the generative contexts of presentation venues in art, literary, and creative digital communities.

Many friends and colleagues have advanced adversarial and supportive dialogue to help me clarify the arguments made here. Without the occasional or sustained exchanges I have had with Susan Bee, Charles Bernstein, Linda Daitz, Brad Freeman, Ernesto Grosman, Pattie Belle Hastings, Natalie Kampen, Alice Mansell, Emily McVarish, Marjorie Perloff, Jim Petrillo, Louise Sandhaus, Heather Schatz and Eric Chan, Mira Schor, Stuart Sillars, Constance Wolf, and Janet Zweig, this book would not have the shape it has. Mike Montgomery had more influence on this book than he would probably imagine, since our conversations took place twenty years ago. My two readers for University of Chicago Press, Kristine Stiles and Erika Doss, were very helpful in pointing out places to strengthen this manuscript in the final stage. Heather Schultz contributed her infinite patience and care to the acquisition of images and permissions. Jessica Feldman offered a careful, useful, and encouraging reading. Most immediately, Jerome McGann pushed me to think through my own assumptions and to have the courage of my convictions in a manner to which he is uniquely suited, both by disposition and by the example of his own work. Nothing repays effort like delight. The pleasures of engagement are their own reward. But my stated, respectful, and affectionate appreciation to all of these named persons may at least signal to them my regard for their otherwise unacknowledged contributions.

SWEET DREAMS

Fine art criticism is currently poised between a state of activity that is passing out of step and the awakening of a newly insightful awareness. The crepuscular image of liminal transition suggested by Gregory Crewdson's Twilight photographic series is an apt metaphor for our condition. Rarely have the critical terms of modernism hit so stagnant a spell as in their current slumbers. The siren call of vibrant new work needs to wake our critical impulses out of their somnambulism.

1. Twilight

Pale as death, the young woman stretches across the foreground of a photograph that displays all the evident hallmarks of a staged image (plate 1). The unnatural light flushes blue around her photogenic flesh. The fine fea-

tures of her face turn toward us to advantage. The vintage cotton slip of handmade eyelet covers her slim form with a virginal modesty. Along her flank the cloth sticks with wet–tee-shirt suction to her flesh. Mixed messages are present from first glance. Small town motifs waft through the air, ephemeral as the night sounds we cannot hear but can well imagine as background to this macabre scene. An American Gothic Ophelia, she floats on still water, eyes open, hands at her side. Her body is reflected in its stillness, hair fanning out around her head. Her mouth is open, fresh and unspoiled, the teeth pearly in the parted lips. Her staring eyes are rimmed with slight red color that suggests she had been weeping. The signs are enough to pique our sympathy but not destroy her cosmetic appeal. Our eyes linger on the details. Following the profile of her chin, neck, shoulder, breastbone, we linger on that exposed throat, as open and inviting as vampire bait in a classic scenario of horror. Every trope of exploitative gendered relations is present, intensified in the Technicolor highlights of an eroticized image that could be a David Lynch film still, so perfected and resonant are its motifs. Here lies innocence. Maybe.

What is Crewdson doing in this work?

Try this: He employs the same high production values as the machines of the fantasy industry. He engages without flinching, taking the very apparatus of illusion and making use of it to "transgressive" ends. The disturbing dream is alluringly seductive. But Crewdson uses beauty against itself, to insist on the ideological bad faith of the culture industry's exploitation of cheap thrills and our entrapment in insidious devices. The inherent perversities of the profit-making illusions of the Hollywood dream machine are intimately bound to the repressive strains of American culture. In denial, the citizenry pulls their shades against the reality of violence that runs through the very fiber of daily life, the warp and woof of contemporary existence in even the safest-seeming neighborhoods. The political import of this work is clear. The "twilight" theme is a liminal zone, late in the day of late capitalism, perhaps the harbinger of its demise. The absence of clear distinctions between good and evil, black and white, are characteristics of the hours between sunset and creeping darkness. Crewdson is perhaps our latter day Goya, whose work was associated with the twilight of the Enlightenment. Like the harsh Spanish critic whose unflinching eye and deft hand revealed the horrors of his contemporary life, Crewdson pulls back the

bland surface of habit, using the beauty of his images to produce an edgy commentary on our addiction to illusion. Right?

Well, not really.

Better to say, a *not* very edgy and a *very consumable* engagement with illusion. Through every feature of production in this work (thematic and technical), Crewdson shows us that he knows the world in which he participates is corrupt. Exploitation and seduction are twin engines of voluptuousness charging his work with consumability. The special effects that drench this photograph are those of high-end advertising. Crewdson embraces the industrial light and magic of Hollywood's best equipment. The finely cultivated technical sensibility is entirely formulaic. Crewdson is the very essence of complicity. His images are aligned with mass culture values—the exploitative voyeurism, the fakery, the sensationalism of a perhaps dead young female displayed for our prurient delectation. We can even imagine that Crewdson's interior life has been fully colonized by the schlock-in-trade of the cultural mainstream, the stuff of daily dreams and marketed illusions packaged for consumption sources. His work indicates no qualms, no hesitation, no flickerings of guilt or sense that these are lesser sources than those of Leonardo, classical antiquity, or the great works reproduced in Janson's *History of Art*. By the time the slides went up and the lights went out in his first art history class, Crewdson's image banks had already been filled with the stuff of *Fantasia*, the Magic Kingdom and the Emerald City, the worlds of Pooh, and Never Never Land.

Opportunistic, trivial, significant, suggestive, profound—whatever one thinks of Crewdson's work his imagery is popular and current. Criticality? The somnambulant landscapes of Crewdson's constructed tableaux are meant to provide pleasure. Crewdson's work makes a self-conscious exhibition of the value of aesthetics as art and artifice. Let's entertain for a moment the idea that the most direct parallel for Crewdson's work is not among his contemporaries, but with John Everett Millais.[1] The late-nineteenth-century painter was renowned for his "meticulous" attention to craft. Technical accomplishment distinguished his canvases, including that of the drowned Ophelia so clearly quoted in Crewdson's photograph. Replacing forest glen with a front parlor and an English maid with a woman of the American heartland, Crewdson exploits every technical possibility to achieve his effects. The exercise of skill in Millais also focused on virtuos-

ity. Aesthetic effects serve as the material of art, not merely its means, in both instances. Crewdson's expert manipulation of effects is a way of showing off, but it also is a way of incorporating the techniques of industry production into his work as subject matter.

Here lies innocence. The body of the young woman is laid out for our pleasure, without moral compunction. For this is the corpse of an old aesthetic sensibility. We can't mourn its passing. Nor can we wake it from its cold slumber, only from our own. We're so accustomed to the commodification of criticism that the idea of an image that functions as a commodity without embodying a critical position seems immoral. Why should it? Crewdson reinvests these images-from-images with the exquisite specialness of dreams. Painters of another generation might have yearned for an absolute of pure representation, self-sufficient and self-evident abstraction. Earlier yet, they may have struggled for true apperception of a person or thing, making it into a transparent image. Crewdson draws on images as the original object of inspiration—he isn't representing life, love, religious passions, nature, spiritual belief, or any thing at all except images.

Such an attitude has its own critical pedigree. The legacy of postmodernism is conspicuous. When Douglas Crimp curated Pictures in 1977, the point of view expressed in his accompanying essay in the exhibition catalog became a rallying point for definition of a postmodern aesthetic, particularly as it came to circulate around the artists of the New York scene.[2] Robert Longo's Men in the Cities, Sherrie Levine's rephotographed works, Jack Goldstein's endlessly repetitive loops of fragments—these exemplify, each individually in their own way but also collectively, the condition of postmodern representation. Crimp's argument was that all images already existed. Nothing new could be invented or expressed. The notions of original authorship and creativity were played out. Nor could an image hold its own against any other. Like Gerhard Richter speaking of his Atlas project, the artists of now canonical postmodernism saw ordering and selecting as the only meaningful task.[3] Even that gesture was premised on futility of purpose and emphasis. No image could mean more than another or be better, more valuable, than its infinite brethren in the crowded fields of visual culture. Richter explains his exhaustive display of photographs thus: "In my picture atlas . . . I can only get a handle on the flood of pictures by creating order since there are no individual pictures at all anymore."[4]

Crewdson counters this attitude with his dramatic investment in the auratic value of individuated works. Crewdson's image fascinates because its artfulness seduces. The theme—the "death of a beautiful woman"—has been politically incorrect for a century and a half of modern art, condemned by Edgar Allan Poe's critics as inappropriate material when the nineteenth-century writer suggested otherwise.[5] We can't ignore the subject matter of Crewsdon's photograph. We don't see beauty in spite of the theme, but in it. Aesthetics has no independent moral order.

That, above all, is the terrifying, liberating message of this image and its effect. His images don't have an "agenda" in the tendentious sense. They don't create a "to do list" of actions meant to change any particular circumstance or condition. In interviews Crewdson claims to be doing nothing other than making photographs that bring his imagination forth in visual form. We can't blame this impulse to create individual expression on the culture industry since it works so hard to eliminate the distinguishing features of personal expression that might trouble the seamless surface of consumable effects. No, Crewdson works from a very different starting point. His motivation arises squarely, firmly, from within the realm of art. Aesthetics has no transcendent moral existence—it is not outside the other ideologies.

In an already fully corrupted world, one in which consumerism holds sway, commercial images provide a standard for production. In an administered world such as our own the purpose of aesthetics—the awareness of artifice, the appeal to pleasure, beauty, and imagination—is a necessity in its own right.[6] It cannot be harnessed to another purpose. The sites and sights of "resistance" are almost gone. But aesthetic effects still provide a momentary disruption in the cycle of sheer consumption through the very undirectedness of artistic work. The negative, critical charge has diminished. It depended on rhetorical and actual strategies of opposition, both of which have faded. That rhetoric has gone formulaic. The oppositional resistance has become aligned with entrenched interests, including its own. Artwork termed "political" often serves a stabilizing function, helping to maintain the cultural status quo.[7] The twilight in these works announces a change, one that has been long in coming but now falls fast. Recognizing the character of this new art, how can we respond to its condition—and ours?

2. Reawakening and Imagining Otherwise, Again

T. J. Clark's *Farewell to an Idea* is a melancholy book, and its appearance in 1999 marks a striking milestone in late twentieth-century art history. Sadly self-conscious of the end of the utopian dream of a particular modern agenda, it embodies for my generation the crash-landed trajectory of an important critical approach to modern art. For those of us formed intellectually in the shadow of Greenbergian modernism, Clark provided a way to think beyond the sterile formulations of formalism and arrive at a sense of the social purpose of even the most esoteric aesthetic practices.[8] He offered scholarly evidence and principled justification for the belief that modernism was more than a game of forms, more than mere rhetoric of opposition, and more than a way to glamorize a rarified product for an elite consumer market.[9] Clark countered description of style with analysis of substance, superficiality with argument, and cynicism with moral conviction. He also countered orthodoxy with subtlety. These are all nobly useful principles. But the funereal sadness that pervades Clark's book suggests that though these contributions may have successfully (even monumentally) shifted the critical ground on which we have understood the past, they may no longer serve to assist us in the present.

Clark's major theme is that modern artists tasked themselves to "imagine otherwise." That cry echoes now with considerable poignancy. For Clark is the figure who took modern art and its autonomy and redirected it towards a historically grounded cultural activism.[10] Clark demonstrated the extent to which those claims to autonomy within later twentieth-century art practice and its critical reception were themselves a part of cultural processes of compensation, recuperation, and ideological production. Clark re-examined the older terms of modern art and found in them new potentialities, demonstrating for us that it might be possible to take seriously the notion that to "imagine otherwise" was a potent act of cultural discourse. But at this historical moment, the beginning of another era clearly trumpeted in the millennial hype, do these premises still hold?

Underlying Clark's characterization of modernism as a radical belief system was a faith in the socially transformative potential of art as an activist cultural practice.[11] If artists could function within a political sphere through their intervention in symbolic cultural discourse, then one could believe that their energies might be joined to an effort in which the unchecked forces of

rampant capitalism might be brought to account.[12] For the utopian dream that underlies Clark's work—and that of the artists' of whom he writes— is that the social order wrought by capitalism might be transformed. If it could not be overthrown by radical revolutionary activity, then at least its policies might be modified—either by progressive measures or by acts of strategic intervention—and that art had a part to play in bringing about this change. Experimental, avant-garde "art" wasn't necessarily supposed to do this single-handedly, yet this mission provided a compelling justification for fine art.

But the stance of aesthetics-as-politics was often two-sided. The appearance of radicalism cloaked the careerism of many artists.[13] The rhetoric of opposition often allowed elite practices to pass themselves off as politically useful. Tendentious activism marked its distinction from normative, consumable discourses of mass media culture through deliberately adopting obscure and difficult visual and verbal means. In the process of secularization that came with cultural modernism, aesthetic and artistic activity came to substitute its own forms of salvation for that of religious redemption, moral improvement, and spiritual transformation—but according to the same model of faith-based energy. The efficacy of these two belief systems—"political" aesthetics and religious faith—is much the same. Each believes that intervention in and through symbolic formations can have instrumental cultural effect. The limits and qualification that have come to limit the belief are many, even as the project of redirecting the course of capitalism's reach has proved difficult, if not impossible, however much we may still want to hope otherwise.

The impasse met by such belief didn't originate in response to Clark, nor is the continuation of such belief systems to be attributed to him. But the bald fact is that the oppositional rhetoric of radicality in fine art and criticism has become formulaic and academic in the worst sense. Esoteric works, often highly illegible to any but a few insiders, are assumed to serve as the radical conscience of the culture. This model of current criticism pervades the art world with its galleries, museums, auction houses, alternative and mainstream exhibition spaces, publications, sales, and subventions. It dominates graduate schools in fine arts and programs in art history. And this discourse has been so blind to its own pernicious limitations that its mere survival is itself a marvel.

But the institutionalized domains of power replicate such discourses as

part of their daily activity. The publication of every bit of wall text and cat-alog copy, the hiring of every new eager recruit, the anointing of yet another young aspiring artist—every act is part of the replication of the social re-lations of production. The departments of art and art history (and of mu-seums, galleries, and publications) that operate at the perceived center of power continue to self-select toward the conservative versions of old mod-els of thought—the academic party line—even as these are self-characterized as radical. The many regions of this empire are peopled by artists who si-multaneously desire to dismantle and to be taken up by these institutions. The phrase "my work is a critique of" figures regularly in artists' statements, as do the equally meaningless bromides in critical writings about the "trans-gressive" or "subversive" character of an improbable array of visual works.

If we take seriously the task of "imagining otherwise" in a contemporary context, then it means being willing to make some rather unwelcome ob-servations. So be it. The end seems to merit the means. So much is at stake. If genuine alternative culture is to have any chance for vitality, then the terms on which it operates have to be rethought. This includes the task of serious reflection on the assumptions on which criticism operates. Academic cul-ture has become as much the enemy of independent alternatives as the cul-ture industry. The former continues its outmoded case for opposition, neg-ative criticality, and esoteric resistance. But artists in large part are working in recognition of their relations of compromise and contradiction, their more self-consciously positive—or nuanced and complex—engagements with the culture industry. A certain risk attaches to flirting with the potent instruments of capital. Artistic practice is always charged with a treacherous task when cultivating a dynamic relationship to mainstream power. But the dialectics of that relation suggest a mutual necessity that persists, even now. The assumed values of administered culture and the insidious technologies through which they function have become invisible to us. We don't even per-ceive the constructedness of the world we inhabit.

Throughout the period of modernism, art was construed as "other." We could substitute the phrases "other than the state," "other than religion," "other than commerce," "other than the culture industry" among other practices and institutions.[14] What the exuberantly engaged and reoriented work of the 1990s has begun to make clear in new ways is that modern aes-thetics always benefited from that supposed "otherness" and returned a benefit as well by affirming certain key tenets that undergird the status quo.

At any given historical moment such relations have a specific form, and aesthetic manifestations use their formal and thematic means to signal this specificity. Fine art was always dependent on and in some ways beholden to mainstream culture—Greenberg's "umbilical cord of gold."[15] Complicity suggests mutual gain. This relationship is not direct or unmediated, and not obtained through a simple sellout but via a complicated set of interconnections. The "other" was never outside of culture but was an integrated component of its values, systems, and operations.[16] This insight doesn't spoil the game. It renders explicit some of the terms on which it has been operating. Political rhetoric and the stance of resistance became, like other attitudes, material for artistic expression—and as able to be sustained in their claims as the tenets of any other faith. But they must cease to be the trump cards of a marked deck. Artifice, the very essence of artistic activity, is the potent instrument of insight into the machinations of the real and to the constructedness of the "real" within the shared imaginary of any culture. Making that experience into formal, material expression creates the cultural legacy and memory that is art.

Some of my critics (the first versions of this manuscript elicited extreme responses on both sides) will accuse me of cynicism. I don't see this. I can't imagine how pointing out the hypocritical inadequacy of current thinking and the need to move beyond the impasse into which the academicization of old modern avant-garde has placed us can be construed as cynical.[17] Pointing out that this impasse exists can hardly be news to anyone even if it's been convenient for many people to ignore it. Nothing stands to be changed. Except the way we talk about what we do. And think about it. And conceive of its efficacy in the world.

So we arrive at a moment when the most crucial thing to "imagine otherwise" may be the critical foundation on which that imagination itself is premised. Nowhere am I suggesting that the culture industry, once deemed the devil incarnate, is now our new best friend. Nor am I pretending that the politics of independent or alternative thought should be abandoned. Quite the contrary. My reason for writing this book is that it seems glaringly, even terrifyingly, apparent to me that the terms on which avant-garde orthodoxy and its intellectual descendants have kept a rhetorical flame alive have blinded us. A flagrant, and even hypocritical, connection exists between supposedly oppositional discourse and repressive power structures in academic and cultural institutions. The rhetoric of radicality serves to

replicate those very structures that reproduce the social relations of production *as* a status quo. The intertwining of the mythic values of a fine art and supposed criticism with the culture of late capitalism is a reality to which we need to wake up. And about which we need to begin to think differently, if we are to preserve any power of imagination—whether for spiritual, personal, aesthetic, or political ends.

If we return for a moment to Crewdson in light of this rallying cry, then what can we extrapolate from observation of his work? What features of his attitude are fundamental to a new criticism of aesthetic objects?

First, although the concepts of purity in regard to a medium, once central to modernism, have been jettisoned in favor of an approach to facture as a complex, multivalent core of artistic production, formal approaches got thrown out with them. Artifice and constructedness are the catchwords of recast notion of complicit formalism. The photograph, in Crewdson's case, is hardly a document of the real. Nor is it a formal play of light and dark arranged on a surface. It doesn't even index an actual event, but rather, plays with the inconceivable unreality of a staged image, daring us to believe in the fantasy it projects. Often contradictory, always indexical and complex, the formal properties of such new works are dynamically, markedly impure.

Just as we can trace a shift between modern purity and contemporary complexity, so we can also see how the notion of autonomy, which was central to modernism, was displaced by contingency, and now by complicity. Postmodern critique, marked by strategies of appropriation and contingency, inscribed an arch ironic distance to both making and representing. But in the place of this diffidence and disdain, a distinct mood of engaged, expressive affectivity has come into play. Crewdson loves his sources, and he clearly aspires to have his own work approach their condition of production in every way. We may imagine, or want to project, some edgy distance into this relationship, but the evident admiration will not dispel no matter how rigorous a censure we introduce. Critical opposition and resistant aesthetics, so intimately bound to the principle of autonomy, have been replaced by a reflective, self-conscious artifice.

Instead of imagining that works of art either resist or (in another image of hardness and boundedness) reflect contemporary culture, we can imagine instead that fine art embodies our perception to shift it out of phase. No work of fine art is ever finished, never in a condition of static completion. We intersect with works of art in a specific historical moment, our own, even

as a work's capacity to elicit response changes as it moves through a historical continuum. We respond to Crewdson's images because they seem familiar *and* unfamiliar. They remind us of B-movies or gothic tales we might have seen, but not ones we can recover in their entirety. They never existed intact. These are provocative reminders of a shared, vague field of references. The seamless image, made according to production values that Crewdson appropriates from of image-culture, shatters along the fault lines of an out-of-phase and not-quite-in-synch representation. The image we see doesn't function autonomously. We don't respond only to the thing "in itself" as if it simply offered meaning unequivocally. Instead, these images are a means of mediating our relation to other images, past and present, in zones from fine art to vernacular and popular culture. When such works have as high an aesthetic valence as those of Crewdson, are as consumable in their repulsive-but-appealing tension, then they resonate profoundly through our shared cultural knowledge base.

Crewdson also shows dramatically how aware he is of his own compromised condition. He knows he is an artificer, and thus he also calls attention to the discrepancy between "art" and "real" (the constructed-ness of the latter being only evident through the machinations of the former). Clearly seduced by the artfulness of his own art, Crewdson doesn't flinch from acknowledging his allegiance to major systems of cultural production on which the specific character of his work relies. His exposure of this particular "bad faith" is what allows the critic to be honest, for a change. This admission of complicity, in which self-interest plays a part, rather than a claim to "resistance," or "aloof separation," or "distance," is the starting point of critical awareness. We are all within the ideologies that artistic means bring into focus and form.

Works of fine art provide a point of purchase on individual experience within cultural and historical circumstances. They take the ineffable, ephemeral, and transitory nature of subjective experience and make it over into representation. They preserve and communicate cultural values as memory within a continual process of historical change. The artistic act is fundamentally constitutive—not of things, objects, images as self-identical or fixed forms—but of formal expressions that provoke interpretive response. Fine art is thus always transformative. And the role of contemporary criticism is to read the specific character by which these transformations appear to us in the form of new aesthetic objects and practices.

2

CURRENT CONDITIONS

Taken at face value, contemporary art often seems improbable, even unten-
able. How can a room filled with store-bought items, trash, mass-produced
images, office furniture, string, a naked and self-mutilated body, a single
plywood panel, a mass culture icon, pages torn from mass circulation mag-
azines, or any of the other items identified as "art" in the current climate be
considered anything but detritus—or some extreme version of the em-
peror's new clothes? Such work has obvious roots in dada, pop art, concep-
tualism, arte povera, and postmodernism. In these movements artists used
found, appropriated, and/or ordinary objects to question traditional tech-
nical proficiency. Conceptual issues replaced formal accomplishment. But
the relationship of the production values of works to their symbolic value
continues to be a key factor in the function of fine art as a distinct category
of cultural activity.

At one extreme, then, much of art exhibited in contemporary contexts seems to have abandoned all relation to traditional craft or skill. But these same gallery and museum spaces contain pieces that are virtually indistinguishable in their imagery or material form from objects and icons of mass media or consumer culture. Slickly produced works with high production values and prepackaged imagery recycled from the realms of culture industry, made of material or objects bought in malls and outlet stores or put on display using modes copied from the highest end showroom environments all show up as regularly as do the "unconstructed" works that flaunt their disregard for conventional art-making techniques.

THIS CONTRAST OF EXTREMES in attitudes toward production seems to correlate with another striking feature of contemporary art: the discrepancy between its continued viability as an industry (economic and cultural) and its house-of-cards improbability. Much of what is traded or given credibility within this arena of activity seems not to merit a second glance, let alone be suited to command intellectual respect or a high price tag—or is indistinguishable from the artifacts of advertising and consumer culture. Between the Scylla of the barely crafted object and Charybdis of appropriated mass imagery, modernism's living legacy and postmodernism's critical claims seem perilously endangered. Given all this, how is the industry of contemporary art sustained? How might we understand the ideological values embodied in these works—and how they help keep fine art alive as a discrete category of cultural activity?

Modernism's own self-reflective gaze brought the conventions, institutions, and social practices particular to fine art into focus. Marcel Duchamp and Yves Klein articulated the framing strategies whereby fine art is identified and functions. In recent decades the extension of their approaches in conceptual and postmodern critical work has increased our awareness of the way fine art objects are constituted at the intersection of symbolic discourses and social practices. Such analyses have not done away with fine art, and if anything, many such "critiques" have come to be as much a part of the stock-in-trade of ways of art-making as traditional woodcarving or casting once were. But useful as it is to note Duchamp's naming, signing, indicating strategies as definitive in establishing an artwork's identity, the deeper shape of ideological values in current work can't be apprehended through those rhetorical devices alone.

Obviously, as a system of specialized activities, fine art serves important cultural functions. Mythic, steeped in ideology, and as aligned with many mainstream cultural values as advertising and mass media, fine art is nonetheless distinguished by the conditions of its production and circumstances of reception. We always receive works of fine art within these established frameworks and thus are prompted to read them with regard to key issues: individual subjectivity, the fetishization of work and labor, and the value of symbolic discourse as a site for cultural activity.

Contrary to the ideological mythology of modernism's critical legacy, fine art does not function through autonomy, opposition, or other formulaic categories of negativity such as "subversion" or "transgression." Simple binary oppositions—ideas/form, fine art/culture industry, critical/ compromised, negative/affirmative—no longer provide the basis on which fine art's identity is grounded, if they ever did. I would hasten to add that much that can be said about contemporary art holds true for much of modern art, and especially those works left out of the standard canon of modernism (in the twin trajectories of formal innovation and avant-garde rhetoric). Quite a few artists work with the awareness of the critical ambiguities of their situation. A recognition of fundamental compromise is apparent in the conceptual-formal terms on which much contemporary work is based as well as in the thematics of imagery, materials, and production methods through which it finds expression.

But perhaps the key conceptual distinction on which fine art's identity depends is its capacity to produce symbolic value. Symbolic value can only be perceived in material expression. The symbolic currency of contemporary art draws on the fullest possible range of current and historical artifacts in ways that are embedded and entangled in conditions of complicity.

1. Symbolic Currency

Vanessa Beecroft's Show series features fashion models in various states of undress. In one work in this series, the young women stand in a tightly arranged, almost military, formation in the midst of a gallery. They are clad only in skimpy, black undergarments and high heels. In another, they wear short, tight, long-sleeved, high-neck sweaters but nothing below the waist except for their black stiletto pumps. In yet another, lace thongs and bare breasts comprise the formal elements of the scene. Expensive to produce,

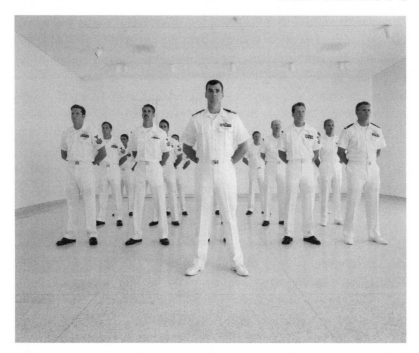

1 Vanessa Beecroft, VB39, San Diego Museum of Contemporary Art, California, 1999. Photograph of U.S. Navy Seals performance. Copyright 1999 Vanessa Beecroft, Image courtesy of the artist

these ephemeral performances fly in the face of feminist political correctness and highbrow good taste. This parade ground choreography is performed by Navy Seals in another variant in this series. Here the exploitative use of female nudity is replaced by the subtler shock of seeing a military unit deployed for gratuitous display (fig. 1).

Fashion was the buzzword for art of the mid-1990s. An affair that passed, like the wave of affluence which it rode, this art world fixation seemed compensatory. The longing of the unstylish sibling to compete with the trendy glam-queen whose equally ephemeral modes seemed so much more consumable, attractive, alluring. But what is Beecroft's work about beyond the immediate response it generates (of dismay, titillation, amusement—depending on the mood and disposition of the viewer)? Is this art? Or just opportunism? Or does its approach deliberately make this distinction impossible?

Beecroft's work is highly successful—if success is to be measured in conventional terms. Her pieces are regularly exhibited to critical acclaim in galleries and international art fairs, from whence they are sold to major collections, thus passing through the mediating gateways of the art world to become canonized as important work of our time. From the point of view of certain art world insiders, these pieces are considered innovative and aesthetically seductive. From another, equally informed, perspective, this work is opportunistic, trading on the worst habits of gendered cultural politics. But from the "outside"? Beecroft seems to supply a perfect of example of work that creates amazement that contemporary art continues to function at all given the almost mind-boggling character of such work.

Beecroft's Show works read as exploitative to many critics.[1] The use of women as display objects has all the conspicuous sexual biases of patriarchal traditions combined with the sensibilities of an industry that is notoriously destructive to (especially young) women's self-esteem. The trivial, superficial glamour of the women gives off the slick aura of Las Vegas call girls. But to characterize this work as a critique of crude pandering to sexual appetite or as a statement against the industries that gain their dubious livelihood through exhibitionist techniques would be extremely difficult. These are works of spectacle, made for consumption. Whatever the effect might be of reading these assembled bodies in the framework of a "critique" of culture industries (and this would be a stretch), the show of fresh flesh conforms to fashion, replicating its attitudes without evident critical distance.

The models stare into space, avoiding eye contact, but they are unequivocally there to be looked at. Aesthetic objects, their existence is predicated on their consumable visual form. In no way can these images be read as "a postfeminist critique of the catwalk" or as a devastating subversion of "the beauty myth," as Sara Adams tries to suggest in a loophole of rhetoric.[2] Working women, the models are hired for these events. No individuality attends to their presence. They aren't redeemed in a narrative of sentimentality, brought into human focus by good deeds or warm hearts. They stand stark, alienated, unflinching as the materials of Beecroft's compositions. When Yves Klein engaged women models as the paintbrushes for his *Anthropometries* in the early 1960s in Paris, the settings were no less formal than those in which Beecroft sets up her models. In one instance, Beecroft had use of a highly theatrical hall in the Ducal Palace in Genoa. Klein's work has

been criticized as an ultimate gesture of sexist machismo. Beecroft's? Money and power are everywhere in abundance. Her photographs of the stagings are as technically sophisticated as money can make them. Does she love this "world of fashion, feminine stereotypes"—or read it critically in order to show us "the model as machine lacking subjectivity"?[3] What if the answer is *both*?

Works of fine art are capable of sustaining contradictions, performing oppositional or resistant functions while simultaneously serving mainstream interests. Fine art frequently is also both what it *claims to be* (independent thought, discrete from other forms of cultural expression, a separate domain of alternative values) and what it *pretends not to be* (bound up with the values of the status quo and the ideological system that sustains it).

Jerelyn Hanrahan's Gesture As Value project makes a strikingly useful contrast to Beecroft's highly capitalized performance installations, though both artists are engaged in similar moral ambiguities about the social value to which fine art lays claim through its enactment of symbolic presentation of economic value.

"What if: instead of money, you could withdraw a personal expression?" That question stretches across a strip of paper, a generic Xeroxed reproduction, and serves as publicity for the project, which viewers accessed through automated teller windows (fig. 2). Thus dollar-bill-sized works contributed by various artists were dispensed from ATM machines as a "valuable commodity." Passing and ephemeral, the project nonetheless had international scope since it was installed in various locations in the United States and Europe.[4] The overt theme of this fleeting instance of new conceptualism is the transformation of personal gesture into currency that can be put into circulation. Personal gesture transformed into a commodity is the basis on which works of fine art function as rarified objects. Obviously aesthetic value, however defined, is a crucial component of this equation. But less obvious is the way *economic* value is reinforced by the mythic concepts that promote *aesthetic* value: the ideas of the individual, rarified labor, and the auratic object bound up in material form.

The Gesture as Value project plays with these notions. The artwork "receipt," a slip of paper with its Xeroxed image declaring the "value" of art as currency, is about as *ordinary* an item as one can find on the streets of any city. The giveaway artworks that conform to the dollar-bill-sized requirements of the ATM might have been exquisite gems of original artistic ex-

2 Jerelyn Hanrahan, *Gesture As Value*, 1998. Transaction in Bern, Switzerland. Courtesy of the artist.

pression, but they were made with an emphatic disregard for—even denigration of—production value.

Auratic value was much debated in famous exchanges between Walter Benjamin and Theodor Adorno in the 1930s.[5] Benjamin welcomed its demise, perceiving progressive forces in mass production and media. Adorno felt aura was reinforced in the contrast of mass-produced and unique objects. History has borne this out. The auratic and economic values clearly reinforce each other, as the daily activity of auction houses and galleries attests. But the link between mass culture's objects and those of fine art is closer in tenets of belief than either Benjamin or Adorno could have imagined.

Long-held academic wisdom suggests that modern art gained its identity in contrast to mass production.[6] Methods of production pit artisanal and

industrial modes in supposed opposition, keeping fine art and mass culture objects distinct. Most works of fine art still bear conspicuous signs of their making; even if exceptions to this general rule could be cited—the fabricated works of minimalist sculpture or pop art's silk-screened multiples—Beecroft's materials are those of a highly refined, hardly artisanal, industry. The milestone in the transformation of this attitude was conceptualism, and Beecroft, like Hanrahan, trades in ideas, not materials. But what about the belief system that both mass culture and fine art sustain and are sustained by?

The fundamental cultural values validated by "art" activity, particularly in first-world, capital-driven, consumer-oriented American culture, are also the central myths of modern and contemporary art activity. Most important among these are the status conferred on individual imagination and thought, the value of idiosyncratic and fetishized labor, and the capacity to distinguish permitted from prohibited behavior in confrontation with social systems of controls, taboos, and censorship. Other concepts explicitly align with the symbolic discourses of visuality and fine art, such as our notions of history, national identity, ethnic and cultural identity, gender, and sexual politics. In these zones fine art engages directly with broader cultural discourses, not with those questions of form or practice that are its specialized concern. Likewise, ideas of public standards and private taste, mutually defined in contestations over censorship limits and free speech issues, are often brought into focus by provocative works of fine art.

But concepts of agency and genuinely effective politics seem entirely mythic, even earnestly naïve, in a world in which Beecroft's performances command significant attention. When her work gets redeemed by a "critical" rhetoric, the effect is clearly straining our capacity to take seriously the idea of Beecroft as engaged in any kind of "oppositional" practice. Sara Adams's statement that Beecroft seems to be "looking for individuality within a sea of conformity" seems rather like wishful critical projection.[7] We simply can't find a formulation adequate to Beecroft's work within those oppositional terms.

Questions about the troubled status of individual identity may lurk as critical questions in Beecroft's work (highly unlikely), but the overt text is that a work of fine art can command high-price-tag resources and compete with the power of the fashion industry on economic terms, turning its material for consumption into another, even more rarified product in the form

of images. Fine art is kept alive on rich bullion because the values reinforced through artistic practices sustain the basic myths on which free market economies and the ideologies of "democracy" function. As a full-blown symbolic activity, fine art functions more effectively as a site that reinforces the consumption-oriented display-driven world of contemporary mass culture. Beecroft aspires to be part of the fashion world, even as her use of models and military formations echoes again and again the very motifs her critics would like to see her calling into question. Surely she calls to our attention the situations she is quoting. But the symbolic function of bracketing, of citing and thus attending to links between capital, marketing, and military parade, is equally matched—even outstripped—by the celebratory participation in that same world. To label her work "co-optation" suggests a pejorative judgment based on precisely those standards of negative criticism that her pieces in fact outstrip. To suggest that Beecroft has fallen from a condition of oppositional grace is absurd. To propose a critical reading that validates or sanctions her gratuitous and eager engagement with the corrupt practices of exploitation she is using would be perverse. Better to suggest that this work is compromised by its allegiances from the outset, knowingly, and then ask what we are to do with that insight.

Such pronouncements suggest that fine art is embedded in the very value systems that the avant-garde was traditionally assumed to oppose. Opposition is almost always opportunistic, momentary, and transient. Artists who succeed in establishing a "critical" voice are often caught up in the familiar process of recognition and acclaim. Early twentieth-century artists such as the dadaists and futurists tried to do away with the identifiable image of individual talent through strategies like Tristan Tzara's chance compositional methods or Duchamp's readymades. Later twentieth-century artists continued this strategy—think of Andy Warhol's affectless appropriations or Sherrie Levine's critiques of artistic originality.[8] All of these instances conform to the avant-garde denunciation of the bourgeois concept of the artist. These very same artists pronounced the death of auratic objects even as they created their own brand-name products for the fine art marketplace. Signature works of fine art are simultaneously at odds with and sustained by the precepts of opposition. Through one and the same sets of gestures, Beecroft and Hanrahan, though at opposite ends of the spectrum of capitalization and canonization, seem to participate in the corrupt world and also show us how corrupt it is.

Thus their work suggests that fine art is in a condition of aligned self-interest, even as it functions with equal force to offer insight into contemporary culture. The fundamental contradiction at the heart of contemporary fine art, therefore, is that it is simultaneously *complicit with* and *alternative to* the ideological values of mainstream consumer culture.[9] Fine art shouldn't be condemned to the trash bin of ideological bad faith. Not at all. But keep in mind that fine art operates as a successful industry because it serves the status quo. Works of art create a set of standards on which "value" operates. The esoteric practices of fine art calibrate symbolic activities in much the same way that gold standards work across a spectrum of economic activities: fine art ideas establish a metric, a scale for assessment. But such work is *complicit* because at the same time that it seems to operate on the basis of inherent values (as gold seems immune from crass commerce, somehow valuable in its own right) it reifies many of the most conventionally repressive values of contemporary culture (such as the mythic idea of individuality). As an alternative form of symbolic expression, fine art appears to operate in critical relation to the values of the mainstream. But in fact, it functions as hegemony's most loyal and useful "opposition."

The co-optation of the avant-garde into a set of promotional marketing strategies has a history almost as long as the avant-garde itself. Why, then, does the rhetoric of oppositionality, of "political" art, persist in contemporary criticism?[10] The concept of symbolic value is well served by contemporary art. Go back to the images on which this section opened. Imagine a pile of string or a room containing a trash heap or a group of nearly naked fashion models. How can these have economic value beyond their acquisition, rental, or removal fee? Fine art confers value through its symbolic *discourses* rather than through production.[11] Far from "getting away with something," works of fine art demonstrate an important principle. Hanrahan's "gestures" contain so little manifest value of any kind that they operate in the service of what might be the most important feature of capitalist ideology: *the idea* of value. Lest this become too abstract, return to the image of Hanrahan's "objects"—and their bid to substitute a conceptual work for a financial instrument. The idea of "currency" takes on another "value" immediately.

By appearing to be entirely aesthetic (its forms and expressions entirely contained in the visual appeal to the senses and lacking in any prescribed or circumscribed purpose), fine art sustains the concept of value as a notion by pretending to be autonomous. The "value" of a work of art is never to be

accounted for in the cost of materials and labor or in the investment in production. Fine art appears to be far from the crass worlds of commerce and remote from the realm of factory production. Fine art distances itself from the systems that in turn exploit these myths to advantage. Art is not a shell game or a poker bluff, but an assertion of the symbolic basis of value production. Thus it must be aligned on some level with mainstream conditions to operate within them.

In Gesture as Value (for example, the version *Transaction in Berne*), the work plays with expectations about the role and identity of currency but also struggles to distinguish itself as rarified. The artist wants to use the system she is critiquing and wants to substitute the value of the small paper artworks for the values of currency. "See," they say, "I am not money, I am better than money, I am art—a personal gesture, not a form of 'common' currency." But the artwork also says, "I am worse than money—I pretend to be something I am not." They show that value depends on systems of circulation. Fine art systems function like those of other signs, establishing value in relative terms. Nothing intrinsic inheres in a fine art object (beyond the obvious original investment in materials)—value depends upon circulation.

But doesn't fine art communicate the values of personal expression rather than those of commercial interests? So the mythology goes. Here again, Gesture as Value calls this bluff by making the two interchangeable. But by sustaining a moral judgment, this distinction conceals the economic and social efficacy that is performed as a result. Although it sounds tautological and reductive to say so, one of the functions of the distinction between fine art and mass culture is simply to maintain the border separating them. Gesture as Value inserts itself into the familiar systems of currency distribution, in Wall Street and other financial districts, in order to interrupt the usual business of ATM machines. These were not "subversive" interruptions but announced and identified ones, thus carefully respecting the lines that were being "transgressed."

As a final point, the humor of Hanrahan's piece deserves attention. Humor mobilizes those techniques of "epistemological de-familiarization"[12] still vital as the legacy of the avant-garde. The work takes you by surprise. What *does* come out of the ATM machine? And what does that mean? Hanrahan's piece is "cultural capital" in the literal as well as figurative sense. Without the art object—even something as insignificant as Hanrahan's slip of paper, the art value couldn't be sustained.[13] The use of this value, the sym-

bolic currency that fine art possesses, resides in its capacity to show the machinations of value production, not in any overt "political" statement. Thus we confront the mythic notion sustained within a certain line of critical thought that intervention in the symbolic order was in itself a politically efficacious act. Perhaps the single most important function of art is shown to be just that—mythic. We should keep in mind that "mythic" does not mean "unreal" but rather points to the realm of symbolic discourse in which representation constructs our shared, imaginary sense of the real.

There have been very few instances in twentieth-century politics in which the manipulation of cultural symbols or the resistance of art groups working within or against the symbolic altered any single aspect of the structure of power. The Soviet agit-prop trains, situationist activities immediately prior to 1968, or the publicity campaigns of ACT UP, seem to offer compelling counter-examples.[14] But these are moments in which the symbolic functions of visual art surface in public awareness or claim attention in a public sphere, so they serve as touchstones for issues crucial to the social structure of power relations. Symbolic discourses are real domains. We know this. Contested images have brought test cases into the legal system. Robert Mapplethorpe's photographs and the *Sensation* show, with its heretical-seeming images and explicit sexual themes, engendered battles with real world outcomes.[15] Until they are violated, protocols of decorum seem almost nonexistent in jaded, secular Western culture. Fine art is a site of cultural power struggles. The consequences have an actual impact. David Hammons's publicly displayed billboard of a blue-eyed, blonde-haired Jesse Jackson made a creative act into a civic dispute, raising its thematic and formal concerns to a high stakes contest with a visible profile. But visual and verbal representation are most effective in those arenas in which symbolic representation is an *instrumental* activity—such as in identity politics, free speech issues, or censorship limits.

Works of art can provoke public debate in a broader sphere and participate visibly in controversial issues that have policy and legal implications. Certainly in the case of AIDS the activist efforts of art world organizations and individuals contributed significantly to public awareness—with real world results. Fine art finds its strongest "political" identity as a player in the development of public discussion and opinion.[16]

The term "political" has been used to mean everything from "transformative" (a term that suggests almost magical powers), radical revolutionary

activity, to progressivism, to the resistant esotericism of technique advo-cated by Adorno.[17] The difficulty of mapping older art historical models onto contemporary activity comes because the conditions on which agency, opposition, and revolutionary activity were conceived within those earlier political models no longer exist. The locus of power was once identifiable in centralized, nationalistic, generally urban concentrations.[18] But where is that locus of power in advanced, transnational capitalist economies? Power resides in the capacity to control real or fictive capital, its movement, and ex-change, and the symbolic forms in which hegemony is sustained. There is no Versailles, no City Hall, no State House, no public square, and no local factory that can be targeted for protest. In contemporary culture, with its flows of capital and tensions between multinational interests and residual structures of nation-states, power is always elsewhere by definition, since it resides in no single place and is controlled by no single system. The urban setting, which was so central to the avant-garde and modern proj-ects, no longer functions as an effective staging area (think of the recent media blackouts of massive demonstrations against the United States' war in Iraq or of protests against the WTO meetings).[19] Inner cities are dead zones, the margins of economic centers are too expensive to support artis-tic communities, many artists live disenfranchised lives—others live suc-cessful existences as professionals or academics. Some have political prin-ciples. Others just want to make things that sell in a rarified market. Hypocrisy kicks in when success is perceived as anathema to the purity of "political" purpose—especially since "politics" is generally just a term iden-tifying a thematic flavor in an esoteric work.[20]

The "alternative" site of art is one move in the broad game of cultural hegemony. The career trajectories of artists, curators, and academics par-ticipate in this game. But alternative discourse is largely a managed dis-course, usefully symbolic, and largely ineffective on an instrumental level.

To say that the art world is a long way from revolutionary politics is to make a pronouncement so naïve-sounding as to be painful. And yet, the per-sistence of mythology requires such bald assertions. Fine art should be re-lieved of the requirement that it function as a so-called "political" instru-ment of opposition. Recast fine art as a cultural practice of complicity—and its imaginative possibilities expand. Such a reoriented aesthetics escapes the predictability and formulaic repetitions that obtain within the coercive agen-das of an academic avant-garde rhetoric of radical opposition. Fine art gives

form to expressive, imaginative gestures, demonstrating that value can be created in symbolic discourse. The function of aesthetics is to understand the way thought appears and is preserved in sensible form. The work of art is to create such forms. That act constitutes its only alterity. To expect—or worse, prescribe—that fine art should conform to oppositional or alternative positions, either through formal difficulty or thematic content, misses the fundamental point: the making over of experience into imaginative, symbolic expression is an act of transformation. The spectrum of rhetorical devices stretches from the "making strange" to the "reification of the truly normative" (or, as we might say, from recognizably avant-garde to conspicuously kitsch).

Return for a final consideration of the image of Hanrahan's work—that slip of Xeroxed paper spewed out unexpectedly from an ATM machine as if it were a "receipt." This putting into circulation images as if they were currency withdraws the distinction that sets fine art apart from money. The interchange, or exchange, between the value of an art artifact and a currency value "cashes in" the very idea that art is better than other forms. How can fine art continue to claim special status if it admits that it is "the same as" that most debased of objects, the mere sign and token of exchange of capital? The "gesture" that gives art its cultural "value" also shows how tenuous that value structure is.

2. Complicit Sensibilities

Robert Colescott's voluptuous 2001 painting, *Tastess Lik Chickens*, provides a vivid instance of the integration of painterly traditions and contemporary issues (plate 2). The sensual pleasure exhibited in its painterly reworking of fine and mass culture imagery expresses an active engagement with the world of which it is a part. The painting is not an expression of oppositional negativity—even though the iconographic program reveals an edgy play with stereotypes plucked from the culture with a pointed commentary in mind. A range of symbols are strewn across the surface: hamburgers, bodies, a light-bulb sun, a row of small pyramids, and a heart pierced by an arrow, a black-faced figure, a red-skinned woman, and a white-faced man swimming in a quilted landscape. The painted surface is alive with color. Streaks of pigment barely tied to any figurative referent interlock with decorative motifs created out of specifically recognizable visual forms. The

cartoonish lines describing the central couple barely separate their outer boundaries from the surrounding mass of red that dominates background and foreground. The ambiguity of spatial specificity bespeaks a modern lineage going directly to Gauguin's tropical works and the hot renderings of Matisse's studios and interiors.

Although the painting is irrefutably related to high modernism in its formal credentials, the painting's title shifts its reference frames toward the vernacular. Colescott's work emphasizes stereotypes, flaunting the interracial relations of the naked, romantic couple while the words of the title lilt across the upper edge of the canvas, invoking sexual and cultural innuendos. The subject matter of this image interweaves popular, vernacular, and fine art motifs. The rows of bobbing hamburgers and the plump heart with its bright-toned reflective high-light are from a distinctly mass culture universe, while the worn shoes of a figure whose outline comes and goes in the painting might claim some relation to those pictured in Van Gogh's famous work. A stew, a mélange, a gumbo of approaches, all interlink in the whole while keeping the disparate elements before a viewer's eye. Critical and frankly celebratory attitudes are intertwined in this work, and the exuberant celebration of erotic, romantic love gains energy from the vigorous brushed surface and its display of strokes that exhibit their painterliness with conspicuous intention. Joyful and contradictory, the work is as keen to pull out all the stops on its aesthetic capabilities and expression as it is to slap public sensibility in the face with a confrontational image of mixed-race intimacies. A powerful urge to participate in contemporary life charges this work—even as it calls attention to the grotesqueries that characterize contemporary Western culture in many ways.

Colescott is exemplary of those contemporary visual artists, especially from the 1990s onward, who flaunt their enthusiastic fascination with mainstream visual and material culture. The expressionistic figurative approach that characterizes his work was much celebrated as "new figuration" in the 1980s reception of particularly German and Italian mostly male artists. But in the 1990s Colescott's work received a good deal of attention. This is not "new figuration" reheated.

Part of the vibrancy of this work derives from its reengagement with historical precedents whose figurative, narrative, and/or commercial roots had thrust them to the margins, outside the consideration of dominant theoretical paradigms. What had been off-limits? Attitudes as much as specific

iconography or approaches to production. The sensibility that distinguishes new work is its affirmative orientation, one in which the distance once considered so fundamental to artistic and critical practice is replaced by a reversed polarity of engagement. Such work can be and often is "critical" in its expression of alternative or independent thought. But the work has a positive spin, revealing its own enthusiasms and engagements, a central feature of that expression.

For this is a sex painting, a work of erotica. Two figures are engaged in intimate exchange. The intersection of their bodies occupies the center of the canvas. Head to head, eyes staring lovesick or lustful into each other's, they are intertwined even as a flow of other figurative forms swirls around them. The stream of burgers piles up behind the man, but he is oblivious. Behind the woman, the pyramids of Egypt link her to the North African land. A bare lightbulb in the upper left corner reveals as much in its undecorated condition, stark poverty of circumstance, as it does through the light that it provides. Other symbols, more and less explicit, connect this couple with religious and social situations. But over and around all of this the bright, red field of activity surrounds the pair with a heated intensity. All the outlined and swirling and partitioned sections of the canvas point inward toward the two; even the plump heart with its cupid's arrow pins them into its double-cushioned shape, itself echoed in the lines of what might be hills, landscapes, limbs, and other real or imagined territories. Whatever else this image might be or however else it might be read, the work is a pop art painterly valentine of sorts, celebrating the capacity of erotic love to cross all manner of boundaries.

In the last decade, theory brought postmodernism into relation with postcolonial thought, transforming relations between once-absolute centers of power and now-significant margins.[21] Colescott surely knows his theory. The painting is filled with references to racial and cultural strife. The historical suggestions and the current situation raise pointed questions. How is identity understood and enacted, performed and replied to, in the complex but also direct exchanges of individuals who both are and are not only "representatives" of their demographics? The painting's graphic lines suggest a cartoon approach to serious issues. The playfulness that arcs through the sure hand and loose drawing style would make quick mockery of self-serious critical considerations, even as they make a pointed case for an inter-related graphical and cultural complexity. Colescott is demonstrat-

ing his obvious and evident engagement with the cultural mainstream. Adoration, envy, longing—all kinds of desires flow from individual artists toward the realms of popular entertainment and its forms. Colescott's visual sensibility is not "outside" but within the visual vernacular and painterly sensibilities of modern abstract simultaneously. We live with mass culture and we respond to all of these registers. The modern myth of the self-evident object has long been qualified by recognition that artworks are embedded in complex perceptual and cognitive relations, themselves inflected by cultural circumstances.

In Colescott's painting the luxuriously opulent and outrageously lush surface and visual effects act as the site of exchanges in which cultural symbols get reworked. Interwoven combinations of familiar tropes and themes from the history of art and their relation to popular forms of expression permeate the canvas. Attending to the *values of form* in such a work is still crucial. "Value" is associated with economic currency, as well as symbolic exchange, but also suggests moral assessment as much as intrinsic worth. For the value of a work of art to be perceived, the difference between fine art objects and those of other realms of culture has to be readable and recognizable. But what is that difference and in what does it reside?

Colescott's painting suggests that the pleasures of remaking imagery offer a commentary on the culture of art as well as on its thematic and formal concerns, but also that the work performs its self-conscious awareness through emphasizing the artfulness of Colescott's visual means. The categories of understanding through which we frame our perception of his work can't be reduced to simple statements about its "politics"—however overt and complex these may be. The visual presentation embeds such polemics in a *painting*. The effect is a transformation of perception in the realm of representation—not of ideology. The painting is an effect, not an instrument. It appeals through the senses, as an aesthetic work, rather than by asserting or communicating an idea outside of material form (as if that were ever possible). And it does not result in direct change in the social order.

Institutional and political struggles brought all the "others" into the game in the 1980s and 1990s. But a certain ghettoization was still frequently reinforced by what Kobena Mercer, writing in 1990 about black art, so aptly termed the "burden of representation."[22] The 1990s saw greater latitude about how the categories of identity may be exercised and how "others" may form their artistic identity in formal terms. Artists intent on playing

with the formal elements across a wide spectrum of visual sources have brought once-shunned visual motifs into contemporary focus. Identity-marked work, a necessary gesture for a first generation of professional artists gaining recognition after long exclusion from mainstream representation, has given way to more nuanced and complicated presentations of identity formation. Colescott's paintings, borrowing eclectically from modernism's masters, commercial culture, and vernacular visual language, are exemplary of a sensibility that no longer requires of its "others" that they make their identity the sole subject matter of their work even as they call attention to the symbolic visual discourses in which such identities are constructed. The ideological character of representation shows clearly, even as Colescott's work eschews didactic superiority.

Because negativity became so much the dominant trait of twentieth-century art (and the outstanding feature of its critical armature), work that celebrates life, expresses faith, or admits to the existence of spirit, even work that sits ambiguously between "critical" recognition and affirmative engagement, has come to be perceived as conservative or retrograde. Among contemporary artists, enthusiasm for the act of making is too often couched in apologetic terms: the pleasure of production—painting, drawing, shaping materials with one's hands, mind, body—is frequently put at the service of "critical" agendas that justify this "indulgence." (Even the use of the word "production" carries considerable baggage here, especially if contrasted to the more traditional "creation.")[23] Work that has a positive relation to experience or imagination is practically prohibited, seen as naïve, Pollyanna-ish, in poor taste, or worse, aesthetics. Why? Is the tendentiousness of affirmation any less constrictive than that of formulaic opposition? As fascism taught us all too well, art that serves an apparently instrumental end is almost always subsumed by its agenda. Artwork conceived primarily as an aesthetic expression never wins the political game if the terms of perception are set in advance—even though "aesthetic" work actually makes the case for the ideological character of all artistic expression. Directed art can only serve, and in serving, be lost or seriously compromised (aesthetically and politically) by adherence to constraining agendas that are easily recognized, reduced to familiar statements, and dismissed as uninteresting art and unsuccessful politics. Art must remain quite useless, not directed toward any specific aim. We know, of course, that we have to grapple with the ideology of that uselessness, not imagine that art is somehow

outside of ideology. Millennial aestheticism admits its ideological complicity, rather than eschewing it through a claim to pure art. The old claims to autonomy have all dissolved in the play of brush and image in Colescott's resonant work.

It seems almost naive to suggest that an attitude based on complicity could be an independent attitude, one that sustains the individual voice within the mainstream. But the experience of creativity as an act and means of intensified perception, one that might create an artifact of memory, should not be circumscribed and qualified. Changing this attitude only requires replacing any lurking, residual attachment to outmoded concepts of avant-garde oppositionality with a viable conception of alternative discourse. Independent culture, individual experience, affirmative vision, critical insight, and creative imagination—these premises underlie work that is productive in positive ways even as they are, as Colescott shows, works that exhibit their relation to mainstream and vernacular culture. (Collective or collaborative activity remains tellingly marginalized, its manifestations largely grouped under the "community building" or "therapeutic" rubric.) Work that admits its unabashed use of a wide range of sources doesn't have to be made only in relation to mass media, but it does function as a testimony to experience within contemporary life as lived, a contribution to historical memory that takes in to account our relation to mass culture. The repression of the false consciousness (and claims) of opposition that have been the dominant illusion of art world ideology have established orthodoxies to distinguish good and bad objects. But in effect, a work may operate with an expression of bad faith and perform a positive, affirmative act. Colescott isn't setting aside his fascination with the machinations of mediated identity or its distortions and fascinations. He is flirting with these forms, picking them up and remaking them in another image. Such affirmation is not conservatism; it is instead an admission of the rather more complicated ideology in which artistic practices participate.

Evidence of artists' positive, if qualified and nuanced, engagement with the mainstream can be found in almost any venue in which contemporary work appears. To test this idea, I took an issue of *Artforum* off the shelf at random as I sat down to compose this essay. In the December 1998 issue were two complementary examples that within a couple pages of each other immediately created a vibrant dialogue. The first was an ad for Richard Prince's winter 1998–99 exhibition at Regen Projects in Los Angeles. The second was

a black-and-white reproduction of a color painting by Karen Kilimnik ac-
companying a review of an exhibition.[24] In the Prince ad, a photograph of
film star Cameron Diaz, with an inscription to Prince, was framed by a black
border in which white drop-out text announced the dates and location of the
exhibition.[25] The effect of the border—cutting off, framing, surrounding
the image—is emblematic of the formal sensibility that appropriates mass
culture imagery within fine art. The gesture is an ironic, if rather flat, com-
mentary that self-consciously reinforces the significance of crossing the line
from aesthetically profane to aesthetically sacred space. A few pages (and
a generation) later, Kilimnik's painting, titled *Princess Di, That Dress* (1997),
reworks a glamour aesthetic into an image conspicuously exhibiting the
artist's "amateur" technique.

Prince and Kilimnik are as likely and unlikely a pair as any on which to
make my case. These two artists are equally exuberant in their unfettered en-
gagement with media imagery, mass culture, and the industries of con-
sumer production that flood the contemporary visual and material world.

The filter of fine art creates noticeable effects. The difference between
these works and their sources within domains of mass, material culture is
clearly marked by the ways they are made and the sites in which we receive
them. But these works also bespeak an uninhibited enthusiasm for the
modes and icons of mass culture. They feed from the same sources as Co-
lescott, though their distance from traditional fine art is perhaps greater.

Prince and Kilimnik's formal rhetorics show, by the differences between
them, how much contemporary art has changed in its attitudes in the last
twenty years. Acts of appropriation or strategies of display have lost their
compelling potency as rhetorical gestures. Recent artifacts are more fre-
quently reconstituted objects that display conspicuous signs of making
(whether these are virtuoso displays of fabrication-level skill, or outrageous
acts of amateurism, or something in between). The rhetorical capability of
formal values is pressed into service—the remaking of these images is a
central argument of the work. The sign of the individual still registered in an
administered world. In the Prince ad we can see the distance he has traveled
between his 1980s cool, postmodern sensibility and the 1990s heat of af-
fectionate engagement.[26] Prince has left far behind the distanced surfaces of
the Marlboro ads and martini drinkers of his earlier, flatter, work. Although
he remains affect-less himself, avoiding any artistic presence in the work,
his choice of imagery indicates an increased bid for attention. Diaz, photo-

graphed in a skintight tank that creates an appearance of utterly consumable nakedness, pushes her young, perfect image outward. She has inscribed her signature with black magic marker across her chest. Not a trace of Prince— in any formal sense of handmade marks—shows up in this work. But a notable increase in intimacy characterizes this image and its capacity to produce effect when contrasted with those with which he worked fifteen years ago. (Did anybody look twice at those Marlboro men? Or the cosmetically slick models plucked from cocktail parties? They were about *not* looking, about a sense that images had been so exhausted by consumer culture that they couldn't produce meaning anymore.) Diaz, whatever else one thinks about her or Prince, projects a compelling image. We can, it turns out, still be *very* interested in looking. Images have seductive power, engaging intrigue, and the artist's capacity to inflect images with new meanings by significant acts of transformation or creation, remaking or making, is still highly charged.

By contrast, Kilimnik's *Princess Di, That Dress* brings the handmade and artisanal back into the formal arena while engaging enthusiastically, rather than ironically, with her media objects. Kilimnik shows us the distance between the media perfection of the original published photograph of Britain's Princess Diana (with all the traces of its original appearance in a mainstream venue) and the small-scale, crude rendering into paint. The very degradation of the image from its original slick condition declares the artists' hand as an instrument of individuality. Everything about Kilimnik's image declares its mediating effect: this is a painting *by* someone, this is an image *transformed*, this is *not the same* icon as that to which it aspires and which it admires.[27] The photographer on whose work the painting is based preyed on Diana, in the familiar conventions of paparazzi journalism. The high-angle shot onto the top of her head and into her plunging neckline are all recognizable features of the celebrity pose. Di is getting out of a car or in the process of making a curtsey, postures that were part of a public and publicity-oriented construction.

In the received critical attitude of radical theory, Kilimnik would have to be characterized as seeing through the mythic fabrications of mainstream culture to reveal them as perverse machinations of status quo false consciousness. Such rhetoric dictates that Kilimnik necessarily critique the perpetration of this icon of martyred royal innocence. But does she? Or does

she reinforce our awareness of this production of the press and its elaborate celebrity apparatus while showing her own interest in consuming these images? We see the consumer entertainment machine at work in all its necrophiliac opportunism. But what we also see is that Kilimnik loves the celebrity *and* the images of her. She adores the smooth shoulders and coiffed blonde hair, the dark dress that disappears into the high-contrast background of the original photograph and her rendering of it in paint. This is an act of homage. Kilimnik's deliberate semblance of artlessness, her disregard for the traditional drafting skills of high art, constitutes a finely pinpointed stance. The formal qualities of her painting, with their deliberate quotation of the style of teenage girl doodles or drawings, are at an equal distance from high art aesthetics and media culture's production values. Kilimnik's individual identity is marked as a processing filter. The transformative hand remakes the image so that it becomes something distinctly, formally, rhetorically other than mainstream culture.[28]

What are we to make of this? After all, modern artists also flirted with mass culture. But in many cases, their attitude was characterized by the patronizing affection of a securely smug social superior slumming in the mass market realms of bright baubles and vivid but vapid media. The damning of kitsch was essential to the early avant-garde's identity.[29] Pop art's direct engagement marked a reverse in energy flows and influences. The long struggle to frame the work of Andy Warhol, Roy Lichtenstein, Jasper Johns, and Robert Rauschenberg in "critical" terms misses much of the point of their flat tone or appreciative humor. Many postmodern artists' cool criticisms worked their irony through multiple strategies that conspicuously marked emotional and aesthetic distance between the fine and the mediated, making them closer to their modern predecessors than to the pop artists of a generation earlier. Such simplifications invite objections, many of which might be valid. But none of these would change the glaring fact that one prevailing characteristic of art in the 1990s is its full-blown affection for the materials and images of mainstream media culture. While journalistic responses to this contemporary art are allowed to exhibit a promotional enthusiasm, justified by their place in commercial publications, so-called "serious" writing always takes another, predictable approach. The dominant critical paradigm within, in particular, academic writing about contemporary art remains resolutely grounded in the belief that an aesthet-

ics of negativity (characterized by formally esoteric and notoriously "difficult" work) is the only way that visual art can distinguish itself from the so-called culture industry.[30]

With the examples of Colescott, Prince, and Kilimnik before us, we see that this construct is pernicious. It prevents any serious reconsideration of the historical and contemporary dimensions on which current practice can be assessed. It provides no basis for a useful articulation of the ongoing but seriously reconfigured grounds for fine art to function as an alternative space within mainstream culture.[31] Fine art practice has fortunately escaped these critical frameworks. The awkward application of this outmoded paradigm is hauled out with depressing regularity to tout the "oppositional radicality" of one new young artist's work after another. The aesthetics of negativity and its attendant vocabularies are as helpful to understanding this work as a nineteenth-century phrase book is for twenty-first-century travel. The work of Karen Kilimnik has as much relevance to the critical premises of the Frankfurt School as an Adobe Photoshop manual has to the work of Alexander Rodchenko (which is to say, lots and none, but not along an unbroken continuum of aligned sensibilities or assumptions).

A more credible theoretical position allows the material, formal properties of these contemporary works to be read into a general set of insights about the condition of this work as a form of cultural practice. This work had pop and conceptual art as its antecedents, was born of feminist, postmodern, and identity-politics sensibilities. But the contradictions and complexities it embodies are consistent with its appearance of self-promotion and self-interest—of a shared ideological condition in which Kilimnik declares herself an active participant in the consumer-driven commodity culture. A certain pathos attaches to this work as well, since it suggests a buying in and selling out, a concession to the power of the culture industry as source for the images that inform our imaginative life. Under such changed circumstances, the act of transformation that shifts images out of phase and performs an epistemological defamiliarization is poignantly charged.

Kilimnik and Prince create their resonances with the imagery of the contemporary entertainment industry. But current flirtations with visual culture also create historical rhymes through their technique or their imagery (or both). Catherine Howe's alluring image of a fairy-elf teen-nymphet, *Yellow with Mushroom* (1999), flagrantly delights in such high-kitsch sources and provides a very different instance of dialogue with mass culture (plate 3).[32]

Between the nymph in its new incarnation and its historical pasts, a world of references and aesthetic manipulations circulate, materially mediated on their way into fine art artifacts. Seductively finished, Howe has her voluptuous nymphet embrace painting-as-painting in a way that Kilimnik never would. The image reeks of old sentimental kitsch, flaunting the conspicuous use of attributes of consumable art considered by high-art and theory-based critics to be in the worst of all possible taste. Howe's visual style is the stuff of illustration and candy boxes but with a self-consciousness that suggests a complexity to this image missing in such mass-produced icons. The figure nods at us with a recognition of its kitsch antecedents and flirtations with bad form, taking full advantage of the coy pose, finished surface, and appealing iconography that are standard features of formulaic commercial art. Howe's female figure is a bit too full-bodied and too sexualized to pass as innocent. Our nymph is knowledgeable and material, not virginal or spiritual, so the kitsch look shows some wry sense of perversity about its own presumptions and possibilities. Critical apprehension of this work suggest a more complicated relation between fine art and mass culture than simple opposition or presumed superiority preserved by formal difficulty.

The image reflects Howe's complicated relation to sources in the fairy paintings and fey imaginings against which this image reads "transgressively." At one level the image goes against the grain of conventional moral codes. The moral order of a Christian culture stigmatizing the pagan world (in which the nymph is characterized as an image of undisciplined female erotic impulses) is overwritten here with a late capitalist self-consciousness about cultural taboos against (and promotion of) looking at adolescent girl-women. But on another level the image goes against all manner of politically correct feminist attitudes toward representation. The nude figure wears her hair styled in a 1950s bouffant that can only be held together with hairspray. The fairy-nymph is already transposed, archly aware of her own attractiveness and wickedly involved in the games of prohibition and flirtation that threaten the stable divide between acceptable and unacceptable gazes. Thus the imagery and the artfulness of the painting engage in the same negotiations of permissible and prohibited behaviors.

If this image had merely harked back to the nineteenth century, it would never have the force it has by introducing that 1950s reference, and with it, the commodified, reified mass culture sensibility that puts it into such com-

pelling relation to the image of Cameron Diaz in Prince's exhibit ad. Diaz is all code, all formula, all prefabricated packaging, and her image remains stable as an image within those codes. The Howe nymphet violates stable boundaries. The painting quality suggests that high art is playing with a history it has repressed for a hundred years of modern work. Howe thus introduces a fully perverse fetishized image of visual desire within a field of meaning that can't be simply aligned with kitsch or mass culture domains or with high art precedents and their games of visual appeal. Howe is clearly drawing on, but also not duplicating, the forms of kitsch imagery, and the impulses of imitation and differentiation are mutually reinforcing.

The attitudes toward artistic sensibility that arise from discussion of these three images—Prince's ad, Kilimnik's Di and Howe's nymphet—extend attitudes of affirmative flirtation and reflective awareness evident in Colescott's work. The readings of these works give abundant indications that a changed set of critical principles need to be articulated that extend, and in some cases supersede or contradict, the terms on which modernism, and to some extent, postmodernism, have been discussed.

Any adequate reading of contemporary art begins with direct engagement with the formal properties and visual content of these works. But assumptions of apparent, self-evident properties or of our ability to simply understand a visual work by looking at it miss the larger question of the way its formal existence is produced at the intersection of complex cultural systems. If we emphasize facture rather than form, then properties of making show that the work is embodied in a network of conditions and circumstances of production and perception. Facture is the indexical link by which the materials and forms of aesthetic artifacts can be read in historical, cultural, economic, political terms. Kilimnik's girlish hand, Howe's illustrational deftness, Prince's photographic reproduction—these are each forms of making endowed with significant and legible properties. Kilimnik's drawing leads us back to a girl's bedroom, strewn with magazines and other paraphernalia of teen life. Howe's skilled superficiality is imbued with commercial training. Prince's ad links to the glamour world of fan clubs and trendy networks on the margins of celebrity culture.

The formal qualities of these works make a useful starting point for analysis. Old-style formalism in a modernist mode had a conspicuous allegiance to a kind of formal essentialism or faith in the power of an object to communicate directly as a form.[33] Complicit formalism, by contrast, draws on

the legacy of Russian intellectual circles around Viktor Shklovsky, Mikhail Bakhtin, and Roman Jakobson, for whom the material existence of artifacts embodies cultural systems of meaning production in full recognition of their ideological life.[34] In this approach, meaning is never self-evident. Neither is it immanent or apparent. Nor is it ever autonomous in the way that came to characterize, finally in caricature, the premises of high modernism at midcentury. Formal properties of works of art were merely incidental— at least this was the suggestion in many discussions of conceptual art, neo-conceptualism, much theory-based work of the 1980s, and more recent identity-politics work. Discussion of formal properties, however, is too often used to bludgeon the thematic content reflecting unpopular points of view. The encouraging trends of the 1990s suggest a full-scale reintegration of material practice and conceptual insight.

Too many of the critical glosses that elaborated extensive arguments for much visual work of the 1980s and early 1990s failed utterly in this regard, and this resulted in criticism and artwork that lacked formal sophistication—or a clear connection between the visual forms and critical claims asserted on their behalf.[35] In that theory-heady era, both the production and analysis of visual qualities got short shrift. This conspicuous absence of attention to aesthetics was one of the prevalent strains of 1980s postmodernism.[36] The contrast between Barbara Kruger's critical use of commercial images and Kilimnik's, or that between Prince's earlier work and the Diaz fan photo shows the dramatic distance from the apparent need to put critical art in opposition to visual pleasure and material expression. Reading works to understand how they function through the specific properties of construction, association, and provocation rather than for the meaning they produce is fundamental to seeing the independent expressions created by affirmative sensibilities. The presumptions of autonomous opposition, by contrast, depended on resistant isolation.

Reading cultural artifacts for what they conceal and how, as well as for what they reveal, is a crucial analytic instrument in understanding the social production of meaning and symbolic value in cultural systems. The apparent value of a work is almost always bound up with its opposite, or at least with some condition of contradiction. Kilimnik's work is about originality and marks its individuality through its handmade character. But the image is also about the impossibility of separation from the mediated context and sources of her production. Colonized by mass culture images, the imagi-

nation can hardly claim original expression or point of view. And yet, the marked shift out of mass commercial production into the creation of a handmade artifact is a demonstration of the power of artisanal production. The work seems to obviate the possibility of originality while reinforcing it in a new vein.

Power and communication play within dynamic systems; they are not static conditions for meaning production. A representation works to produce value and effect; it does not deliver meaning. How is Prince's image of Diaz used to define his relation to celebrity culture? He aligns his "artist's identity" with those "crass" systems of personality production and consumption, posing questions about the status of looking and images to be looked at or ignored. Of course, he stands to gain by these acts, to profit, literally and figuratively. Commerce is everywhere within the system of fine art trading even as it parades itself as a theater of imagination.

The works of Kilimnik and Prince discussed above can't be separated from their place in the editorial and advertising venues within the pages of a very commercial, contemporary art magazine. Kilimnik's painting will appear differently in person; the work in Prince's show will have another scale, another presence, another set of formal, dialectical, and ideological frames.

A considerable number of artists in the 1980s and 1990s took up a systematic investigation of many of the institutional practices of fine art.[37] Hans Haacke, Joseph Kosuth, Fred Wilson, Ann Hamilton, James Luna, and earlier, Louise Lawler, Barbara Bloom, or David Diao, to name a conspicuous handful: all are artists for whom the cultural functions of institutions and discourses have served as subject and theme. They extended Duchamp's earlier calling to attention of these frames as the preconditions in which fine art obtains its cultural value.[38] But much of this work also distracted us from attending to the way fine art functions as a site of complicity within mainstream culture. The ultimate questions in this discussion always concern whose interests a particular work, critique, analysis, or discourse serves— and how it does so. In almost every instance, fine art participates to some extent in preservation of the status quo. In spite of its wish to be otherwise, fine art is not the same as radical politics. Activist work exists at grassroots levels. But such work is usually markedly different from the well-staged and carefully calculated work designed to represent "activism" within highly capitalized venues. The aesthetics of complicity suggest that the many responses elicited by works of art and the range of impulses from which they

are produced include recognition of the ways such contradictions and complexities are sustained. This acknowledgment is a step toward reading works of art as participants in an ideological agenda rather than as objects or attitudes existing outside of ideology.

Recognition of an admittedly compromised position is crucial to understanding Kilimnik and Howe and to unmasking Prince's posture as well as to taking note of the difference between a range of reflective critical capabilities and a more formulaic and fixed set of binary oppositions. Kilimnik's image shows us something about the way mass circulation photographs produce meaning for and through us. Her transformation isn't meant to undo the operations of these mass-mediated artifacts but rather to embody a commentary upon them that breaks the unified surface of mass culture into a dialogue. The space of splitting, of reflection and refraction through an individual subject, is one space of aesthetic criticality, but the affirmative sensibility of Kilimnik's work is equally charged with a sense of longing, belonging, and engagement with the objects of her own desire. Mass media culture shapes that desire, and Kilimnik seems to suggest that we should restructure our relation to that desire by acknowledging the pleasure its affords and our participation in these varied means and systems of production.

The artists of the world we live in produce materially engaging, viscerally seductive, visually smart work. Ours is emphatically no longer the world from which the critical sensibility on which we've depended for so long developed its analyses.[39] Even if one wanted to sustain a model of politically efficacious art, the project would have to proceed with full recognition that many of the cultural formations that once served as targets of radical opposition are no longer located in the same place within literal or symbolic social spaces. Artistic gestures premised on political attitudes that took their shape from nineteenth-century dynamics and early twentieth-century formations are as anachronistic as the dress and manners of those times.

Colescott, Kilimnik, Prince, and Howe acknowledge their relation to the warp and woof of material culture and also tweak the self-serious posture of a critical establishment that is intimately bound to administered culture. Contradictory? Not really. The rhetoric of opposition has long dissembled, concealing its official platform with the bunting of independence, a fact barely worth announcing to even those still steeped in adherence to its practice. Hardly a heretical statement, mentioning that the art establishment,

including its most rabidly anti-culture-industry advocates, is itself intricately bound up with the machinations of what Althusser terms the "replication of the social relations of production" through which fine art functions.[40] The insistence on radical agency—and the presumption of art's ability to be outside of ideology—is perhaps the most pernicious and damning of instrumental ends to which fine art has been put. For if fine art opens any critical space at all for reflection through imaginative invention and the generative acts of form giving, then it can succeed only if this activity serves no instrumental purpose. None at all. Artistic autonomy as understood within a late nineteenth-century sensibility—in that period of "decadent aestheticism"—was hijacked to serve the rhetoric of an avant-garde sensibility in the course of the twentieth century (one, albeit, with its own roots in early nineteenth-century reformist tendencies). To recover the purpose of artistic identity, it must be pulled back from the instrumentalism to which it has been put. The opportunistic sensibility of artists still manages, ultimately, to outstrip the rhetoric that would contain it without formulae of already-familiar thought.

Current conditions clearly require new premises. In the 1990s, the first-world centers of a global economy were flush with consumerism and rampant commercial success. The relations of labor to industry, power to nation, individual mythology to ideology, commerce to aesthetics, and all of these to art as a specific domain of cultural activity have been reconfigured. As visual culture exploded in the advertising and info-tainment joyride of media communication universes, the place of fine art imagery has shrunk to a mere preserve of rarified, possibly even endangered, practices. Any analysis of contemporary art begins here, with this recognition of its dangers and fraught complexities. These new realities pose threats to long-held beliefs—beliefs that are no longer viable.

On the one hand, mainstream fine art (by which I mean most of what is exhibited in contemporary museum and gallery settings) has suffered the sad fate of becoming a part of official culture. But on the other hand, there have been harbingers of this transformation for decades, injecting tiny cracks of humor, affirmation, wry self-reflection, and playfulness in the austere face of difficult art. And much of what has been ignored in the history of the modern period is work that didn't comport with the stance of mainstream critical rhetoric. Insights gleaned from the contemporary scene could return a new set of possibilities into our understanding of the role of

historicist, subjective, and entangled work within the field of fine art (in contrast to the emphasis on autonomous formalism on which oppositional rhetoric was sustained). Recognition of the repression of historical self-consciousness, located identity, and ideological compromise within the history of modern art and criticism underpins my arguments about contemporary art. The task of recovering, even of reconceiving, that history comes with acknowledgement of the continuity between current activities and certain still-marginalized concerns in the modern period.

New critical precepts can be readily elicited from a description of prevailing trends in contemporary art. Artists are engaged in an enthusiastic renewal of studio practices and playful flirtation with mass media culture, alongside the revival and use of historical and traditional sources and methods of production—all with full recognition of the crucial legacy of conceptual art. The attitude manifest in their work extends the long-standing belief that aesthetic form makes over and transforms the meanings and values of symbols in contemporary life, and in so doing it gives new life to that symbolic domain in which we find the possibilities of effective insight and communicative exchange. All else proceeds from this, after the fact of creation, in the effects of reception: political and social change in the mores and categories of thought and action, assumptions undergirding pedagogy in practice and theory, conditions for acceptance and success, and assessments of value and foundations for acclaim.

3. Forms of Flirtation

Many new trends came to the fore in the 1990s. These compel us to think in new ways about what art is now and how it takes the forms it does. Cutting across media categories and genre distinctions, this work constitutes a current, specific moment in its exuberant variety and particularity.

Hybridity became a theme and an attitude, dealing a final death blow to any residual modernist pretense of the purity of form, postmodern critical distance, or clinical theoretical frameworks.[41] Mutations came into the production and conception of fine art objects. Recombinant aesthetics reworked the neatly defined categories of older classification systems for media. In addition to its implications for physical conditions, hybridity also serves as a metaphor for cultural ones. Borderlines of older cultural norms and locations are blurred, synthesized into a radically different mestizo

sensibility. Hybrid aesthetics suggests that random transformation occurs at a categorical level, even at the intersection of natural and cultural domains. Breeding of all sorts occurs with wild, wanton abandon of controls. A fever pitch pushes the generative processes toward unpredictable outcomes.

Identity politics have matured into a rhetorical exploration of identity. An autobiographically located specificity exposes individual identity as an elaborately complex site, de-essentializing artistic profiles and unlinking any single connection between particular identities and forms of expression.

Eclectic materialism and ludic formalism have exploded the physical bases of production displacing the conceptually rooted, antistudio, semiotically centered approach. More and more materials have been brought into studio practice. The list is endless: toothpicks, twigs, chewing gum, broken glass, found plastic, castings of body parts and orifices, fingernail clippings, stickers, and plastic tableware. The detritus and surpluses of consumer and quotidian culture have been pressed into service as the raw material from which the cooked products of fine art can be made. Everything is a means to make art, no substance is too base, too trivial, too precious, or too loaded with associations to serve as the stuff from which a thing can be produced. In many instances, this eclectic sensibility creates a striking formal tension between the material used to create a representation and the thematic imagery in the work. A dialogue of form and material charges these works so that we have to attend to their means as well as to their meaning.

Such "things" emphasize that they are produced as a curious conceit of artifice. They are marked as consumables rather than passing as an elevated object presenting timeless experience in a well-realized form. Artworks are as likely to crack, peel, drip, slurp, slip, or diffuse themselves as they are to maintain their boundaries or fixed shape. A contemporary work is as likely to bring its peculiar discrete components into the foreground (pills, laundry baskets, flea market items) as it is to hold its illusionistic, representational form. Materials and imagery are both thick with associations that weave fine art together with other works in an interlinked chain of references through a vibrant recycling of stuff into form.

A subset of such eclecticism involves games of deception and attempts to foil the "truth" in materials. Acts of optical play offer themselves up for obvious deconstruction, unable to maintain the physical integrity of their ar-

ticulate form. The beauty of the fleeting image poses for a moment as permanent, neither quite a performance nor a mere trace of process.

Meanwhile, photography has leaped far ahead of its historical legacy, going beyond the index. The usual measure of equivalence connecting the indexical play of light and the receptive surface of film as a record of incidents has elastically warped. Digital means extend the technical vocabulary for such inventions; some of the most effective calls to question the nature of the photographic assumption of truth are those in which optical processing registers with excruciating accuracy. Scanner-based work reflects on the role of visual technology in creating a belief system based on ever-increased degrees of photographic resemblance.

Residual taboos against narrative and figuration have been lifted. Real stories, extended documentaries, mythic cycles all find audiences and figurative works are no longer restricted to a few highly circumscribed zones. Emerging artists don't even know that modernism had a set of proscriptive and prescriptive prohibitions against the conventions of storytelling and personal tales. Or that the melodramas of popular culture, like the figures in illustrational works, were considered off-limits. Narrative was outlawed in the era of abstraction; figuration was too conventional for conceptual avant-gardes. These forms reappeared—but barely—in postmodern work. In the 1980s, narrative was always under theory constraint, held in the grip of deconstruction, subject to pastiche and other transformative modifications.[42] Now figuration has returned with the full force of its many engaging capabilities.

Realism had come to seem like a conceptual impossibility within certain strains of modernism in an earlier generation. The world—and experience of it—could no longer fit the conceptual parameters of such representational devices and their presumptions of coherence. The use of figure and narrative bespeak a humanist quest for reference frames within the chaotic conditions of contemporary life while posing anew certain questions about the function of realism.

An active flirtation with the culture of mass production—including the fashion and entertainment industries—has sprung up. Enthusiasm for commodity culture has led artists to the unabashed creation of product lines that blur the distinction between fine art and commercial product. New technologies have also played their part in blurring these boundaries by allowing video games, computer-driven work, desktop publishing, and 'zines

to creep into digital art venues. Web sites for fine art are indistinguishable in material terms from those of commerce or entertainment. When a work of art has to provide clues to its identity in an unmarked encounter, the task of the viewer is to figure out whether or not they are having an "aesthetic" experience. Finding work on the Internet that looks just like television or a *Sports Illustrated* spread, we find ourselves asking not only what the distinguishing characteristics of art might be, but why we should care to make them. Under these circumstances, an old-fashioned critic might begin to imagine he was witnessing the end of art.

Networking and real-time transformation have become an integral part of display modes and installations as digital media and computer-mediated work introduce new formats of interactivity into audience's experience with works. Works that involve participation in viewing or display often rely on ideas fostered by new technologies whether or not they are a result of innovative engineering capabilities. Works that respond or react to their viewers' participation within a specific temporal duration have transformed our expectations about how we view a work—as well as our sense of what a work actually is. The myth of the stable, autonomous, and self-identical object, long called into question from a theoretical standpoint, has been replaced. Objects now embody dynamic principles of contingency in their very structure and operation. This shows the extent to which interactivity is a constitutive feature of any art object. Programmed and programmable, participant-determined, collaborative and collective as well as networked—these terms derive from electronic sources but have implications far beyond narrow application to specific technological domains.

Historicist dialogues have produced a range of self-conscious engagements with the techniques and imagery of cultural traditions. One of visual modernism's conspicuous efforts, the search for transcendent universal visual language, depended on repressing historical references. This repression became a blind spot to self-awareness of modernism's own historical condition as well as to that of any and every visual form. Modern art was also rigorously secular in its approach, at least officially, and systematically repressed faith-based work or imagery grounded in allegory or the presentation of mythical figurations. But such interests never disappeared. They simply fell out of favor, and their recovery as objects of practice and criticism reveals strains long-repressed by modern and postmodern mainstreams.

A new self-conscious revival of studio techniques with historical pedi-

grees has become evident—even a re-engagement with old master techniques. Thus a dialogue with a historical past is created through ways of working with materials as well as through citation and quotation of imagery. At the same time, a striking "impurity of media" characterizes approaches to painting. This parallels the electicism rampant in sculptural and installation works. Anything at all can be put into the same visual frame, violating all distinctions of register to establish a maximum of cognitive dissonance within a single, still-unified image. Painting, once the purest of modern forms, has fallen from grace and landed as the best condition of invention and experiment.

The global context of art reception and circulation has produced a lively international scene. Time lags and distances between traditional centers and margins have shrunk, though the initial resulting effect is a peculiar form of biennialism or art fair fare that has its own consumability and qualities of cultural tourism. These trends teeter dangerously close to an exploitative tendency to present disparate artifacts in the homogenizing frames of art fairs that court the attention of the glossy-publications industry. But the global phenomenon has opportunistically tapped local sources of art making to reinvigorate the weary artifices of the post- and neogenerations. A vibrant internationalism has expanded visual vocabularies of imagery and materials, licensing frames of reference once marginalized as remote zones of the globe. If the old tropes of "exoticism" and "primitivism" are gone, in their place come new and equally complex modes of exploitation that embody a politics of displacement and display. Contested grounds of cultural authority wait to be exposed in the growth industry of biennials and art fairs, even as the processes of curatorial expansion benefit from conscientious attention to the crimes of the past to avoid them in the present. The time lag that used to accompany the diffusion of art from centers to margins has shortened, in some cases even reversing the tide, letting the so-called margins flow back into the cities and publication centers.

Globalism is a key word in biennials and art fairs, and an artist whose exhibition record reads like the accumulated lists of steamer trunk labels is no longer a novelty. But where the modern "international style" strived for a streamlined, deracinated neutrality of clean abstract forms, the new "globalism" displays its sources conspicuously, stressing visual dialects and material accents, local color and indigenous motifs, with complete disregard for allegiance to authenticity.

A host of other trends could be added to these, including gender ennui (a manifest discontent with polemics of identity in binaristic terms), slacker aesthetics (disregard for protocols, older production standards, and theoretical correctness), and mutant formalisms of any and every variety. Formalist sleights of hand, excessive artifice, superficiality and blind taste, a curious "diss-ing" of opticality through subversion of expectations, an ironic fascination with monumental scale, and an engagement with surprisingly incidental and ephemeral production—themes and subthemes abound.

Greater risks of exposure and a higher ante in the play for an audience's attention are evident, but also a fundamental concession (in the good sense) to the production of visually seductive imagery has come to the fore in the last decade to an overwhelmingly conspicuous degree. The stingy imagery sensibility that had often starved the sensual appetite in the 1980s has given way to luscious, sometimes irreverent, but highly inventive use of "stuff" taken from every zone of material culture.

No form of industrial or technical or technological production is off-limits and the contents of an industrial kitchen or the results of dumpster diving are equally likely to provide the departure point for a new work. But the days of showing such items for their own sake has also passed. Process and fabrication have been overlaid with a myriad of associations as impossible to ignore in the latter case as they were difficult to recover in the first instances.

This mongrel formal sensibility is paralleled by participatory pluralism. Anyone can play (though it would be naïve in the utmost to imagine that anyone can win). Commercial success and the courting of celebrity status are hardly covert goals among aspiring artists in our times, but the realm of aesthetic expression continues to maintain a space for preservation of the independent voice within mainstream culture. Striking, distinctive characteristics emerge from this array: a disregard for the prohibitions and constraints of critical postmodernism and a considerable historical distance from the strictures of high modernism as these became, for all their secularity, a regulating orthodoxy.

The "modernism" acclaimed by critical theory was configured as an oddly conceived history, narrow in scope and meant to serve a specific ideological agenda through aesthetic and critical means. The intentions may be laudable, but the means introduced distortion, eliminating much that turns out to be interesting to us now. For example, the work of the Ashcan school

painters, including Reginald Marsh or Thomas Hart Benton, are dismissed as "not" modern, though their subject and forms are distinctively early twentieth century. When addressed at all, they are treated as social documents rather than examined for their aesthetic properties. We have the benefit of hindsight with which to review the choices made by those pioneering spokespersons for modernism's cause (Alfred Barr, Albert Barnes, Meyer Schapiro, Michel Seuphor, Clement Greenberg, Harold Rosenberg, and in their wake, Rosalind Krauss, Timothy Clark, Richard Schiff, and Yve-Alain Bois). But as the critical response generated by contemporary art allows us to recover much of the lost material of modernism, it has provided a new critical frame through which to recast our understanding of that past and this present. Postmodernism, that short-lived critical product of theory-meets-studio sensibility, bequeathed useful residues by legitimizing a wider visual and material range than conceptual, minimal, and even pop art had allowed (even as these had put aside the earlier constraints of abstraction). But ultimately, the postmodernism of Craig Owens, Douglas Crimp, Brian Wallis, Hal Foster, Benjamin Buchloh, Allen Sekula, among others, was just that, an extension of the same modern criticality that assumed superiority to mass culture and required of its practitioners at least lip service to resistance through resistant aesthetics. The shared conception for modern and postmodern critical positions was the same: that fine art operated outside of the rest of culture, its moral superiority grounded in autonomy and opposition.

The formal range of recent art has made us keenly aware that the received traditions of modern art have misrepresented the richness and diversity that was actually present (if undertheorized) in nineteenth- and twentieth-century dialogues with visual culture.[43] We see now that narrative and figurative work—and strains of historical (and referential) self-consciousness—were not entirely missing during the era in which the idea of the self-evident object seemed to blot all other artifacts from view. The value of hindsight is that perspectives shift. Once foreground objects slip into perspective, the broader topography of what was modern art appears. Similarly, the era dubbed "postmodern" contained far more diversity than the first (1980s) canonization of its attitudes and artifacts suggested.[44] Nothing in the 1990s sprang from thin air. Rather, the simmering potential of new enthusiastic attitudes toward art making were let loose from suffocating constraints. Now, with such potent evidence suggesting its many and fertile directions, criticism must rise with equal exuberance.

Some of what has been released may be the demons of demise, the final announcement of concession to the greater power of visual culture and its industrial strengths. To describe fine art as a cultural practice, we have to face all this and ask ourselves: What is it that matters? What must be kept alive in this particular domain? Institutions? The ideological agendas they sustain? Or the ones they subvert? Works? Values? Communities? Mythic individualism or a symbolic notion of individual voice? Epistemological defamiliarization? Or the possibility of imagining the world in some form other than what it is or appears to be? For all the dazzle, brilliance, exuberance, and excitement, this may well be a twilight moment for everything we have believed in our modern lives about fine art as a cultural practice. Insofar as we are attached to the notion of art as a space apart, as a cultural practice with a distinct identity, ours are still modern ideas. If we accept the complicit condition of fine art, this may be a moment of superb reinvigoration. The realization that the ground has shifted provides new possibilities. Here we hang, suspended in the present with all its potential and uncertainties. Are we on the verge of a farewell? Entering into new illusions? Or reempowering the force of creative imagination? Sweet dreams indeed—but are we being lulled to sleep or a new awakening?

3

CRITICAL HISTORIES

The belief that difficult works of art make gestures of political resistance through their unconsumability is a legacy of the avant-garde. The idea that aesthetic expressions should be marked by a conspicuous difference from the forms created by the culture industry is the critical lynchpin of this belief system. Tenets of this orthodoxy have (fortunately) failed to control the un-ruly enthusiasm of artists—even if such concepts dominate the critical rhet-oric that attends to their work. As suggested, in recent decades artists have produced a very different dialogue with culture broadly considered. Hard and fast distinctions of "mass," "ordinary," or "high art" don't always hold. Nor do they have stable material conditions in which to operate, however much institutional boundaries or discursive zones demarcate fine art from popular aesthetics.

That stubbornly persistent belief in radical aesthetics is the baby to be

thrown out here. The tenacious core of outmoded discourse is that art exists to serve some utopian agenda of social transformation through intervention in the symbolic orders of cultural life. Its dreadful, reified rhetoric of elitist posturing passes itself off as the spirit of political heroism. Far from the fray of real politics, from grass roots community organizing or lobbying agencies, this has become the managed, bureaucratic discourse of new academicism, as repressively formulaic as any of the nineteenth-century salon and atelier styles it disdains. The unthinking position continually replicates itself in elite institutions and esoteric, policed languages of high criticism. Entrenched and unchallenged, this academic discourse largely serves careeristic or professional interests, while claiming a revolutionary, even proletarian (can we really even still write that word?!?) agenda. Getting free of the grip of habits of thought engrained in this critical legacy is essential if we are to reimagine our relation to the world of aesthetic experience—and of actual politics as well. My intention is not to demonize academic discourse on account of its conceptual complexity but, rather, to suggest that the insights therein have become so enmeshed in their own administered culture that they don't serve the exuberant vitality of contemporary art. In particular, the remaining traces of a concept of autonomy on which radical aesthetics was based needs to be held up to serious scrutiny.

1. The Legacy of Autonomy

Rachel Whiteread's resin cast sculpture, *Water Tower* (1998) perches on a wooden scaffold atop a New York City building (fig. 3). The still-functional—and usual—means of supplying water pressure to most New York buildings, the water tower is a curiously untechnological element of the contemporary urban landscape. Its cylindrical barreled form, banded with what appear to be strips of metal shaped by a cooper, is so instantly recognizable that the anachronistic nature of its humble origins disappears behind the familiar image. Like rail lines or gas lamps, the water tower is a relic of technological capabilities now several centuries old. The water tower is, in fact, older than high modernism. The contrast between its obvious, apparent isolation—alone on the rooftop outposts of urban life—and its actual integration with an essential infrastructure of water distribution and plumbing—makes it an interesting piece through which to frame issues of contemporary artwork. Whiteread's literal recasting provides an opportune

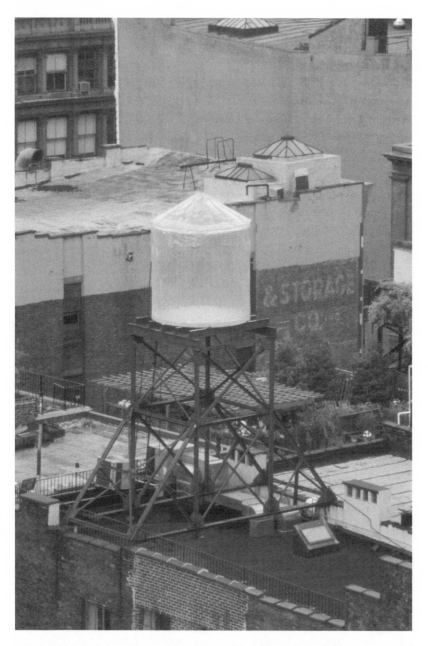

3 Rachel Whiteread, *Water Tower*, 1998, resin cast of the interior of a wooden water tank, 11′2″ h × 8′ d, located at West Broadway and Grand Street. Courtesy of the Public Art Fund. Photo: Marian Harders.

point of self-conscious reflection. *Water Tower* references the concept of formal autonomy while actually resonating with historical echoes and integrating its aesthetic gestures into the fabric of the lived.

Whiteread's shimmeringly nacreous sculpture reads without equivocation as an artwork. Such an object, elaborately made and inserted into the landscape, can't be mistaken for anything but an aesthetic object. What else could it be? But what kind of aesthetic object is it? And what follows from the observation of its essential properties and characteristics? This work neither references its medium nor pretends to simulacral mimicry. "I am not a modern object," it says, flaunting an object-ness rife with historical and cultural meanings. "Nor am I a postmodern object," it declares, equally modest in its resonant associations with the seductiveness of visual forms of vernacular culture. Elegantly beautiful, manifestly, visibly present, the work has an immediacy in its material form. Critical gloss is useful, but not essential, to this work in its ability to engage the viewer. The formal means of production extend the referential field of studio art into a dialogue with the conspicuously public (but drolly remote) site for "high" (skyline level) culture. An easy joke, but a profound one, this punch line of the work with its context is consistent with the historical commentary for which Whiteread has become known. In other words, as an aesthetic work, this sculpture puts the apparent "transparency" of its medium into play through associative processes. The art object invokes the formerly present water tower in an exchange initiated by the replacement of the original. This cast-resin replica is a contemporary image in clear dialogue with a specific historical past. This representation of a functional mechanism calls attention to the formal qualities that are (perhaps overlooked) virtues of the original, but not out of nostalgia for the mechanical age. The sculpture inserts itself in cultural history as an act of substitution, but without negative criticality. Quite the contrary; if anything, the work is a modestly elegant celebration of the aesthetic properties of the ordinary—properties to which works of art can call our attention.

As an iconic form, the water tower recalls the industrial architecture exhaustively recorded over several decades of the late twentieth century by photographers Bernd and Hilla Becher, as well as the playful appropriation of mechanical forms that figured in the works of Francis Picabia, Fernand Leger, and Marcel Duchamp in the 1910s and 1920s. But Whiteread's work is as far from the playful anthropomorphism of the early modernists as it is from the rigorous, decontextualized, and antihistorical sensibility of the

Bechers' conceptualism. Her gesture is historical, self-consciously so. We are meant to see the water tower as an object that has its own lineage as well as being fully contextualized within the current moment—a thing functioning in the present but with the recollection of its past quite evident. *Water Tower* preserves the historical image as an artifactual icon in an affirmative, but reflective, act of art making.

Where are we to place this object and gesture within the history of critical discourse? Whiteread seems enamored of material culture, keen to call our attention to the aesthetics of everyday life. The art object *Water Tower* is usefully other than that which it replaces. Its specificity makes it a work of historical reference but without an agenda. The sculpture comes into being first and foremost as an aesthetic object, manifesting a thoughtful commentary upon the real and lived but without any intention to prescribe social transformation through cultural means. Does it signal a change of sensibility? Even that might be too strong a suggestion for this work, which instead seems merely to be a manifestation of form for the sake of producing awareness, momentary surprise.

But if this sculpture is in any way representative of what now passes for "art," then where would the critical discourse for its discussion fall within the lineage of art historical debates? Contemporary criticism carries many burdens in its basic formulations. Critical autonomy is the central tenet of this legacy. Fine art's distinct and separate identity depends on this notion if it is to serve a leveraging site from which to provide salvific—utopian or moral—narratives. Modern secularization shifted the values that fine art's autonomy was supposed to serve, not the role it was to play. But concepts of moral uplift betray radical fine art's deep roots in Western religious thought and its assumptions. We are so attached to the idea that art improves us that we attach a wide range of riders to the moral law we think fine art serves. Religious tolerance, self-knowledge, ecological consciousness, understanding of others—these and many more such concepts have been attached to the enlightening function fine art is pledged to perform. The hierarchy of value that becomes aligned with the path to virtue is still fraught with the image of an "ideal" to which art aspires—even when that is a utopian image of cultural reform rather than an image of perfect form.

To revisit the long history of the concept of autonomy and the foundational role it played in the critical conception of modernism might seem at first glance like a frustrating, or even irrelevant, exercise in our new millen-

nial mode. In many ways, the critical discourses of postmodernism appeared to move beyond this concept through their radical overhaul of modernist notions or their intellectual forebears. Certainly much contemporary criticism appears distant from precepts rooted in Platonic ideals or the classical concepts of harmony and proportion. But it also seems far from the early twentieth century's search for universal formal languages of art—and other earnest but outmoded-seeming approaches. Certain ideas associated with modernism—such as the teleology ascribed to the specificity of media and self-evident visuality—can't survive the critical light of day. But the idea of autonomy persists. Fine art is conceived of as a cultural activity that is distinct, discrete, and independent enough to critically comment on the culture. We might even suspect that this conceit is glaringly overlooked because of the assumptions necessary to conceive of fine art as a political agent. A brief survey of the ways autonomy has been conceived within modern aesthetics provides a means of laying bare the strategies on which the idea operates. The exhaustion of modernism in visual art practice coincides with the demise of a longstanding (if much mutated) philosophical paradigm, and also with the end of the art historical trajectories that have depended upon it. In many instances the concept of autonomy has become so naturalized that it is almost invisible. Art that makes claims for political efficacy rarely acknowledges the presumption of autonomy on which it operates or its condition of compromise with regard to aligned interests or benefits.

The emergence of critical postmodernism in the 1980s articulated changes that had already been affecting the modern project for several decades. But work like Whiteread's shows how far the current historical moment extends the artistic activities these changes have occasioned. She clearly doesn't conceive of her work within the reactive stance of a postmodern response to modernism's strictures. Like many artists of the later 1980s and 1990s, Whiteread employs a material voluptuousness that marks her distance from formal precepts of autonomy. Ahistorical form, nonnarrative modes, and self-evident identicality were modernist precepts. Whiteread overturns them all. But her embrace of the qualities of historical narrative and embedded formal relations distance her almost equally from postmodernism. Its critical terms were just as stringent as those of modernism: stingily self-conscious acts of appropriation, critical contingency, and an arch-cool superiority to mass culture.

These traits were symptomatic of much postmodern work—which went

out of its way to lead with its theory credentials almost to an extreme degree, cloaking visuality in discourse to keep the seductive capabilities of material form at arm's length. Part of the response, of course, to modernism's long insistence on optical self-presence or of an aestheticized embrace of formalism, this postmodern sensibility was oddly puritanical in its rejection of the pleasure of material expression (either for the artist or the viewer). Barbara Kruger's graphically antivisual polemical statements, like Peter Halley's flat, neo-geo works, Jeff Koons's storebought commercial-object sculptures, or Sherrie Levine's reappropriation strategies demonstrated visual disaffection. They embodied a nothing-left-to-be-looked-at sensibility.

Counterexamples exist, of course. Julian Schnabel's painterly surfaces and Cindy Sherman's visually intelligent and engaging film stills are canonical postmodern works with an abundance of formal pleasure. But critical language bore much of the burden of communication in postmodern rhetoric. Fine art objects served theory purposes rather than the opposite. Critical discourse took center stage. Fine art objects illustrated rather than embodied their precepts. The late 1990s–early 2000s has witnessed a reversal of this trend, though the critical self-consciousness that is the longstanding legacy of conceptualism in late twentieth-century art remains integrated into the sensual expressiveness of recent work.

But how did we get here? Past the postmodern, inheritors of its viewpoint, and still much influenced by modernism's legacy? Modernist autonomy serves as background and contrast with what came to be identified as postmodernism's insistence on contingency. But neither of these provides the critical frame for understanding the condition of replete, even contradictory, *complicity* that characterizes art at the millennium. Complicit aesthetics acknowledge the beneficial relation of artist and fine art in the system in which they function. Contingency suggested networked dependence, a semiotic reading meant to correct the modernist bias toward self-evident meaning (thus the use of phrases like "reading across" sign systems or "within contexts of production"). A complicit stance goes much farther in revealing the self-interested nature of fine artists' situation within a system of ideological values. Willing, if complex and contradictory, participation is a feature of acknowledged alignment with the status quo that erases any basis for a sense of superiority or separate spheres of activity.

The distinctive paradigms for modern art as an autonomous realm were formulated in the late nineteenth and early twentieth centuries. Many of the

critical concepts supporting these paradigms have a longer history through which they emerged into their focused, modern forms. The contemplation of beauty as truth in classical philosophy was readily adopted in Western tradition as a basis for theologically inflected beliefs in the virtues of contemplating the divine spirit.[1] In a premodern era, such precepts dominated philosophical systems. The modern concept of autonomy was marked by its apparent freedom from such religious obligation or fealty to a royal patron (supposedly). But elements of modern autonomy found their roots in the intellectual structure of these practices, and assumptions that underpinned them were passed into secular form as a transformed, but still related, inheritance. For instance, the necessarily unmotivated nature of contemplative practice centers on faith as an end in itself, not a means. The transcendent character of such contemplation—for example, Saint Augustine's self-sufficient divinity—might be far from certain engagements with sensual pleasure in material form, but such philosophy bequeaths to modern aesthetics a commitment to cognitive or spiritual insight.[2] With this legacy comes attachment to a moral value expressed as a faith in revelatory or even more applied instrumental effectiveness. From such roots, a fundamental tension comes into modern aesthetics—between an autonomy that provides a point of leverage for some other purpose and one that is free of such responsibilities.

The economic and intellectual independence of fine art from religious or political institutions is a characteristic of the cultural condition of modernity—and this independence finds philosophical reflection in the aesthetic precepts of Alexander Baumgarten. His 1735 dissertation gave modern aesthetics its initial definition as "the science of how things are to be cognized by the senses."[3] Baumgarten's influence is evident in Immanuel Kant's concept of autonomy in the *Critique of Judgment* (1790), and it also provided a foundation for Gotthold Lessing's attention to the specificity of media in the *Laocöon* (1766).[4] Touchstone works for modern art criticism, Kant's famously conceived "disinterestedness" or "purposiveness without purpose" posits aesthetic judgment as a faculty of taste–one that shows human capacity for appreciating the formal design of an object or artifact independent of any utility. Moral value ultimately triumphs in Kant's system, however, and his concept of aesthetics is far from the radical autonomy of French avant-gardes or English aestheticists. Political struggles in nineteenth-century European culture poised the fine arts for struggle. Saint-Simon and his fol-

lowers believed in the autonomy of fine art as a means of revelation.[5] Fraught with all the moral values such terminology suggests, this attitude also embraced the rhetorical potency of fine art as a direct means of influence. Effectively produced mass communication aiming to achieve revolutionary goals became the liberatory dream of a fine art released from patronage to serve the higher moral agenda of breaking the chains of the oppression of humankind. Marx's aesthetics caught their initial impulse from Saint-Simon—with the result that moral righteousness has remained a feature of contemporary criticism on the left as well as on the right.[6]

Reconciling Kant's autonomy of disinterestedness with such a revolutionary outlook requires certain intellectual gymnastics. But the unifying principle resides in a conviction that fine art has an independence from other cultural forms. The boons granted by such autonomy are also construed in relation to the Platonic hierarchies of truth and imitation. Mimesis was stigmatized as a debased form of discourse, imitative rather than constitutive.[7] Long-standing debates about the truth value of different arts included competition between poetry and painting according to their means of representation. Witness the extent to which Horace's famous passages from Ars Poetica are engaged by successive generations intent on grappling with the comparison of pictura and poesis.[8] The claim made by modern, twentieth-century formal abstraction in the visual arts is an answer to this age-old debate.[9] By asserting the legitimacy of nonrepresentational, abstract, nonfigurative forms, painting could at least bid for truth status by being rather than representing an aesthetic idea. Kandinsky's formalism materializes such claims, combining the several strains of autonomy in a visual approach that was independent of reference, visually self-evident, and truth-bearing on its own formal terms.[10] Kandinsky's work fulfills Kant's concept of purposiveness in its design while escaping the stigma of mere imitation of an appearance—doubly removed from truth—that consigned painting to a debased and suspect status in Plato's system.

Kandinsky's work presents an instance of visual autonomy that is both formally self-evident (it is rather than represents) and aesthetically independent (without apparent purpose), but it does not exhaust the categories of activity assigned to autonomous art in the late nineteenth and early twentieth centuries. Kantian ideas that aesthetic form carries a moral value (beauty is truth, truth beauty) lurk in the familiar, Arnoldian premises of the idea that art enlightens, educates, and/or ennobles the human mind (or soul, if one is

so inclined).[11] Purposelessness is quickly subsumed into an agenda, popularized as the idea that since fine art contains the very "highest" expression of human thought, it may reveal, unmask, or embody some absolute value or virtue.

Hegel's teleological aesthetics embraced the dialectic as a means of progressing historically and philosophically toward a condition of enlightenment. Convinced that classical art was the apogee of human creative expression, he established a rigid developmental vision according to which art had progressed and then overreached itself in Romanticism. Classical art had demonstrated its capacity for revealing truth by achieving a fine match between form and concept. In Romanticism, the elevation of "the spirit to itself," as evident in the expression of individual artistic subjectivity, split form from concept.[12] Hegel's belief that nineteenth-century visual work was inadequate to fulfill his concept of art as a philosophical concept led to his exaggerated pronouncement that "art is dead."[13] But the link he forged between visual art and the process of revelation of truth for the purpose of spiritual enlightenment remained the basis of the claims to "purity" or "truth" within many strains of modern visual art (from formal to revolutionary). This laid the groundwork for a notion of art as an agent of change. A "truth" could be materialist (historically specific in its revolutionary or utopian vision) or idealist (invoking a higher plane of spiritual value—universal, ahistorical, and transcendent). Visual art claimed a philosophical legitimacy so integral to its function and conception as to appear to be a "natural" aspect of its identity in the modern period.

Only in the Romantic period did imagination come to play a significant part in the drama of autonomous aesthetics. Aristotle may embrace the notion that the poet is able to envision those things that have not yet existed, but the spirit of imagination as a liberating force came to the fore in the romantic ideologies when the idea of imagination as the liberatory engine of humankind found fervent advocates in the early nineteenth century. Through Samuel Taylor Coleridge and William Blake the voice of the artist assumes a primary place within philosophical debates.[14] Blake identified his "great task!/To open the Eternal Worlds, to open the immortal Eyes/of Man inwards into the Worlds of Thought, into Eternity/Ever expanding in the Bosom of God, the Human Imagination."[15] The Fallen condition was humankind's separation from imagination, and the visionary energy of the poet is charged to bring about very real consequences. The romantic spirit

expressed in Blake and Byron or Delacroix is a promise of freedom from the constraints of convention. The avant-garde inherits this legacy as well, as a central tenet of the privileged role assigned to autonomous work in its guardianship of the spiritual life of humankind. Autonomous aesthetic expression is a cherished and protected province in which imagination reigns supreme, cultivated—even fetishized—as the only instrument perceived as capable of renewing the soul dulled by modern life in its mechanistic and formulaic repetition.

But autonomy also gains currency as a concept of a self-sufficient plastic or visual means. Expressing the aestheticist spirit of the late nineteenth century, Konrad Fiedler argued that artistic materials could present a "truth" in themselves.[16] Fiedler's published work of the late 1880s claimed the "autonomy" of the visual arts as plastic forms—capable of signifying through formal means rather than serving as part of a representational illusion. Painters embraced these tenets from within the studio practice. In 1890, Maurice Denis exhorted his viewers to recollect that a picture, before it was "a battle horse, a nude woman, or some anecdote—is essentially a plane surface covered with colors assembled in a certain order."[17] This position found fuller articulation in the mid-twentieth-century critical framing of early modern art. Michel Seuphor, a major proponent of modern abstraction, practically declared the teleological inevitability of such visual autonomy: "there had to be a painting wholly liberated from dependence on the figure, the object—."[18] An abundance of statements from artists and critics enamored of abstract formalism expressed belief that such visual means are universal, ahistorical, and manifestly self-evident. The work and writings of Kandinsky, noted above, served as one among many examples. Another was provided by Leger's statement that abstract art combined desire for "perfection and for total liberation."[19] Such work was derived, as Apollinaire noted of Delaunay's canvases in his notes on Orphic cubism, "not from an external subject, but from an internal subject."[20] Thus its originating impulses as well as its means demonstrated abstract work's claim to autonomy from the specific contexts that conditioned their making. The ideological implications of such postures only later came to critical attention, evident in the advent of poststructuralist criticism of the 1980s.[21] At that juncture, the assertion that visual means were capable of direct, unmediated signification or meaning production in and through their formal properties was held up to scrutiny and justly critiqued.

But the twentieth-century concern with abstraction in the visual arts also must be understood as an extension of a long struggle for visual form to free itself from a mimetic inadequacy and come into its own as a truthful, meaningful system. Colors, shapes, rhythms, and harmonies were not expressive of or surrogates for anything else—but were to be apprehended in their self-sufficient and fully apparent visuality. These investigations found their parallels and echoes in every location in which artistic expression took on a chaacteristically twentieth-century modern form: Stravinsky's music, Klee's treatises on visuality, Le Corbusier's architectural systems, Bayer's typographic principles, Albers's color theory, Vertov's film editing techniques, Stein's literary compositions, and Pound's poetics. Debates among Russian formalists quickly splintered along lines that either forged or denied links between artistic form and the production of ideology, history, or social meaning. While *zaumniks* like Velimir Khlebnikov searched for universal, transrational meaning in morphemes or among the formal mechanisms of El Lissitzky's *prouns*, Mikhail Bakhtin's dialogical method insistently pointed to the embedded condition of all forms of human expression. The "how" of formalist inquiry was the springboard from which the materially embodied condition of meaning could be specifically engaged for interrogation of ideological forces. Fine art's self-styled "autonomy" could be construed as a device among others, a conceit according to which it functioned effectively.

Important contribution to twentieth-century concepts of autonomy also emerged from the work of English aestheticists Clive Bell and Roger Fry. The art-for-art's sake sensibility flamboyantly espoused by Oscar Wilde and Aubrey Beardsley built on certain themes articulated by Pre-Raphaelite artists. The self-reflexivity of Dante Gabriel Rossetti's work embodies such aestheticism. "Painterly invention," Jerome McGann tells us, is the actual subject of such work, rather than the nominal subject matter. Like their predecessors, Wilde and Beardsley did not abandon content or narrative but instead exploited carefully chosen excesses within representational means as a way of asserting what Ruskin termed "poetical" values.[22] The conceptual thrust of Wilde's approach can be conjured in defense of figurative works as well as the nonobjective ones about to appear over the horizon of the twentieth century. Uselessness is the dandy's version of Kantian disinterestedness, replacing sober philosophical moralism with scandalous rhetorical extremes.

Among the tenets of British aestheticism, few had more impact than Bell's concept of "significant form."[23] A twentieth-century extension of those philosophical claims for the legitimate value of formal means, Bell's approach could be used to describe the central impulse of works with representational properties while it would also easily be applied to abstraction. Investigating these approaches to the concept of autonomy leads to an inexhaustible number of individual examples. Each has its own relation to the overarching premise of formal autonomy: fine art's destiny was fulfilled through *being*, not *representing*, thus fulfilling its capacity for autonomy as an aesthetic—as well as cultural—expression.

By midcentury, visual formalism came to be inextricably bound to the writings of Clement Greenberg.[24] Greenberg's critical premises contain a necessary note of desperation in the late 1930s as abstract or "advanced" art obtained value as a cultural symbol that linked a free world sensibility to its visual forms. The ideologically incongruous pact between Hitler and Stalin shook the intellectual left to its very foundations. Only a pure aesthetics could be seen as salvific under such circumstances. Greenberg's assertions of material purity, his search for the essential and exclusive qualities of media (particularly painting) as self-sufficient and fully realized came to be called Neo-Kantian. But his emphasis on materials and objects in his formalism was closer to the work of Lessing than to Kant's idea of a disinterested critical judgment existing in the mind. And the function assigned to abstraction in Greenberg's persistently cited 1939 "Avant-Garde and Kitsch" discussion was to save what remained of culture—an expression of desperate hope that civilization would survive Nazi fascism.[25]

Greenberg's ideas about the essential character of any medium as the proper subject matter for expression were the ultimate expression of that "plastic" formalism apparently fulfilled in abstract expressionism. But the focused attention to production concerns was now without effect because it provided a basis on which the works of art could be conceived as culturally discrete. If the identity of a work resides entirely in its form and that form is the self-reflexive content of its production, then its aesthetic identity is secured through visual means. Conceptual work flies in the face of these assumptions. Duchamp's urinal makes clear the extent to which aesthetic conventions are undergirded by cultural and institutional ones.[26] Autonomy as an aesthetic notion relies upon—and reinforces—distinctions between art objects and everything else. Throughout the twentieth century, and cer-

tainly in the opening of the twenty-first century, that distinction becomes very difficult to make on formal grounds. Greenberg's extreme articulation becomes the terminus of a line of formalist criticism, even as it was taken up in another guise by a generation of highly influential critics and scholars. The generation of postpainterly abstract artists who reacted to abstract expressionism—Morris Louis, Frank Stella, Jules Olitski—institutionalized Greenberg's principles in their visual work in the late 1950s and early 1960s. Artistic investigations of "pure" form reached a further apotheosis of a reductive extreme in minimalist work of the 1960s and 1970s. Barry Le Va's shattered glass works, Agnes Martin's nearly monochrome canvases, Robert Morris's felt sculptures—such productions forced the issue of what is the "least thing" that can still be distinguished and characterized as art. Carl Andre's prefabricated metal plates aligned in a grid on a gallery floor— raised barely half an inch into the space, seem to challenge the distinction between art and nonart. So, of course, do Sol Lewitt's grid drawings, even if they are indisputably "pure" with respect to their use of media.

At the same time as this end game of modern formal assumptions was played out, pop art's capitulation to the iconicity of mass culture challenged the legacy of Romantic subjectivity, which had woven through late modern expressionism, even sustained in the "purity" of earlier modern formal abstraction. The distinguishing terms of formal autonomy were challenged by the erosion of the distinction between fine art and other visual and/or material productions. Conceptual art answered this challenge by shifting the grounds of art's identity onto a discursive, rather than a productive, plane. Joseph Kosuth's "art as idea" was an explicit rejection of formalism's capacity to define art in material, visual, or production terms.[27]

In summary, then, by the mid-twentieth century, in the prevailing mainstream of Anglo-European-American criticism, autonomous art was assumed to be free of any relation to historical contexts or cultural frameworks. Fine art was meaningful in a self-evident visual way.[28] Thus perceived, visual art could produce a spiritual revelation either of transcendent truth or of a literal truth of the essence of material form.[29] Tension arises when this formal autonomy is linked to claims for the political efficacy of visual form.

The premise of radical aesthetics is that art is distinguishable from every other area of (ideologically compromised) activity. In two major discussions of the theoretical character of the avant-garde, Peter Bürger and Renato Pog-

gioli discuss the impact of autonomy as the founding concept of avant-garde art.[30] For Bürger, the chief function of the avant-garde is strategic opposition to institutions and conventions according to which bourgeois culture is defined. Bürger realized that the "purely aesthetic" could not be socially consequential, but "apartness" was an essential part of its praxis as well as its content. Bürger examines the contradictions inherent in the need for autonomy as a logical foundation for opposition, recognizing that art must be recognized *as* an institution in order to pit itself against the entrenched hegemony of bourgeois culture. But autonomy, Bürger recognizes, is a fiction, an untruth insofar as it is itself "a category of bourgeois society."[31] But in calling attention to these paradoxes, Bürger suggests that the avant-garde did away with the distinction of "pure" and "political" art. Nothing exists "outside" of cultural conditions. Autonomy is fictive but works as an idea. Bürger sustains his belief in the critical capacity of avant-garde art as an institution capable of operating without the taint of capitalist ideology— still in opposition to it.

Attacking social and cultural values in the shock-effect mode is the hallmark of the avant-garde for Poggioli. His work is less concerned with institutional sites than it is with symbolic practices in literary forms or artistic works. Autonomy is seen as the necessary precondition for critical art. But is criticality the necessary effect of autonomy? Can fine art, unfettered from its old allegiances (sacred and secular domains of power linked to traditional iconography and forms of patronage), serve a political purpose? The avant-garde, according to Poggioli, participates in the project of liberation (of spirit from matter, of consciousness, and/or of oppressed classes from the structures of oppression) of the same philosophical Enlightenment that fostered modern aesthetics. The historical framework of modernity spawns both the context in which modern art assumes a new form and the critical apparatus that provides the mythic identity of that new form. Such convictions are not the exclusive province of the left. A conservative position asserts that art can embody the noblest goals of humankind, provide a realm of transcendence and moral uplift, and encourage the soaring human spirit.

Of course the intellectual trajectories on the left span a wide spectrum. Positions are as varied as artists: revolutionary inflammation (Gustave Courbet, Filippo Marinetti), progressive support of activist politics (John Sloan, Ben Shahn), anarchism (Tzara in the nihilist vein, Newman in sublime mode), desperate retrenchment into preservation (Mark Rothko). To

invoke that full history in even so brief a mention is to suggest the lineage within which the contemporary critic struggles.[32] Among the latter-day influences, none is stronger in current academic circles, however, than that of Theodor Adorno. Adorno proposed withdrawal into difficulty of technique in order to resist the instrumental rationality underlying both totalitarian fascism and consumer capitalism. Adorno's work provides justification for much contemporary criticism supporting the political efficacy of elite art (as opposed to the avant-garde justification of provocative or outrageous work). If the challenge is to sustain belief in the efficacy of alternative discourse (within the hegemonic monolith of capitalist culture in its complex interlocking of ideological state, media, and cultural apparatuses) then is Adorno's the most useful line of argument?

Because of the emphasis he placed on formal difficulty as a necessary feature of "negative" aesthetics, Adorno's position can be readily used to justify as "political" work that operates within highly refined vocabularies and rarified domains. (Putting the word "political" in scare quotes calls attention to our need to denaturalize its use, calling its habitual meaning into question.) In its turn toward dystopic despair and away from utopian optimism, Adorno's late work forestalls questions of instrumentality in advance. Adorno dismisses the usefulness of "tendentious" or "committed" art—disdaining its methods as "bleating what everyone is already saying."[33] Modern art should supply a "political corrective to the ideological functions of mass mediated art."[34] The social function of advanced art becomes alternative rather than socially transformative. Through its "technical progressiveness" and "experiential depth," modernist works "resist the commodification of consciousness."[35] But how? For Adorno the question is left hanging. The contemporary critic rushes to fill that gap with naïve enthusiasm for so-called or self-identified political work. If a work of art is difficult—in many cases, *especially* if it is obscurely encoded and esoteric in its references—then it is political. Real politics, we are to believe, do not give themselves away in mere didactic messages. Sophisticated politics are illegible. Further justification is not required.

But even if fine art creates its own cultural territory (as Bürger and Adorno suggest), its premises are not necessarily oppositional. Fine art embodies *alternative forms of expression*—but not always *values* that are opposed to those of administered culture. The tricky character of this alternative is that its values often serve the interests of that culture even as they masquerade as

critical or oppositional. The self-interest of the artist is supposedly absent, utterly suspended, from the work. The ideological subtext of the artist's own situation goes unacknowledged. The idea of complicity suggests closing this gap. The interconnection of value systems is fundamental to fine art as a cultural practice, as poststructural critics of modernism, as well as postmodern theorists have amply demonstrated. In a complex cultural sign system values were always created, not given. Complicit practices extend these critical insights, embedding the last vestiges of autonomy in an acknowledged condition of mutual interests and benefits. The gap between a theory of autonomy and an actual condition of complicity is broad indeed.

Artists and critics of the current scene rarely draw on the fine points of aesthetic theory. Perversely, many claims for the politics of contemporary work draw on popular (rather than studied or critically nuanced) concepts of the avant-garde. Shock effects, transgression of social mores, and radical innovations in form continue to supply mainstream clichés expressing such attitudes. Long familiar within twentieth-century rhetorics of art, these terms tend to be taken at face value rather than held up for new, sharp scrutiny. Such habits of thought suppress other approaches. The idea of art as a progressive or positive imaginative activity is inconceivable under these circumstances—and exposing the hypocrisy, or at the very least, the contradictions, of most so-called politics of most esoteric fine art is considered critical heresy (or worse, damningly labeled "conservative"). The cultural practice of art continues to be defined in opposition to the culture industry. This oppositional definition has tended to blind us to the realities of art's own emergence as an elaborately administered industry in its own right. The new academicism that preserves the discourse of oppositionality is a crucial piece of that industry. Attached to clichés of radicalism, its elitist activity takes place at a remove from politics, creating promotional copy for highend products in a rarified market catering to specialized tastes. Such a condition, if admitted, would assume a just proportion—but it borders on ludicrous in the absence of such self-consciousness.

British cultural theorist Raymond Williams offers some useful alternatives. He examines avant-garde activity within a nontotalized model of culture. Rather than posit the avant-garde as a site of resistance to the mainstream, Williams conceives of each area of cultural practice as contributing to the balance among parts.[36] Culture has no "whole," no single economic base of which a superstructure is the manifestation. As a domain of activ-

ity that generates its own arena of influence and power, fine art participates in the heterogeneous realm of cultural power relations.[37] In Williams's description of cultural practices, no given binary opposition exists. No clear structural distinction between esoteric art and culture industry acts to sort activities, rather, a continually negotiated set of relations is continually in play. This mutability provides a more flexible model of art's own identity as well as its basis for assessing its potential power and effect as a cultural practice. The theoretical presumption that art *is* oppositional can be restated as a question: In what ways is art oppositional—*if at all?* This leaves open the realization that fine art may be quite complicit with the ideological condition of mainstream culture, serving its interests while expressing alternative perspectives.

Here Whiteread's water tower sculpture returns, a ghostly manifestation of history fully embodied in a quasi-translucent form in the present. The history she invokes is not political but cultural, by which I mean to say that it is replete with connections produced by and thrown back onto the material efficacy of the work as a product of social forces and relations (which can be understood as the parameter that provide the limits for what can even be thought of as art at any historical moment). The work is well suited to description within the terms of complicit formalism, not as autonomous but as associative and provocative. By making an aesthetic addition to territory, placing itself in a context in such a way that it cannot help but invoke the diachronic quality of its meaning as an image/icon, the piece literally inserts itself within the contemporary geography that is simultaneously a lived, material world and one in which an aesthetic gesture can register. In a curious inversion, unlike a functioning water tower, whose aesthetic properties emerge from its utility, works of art conceal their utility in an aesthetic stance. Both are part of systems of interrelated needs and requirements from which the literal shape of the tower and the form of its conception come into being.

The techniques of Whiteread's work distance her from her immediate postmodern predecessors as sharply as they do from the remote frames of a modern sensibility. Imagine, for a moment, the work of either Jeff Koons or Haim Stainbach, two sculptors whose work in the 1980s and early 1990s contributed indisputably to postmodern discourse. The cast-resin forms of Koons's aptly titled *Ushering in Banality* (1988) or of the porno-kitsch erotic

life-sized embraces of himself and Cicciolina (as translucent as the Water Tower) are siteless and unsituated, deliberately so. Koons's works were made to emphasize the circulating commodity aspect of art object production and to embrace with crude abandon the overtly ahistorical claims of such production. Of course these objects have a history; they are not mere simulacra, signifiers floating in an ether of unmediated presentness. But Koons had no interest in bringing those characteristics to the fore through either formal or discursive strategies. The major substantive gesture of his work was flaunted disregard the critical distinction of kitsch and avant-garde. After almost two decades, such crass aesthetics are insufficient to constitute a work.

Whiteread is hardly crass. Her work is elegant in the deft manipulation of form and reference, aesthetic "transparency," and specificity of site and conceptual frame. In this she is closer to the sculptural projects of Mary Miss and Alice Aycock. Their site-specific, conceptually inspired installations were intellectually eloquent in their relation of project to situation. But Whiteread cares about site in relation to object and dialogic system. Her work is made, as Koons was, to be sold. But where Koons flaunted his all too self-conscious salesmanship and marketing strategies, Whiteread's work aesthetically appeals to the senses and has a call to visual experience as its imperative—not a snide, clever one-upsmanship or an attitude of critical superiority to kitsch culture as its impetus.

The return of this aesthetic imperative as a motivating force, or to put it more correctly, the critical rerecognition of the aesthetic value of material experience as a point of departure for the discussion of works of contemporary art, is what allows the concept of affirmative "complicity" to absorb and extend the idea of "contingency" that prevailed in postmodern writing in the 1980s and early 1990s.[38] Contingency suggests critical self-consciousness, an awareness of the relation of any culturally produced artifact to others. The striking quality of Haim Stainbach's gallery shelf pieces, artfully composed, beautifully arranged, resides in their capacity to take the untransformed object and remake its meaning through an act of display. The contingent capability of meaning production, latent and potent in any artifact, could be realized through these acts. And it achieved this effect by distinguishing the "art" artifact from the storebought masks, vases, walkers, bottles, and legions of other items through a gesture that relied on art context as frame and art discourse as response. Fair enough. But to some ex-

tent the sheer pleasure of sensual perception was excised out of the critical reception of this work when it was touted mainly in terms of its "tactics of display."

Whiteread, by contrast, takes one by surprise in the already unframed landscape. *Water Tower* doesn't need to announce its critical distance from the world. It is neither a storebought nor readymade object. Crafted for the sole purpose of coming into being as a work of aesthetic appeal and without any other apparent purpose or end, it comments upon the world through its visual and formal means, reengaging historical references and processes. Engaged and associative, the piece recognizes its relation to the world of material objects. Made for consumption and added into the universe of things already there, the work inserts itself without negative judgment into the textural structure of the world. As an invented artifact, it substitutes the representation (cast in resin) for something else (the ghostly presence of a once-solid water tower). But not a whiff of the critical superiority that marked the postmodern relation to mass material culture can be found in this work. Resplendently unique, out of and in place, flaunting its status as an odd, unusual thing, the *Water Tower* is emphatically embedded. The object doesn't depend upon linguistic discourse for its meaning but functions through an embodied game of situated relations and visual references. It succeeds without extravagant claims to subjectivity and individual voice. No hint of the expression of personal angst or emotional experience hangs about this work. Nor does it depend on a rhetoric of "opposition" to justify the formal traits embodied in its appearance. Without any claim to moral superiority, *Water Tower* offers a disturbance to our conventions of viewing through its reworking of the landscape of habit. An interruption through which a light of insight passes, only to be refracted through its translucent substance back as a reminder that there is an object here.

The critical tradition of the avant-garde cannot remember what it did not know. The aesthetics of negativity never had a language for form in which material properties and their aesthetic appeal could be appreciated—unless they served some other "critical" purpose. But form giving serves no moral, political, or critical master in Whiteread's work. If we were to add that it served no "religious" purpose either, the reader would likely laugh. But why? Moral, political, and critical issues are equally rooted in belief systems that operate on tenets of faith. We've just come to assume that "political" values somehow possess, by their secular quality, a different relation to symbolic

formations than do religious ones. Why should we? The point isn't to engage in celebration of religious works but to defamiliarize a habit of thought accustomed to construe the symbolic engagement of art with "politics" as more real than that of its engagement with other belief systems.

Whiteread's artifacts become elements of the lived, material world to be perceived in their resonant repleteness, with the complex dialogic exchange of imagery and references of which they are capable. They give lie to the idea that fine art stands aside, apart from the world, in order to "critique" it. Nor does her work seem to presume to move us toward a hierarchy of spiritual (or political) values. *Water Tower* offers the opportunity of recognition and articulation of the changed context in which these objects come into being and thus afford an alternative site within, rather than opposed to, their conditions of existence.

Why complicit? Because the work simultaneously disrupts the norm and makes use of its situatedness. The piece is integrated with the systems to which it calls attention. Whiteread isn't working outside of or in opposition to the world, but within it. Socially, culturally, historically her work employs an aesthetic gesture as an instrument of perception. *Water Tower* provides a link between perception and cognition, connecting sensation to knowledge of culture and history. The artist doesn't seem to imagine she can restructure economic or political conditions with this work, nor does she offer a didactic treatise or moral sermon. By its presence, the work lifts our awareness out of directed activities and frees them to return to the process of perception itself. Complicity is neither salvific nor nihilistic; its transformations do not prescribe the consequences that might follow from the aesthetic experience works of art provide, even as it suggests the many routes of entangled and embedded provocation to which their artfulness gives rise.

2. The Reconceptualization of Art

The premises on which art images were distinguished from all other forms of visual or material culture in the founding period of modernism have been systematically challenged—even eliminated—in the course of the twentieth century. The basic conventions of production, expectations about content, and assumptions about the institutional locations of works have all been expanded exponentially. Think about it. The materials traditionally associated with fine arts—framed oil paint on canvas; handprinted printed

graphics; sketches; life drawing studies; cast and/or hand-carved sculpture in stone, wood, metal; works on paper; framed, matted, and glassed images—have been deemed unnecessary as distinguishing characteristics of works of art. Artists *may* use conventional means, but they aren't required to, and even more, they often have to struggle to legitimate easel painting or traditional casting amid critical proclamations of our supposedly post-studio condition. Works of art show up anywhere and everywhere, often seeking to escape the usual institutional or conventional boundaries. Such gestures no longer constitute a striking act of refusal but are simply a matter of course, most often a stage in a larger strategy of career building. The rubric "fine art" no longer refers to a category of objects but to a set of practices that express concepts and beliefs.

Why have such radical transformations been sanctioned from within the mainstream of contemporary art? How have they come to be part of the norm of its operations? And what do these changes mean for the future of art in a culture now supersaturated with visual images? How are we to understand the implications of this reconceptualization in terms of the critical frames we've inherited from modernism? Is current art really formulated on different terms than that of its predecessors? Or is it the critical insight that allows us to reconceive fine art in new ways? Might these insights offer renewed understanding of many eclipsed aspects of modernism? In addressing these questions, I'm particularly interested in the way the relation between mass media culture and fine art has been formulated and on the claims for fine art's political efficacy sustained by that formulation.

Traditional works of art were almost always characterized by qualities of the handmade, individually wrought, and carefully worked embodiment of artistic vision. But with the advent of industrial methods of production and image reproduction from the late eighteenth century onward, the relation of art to production took on a new charge. Modern art was increasingly dependent upon its crucial capacity to be distinguished from works of mass production.[39] Why? Most simply, because industrial methods of image production posed a threat to the unique authority of fine art images in visual culture.

But of course, no cultural activity can be explained that simply. Another value was served by keeping fine art aloof from what was becoming mass media. According to the moral precepts that undergird modern aesthetics so eloquently stated by that still-influential (if largely unread) figure of the

nineteenth century, Matthew Arnold, spiritual progress is produced in humanity by exposure to culture—the best that is known and thought. As the discussion in the previous section points out, such moralistically charged hierarchies have their basis in a theologically charged philosophy. But so does the equally moralistic (if more covert) radical position derived from the secular faith of utopian transformation. Both are functions of capitalism in its nascent form; both become institutionalized as cultural formations that evolve in tandem with the supposed secularization of art. And in both cases, the moral superiority by which fine art is to perform its transformations, spiritual or political, is through its distinction from the polluting dross of mass production. Perceived by the noble spirit or the discerning, critical eye, fine art can function symbolically as a mark of "distinction" (in Pierre Bourdieu's sense of the term, as a sign of class position) or as an instrument of cultural activism (the "revolutionary language" of Julia Kristeva). But it has to distinguish itself on some reliable terms. The task of criticism within modernism has been much bound up with conceiving and defending those terms.

By the early twentieth century, mass media culture had gained powerful seductive force. Technological innovations made imagery cheap and widely available, creating a previously unheard-of richness of visual artifacts for popular consumption. Mass circulation magazines, photogravure color sections in the weekly press, inexpensive cameras for personal use, the cinema, advertising ephemera—all of these put visual images into everyday life.

What was the fate of fine art? In the course of the twentieth century, fine art retreated to higher and higher conceptual ground. Actually evacuating fine art works of explicit or recognizable content became one strategy for differentiating them from images in mass media culture (editorial photographs, illustrations, advertising graphics, among other things). Thus we see the peculiar extremes to which abstraction goes to eliminate any trace of content in works that are primarily about their medium and making. Consider the trajectory of formal abstraction in painting from Kandinsky and Mondrian to Robert Ryman and Agnes Martin. Ryman and Martin's minimalist canvases consist almost entirely of marks whose significance is that they were made by a single individual whose authentic originality is in turn revealed in the trace of the hand. Or perhaps only a trace of the mind, if we extend our examples to include Sol Lewitt's assistant-produced wall drawings.

Like the circular, self-referential logic on which their critical legitimacy is

grounded, such works became exemplary of the rarified visuality exclusive to the fine arts. These esoteric artifacts—nearly blank canvases, torn ephemera, scattered debris—could not be absorbed into a mass media industry except within the scare quotes of "art." Not much chance that a blank, all-black, or merely white canvas would be co-opted for a cigarette ad or a set of children's bed sheets. Abstraction, handmade or conceptual, became both the embodiment and the sign of a resistant, nonconsumable strain of visual thought. These works of "art" could not be confused with entertainment or commercial communication. And that was the point—the justification for and effect of their existence.

As the twentieth century progressed, new media and production means (video, silkscreen, enamel paints) borrowed from the worlds of the commercial image industry and entertainment and found their place in the art world. These challenged the authenticity of the old boundary lines that had preserved the remnants of artisanal production in even the most anemically distilled formal abstract compositions. Production criteria finally ceased to operate as any kind of crucial mark of identification for a work of art.

Continuing in this line of reasoning, we can map twentieth-century art in terms of production values as a mark of "art" identity. Often the critical status bestowed on these works betrays the prejudice in which they were held by the critical mainstream. In the 1920s and 1930s, Stuart Davis adapted commercial signage to his jazz-inspired abstractions and found critical acclaim within his own and later generations. But Isabel Bishop's vignettes of everyday life or Grant Wood's figurative works were considered beyond the pale of serious critical study. American art historians remained committed to a social art history, treating these works as documents, rather than seeing in their formal structures a means to broaden the base on which modern aesthetics is conceived.[40] Because of its connection with popular forms from mass-circulation print media, early twentieth-century American art was relegated to a critical limbo from which it has yet to be fully rescued. Modernism was defined as abstract and autonomous, with American art always perceived as derivative and secondary in relation to European trends. Figurative, illustrational work could not be considered fundamental to modern aesthetics, only to its cultural history.

That legacy of stigmatization of certain kinds of popular imagery as necessarily outside the elite esotericism of fine art is still with us. Artists and critics in the 1980s may have been obsessed with the "forest of signs" by

which commercial culture could be identified (and the rhetoric by which it could be contained), but sentimental illustration and other forms of popular visual culture were considered taboo until much more recently. (Walter Keane's big-eyed paintings do not populate the archives of major modern art collections.) The difference between Eric Fischl's approach to figuration, always read in relation to high art humanism, and that of John Currin's far more popular and vernacular roots makes clear the way these strictures have been loosened in recent years. And not only were production values used to guarantee the distinction between fine art and visual culture, but the boundaries of content and genre were also strictly policed.

If the terms of style and content were strictly governed by protocol, so were materials and sites of production subject to their own disciplinary regimes. In the early twentieth century, Italian, German, and Russian futurists could incorporate mass-produced print materials into collage or assemblage—but they were usually careful to hold aloof from direct participation in the production of designs for mass production themselves. For a brief moment of the late 1910s, early 1920s, when constructivist-turned-productivist artists aligned with the machines of factory production supposed to create a new utopian age, this prohibition was put aside. The work of artists who used their artistic talents in commercial venues suffers a singular transformation when presented in a high art context. A major exhibition of John Heartfield's book and magazine covers stripped them of their original cultural and production history. This approach reinforces the ways in which the academic industry requires that modern art give up its relation to utilitarian or commercial purpose as the price of entry into the canon. Almost any engagement with material culture production within the decorative and applied arts by definition puts a work outside the realm of fine art. No amount of discussion could effectively lift this sanction. Fine art, by modernism's stringent set of rules, had to be conceived and perceived in opposition to the applied and popular arts.

A distinction between mass production and artisanal originality lurks at the core of this position. That legacy of industrial versus unique object is still with us, but the terms have changed as the use of fabrication and other commercial, manufacturing technologies were carefully, selectively introduced in fine art practice. Because fine art was supposed to be grounded in its oppositional autonomy rather than its acknowledged utility, we were instructed to read Heartfield's collages *exclusively* as political criticism rather

than as part of the publishing industry's marketing strategy and appeal. But in excusing the day job status of Heartfield's work, we cheat ourselves of important historical insights. Throughout the modern period, fine art has engaged many kinds of relations to popular visual culture and mass media production, often without a shred of oppositional rhetoric.

Since the 1960s, fine art has looked the popular culture rival squarely in the face in thematic, material, and production terms. Rejecting the earlier tactic by which it refused mass culture through resistance and esoteric formal means, fine art has tried to absorb the successful strategies of commercial culture. Pop art seemed to concede that mass media had higher production values and even higher seduction values than fine art, and so it attempted to remain competitive by adopting a stance of critical mirroring. Pop and minimalist artists made use of the images and production methods of mass culture, but in order to bring the trophy objects back into the sacred space of an implied, if not explicit, critical fine art.[41] Fine artists dared to plunder mass culture, secure in the belief that their work was guaranteed a privileged status that held the "other" of the popular up for critique as "other." If fine art was demonstrably no longer the research and development arm of the culture industries, it could, at least, be the loyal critical opposition.[42]

Thus, for all their apparent flirtation with mass culture materials, the borrowings and appropriations of postmodernism were all carefully framed by theoretical discourse. Richard Prince's Marlboro Man was always qualified in critical terms like "re-presentation." This attitude of critical distance (i.e., superiority) has kept the art world sneering at television, tabloids, and popular entertainment until the late twentieth century. Just as surely as belowstairs philandering in hierarchical culture cuts only one way in the movement of persons across class lines, so aesthetic boundaries have always depended on artists' and critics' disdain as a gatekeeping safeguard. The message was that fine art is self-conscious, aware, and ideologically sophisticated, while popular culture is premised on bad faith and false consciousness (if it has any consciousness at all). That legacy of superiority persists even as cultural studies and media studies have gained ground, bringing popular objects under scrutiny.

So securely marked are the distinctions between fine art discourses, their conceptual boundaries, and those of commercial production that by the 1980s an image in a fine art context could be identical in visual content to

that of a commercial, entertainment, or culture industry image. The prevalence of "appropriation" as a postmodern term and strategy shows the widespread belief that movement of aesthetic property across the boundary from commercial contexts constituted sufficient grounds on which to define fine art. (Again, Prince's re-presented Marlboro man only calls attention to itself as an aesthetic object by a shift in the institutional venue and critical frame in which it appears.) Such gestures raise serious questions. Critical practice quickly turns to anthropology and sociology under these circumstances since the material artifact undergoes little or no significant formal transformation from its commercial original. A striking difference can be noted here between Prince's "postmodern" appropriation and earlier, pop art–style approaches. Consider three giants of pop art: Andy Warhol, Roy Lichtenstein, and James Rosenquist. All made use of the production means and stylistic vocabulary of commercial work but at the service of individual expression in a recognizable authorial style. Prince's work asks us to consider how art images continue to be identified, let alone function, in a climate of flirtatious nondifferentiation where they consort with their upscale commercial rivals.[43]

Lacking clear thematic grounds (and also, often clear material bases) on which to guarantee an identity, works of art have increasingly been assessed on the grounds of *conception*. Ever since Duchamp demonstrated that the identity of art objects depended on their place within institutional and critical conventions, the precepts of conceptualism have played a major role in granting legitimacy to the work of art. The notion of art as "idea" asserts that it is concept, not production or content, that grants art its identity. But is the "concept" of art to be grasped through the discursive practices in which it may be identified and articulated, or is its conceptual identity automatically, inevitably manifest in the work because of the "idea" quotient of the work? Are there "art ideas" just as there were, formerly, art production modes? Or is it necessary that artworks be recognized by being perceived within an institutional framework that participates in these premises? In other words, must the work in question already be designated as belonging to that realm known as art? The defining terms of art's identity now depend upon a tenuous intersection of concept and location. Fine art has become a carefully nurtured domain, framed by a sleight of rhetoric within consensual communities of belief. Art became *idea* in order to keep itself distinct from the concept of *image*—since images had so clearly become the prove-

nance of mass culture media. Paradoxically, of course, only when they exist in and as images (or at the very least, visual artifacts) can ideas function as art.

THE MULTIFACETED HETEROGENEITY of contemporary art began to emerge from the critical strictures of a highly regulated modernist critical paradigm in the 1960s. Conceptual art, pop, and minimalism were the three major strains of mainstream art of the 1960s. Each in their own way reconceptualized art practice in a set of antimodern gestures (doing away with the object's discrete identity as a material object, as an artisanal object, and erasing the distinction with mass-produced or industrial objects).[44] Each of these was a challenge to modernism's autonomous framework and the avant-garde's strategies of opposition.

In one notable (if notably failed) effort to articulate the critical condition of contemporary art, Arthur Danto takes his point of departure for the historical changes that signal the demise of modernism from the 1964 exhibition of Andy Warhol's Brillo boxes at the Stable Gallery in New York City.[45] In *After the End of Art*, Danto pinpoints the origin of what he rhetorically refers to as "the end of art" in this specific event. In his opinion the exhibition served symbolically to mark the end of any *formal* distinction between an art object and an ordinary object. Many art historians would consider Duchamp's urinal a more potent referent for this end, pointing as it does to institutional and critical frames rather than focusing on the supposedly inherent attributes of an object itself. But for Danto, Warhol's boxes, made expressly to be *new* artworks indistinguishable from mass-produced artifacts, collapse the distinctions differently. From that point forward, the identity of fine art objects no longer resided in their form or mode of production, but only in their institutional sites and critical reception. Referring back to Hegel's famous formulation, Danto constructs an analysis of the contemporary condition of fine art in teleological terms. Art's demise is marked by lack of formal consistency and absence of style, and thus it cannot conceivably embody an era's spiritual quest. This formulation neither matches the actual condition of art production in the 1960s nor furthers the larger critical project of trying to elicit from such production an insight into cultural and historical concerns. Although he historicizes art (acknowledging a temporal continuum of styles and critical approaches), Danto doesn't historicize the concept of art (the terms of cultural plausibility). Because his

idea of art is itself fixed and static (original work, separate from mass culture), it is susceptible to being outmoded. But artists demonstrate daily the lie of such a stance (making work based on original thought within mass culture). Art is over, his argument states, because no unified stylistic mode is possible, so teleological unity at a conceptual level can't be sustained. But why should we expect stylistic unity from contemporary work? Do we really imagine it was ever a characteristic of modern art? Can we reconcile mid-nineteenth-century modes of academicism, Manet's modern compositions, commercial illustrational techniques, traditional portraiture and landscape, and American heroic landscape painting on stylistic grounds? Modernism distinguishes itself by its eclectic plurality, the eagerness of a greedy market for niche products, and a proliferation of styles and forms of aesthetic expression. And it continues in this vein.

Contemporary art is, if anything, arguably possessed of a *greater* unity than the work of earlier modern decades—if only because it has become aware of the conceptual ground shared by a range of formal styles and means. Such uniformity likely results from the influence of mass-circulation art magazines, art school networks, communication, advertising, the generally homogenizing influences of contemporary cultural conditions. That awareness was being clearly articulated in the 1960s, when the conceptual artist Joseph Kosuth pointed to the "idea" of art as its essential identity. Kosuth's "Art after Philosophy" might be read as the death knell for modernist investigation of self-conscious formalism. If material doesn't matter, then formal means are irrelevant and fine art is, in essence, reduced to its inventory of ideas. Kosuth's "idea" liberates art from the anxiety of competition with far more advantaged commercial rivals. In the late twentieth century, artifacts of material culture regularly triumph over those of fine art on the basis of their production values. But as ideas, such mass culture artifacts are frequently formulaic, the product of culture industries with a distrust of imagination and a vested interest in keeping self-conscious critical awareness to a minimum. Ad Rinehart didn't want his cartoons to be confused with Disney productions. Richard Prince feels sure that his work won't be read as an advertisement for cigarettes. But idea alone doesn't suffice in the current scene (if it ever did). Conceptualism has gradually slipped back into a rich dialogue with studio practice. Formal voluptuousness returned in the 1990s, and a material intelligence is everywhere in evidence. The combination of "idea" and material in a synthetically imaginative mode of art mak-

ing has revitalized conceptualism while extending its reach. This "recon-
ceptualization" has shifted the grounds on which contemporary fine art
should be historicized—and how it should be understood in critical terms.

Once again, we can ask, how did we get here? The decade of the 1960s
spawned a wide variety of innovations in artistic practice, and in the 1970s,
visual art practices exploded even beyond the limits of the well-orchestrated
critiques and extensions of modernism exemplified by minimalism, pop,
and conceptual practices. Communities of artists from a wide political and
social spectrum each in their own way lost faith in the paradigms of mod-
ern art. Belief in the canonical forms (and formalisms) of high mod-
ernism—which had come to exert such a monolithic stranglehold on the
New York scene and, by extension, on the American scene (functioning
effectively as a policy of control and exclusion through its insistence on its
own terms as those of the art world critical hierarchy)—crumbled.[46] Politi-
cal and social crises in the late 1960s and early 1970s had ramifications for
the assumptions artists made about the politics of art, artists and the art
world, and the politics of instrumental public policy.[47] A case in point is the
self-questioning that occurred in the New York scene as artists organized
to protest the Vietnam War, the relation of the Museum of Modern Art's
board to the war economy, and the politics of curatorial license.[48]

The confluence of these apparently unrelated issues pushed individual
artists to reexamine their own practices with respect to the question of the
political efficacy of form and action.[49] How can art enact a politics? Through
form? It seemed unlikely to activist-artists of the late 1960s and early 1970s
that the urgent impulse to stop the war in Southeast Asia could be achieved
by promoting abstract art. Could such goals be attained by making art with
overt content? Such work was immediately labeled propaganda or advertis-
ing or marginalized as activism, not art, thus undermining its claim to high
art status. Artists in coalitions and action groups challenged the institutions
of fine art to recognize their alignment with the systems of power through
specific individuals, their influence, and policymakers. Old myths fell away
in the face of realities. Similarly, the masculinist rhetorics of avant-garde op-
position had to confront their own prejudices and habits of thought. Could
a fundamentally sexist platform really effect political change? Much of the
legacy of avant-garde rhetoric began to look suspiciously like the history of
a succession of white male figures doing Oedipal battle with their elders
without any regard for what had been excluded from that lineage.

The civil rights movement and the women's movement initiated other challenges for a modern aesthetic that had denigrated figuration and the direct processing of lived experience into representational form.[50] Feminist movements reawakened interest in self-representation in symbolic, visual terms. Women and minority artists had a compelling motivation for exploration of visual practices grounded in legible representation, in modes that communicated a broad-based community interest rather than a modern aesthetics of autonomy. It is not by accident that the period in which this occurs, the late 1960s and early 1970s, is also the period of Watergate, of the shift toward a corporate culture, toward a policy of conservative supply side economics, toward a tightening of the economic conditions that had allowed the counterculture to thrive in the 1960s. So too, it is not surprising that this was a period of economic depression brought on in part by the end of the war in Southeast Asia and in part by much bigger shifts in the global economy—an economy that America, in its post–WWII position of economic power, had come to think of as the source and sustenance of an unlimited boom. Formal abstraction and esoteric practice seemed increasingly irrelevant to persons whose self-representation was ill served by the supposedly universal, transcendent, ahistorical, and repressive nonspecificity of much of modern art. First world/third world axes began to shift and change, with postcolonial concepts of self-determination and self-identity replacing the older notions of dependency and imperialist culture's concept of center and margins.

The art practices of the 1970s seem to elude easy characterization as a whole. Their heterogeneity includes explosive new forms, older once-taboo forms—representation; figuration; political art; bad art; unskilled art; art using traditional crafts, motifs, and imagery; art drawing on ethnic, family, and cultural roots. But clearly, in this historical period, modern formalism lost its grip on art as practice.[51] The pluralistic variety of work produced from such heterogeneous aesthetic bases did not find any immediate or easy critical acceptance. A frightening, but exciting, possibility arose that the entire foundation on which modern fine art had been conceived might need to be reconsidered. Not because the formal or thematic heterogeneity of 1970s art couldn't be contained with the paradigm of modernism, but quite the contrary, because it forced awareness that modernism's academic critical stance had always repressed these "others." Women, people of color, and other demographically marginalized artists had been dramatically, system-

atically excluded from academic modernism. But so were the modes of visual representation that were an integral part of craft and popular traditions, as well as commercial arts, excluded from the critical formulation of that version of modernism.[52]

The transformation of the older modern critical paradigm became fully evident in the late 1970s and early 1980s in the theory-dense period of first-wave postmodernism. Feminism was an important—even arguably *the* important—force in bringing about this change. Social and aesthetic directives were intertwined in promoting alternatives to the unitary, hierarchical, universalizing, homogenizing claims of modernist criticism. The idea that modernist thought had patriarchal underpinnings or that the interests of patriarchy were served by modern aesthetic principles was brought into sharp focus by feminist critics keen to point out that the very grounds on which value judgments were made would necessarily keep prominent women (Judy Chicago, Audrey Flack, Louise Nevelson, Mary Miss, Alice Neel, Nancy Spero, Faith Ringgold) relegated to secondary status. First wave feminism broke through the first line of entrenched modernism, making a space for challenges to its critical hegemony. With very different effects and intentions, feminist artists who were in the forefront of late 1970s and 1980s postmodernism and received critical attention often engaged in their own repression of personal and representational work. But current mainstream sensibilities have an indisputable debt to these feminist movements in art and theory, not only with regard to the practices of gendered individuals, but to also with respect to sensitizing scholars and critics to what Amelia Jones has aptly referred to as the "gendering" of terms of criticism and theory.[53]

Feminist histories aligned with postcolonial narratives and critiques to insert alternative and once marginal positions into the art historical arena, resulting in a massive rewriting and rethinking of the past. This turned modernism from the monolith of autonomous formalism into a heterogeneous field of polymorphously contingent practices.

Modernism as practiced in the high theory of either radical opposition or conservative aesthetics turned out to be a false front, a bogus pretext whose sustained existence was a historical anomaly. How, in fact, had we believed for so long? Modernism began to seem like it had been *one* reading of *one* strain of visual work produced in that brief period from about 1913 to 1963 (Kasimir Malevich's *Black Square* to Donald Judd's *Specific Objects*). Within that narrow lens, the idea of self-sufficient autonomy was able to be sus-

tained in certain critical constructions (though, looking at the evidence, it was less frequently operative among artists, only among a handful whose work "fits" the rigid modern paradigm so long espoused). Critics grounded in that received paradigm still confront the 1970s with bewilderment.[54] As Arthur Danto lamented, "The seventies was a decade in which it must have seemed that history had lost its way. It has lost its way because nothing at all like a discernible direction seemed to be emerging."[55] By the 1980s, art historians, particularly in fields in which representational or figurative work had been developed under a modern horizon (such as American modernism), engaged enthusiastically with discussion of modern work that did not fit the "modernist" paradigm.[56] And artists were making art with abundant and fertile energy.

As fine art criticism struggled to find adequate frameworks for those objects within its view, the field as a whole worked to redefine its identity within a broader array of cultural practices. For instance, the critical discourse of fine art has generally operated with an arrogant disregard for the interdependent relation between fine art and visual, mass media culture. But if we situate the reconceptualization of fine art in the 1960s and 1970s and examine Kosuth's pronouncements, Danto's dilemma, and the changes in visual arts practice within that broader history, the pressures on fine art as a discourse among others come into focus. Kosuth's essays are contemporary with the publication of major works by Marshall McLuhan, for instance. But within the art critical frame, making any connection between them would seem almost bizarre, so unfamiliar are such notions to the habits of critical thought. But the decades of pop art, minimalism, and conceptualism in fine art are decades of unprecedented transformation. While it is common to discuss mass media in relation to pop art imagery and production modes, it is highly unusual to suggest that television culture and the conceptual turn in fine art have any relation to each other. But it seems obvious that the ecological niche occupied by fine art and its discourses is radically reshaped by mass media. Inaugurated in the American domestic environment in the 1950s and expanding globally ever since in all manifestations of broadcast media electronic and digital, television radically altered the landscape of visual culture.

Visual art, the once privileged domain of image production, began to lose ground to the commercially driven advertisement/entertainment industry at a scale unmatched by its earlier competition with mass-produced printed

images. Visual art ceased to be able to compete at the level of the culture industry. Production values in the commercial sector outstripped those in the art sector.

With all this in mind, I can now restate the assertion I made earlier about what was happening within the arts in relation to the cultural conditions in which these changes take place. The advent of conceptual art in the 1960s and 1970s signals the realization that the only valid reinvention of artistic practice had to be grounded in idea rather than production. With no other artistic territory left to occupy, no other identity through which it can achieve viability, fine art retreats to this high ground as the last, and most potent, position it can hold.

What might this mean in relation to a specific work? In an innocent and somewhat anomalous way, Lorraine O'Grady's Art Is engages these rhetorical issues through a literal play of framing devices (fig. 4). A photograph records a 1985 enactment of this piece. It shows children on a Harlem street beaming out from an ornate frame. Their hands clutch its outside edges, supporting the decorative boundaries that enclose their radiant expressions. Their bodies extend beyond—into the space of the street. They are compellingly engaged in the performance of the piece. Art Is escapes the usual art world attempt at self-congratulatory "political" rhetoric and succeeds as a continually changing, dynamic work. The photograph of the performance of Art Is is at once the record of a piece and a piece in itself. Both are focused on and question the dependency between visual art's literal and referential borders as a means of its self-definition. This act of bordering/ defining as an act of framing has several implications: for the notion of the art object's status as an entity that is discrete, yet permeable, and as an arena of activity.

Art Is calls many assumptions into question in its structure as well as its thematics. Making use of formal means—a simple frame—it manages to undo the strictures of formalist autonomy. The very act of "appropriation" that produces the work necessarily goes beyond the boundaries of the already-produced image. The frame is a device for dividing the visual field while insisting on its relation to a co-extensive lived environment. O'Grady's work made use of the simplest gesture of framing as a way of un-framing the work of art, of opening its bounded domain into a dialogue with the world as the source and site of productive meaning. The frames in the piece were beautiful, elegant, gold, gaudy, elaborate, and fantastical. They suggested

4 Lorraine O'Grady, *Art Is*, 1985. Photograph courtesy of the artist.

high art and grand traditions of culture. As the float on which they were trav-
eling moved through the streets of New York City, they were handed down
into the crowd. The apparent "emptiness" of this frame was contradicted by
the impossibility of there ever being a void in that space. This frame worked
actively and passively. The moments at which it was in transit, between one
group and another of eager children, demonstrated the continuity of the
frame function. This work was not antiart in any sense. Quite the contrary,
it was art as action, unleashed from moribund constraints—an ephemeral
and yet documented gesture of transformation acting on a broad, unedited
social field in a purely rhetorical way. Once the activity was photographed,
the framing effect was in turn framed again, by the photographic image,
which abruptly cut through the incidental seeming information of the bod-
ies that surround the frame, holding it and supporting its enclosing form.
The emphatic incidentalness of the frame's capacity to function to delimit
a *visual*—and thus an *aesthetic*—field defied—the idea that there was any
material with an a priori claim on a place within the frame.

What was so effective about *Art Is* was its unpretentious inclusiveness.
O'Grady's act of art making was a simple act of distinction between that
which *is* and that which therefore by default *is not* art. Given the twentieth-

century history of art's games of aesthetic nominalism, of designating, signing, pointing, framing in the self-conscious contexts of art sites, this piece had a fresh openness, allowing the permeable boundaries of the art frame to open to an encounter with the social world of the street.[57] Rather than test the limits to which art's identity can be stretched through manipulation of *material* means (by evacuating it of content, replacing fine art imagery with mass culture iconography, or reducing its formal means to a minimal extreme), *Art Is* demonstrated the *rhetorical* identity of art. *Art Is* is a gesture, activity, and attitude, not a stable artifact possessed of specific material or formal properties that distinguish it. Putting into play a line of differentiation allowed the art function to appear, to be perceived, visible, marked. The active demarcation of the frame was the "is-ness" of *Art Is*—but it was only a continually potential capacity, able to be brought into operation, and not ever able to be stabilized as any defining, final, image. *Art Is* was an affirmative embodiment of the theoretical questioning of the boundaries of art as an exclusive, autonomous practice.

If we think about the implications of O'Grady's piece, we see that the apparent dilemma of art's identity after the 1960s can be put aside. The practice of fine art reassumes coherence on conceptual and rhetorical grounds. A permissive and open-ended pluralist diversity produces a new unity of work in dialogue with, rather than opposition to, popular culture and lived culture of all kinds. Ours is a messy condition. O'Grady's piece would hardly satisfy the aesthetic strictures of a latent modernist or a critical postmodernist. Its pluralistic gesture, engaged and participatory, challenges the very elitist view of the esoteric aestheticist.

Neither does O'Grady's work announce a final, terminal condition for fine art. Even as it created a joyously unbounded example of art as idea enacting a lived performance of aesthetics through a framing gesture, alive and exuberant, it kept the dour pronouncements of ends and closures at bay. The apparent unity of modernism as read through the academic narrative of formal and avant-garde practices repressed a multitude of diverse practices under its too-conspicuous surface coherence. Conversely, the apparent pluralism of contemporary art conceals a profound unity—that of contingent, sometimes affirmative, frequently nuanced, reflective engagement that makes sense within a historical frame as well as a philosophical one.

The conceptual turn that transforms visual art in the 1960s and 1970s provides a rhetorical foundation for contemporary work, replacing the earlier

material foundation on which fine art's identity was assumed to depend. But, to return to the questions with which this discussion began, what are the critical implications that follow? If we simply replace a materially grounded autonomy with a rhetorically based one, then what has changed? The deeper shift has to be from a model of autonomy to one of complicity, and that change encounters deep-seated resistance. For at stake is the question of how and through what means the aesthetics of contemporary art might enact or embody a politics. The question is not *should* it, but *could* fine art even do this?

In the 1980s and early 1990s, the agenda of critical postmodernism given voice in the work of Brain Wallis, Craig Owens, Hal Foster, and others struggled to preserve the residual belief in political agency grounded in autonomy. Hal Foster, elegantly following a line of reasoning established by Jean Baudrillard, argued that the basis of fine art's capacity for intervention in systems of power had become symbolic and rhetorical.[58] He called this contemporary phase the "neo-avant-garde" and distinguished it from the historical avant-garde. Struggling for a strategy by which art could escape capital's capacity to recode meaning through endlessly powerful acts of co-optation and recuperation, Foster recognized that the old avant-garde critique could all too easily be absorbed to serve the ends of the culture industries.[59] Genuine political critique was readily subsumed behind the stage-managed politics of the art scene. He was driven to preserve a political foundation for critical art that wasn't grounded in opposition, resistance, or outmoded concepts of revolution. Fine art could not afford to become a "mandarin" culture of elite esotericism nor to continue its adolescent game of mythic, marginal, nihilistic opposition.[60] Paradoxically, this is precisely the kind of work Foster focuses on in finding a "good" critical object. Characterizing the historical avant-gardes as "performative and contextual" in their effect at registering political resistance through aesthetic activity in the public sphere, Foster remarked on the refocusing of fine art's political attention on a wide array of institutional critiques.[61]

Foster preserves his belief in the redemptive power of critical art and the rhetorical foundation of autonomy as the grounds on which such activity can be sustained. The work that attracts his gaze is often entirely dependent on the house of cards pyramid scheme of elite practices legible only to an inner circle of academic critics. For instance, in what world can the pseudo-docent-speak of an artist like Andrea Fraser communicate to any but the

most ennui-stricken members of an art world in-crowd? Fraser's performances are staged in galleries or museums. She poses as a docent or a gallery worker and then leads visitors in a tour of the work. Her claim is that she provides a metacritical challenge to the ongoing business of fine art as a commodity-based institution. But whose interests are really served by this activity? Fraser's, of course. And that of the galleries and exhibitors whose work forms the foil for her clever commentary. Not only is she not undoing the commodity system, in spite of her stated purpose of revealing contemporary art to be a "service industry" (her phrase), but she is successfully succeeding in making herself a consumable art product.

The symbolic value of such activity might, within a certain esoteric frame (and with a willing suspension of disbelief) be read as a political act (by virtue of the criticism of social, institutional, economic, cultural, or other systems and forces in play). But the reality is that the careerist trajectory of individual artists is always within the frameworks of the institutions from which they stand to benefit. The subject of the talk may be critical, but the structure of the situation is aligned with the power structures under critique. Fraser in particular seems the example taken to extreme. Her performances are posed for those same figures who write about it then read about it in the pages of *October*. Rarely has an artist had so closed an arena so carefully delimited and disconnected from any possibility of the kind of change, transformation, or effect that has to characterize instrumental political activity. At a symbolic or rhetorical level, such work is esoteric to so great an extreme, its audience so circumscribed, that it is hard to separate it from this hermetic circle of critical activity.

Many artists of the last half-century seemed to subscribe their allegiance to "difficulty" as a core component of the belief that a politics of resistance was essential to any contemporary art of real substance. But not all. Across a broad spectrum, from outrageous to consumable, important works of twentieth-century art have escaped the requirement of self-serious difficulty. Piero Manzoni demonstrated a profound sense of humor, signing cans of his own feces as works of fine art in the 1960s in a gesture that may be hard to accept but is certainly easy to understand. Similarly, when Lynda Benglis outraged the art community by having herself photographed naked holding a giant dildo to advertise an exhibition in the 1970s, her in-your-face attitude was unambiguous even if many found it offensive. Any number of pop artists made work that was readily accessible, if baffling because it

seemed too easy. Philip Guston displayed much comic irreverence as part of his visual intelligence, painting crude cartoonlike forms of hairy feet and other icons in thick, fleshy tones. The projects of many conceptual artists (N. E. Thing, John Baldessari, Ed Ruscha come to mind) and adherents of Fluxus (Dick Higgins, George Brecht) depended on wry or arch attitudes toward received traditions or sacred cows of fine art. Any of these works can be read within a critical discourse of difficulty and resistance. But is it apt?

The heavy weight of theory has come to burden many artistic practices retrospectively with a framework of seriousness the original work doesn't always bear with grace. The canon of late modern art (by which I largely mean produced after the 1960s in the aftermath of pop art, conceptualism, and minimalism) has been defined within academic circles by a more systematically aligned rhetoric. This places a premium on difficulty as the very sign of political efficacy without ever asking whether either of these are necessary conditions for the aesthetic success of works of fine art. So ingrained are the current habits of critical thought that its foundations are difficult to call into question. But most pernicious is the way the premise of resistance has prejudiced the perception of new work, much of which doesn't conform to such expectations. In the 1990s, a strain of ludic formalism, self-consciously indulging in the pleasures of material practice in all its associative and suggestive possibilities, showed up with increasing regularity in gallery spaces and museum shows.

Where does this leave us?

The problem with a critical paradigm such as Foster's or many other theoretical writers associated with postmodernist neo-avant-garde positions is that it can't be applied to a broader field. It is hard to analyze the success of John Currin or Lisa Yuskavage let alone Bob Berlind or Bessie Harvey. And to dismiss them as unimportant or insignificant seems to miss the challenge—what is the theoretical framework within which works such as these *work*, are successful, viable, well-received, popular, and even critically acclaimed? The fascination exerted by Currin and others for whom the vocabulary of fine art has expanded to include the most travestied versions of the popular is a significant indicator of a change in orientation. The lines of resistance that characterized left-oriented political art and right-oriented conservative art in such a way as to exclude the imagery of popular media culture simply don't hold any longer.[62] Conservatives have long raised the weary standard of allegiance to tradition-without-innovation, and the radicals

have waved the equally weary standard of resistance-through-transgression. Both are now powerless against the long-since-risen tide of a new aesthetic forged in the dialogue of a long historical tradition and a visually saturated, media-permeated contemporary environment.

Fine art performs a mediating function whose efficacy resides entirely in its ability to register the difference between the lived and the represented with some significance. The transformation of experience into aesthetic artifact carries no requirement that it serve the social conscience of the culture in an instrumental way. But the act of filtering experience into form is itself inherently political, if by political we mean the creation of a space in which individual subjectivity is marked, expressed, and preserved with all of its ideological complexity.

Symbolic values are negotiated through aesthetic expression. Fine art's rhetorical spaces express the relations between individual experience and mediated life, between a sense of history and the impossibility of continuity without change, between a sense of identity and the unsustainable myth of individuality, between a public sphere of commercialism and a private domain shrunk to almost nothing through the colonizing effects of media culture. As a young artist said to me recently, she doesn't use media images to compete with them but in the hopes of making work that might have some, any, meaning. The visual vocabularies that construct our imaginary life are drawn as much from media culture as from the history of art, decoration and applied arts, and traditional and industrial sources. The circumscribed domain of art is produced in a differentiating dialogue with what already is, with what has an individual take on the collective whole. The point where this difference registers as significant, the shifting frame of O'Grady's Art Is, remains the defining boundary of fine art's rhetorical activity in its reconceptualized—but very material—condition.

4

FORMS OF COMPLICITY *"But I Thought Art Was Special"*

Formal enthusiasm characterized fine art in the decades of the 1990s to the early 2000s. The pleasures of making had not been so apparent for decades. The minimal-conceptual backlash against expressive traces of human emotion and subjectivity that was itself a response to abstract expressionism extended to the critically bound restraint of 1980s postmodernism. In the wake of these movements, and often in their shadow, a host of vibrant, imaginative, even playful practices had sprung into being. Current artworks demonstrate their capacity for a wide array of modes of engagement with contemporary experience.

This vibrant discourse embodies certain risks. Rendering artistic expression in consumable material always opens it to co-optation, just as any sign of enthusiasm for the mainstream seems liable to the charge of commercial opportunism. Modern art so often and deeply marked its opposition to

consumer culture except as a source for "material" (in an almost literal sense) that many current approaches seem to raise the fundamental question of how fine art distinguishes itself from other forms of cultural expression. But after all, a work of art can—and frequently does—express contradictions, appearing oppositional and critical in its rhetorical stance at the same time as serving the artist's interests in advancing a career. By the same token, fine art has the ability to affirm individual perception and experience through the creation of form, no matter how critical the stance. Work with a self-conscious awareness and reflective insight has as much capacity to desta-bilize our habits of thought as many works conceived as overtly opposi-tional. Reductive approaches cancel the complexity of creative discourse, while attention to the inventions of aesthetic sensibility serve as the best point of departure for critical discussion.

Fine art operates in a formal dialogue with its own (many) traditions and the glut of visual culture's offerings. Imaginative work is currently being cre-ated beyond the boundaries of policed aesthetic correctness, often in ex-plicit dialogue with the culture industry. While visual culture seems poised to overwhelm fine art through its massively capitalized appeal and claim on the market share of public attention, fine art continues to challenge con-sensual norms through surprising means. But while fine art often seems like an endangered activity, its demise seems unlikely as long as we attend to the unique ways fine art contributes to production of cultural memory and ex-pression of what we are, now, capable of thinking in material form. New art provides a way to recognize familiar and formulaic positions within the administered zones of academic and official culture. In so doing, such work provokes a rethinking of the history of modernism as well, particularly with regard to its exclusions. Current productive tensions between fine and com-mercial art, kitsch, tacky, sentimental, patriotic, religious, or otherwise con-ventional forms have been with us since the advent of modernity. What seems most striking in the work of the immediate decade is the explicit recognition of the more complicit aspects of those relations, and thus the capacity to be relieved of a long taboo against discussion of this aspect of modern art in a longer historical view.

Fine art is not advertising. Individual works of art and artistic vision, no matter how complicit, or corrupt, are distinguished by their fundamen-tal undirectedness, by the unpurposed nature of the undertaking. Client-driven, commercially sponsored work that is conceived from the outset in

alignment with a goal, interest, or outcome is simply fundamentally differ-
ent. This is not to say that commercial work contains no insights useful to
understanding our cultural condition—quite the contrary. Much of con-
temporary art engages in precisely the dialogue with commercial imagery
that gives lie to that dismissive attitude. And after all, much of what passes
for "fine art" is simply systematic commodity production, as devoid of spirit
and soul as any crass commercial image. (Nor should we ignore the fact that
commercial interests underwrite much fine art. If the Hugo Boss Prize funds
an installation, how is that different from the way work is commissioned by
Absolut Vodka or Benetton? The answer is not simple, no matter how many
protests of "they don't control the editorial content" arise in response.)

Aesthetic experience, ultimately, is an act of perception and interpreta-
tion, but the capacity of fine art objects to make that experience over into
form is their primary reason for being. When they succeed, as the works in
the case studies that follow do, they provoke unexpected and engaging re-
sponse, often, as with works of Llyn Foulkes, the very question they contin-
ually raise is simply that of the grounds on which work can be identified as
art in a age of mass media and material culture.

I THOUGHT ART WAS SPECIAL (1995), a painting by Los Angeles artist
Llyn Foulkes, summarizes the anxieties that show up in current debates
about the relations of fine art and mass culture (plate 4). His mixed-media
painting depicts a man of middle age, features, and clothing rendered in
thick impasto. The figure is separated from a pastiched, barren landscape
composed of a bare tree and a corrugated-metal-roofed building. A wooden
fence stands between them on which a standardized sign has been tacked
to display its message, "DANGER," in red block letters. The man's head is
haloed in gold, casting his features into saintly martyrdom. But bursting
through his temple from a mass of gray matter is a Mickey Mouse figure. The
small rubber doll bears the unmistakable ears, yellow gloves, and facial fea-
tures of the demon beast icon of the culture industry. Nothing signifies
more than Mickey the domination of mass consciousness by commercially
engineered imagery of the most relentlessly monolithic variety.

The title gives the nightmare image its potency: The first person speaker
of the phrase, I Thought Art Was Special, might well be the man in the image—
either mouthpiece or stand-in for Foulkes himself. The figure may even
represent the generic image of the individual artist, his forlorn expression

revealing the extent to which his long-held faith is being tested by the erup-
tion of the little icon from within his own mental interior. The fact that the
Disney icon bursts from the artist—rather than assaulting him from out-
side—is particularly terrifying. The insidious complicity with mass culture
that this implies may or may not even be a result of conscious choice on the
part of the artist. Having already absorbed the mouse, the figure is now
forced to come to terms with its surfacing through his psyche, his soul, and
intellect—like a carcinogenic pollutant timed to release its toxins in a once-
sacred domain—the interior life from which artistic expression is supposed
to be drawn.

The interior life of artists, like that of most of the population of first
world (and increasingly, global) culture, is highly permeated by the imagery
drawn from the culture industry. The idea that an authentic realm of "lived"
experience exists independently, apart from the "represented" universe of
the media, suggests a specious concept of purity—and a dubious conviction
about the capacity to retain separation between such domains. The Mouse
bursts out of the artist's head in full, violent recognition of its having already
been processed. Interior life is as hybrid and eclectic as the airwaves. The sa-
cred space of individual identity is as constructed in social terms as any pub-
lic arena of communication and display, even if it is inflected differently.
Foulkes's painting is that "special" art thing he bemoans the loss of even as
he enacts its existence. But the "specialness" whose loss he mourns is not
the same as that which he preserves in his work. The concept of a once-pure
domain, beyond the colonizing reach of mass culture, is the special thing
that is lost. Lived experience, on which the artist draws, is so interpenetrated
with mass culture symbolic systems that fine art's individuated expression is
necessarily hybrid and heterogeneous, a teeming inventory of images and
ideas broadcasted, manufactured, advertised, and consumed in the mar-
ketplace of contemporary culture.

Foulkes was a pop artist. The interplay between fine art and media culture
was crucial to his painting until the late 1960s, when he made a definitive
break with pop art.[1] According to critic Michael Duncan, Foulkes repudiated
the flat, thin, graphic quality of media images. His response to the notion
that pop art was "killing painting"—Foulkes's own words—was to intro-
duce a thick, materiality into his surface. Materiality, like difficulty in lan-
guage or atonality in music, seems to resist easy consumption. Materiality
can't be readily replicated in reproduction. The thick canvases can't be

swapped with mass-produced copies. The autonomous integrity of the work of fine art is embodied and thus preserved. Or so the argument goes.

Counter arguments rise quickly in response to the assertion that any particular property of works of art carries a specific ideological inflection. Materiality may be resistant to reproduction and thus be difficult to circulate (or simulate with authenticity) in the easy systems of consumer culture, but the imagery of Foulkes's paintings reads out loud and clear in the reproductions photographed with raked light that emphasizes their physicality. From within the critical debates of high modernism, the threat to painting seemed to come from the culture industry—precisely as Foulkes's thematics suggest. Paradoxically, however, pop art saved painting specifically by importing mass culture imagery into the medium in such a way that the medium itself was called to attention. What distinguishes an Andy Warhol painting of a Campbell's Soup label from the label? The fact that it is a fine art image. That distinction is what has value in the case of the Warhol work, not the iconography. Foulkes painting is fraught with the contradictions involved in making a work that is about the anxious identity of fine art in contemporary culture. For the grounds of that distinction have eroded in the last half-century. On what grounds can the "different"-ness of art be said to function now? In critical parlance, we would say that the dialogic relation of individual expression to the conditions of production operates at every level of material and cultural circumstances. In the vernacular, we might say that the very ability of artists to make works that can be seen as different from those of mainstream culture is what continues to mark art as significant in contemporary life.

1. Slacker Aesthetics

Jason Rhoades emerged as a high-profile "new" artist in 1993 with his debut New York show at the David Zwirner Gallery. The installation, Cherry Makita— Honest Engine Work ("Garage Renovation, New York," detail), had the aesthetic sophistication of a kid's rainy Saturday afternoon diversion (fig. 5). The garagelike shed constructed in the gallery displayed more evidence of playtime activity than artfulness. A large power drill hung suspended, surrounded by all kinds of miscellany. As John Miller reported in Artforum, the piece was composed of "various bits of equipment and shelving cobbled together from cardboard and drywall; tools modeled from tin-

5 Jason Rhoades, *Cherry Makita—Honest Engine Work* (installation view, *Garage Renovation, New York*), 1993, various materials; size varies according to installation, 141″ × 130″ × 180″. Courtesy of David Zwirner, New York.

foil, dough, or plaster; drawings in motor oil on kraft paper; red buckets; chunks of Styrofoam and foam-core, piles of random Polaroids, loose screws and nails, sawdust, grease, and anonymous effluvia."[2] A funky, unconstructed work, it relied heavily on duct tape as the basic means of construction. The basketball hoop hanging off the badly made shed added the finishing touch of kid-play space of the mainly (though not exclusively) boy-art variety. The gendered coding of the work was pushed, (to quote Miller again) by the "exaggerated phallicism" of the large power drill as the one working object—which Rhoades would occasionally show up and run to no particular productive end. "Nothing was finished. Nothing *wanted* to be finished. Rather, the partially formed or transitional elements shuttled the viewer back and forth between the literalism of real tools and work processes and the artifice of dysfunctional or solely representational objects and events."[3]

Rhoades's piece struck me initially as another of those how-bad-can-it-be-and-therefore-get-a-lot-of-attention works that so often claim the spotlight for a season, boost the artist into a meteoric three-to-five year career followed by a bust and (frequently deserved) obscurity. But I soon realized that the very qualities of the piece that had put me off at first—poor construction, disregard for skill, parodying and bracketing of work/labor as functional (both within its thematics and its material form), non-aesthetic funky form, antiartfulness, and boy machismo—had potent value as significant elements. The "badness" of this piece is precisely its point. The slacker aesthetics garnered high critical acclaim. This "unconstructedness" and the low production values had a timely value in the early 1990s, particularly with respect to then-current cultural reassessments of the status of work, labor, and production.

This work has no more to it than meets the eye. No redeeming arguments will transform these installations into works of profound aesthetic value in formal or critical terms. Quite the contrary. These two installations are ephemeral and transitory.

"Why is this art?" Skeptics of contemporary art will often ask with thinly veiled hostility. Such a challenge seeks a response that it can immediately dismiss, not a real answer or dialogue. But what if the question is inverted? Posed as, "What is art since this is it?" the question allows analytic and descriptive answer instead of a defensive one. The art world has its own logic, like any subcultural entity with its own rules, boundaries, and self-regulating institutions and discourses. Within that logic, the work has achieved visibility and validity. Why? Specifically, how do the formal qualities of this work contribute to its effect? What is the value of slacker aesthetics?

Had Rhoades's pieces never been exhibited, never received critical attention, and remained in obscurity until they were carted off to the landfill, they would obviously not be the same pieces. Institutional contexts are essential for the production of the values the work generates. Whose interests are served by the aesthetic precepts in this work? The most conspicuous aspect of Cherry Makita is its devaluation of labor. The thematics of the work link it to the world of automobile mechanics and workers through an act of aesthetic displacement. The value of actual work is covered up through an aesthetic act in which work itself appears to be devalued. Nonwork, lack of work, lack of craft, and lack of skill—these become the subject of an art piece, thus are granted symbolic value in aesthetic terms. At the same historical mo-

ment, the values of real work, craft, and skill were under attack in the economy of real production. Blue-collar labor, particularly unionized labor, was being seriously undercut. Outsourcing, downsizing, shifting of production to third world low-wage environments, and various other labor/production practices were particularly conspicuous in this period of the early 1990s. The compensatory function of the art work is obvious: its capacity to take a "devalued" category—skilled work in the motor trades—and reinforce that devaluation in terms that render labor/work itself a null, useless category.

Labor and value are connected in contemporary culture through fine art. The distinctive features of artistic production have to be marked and legible in visual form for the identity of fine art to be preserved in material terms.

Rhoades's devaluation drops the bottom out of the labor/value scale. Fetishized art labor was the contrasting term of undervalued working-class labor.[4] In a labor-hungry moment of massive industrialization, paramount importance was attached to the distinction between artistically skilled labor and industrial labor from a seemingly unskilled pool.[5] In a labor-glutted environment, reducing the value of blue-collar, industrial work to a null category is one function of an aesthetic production that seems to glorify unskilled, low-effort production.

Rhoades's piece devalues work not only in material but also in thematic ways. By acting out "work" with the oversized drill (a parodic image of potency) Rhoades pushes the tasks of a mechanic into the realm of the absurd, rendering them unvaluable. Repeating the useless acts of drilling at intermittent and unscheduled intervals enacts a disregard for the regularity and intensity of hours of work in the "real" world. The play aspect of the piece as a whole bespeaks an any-kid-can-do-this attitude to mechanical activity, eliding the boy-machismo game with the adult realm of actual productivity, equating them in order to diminish the value of the latter. Finally, the title of the piece is replete with associations. Makita is the toolmaker, but "Cherry" is the adolescent boy term for a fine motor, great machine, a virgin female object of desire, or a highly prized thing. These terms contribute their gendered terminology and associations to the barely concealed racial slur implied in "Honest Engine" ("Honest Injun"). This latter invokes the stereotype of the mechanic as a rip-off artist, ready to cheat the unsuspecting nonmechanical customer. Is there a suggestion that blue-collar workers are schemers running a scam operation, hiking up the price (hourly wages) on a lube job or brake repair in order to bilk the (of course white-

collar) client out of her/his hard earned (salary) money? The inscription of class distinctions functions as a joke between the artist and viewing audience who are all presumably smugly on the "other" side of the wages/salary line.

Cherry Makita is not merely or only about the way in which an internal ideology of art validates the "unconstructed" as a new aesthetic innovation (a kind of upping of the ante of the "bad" art values of other anti-aesthetic gestures of the twentieth century from dada to Fluxus and so forth). Rather, the piece shows the ways in which this specific form of unconstructed art, with its emphatic dismissal of labor as a value, serves particular interests.

For labor to be devalued inside the framework of art production is, by extension, to legitimate its devaluation elsewhere. Aestheticization is a powerful and forceful act. In Rhoades's piece, and even more in the phenomenon of its positive reception and critical recognition, Rhoades doesn't have to make this statement intentionally. The fact that his piece gained so much critical currency demonstrates the utility of the idea rendered in aesthetically perceivable terms.[6]

Cherry Makita demonstrates that a work that at first sight seems an odd choice for major success in the New York art world in a busy fall season turns out to be uniquely suited to succeed. Such work looks useless. It appears bankrupt with respect to the older values of beauty, truth, virtue, moral uplift, and other mythic functions that attached to art in its secular existence. But it turns out that this apparently nonideological aesthetic embodies a value that is far more useful: its capacity to legitimate terms that serve the status quo by appearing to be different from them.[7]

By its conspicuous show of "originality" of form, theme, and technique, the Rhoades piece functions as the quintessential sign of an individual discourse supposedly independent of the ideology of labor. Even after the era of poststructuralist criticism, with its much touted "deconstruction" of authorial originality, the image of the artist as individual persists, with all the trappings of the free-spirited genius working entirely within the unique frame of her/his imagination—the "novelty" of Rhoades's piece. Artistic production is shown to be such rarified and "unalienated" labor that it can "get away" with looking like it is not at all the product of "work."

THE SECOND RHOADES installation, *My Brother Brancusi* (fig. 6), filled an entire gallery room at the 1995 Whitney Biennial, evidence that Rhoades had

6 Jason Rhoades, *My Brother Brancusi*, 1995, carpet, wood, steel, small gasoline engines, tools, plastic, donut machine, 26 3/4″ × 5″ × 113 3/8″. Courtesy of David Zwirner Gallery.

"arrived" as a new artist two years after his first major New York show. A series of photographs on the walls juxtaposed images of Romanian sculptor Constantin Brancusi to images of Rhoades in his garage studio with his brother—whose eclectic collections reminded Rhoades of the sculptor's studio.[8] Rhoades's title emphatically underscored his connection to and distance from the received traditions linking contemporary art to the modern past. In addition, the piece made these links an evident and conspicuous feature at every level of the work from conception to production.

The installation was enormous, complex, and eclectic. The initial impression it created was a storeroom at a hardware or home-repair outlet,

since it was filled with rubber-tired dollies, shiny hand trucks, and tools with hard-baked enameled surfaces in red and black. Among these were stacks of electrical cords, packing blankets, bits of tractors, lifts, and other not quite identifiable fragments of equipment. Fresh pinewood crates offered a contrast of material and tone while the range of heights, masses, and volumes in the assembled collection echoed the formal concerns of early modern sculpture. Freshness and newness pervaded the air, but also a sense of the excess of available equipment rendering each element less valuable for being part of a mass in which the individual items were hard to pick out. The quotation of the Duchampian readymade was obvious, though Rhoades had clearly filtered his appropriative strategies through the postmodern modes of display, self-consciously figuring his chosen objects as prime commodities against the fine art setting. Their aesthetic properties shone forth. Rather than repressing the formal seductiveness of the newly mass-made items, Rhoades embraced it. The massive amount of equipment emphasized the system of reproduction of which these are mere incidental instances. The huge machine of the productive apparatus is apparent behind each dolly, each tool, each standing cart, so that it references the productive capability from which these items emerge. Each item was more perfect in form than any handmade work. These elements were more completely objects-as-products than objects-as-expressive-form or objects-as-artistic-form.

At one end of this amassed collection of stuff, arranged on rubber mats in the center of the gallery leaving only a small passageway around its edges, a donut-making machine produced a nonstop stream of miniature donuts. Stacked on a pole from the floor to the ceiling, they made a Brancusian "endless column" of irregularly similar forms. The tradition of the art machine as the work that makes some thing mocks the artistic process through an anthropomorphic imitation of creativity. Among the outstanding instances of this strain of modern art are Jean Tinguely's elaborate self-destructing mechanisms and Francis Picabia's quirky mecano-morphs. Their playful absurdities qualify the mainstream modern aesthetic celebration of the machine. Traces of Rube Goldberg showed through Rhoades's machines as well, manifest in their overly elaborate system of interconnected operations. The viewer struggled to create an associational gestalt within which to unify the disparate objects in the space. Meanwhile, with a desperate sense of re-

dundancy, Rhoades's machine made its endless stream of donuts while the rest of the equipment was rendered useless, merely on display. There's no winning in this situation—productivity and idleness are equally pointless. These functional objects were being put into a suspended condition called "art." "Uselessness" equaled artness in this installation, in a mockery of that condition of transcendent purity so beloved of modernism in its attachment to "autonomy." Art values reside in the mooting of utility, as use value is put onto the cold ice of art, out of reach, in an exemption from use.

But why did Rhoades pick Brancusi for his "aesthetic brother"? His work appears much closer to Duchamp and to his heirs Haim Steinbach and Jeff Koons with their now-classic postmodern modes of displaying bought objects without any transformation of the things themselves, just of their circumstances or arrangement. By invoking Brancusi and the tradition of high formalism, Rhoades asserted the formal validity of his work rather than dismissing these values. This assertion caused us to take seriously, however briefly, the possibility that Rhoades was engaged with concerns related to that of the modern sculptor. Brancusi's finely made, elaborately hand-finished sculptures, shining with the effect lavished on them, cannot compete with the mass-produced equipment Rhoades has assembled. Industrial, mass production always wins—now. It holds all the cards.

But Rhoades posed the issue of artistic identity in terms of two contrasting historical and personal lineages. As a "young" artist, Rhoades was supposed to define himself in relation to precedents. In the grammatical apposition of "My Brother" with "Brancusi," Rhoades pressed his sense of fraternity with the modern sculptor. At the same time, Rhoades set up the contrast between himself (the artist) and his actual sibling.

Rhoades's brother works on an assembly line. But the photographs ringing the installation showed him in Rhoades's garage studio in their family home. Rhoades implicitly contrasted the privileged nature of artistic labor and that of wage labor, creating echoes with the earlier Cherry Makita piece. The lived connection to his biological brother resonated with the feeling of fraternity toward Brancusi as a spiritual brother, one who shared his imaginative life and aspirations. By combining these various elements within a single piece, Rhoades indicates the presumptions of attempting to position oneself in relation to history while continuing to work through new concepts and old forms. My Brother Brancusi is both celebratory and parodic of modern formalism, seeming to comment on the attempt to engage with and

avoid simultaneously the influential legacy of Brancusi and the long shadow of modern art. History is a burden and a defining ground.

Art doesn't exist without history. Forms, legacies, lineages of concepts, and models of aesthetic and anti-aesthetic gestures are all present in Rhoades's conception of his own practice. He seems to feel he has to acknowledge this legacy, embed that recognition into the work itself. *My Brother Brancusi* is clearly not a work of imitation. The sculptural installation is not about copying; Rhoades isn't working in the style of Brancusi, the "master," but he is acknowledging twentieth-century modernism as the foundation of his own work. Rhoades seems to want that history to be present in the work—or at least, in the gallery as a framework for the installation's perception. Such an attitude is in dramatic contrast to the transcendent formalism once central to the modern aesthetic. History cannot be stripped from this piece. Such an installation couldn't even pretend to be immediately comprehensible on formal terms or to appeal directly through the senses to the mind. Rhoades's relation to the history of modernism is utterly at odds with such a claim—and thus limits of the claim are brought to our attention as well.

The forms that Rhoades uses are industrial, commercial products—not just the "ordinary" material of minimalism or the commercial objects beloved by pop art, but the already made and formed things of the world. These come with associations and cannot help but function with and through those suggestive relations in their performance of their formal duty. Donuts are not just shapes but donuts, with all that that implies. Their forms have art significance through an asserted claim to historical precedent. Named as that precedent, Brancusi provides a means of validating the choices in the work, linking a contemporary practice directly to the historical past. By forcefully invoking such a network of associations and references, Rhoades demonstrates that the formal, signifying, referential, and personal meanings in his work are historically inflected.

A thin line demarcates Rhoades's work from that of one brother while connecting him to the other. This line of faith is drawn in the quicksand of a rapidly changing cultural field. The embeddedness of (all) artistic work within a historical matrix of interconnections, quotations, precedents, and innovations is dramatically evident in Rhoades's work. Rhoades qualifies the very idea of autonomous formalism as a premise. Value is never self-evident or inherent. Allusional and associative value is produced through the system

of culturally determined circumstances. Such notions long ago offered challenges to the self-identity of works of art. In a slacker aesthetics, the very "work" ethic of artworks is undermined as well.

Rhoades's work is a perfect instance of "improbable" contemporary art. Take a half a step toward these cast-off remnants of an overconsuming culture, and you fall under the spell of the "internal ideology" of art—discussing the finer points of the Rhoades piece in the history of anti-aesthetics in the twentieth century. Take a half a step back, and you'll find yourself aligned with the most skeptical nay-saying disbelievers who wag their heads in weary disgust at the inbred institutions within which this stuff passes for "art." The work has no evident value (in use or production terms). This "apparently aesthetic object" of contemporary art can be identified by this uselessness. But the "apparently aesthetic object" isn't an art-for-art's sake object. Nor is it an "anti-art" object. The work pushes past those limits. No more moral values. No work ethic. No redeeming formal qualities. No inherent value. Just an incidental and ephemeral work of timely expression.

The paradox is that within the managed ideology of current culture, art remains the domain in which personal expression and individual voice continue to be validated. But in being validated, they serve a purpose within a specific economic and ideological system.[9] The Rhoades work is a perfect instance of the way the reification of the concept of that individual voice is mythically construed within the internal ideology of art. This reification is complicit with the very system it appears to oppose. The details of Cherry Makita cut both ways—they undercut the seriousness and self-seriousness of "art" in a dismissively playful sense (taking bad-boy bad art to a new place of messy, unskilled, unconstructedness). But they also invoke the ideology of the broader culture, undercutting the value of an underclass of "individuals" whose identity is conceived of in very different terms. "Individual voice" becomes a symbolic construct capable of devaluating individuals as workers. Is such work more progressive than that of the culture industry? How would the music of Bruce Springsteen contrast with this piece by Jason Rhoades? Whose work has a greater impact on public perception? The difficulty in answering this question comes from its unfamiliarity. Art has been assumed to operate in a sphere removed from such considerations— in spite of centuries of claims to political efficacy and clear understanding of the power of images. When fine art is understood as one among multiple

ideologies, the dialogue between its real and mythic operations comes into focus.

2. Violating the Old Taboos of Fashion, Amusement, and Sentimentality

The term "gallerinas" was coined to describe the young women artists whose glamorous appearance gains them space on the pages of style magazines. Only the latest tweak in a trend that blurs the boundaries between fine art and the world of fashion, the term and the beauties it identifies continue a trajectory that began in the early 1990s. A moment of crisis occurred, reflected in the changed editorial policies of mass media publications. Style became the catchword of the 1990s. The sea change announced itself as a turn away from theory. Marked disillusionment with the turgid, language-bound, critically based attitudes of the 1980s was accompanied by a sudden infatuation with fashion. Clothes, consumer everything and unbridled aspirations to be part of a trendy scene—these themes and attitudes permeated the pages of once seriously critical art magazines with the ease of recreational drugs finding their way at an upscale celebration.

Why not? The late 1990s was an era of affluence. New fortunes and dot.com successes and e-everything gave the art world another boom cycle. Expansion in the New York real estate market pushed the colonizing frontiers of the gallery takeover from SoHo to Chelsea. And all the while, the consumer values of late twentieth-century American culture found their pretty face artfully reflected in the fine art glass. Opportunistic careerism became a phrase to guide graduate instruction. Seminars in the business of self-promotion—passing as "professional development"—found their place in syllabi next to instruction in painting, video, installation, and other new media art forms. Old taboos fell with reckless abandon. But new questions arise as a result.

Lisa Yuskavage, a recent darling of the gallery and museum world, a painter of high kitsch icons that borrow relentlessly from the realms of porno pinup illustration and its teasing sexual visual innuendoes, had an exhibition in the winter of 2000–2001 at Marianne Boesky Gallery. The show was wildly popular; her paintings sold to major museums, and the work was widely reviewed in the mainstream press where it was touted as the legacy of Bellini and other exquisite masters of Renaissance art or placed in the tradition of the ever-popular fetishist, Balthus. Placed in one classical tradition

after another, or within these various modern avant-garde lineages, the work was glibly touted as an exercise of great aesthetic beauty and remarkable critical achievement. The paradox here is that Yuskavage's work, as much as that of any artist in the current climate, actually offers the chance to reconcile the critical distance between the popular and fine art realms. Her iconography draws on the traditions of Walter Keane's big-eyed children, Mel Ramos's air-brushed buxomed beauties, and the even more popular sources for these in the work of twentieth-century illustrators along a pulp-to-tabloid commercial cheesecake spectrum. Their soft-focus luminosity shrouds and veils the sexually exaggerated but appealing images that titillate and fascinate—flirting in precisely the same way with the viewer as popular arts have always flirted with the high art realm. Visual slumming, the experience of gazing at such work suggests a transgression that marks the distance from high to low. But Yuskavage's work passes for fine art in an emperor's new clothes regime of critical discourse that seems intent on denying some of her most powerful and obvious sources and affinities. Thus the sexual tone carried by the enlarged breasts and distended nipples is able to be masked as a fine art image of the highest order because of the way it is fetishized in the painting's sensual surface. Our attention is supposedly directed to the quality of the image, not to the erect nipples. A deliberate call for blindness? Or merely a habit of thought within the terms of critical correctness? But it misses the point to suggest that we ignore the visual sources of this imagery within an illustrational soft-core world in order to place it in a fine art pantheon.

Yuskavage's work, like that of many other contemporary artists, engages in a serious dialogue at the intersection of popular, commercial traditions and those of high art conventions. *Big Little Laura* shows the characteristics of her work that allow it to be read through such a combination of contradictory sensibilities (plate 5). But the contradictions her work embodies are not based on the critical precepts that guided the avant-garde or were promoted through the peculiar biases supporting new figurative work in the 1980s. Yuskavage's work appeals to critics precisely because it can be used to sustain a lie—that the fine art image is impervious, self-sustaining, a lineage apart, a pure strain borrowing from within its own traditions and conventions. But on the visual level, the work is using every trick and artifice of illustrational and popular technique available. The images succeed because the pleasure they offer is a complicit pleasure of the slickest, most practiced

variety, one that satisfies like junk food or eye candy. The paintings also repel for the way they embody the stereotypes of sexism, even racism, with their big-busted, sexualized blonde figures. Critics willing to overlook these (striking) features of the work in praise of their participation in a discourse of fine art (excellent surface finish, luminosity) or their titillating naughtiness ignore the implications of the antifeminist streak at work in these images—and their critical reception. But this complexity is what makes the work compelling.

My critical faculties are engaged by this work precisely because of the way the paintings are positioned to pass as fine art while bringing variously conflicted tropes of popular imagery into the foreground. The cross-pollination she succeeds in pulling off can't be assimilated into fine art paradigms— and certainly not into politically correct ones. The creaking of old critical machinery, inadequate as an octogenarian's attempt to squire these hothouse beauties, has a woeful silliness about it. Better to tout the characters of Pokemon as the new *Decameron*, or *Star Wars* as Aeschylus in modern gear, than to honestly attempt to establish legitimacy for Yuskavage as a late Renaissance artist or—more absurdly—one working in a critical avant-garde tradition. And of course it is not by accident that work by a woman artist that flies in the face of traditional feminist values obtains critical cachet with such ease.

This task of reformulation begins by recognizing that the reconfiguration of popular and entertainment images within a fine art context is both a selling out and buying into values of the mainstream. Yuskavage's work simultaneously embodies complicity *and* critical engagement, an admiration and aspiration, a longing and a recognition of the inadequacy of fine art to compete against the idols of the marketplace. But she achieves a real contribution in reconfiguring the old borderlines so that the old hierarchies of value no longer align simply on high/low, fine/commercial, politically correct/ aesthetically proclaimed art axes. What right, after all, did fine art have to so disdain its popular counterparts? More important, whose interests did such a hard line of division actually serve? Whose do they serve now? And on what are those interests sustained?

If Yuskavage's work succeeds by parodying high art through the use of popular forms, thus turning the claims to elite status of an esoteric imagery into a travesty, then perhaps she serves an important purpose. The value of fine art, after all, was never that it was "better" in any transcendent sense,

but that it had a capacity to create interest and sustain imaginative life. The appalling/appealing synthesis of Yuskavage's work performs those tasks admirably, playing along the very lines of tension that have so long been locked into opposition. Embodying that conflict and passing it off as a fine art gesture is no mean trick. Seeing the act for what it is serves a useful purpose—to call the critical establishment to engage as the artist does, with the unsustainable nature of distinction between the old high/low of fine and popular arts. The work is less successful at confronting or reflecting on the feminist concern for self-determination of female eroticism and subjectivity, although by the unease it produces some of these issues come back into critical conversations.

Fine art, like pinup posters and air-brushed calendar girl publications, is an industry with its own rules, regulatory discourses, cultural sites, and institutions. Fine art is a culture industry—not the same industry as that of illustrated pulp magazines or tabloid journals but not so very different, either. Centralized modes of production and organized, integrated systems of distribution may not originate from a single industrial source capitalized to guarantee concentration of power through ideological and economic control in the domain of fine art. But the disciplinary regimes of critical discourse play out clearly through the integrated social systems of academic, institutional sites. The production and reproduction of the social relations through which fine art is sustained are all quite clearly in place. As an "industry," fine art is precisely what it has claimed to be—an industry of symbolic discourse—fraught with all the contradictions of its particular profile.

Contemporary art activity supposedly provides an alternative to mainstream media culture—with its profit-driven, industry-standard, formulaic productions. "Art" represents itself as the activity of individuals making works motivated by the spirit of imaginative creativity, political urgency, or emotional impulse. So why does so much fine art aspire so desperately to the condition of fashion at this turn of the millennium? An earlier discussion in this book touched on the work of Vanessa Beecroft, another artist whose work has enjoyed a certain amount of attention and scandal. In a piece using nude fashion models and another performance staging military cadets she connects the two domains through analogy (both are formal arrangements of human figures in public spaces of display). The nude women are shown off in the terms of that most exploitative of industries and the domesticated, familiarized militarism on parade creates an elision of the worst kind (par-

ticularly with respect to the traditional values of the radical left), turning armed-service force into a style statement. Superficiality, exploitation, gender biases, emaciated women, military repression, fascistic imagery—these are the old enemies (and with good reason) of the critical avant-garde.

Beecroft's work should incite fury (it does, in some quarters) for her blatant display of complicity. But she also garners praise and much positive attention. Her work has even been glossed as a "critique"—an idea that warps the scale of believability given the extent to which her work replicates the structures of consumer industries and hierarchies of power that have supposedly been anathema to the "critical" avant-garde. She blatantly ignores the puritanical taboos of critical postmodern restraint and also flies aggressively in the face of orthodox, school-marmish feminism—much to the consternation of many. Either one has to subscribe to the idea that her recreation of scenes of exploitation are meant as "critical," or one has to see them as participating in the same strategies of exploitation—or so the traditional binarisms would suggest. In a conventional history of novelty and shock value, her gestures can be read as radical simply by the effrontery. But perversely, the content of her work, as well as of her alignments, demonstrates nothing so much as a desire to *be* fashion, to participate in the ready consumability and high price tag market. This blatant complicity crashes through all the old gates of critical restraint, since neither the critical nor the simply exploitative categories apply. She is too self-aggrandizing for the former, too self-conscious for the latter, too keenly aware that her every gesture will raise precisely the hackles that it does. This work is impossible to contain within a critique of opposition since it is clearly a consumable radical gesture. Perverse indeed.

Paul McCarthy provides another example of works that violate taboos while being at odds with the older models of the idea of "transgression" in the critically conventional sense. McCarthy's 1994 video, *Pinocchio Pipenose Householddilemma* pushed that fabled character to a grotesque extreme while including viewers in the work by having them don costumes that matched those of the character (fig. 7). His 1996 installation *Yaa-Hoo* at Luhring Augustine Gallery consisted of oversized mechanized mannequins performing sexual acts in a setting resembling Knott's Berry Farm theme park.

In both cases, the effect was overwhelming. In *Yaa-Hoo*, the nude female forms, their joints and articulated members creaking and groaning on the funky machinery, bent and slid in rhythmic submission to hideous macho

7 Paul McCarthy, *Pinocchio Pipenose Householddilemma*, 1994, installation and kinetic sculpture. Courtesy of the artist and Luhring Augustine Gallery.

mannequins decked out in cowboy outfits, pumping with their steel shank shaft apparatus in an all too uncomfortably regular rhythm. Back and forth in a grinding, humping, garish, and loud environment, these figures moved without ever changing the painted expressions of moronic glee, participatory idiots in a fun-farm carnival of unforgivably grotesque proportions. Everything about the piece was in bad taste. Everything. The work wasn't kitsch; it was grotesque and vulgar. By contrast, Jeff Koons's installation referred to above looked like a Tiffany's window display. Nor was it in politically correct good taste. These mannequins (unlike others of McCarthy's performance works) can't be absorbed into the critically familiar categories of the abject or the *informe*, or other academically acceptable strategies. In such discussions, this work would be construed to "enact a negation of power" through "strategies of self-loathing." But these works exhibit a celebratory engagement with the monstrous mass-produced pleasures of those theme parks so universally disdained except when they are used as examples of the alienated displeasure so beloved of cultural critics.

In *Pinocchio Pipenose Householddilemma*, McCarthy provided masks and costumes. Viewers were made into props, watching a performance in which they were also figured as characters in a drama that is far removed in tone and content from that of the original tale. But the slapstick grotesquerie of his approach to performance and installation is far from the intellectually distant terms of aesthetic negativity or careful critique. Viewers are also made into complicit participants.

McCarthy's pieces don't fit comfortably into these critical categories. Sure, the grotesque figures in *Yaa-Hoo* and *Pinocchio* mock the alienation of formulaic pleasure. Yes they align the sex industry with other aspects of mass production, entertainment, and exploitation. Certainly they confront us with the hideous face of the culture industry as dominatrix/terminators of humanity's humanity. But they were also terrifically effective. The scale of these works created immersive experiences. The flood of sensation provided by masks and video in *Pinocchio*, and the noise, movement, dense saturation of color, activity, and form in *Yaa-Hoo* blasted through the usual defenses. These were not carefully framed assaults on one's finer sensibilities, but bulldozer effects plowing over the aesthetic defenses. There was no sampling version of the experience, no partial just-get-a-glimpse possibility, no distancing oneself for the sake of getting a taste before plunging in. Part of the effectiveness of these works was their total takeover, their rushed

colonization and inhabitation of one's sensorial apparatus. Protracted moments in the presence of other masked viewers or monster mannequins offered one view after another of weird voyeurism and, in *Yaa-Hoo*, the performance of utterly unappealing, nonerotic sexual acts through the windows of the Wild West setting.

In *Yaa-Hoo*, unremitting clunking and thumping went on and conjured a violent contrast to the image of the elegant Louise Bourgeois sex-machine *Twosome* in her Brooklyn Museum retrospective in 1991. As critic Arthur Danto once noted of that work, this dark, mechanical, perfectly geared apparatus was the complete reduction to its rather elegant essence of "the old in-and-out."[10] Elegance made the obvious excusable, if it did not mask the reduction. But just as the crude figuration of McCarthy's piece made unavoidable connections to the entertainment theme park industry, so the old in-and-out had been rendered utterly inelegant, literal, and clumsy in his piece. The old modernist fetishization of machine/apparatus in eroticized art production had been rendered humorously grotesque in the McCarthy rendering of a clunky, noisy set of cheap-looking mannequins ineptly performing acts from which they recoiled with the same mechanical force that they brought to the initial approach. Unforgivable. And to put the face of the entertainment industry on the project in addition served to alienate it from its fine art defenders. McCarthy wasn't using aesthetics as a way of processing popular imagery into art. Nor was he employing a modernist stripping down to essentials to fetishize the erotic potential of the machine. He also wasn't using the postmodern politically correct appropriation as critique of mass culture. Instead, one senses that McCarthy rather likes these inanimate figures and their sex-industry attitudes. Falling on the wrong side of the moral and aesthetic line of fine art critical positions was hardly a novelty for McCarthy. But in this work he had, critics generally agreed, gone too far. Stuffing hotdogs into his mouth, puking, or rubbing disgusting substances into his hair, face, and body parts could all be readily assimilated into the familiar categories of "transgression." But installing theme park mannequins to perform larger-than-life sex acts in a gallery alarmed the radical critics for whom the affectionate admiration McCarthy invoked for these creatures was uncomfortably unfamiliar. A bad-boy Pinocchio was one thing; tacky sex acts were another.

But *Yaa-Hoo* produced striking perceptual distortion. Turning away from the brain-dulling noise of fake gunshot and saloon sound effects, the world

of the gallery building and the SoHo street outside were dull by contrast. Plato's Cave effect in reverse. The "real," rather than being blinding, had a disappointing paleness. The world seemed ineffectual in its inability to compete on any sensory level with the environment McCarthy had created. The full force of the installation only dawned on one in its aftereffects as a sensory rush that had upped the ante of visual/sensual desire, providing a heightened threshold of perceptual experience. McCarthy had produced an effect that theme parks never do, that mall environments fail to do except in the weakest sense of a fragmented disorientation. McCarthy had challenged the disposition to judge the artificial tackiness of the theme park as inferior, pushing the limit of the negative judgment back into a place where it has to confront its own assumptions and prejudices. Why, after all, shouldn't fine art compete with the theme park experience on its own terms of banal, overloaded, superstimulating assault? In the service of religion, empire, and other forces, fine art has historically pulled out all the stops. McCarthy was playing such a hand in full recognition that one arena in which potent aesthetic forces have achieved their contemporary form is way beyond the boundaries of fine art. Incorporating the vulgar force of such forms into fine art objects worked against the received tradition of high/low art distinctions and thus renders itself unacceptable within current critical formulae.

In this work, aesthetic sensibilities merged with that of theme parks and fine art to such an extent that the installation was formally indistinguishable from its commercial counterpart. Clearly distinct at the level of content, this makes it an extension of the many kinds of critical approaches that have characterized the dialogue of fine art and media culture throughout the twentieth century.

This is art now. Yuskavage, Beecroft, and McCarthy are the tiny tip of a giant iceberg of complicit aesthetics. Monstrous as it may be to some to contemplate, Beecroft's work is an admission of such a compromised attitude. She isn't shying away from the industries of fashion or the power structures of military institutions but instead is flirting with them, aspiring to them, incorporating them as aesthetic models that contain ideological values. To critique and condemn is no longer the major premise of imagining otherwise. Yuskavage imagines a female potency through phantasmatic distortion, a pulp image of sexual allure as embodiment of an aspiration, not as a statement of distance. The grotesque humor of McCarthy's vulgar mannequins

distances them and us from their original source. The ludic character of the work gives it "play" in its relation to the conventions of art culture. These artists put forth a specific vision—compromised and complicit as it may appear to be in contrast to the former rules of criticality—that can't be assessed within the critical legacy we have inherited. Whether such works are deserving of praise, acclaim, disdain, or disgust, their presence signals a need to come to terms with their premises.

3. New Monumentality and the "Now" Sublime

The scale of Nancy Rubins's sculptures boggles the eye. *Mattresses and Cakes* rises into the air like a baroque thunderhead, defying gravity with improbable loft (fig. 8). The combination of materials reinforces that sense of improbability. As the title suggests, the work is composed of two elements, each distinctly, perceptibly present. The striped ticking of the mattress fabric emphasizes the bends and curves of the heavy padding. Tied and straining at their restraints, the suspended mattresses have been forced into shapes that have the grace of Rubens-like goddesses, heavy-fleshed but borne upward in the light, their buoyant mass and writhing gestures rising aloft on the strength of an invisible wind.

Rubins's sculpture echoes the scale and daring of the baroque. The elaborate form and antigravitational force of uplift seem to demonstrate the sheer capacity of spirit to raise matter from its inert condition. If this assembly of mattresses smeared with the remains of decorated cakes can rise, then any physical form can be inspired with sufficient energy to fly upward. Historical quotation abounds. One feels the ascending saints pictured in the Counter-Reformation, all stops pulled out to dazzle the multitudes, as the sublime skies open and pour forth light onto the flapping robes. The greasy smear of cake icing darkens the already grimy mattresses. The used and slimy look of spoiled food makes it impossible to keep the sculpture firmly anchored in the realm of the sublime. The truly ridiculous and repulsive impulses are equally evident. And yet, mounted above the viewer, the whole hangs cloudlike and threatening, an image of spiritual power and triumph.

Rubins's monumental-sized works defy the expectations of the viewer with regard to space and weight. In another of her pieces, a collection of airplane parts is assembled so that it appears to spew across the space from a lawn to a roof in 5,500 lbs. of Sonny's Airplane Parts, Linda's Place, and 550 lbs. of

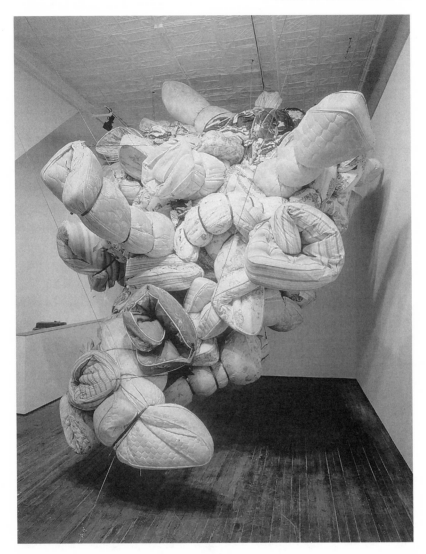

8 Nancy Rubins, *Mattresses and Cakes*, 1993, mattresses, cakes, and wire, 13′ × 18′ × 13′. Installation view at Paul Kasmin Gallery and the artist.

Tie-wire. In daring and variety, the piles of old appliances embedded in cement in *Big Bil-Bored* go far beyond the assembled collections of materials that a pop-assemblage artist like Arman made use thirty years ago. Rubins extends this manner of using recognizable elements to create shapes out of things and parts of things that retain their iconic forms while contributing

to the larger image. We see the mattresses and the cakes at the same time that we are overwhelmed by the larger form whose mass and volume suggest the ascension of bulky martyrs into heaven.

The play between sacred references and profane materials creates a curious tension. So does the link between vernacular culture and the realm of high art, the monumentality of scale and the ephemerality of the actual materials involved. An Ozymandian fatality attaches to these works. Large-scale though they are, they seem if anything more vulnerable to the forces of decay than not. Whether the mattresses fall apart faster than the cakes deteriorate hardly matters. These works are destined for destruction, they even invite it. They begin with waste and offer a moment of order, anti-entropic coherence, but it is only momentary. But their enormous size and its claim on attention does not translate, necessarily, into an extension of the interest in monuments as memorials or testaments, or with the many purposes to which such works attend.

The striking association of transient qualities and monumentality of scale in Rubins's work has a counterpart in the delicate wall drawings produced by Gary Simmons. Francis Alÿs's current projects are also involved in extending the experiments with tradition of monumentality in a very different, equally ephemeral and profoundly moving expression of the human condition and scale, one that does, in fact, veer back toward some of those issues bracketed out of Rubins's approach: record, trace, history, memory, and the shared recollection of a cultural event. Andreas Gursky's photographs provide another coordinate for structuring this discussion. Grand in scope and sweep as well as large in format, Gursky's images remind us of that other set of monumental works of recent times, those of midcentury modern abstraction, as well as the tradition of grand mural paintings and history canvases. Gursky plays with both abstract and figurative references, showing the extent to which the former language was created as an artifice of framing, by bracketing out the referential field that always extends beyond that limit.

Gary Simmons's white chalk drawings are explosively dynamic, large, vulnerable images of ephemeral events rendered significant by their combination of size and delicacy. *Boom* (fig. 9) positively explodes with energy. The tangled lines in *Ramshackle Tumble* roll and teeter. The stars of *When You Wish* trail away in vanishing streaks. Filled with dynamism, Simmons's drawings on green slate blackboard colored surfaces are wall paintings. Di-

9 Gary Simmons, *Boom*, 1996, paint and chalk on wall, 156″ × 312″ (variable). Courtesy of the artist and Metro Pictures.

rect images. Formally resolved works at mural size (12′ × 40′ for *Tumble*), they are made of delicate marks that create an enormous sense of action. They resonate with the large, late canvases of Claude Monet, the paintings of Barnett Newman, the action-oriented work of Jackson Pollock, or the scale and luxurious, expressive repleteness of Clyfford Still. The materials, chalk and board, have their own specific associations in more recent art. Joseph Beuys's chalkboards are tightly associated with the classroom scene, and Simmons's work echoes his lessons in the strain of historicity he continually, if elliptically, invokes. Beuys's pedantry and pedagogical missionary work can't be shaken out of that chalk dust no matter how much one might wish him gone. But neither can Roy Lichtenstein's pop art explosions, with their comic book shorthand energy, be divorced from Simmons's pulsating image. The politics of *Boom?* The conspicuous absence of specific reference seems to release this image from the job of accusatory rhetoric, letting it off the hook of social responsibility or moral call to action. No conscription, no agenda, no partisans, no particulars? Is this just a vibrantly exuberant image of energy released? Or a record of an act of creative fury? Joyous madness? Artistic frustration? Or fulfillment? A tremendous energy per-

vades the image; the round soft clouds and hard spiked lines of force radiate with productive outward movement from the central source of the explosion. Stars race off the margins, their cartoon casual perfection fleetingly marked. Their movement, like that of all the rest of the elements on this surface, is indicated by the streaking path of chalk lines smeared and smudged along the axes of motion.

Boom is the "now" sublime, using monumental scale as a special effect rather than as an invocation of the sanctity or seriousness with which it has traditionally been associated. The particulars of this image are inexorably bound to the decade of the 1990s, with pop art parents and conceptual mentors. The work draws on arte povera's eclecticism in the use of any and all materials, as well as the Fluxus commitment to aesthetic appreciation of everyday life. Rife with art historical self-consciousness and cultural awareness, this work is neither oppositional nor escapist. Boom isn't outside of culture, on the margins, alternative, or condemnatory. The work passes no judgment, identifies no foe, and situates itself within the mainstream by its need for careful preservation. The piece has to claim attention if it is to survive; its delicate surface requires a museum-scale space, a home in a major collection. Significant capital investment will be needed to guarantee the future existence of this work. Funny, witty, charming, smart, skillful, the image is a one-shot drawing depending on the draughtsman's perfect gesture. A virtuoso accomplishment. Neither literary nor figurative nor mythological nor documentary. The categories that this work doesn't fit are as numerous as those with which it makes associative connections. The image quotes action painting with its gestural force, but here hemmed in by referential codes, marks made to communicate a specific something—billowing smoke. Boom is not, however, a work of formal perfection meant to be appreciated for its properties of balance, composition, or aesthetic harmony. Instead, the work provides an opening in which to examine Simmons's reinvention of a notion of the sublime in a contemporary key.

Elegant in their simplicity of materials, Simmons's chalk drawings rhyme with the large, late canvases of Monet. An unlikely antecedent? Not really. Monet's canvases of water lilies show a scene brought into being rather than depicted, a creation not a representation. A late-impressionist sublime, designed for immersive experience. The size of the work and the active field mobilized the eye. Monet had no truck with terror. His domestic universe

satisfied the pleasure-seeking eye. Bourgeois life was a kind of balm, a hedge against the sublime. Who, offered the view of the chance to dwell among the harmonious delights of the gardens at Giverny, would invoke fear and trembling? Quite the contrary—the scale of the water lily paintings invites the viewer to engage with sensual immediacy in the same spirit of abandon as do the scroll paintings of an Asian floating world. These paintings stand as important works in the history of monumental images. Offering their benevolent affirmation of the joys of sensual perception as an alternative to the imagery of vast spaces in the work of Caspar David Friedrich, Frederick Church, or Thomas Moran, those other practitioners of nineteenth-century landscape painting in the romantic tradition. To invoke Monet as the counterpoint, the other of romanticism, introduces an alternative into the narrative of monumental painting in this tradition. For although murals of a monumental scale became an active element of the visual landscape in the 1920s and especially 1930s, they are largely works of social import, bound to historical conditions and expressions. The murals of Fernand Leger or Thomas Hart Benton or even of Stuart Davis are far from the romantic tradition. They express a contemporary aesthetic but not an individual struggle with forces of history within the heroic frame. The large-scale paintings that really take up the romantic charge, however, are those created within the context of abstract expressionism.

In "The Sublime Is Now" (1948) Barnett Newman proposed a reengagement with the concept of the sublime.[11] The legacy of eighteenth-century aesthetics, by way of the German romantic tradition of Kant, Friedrich, and then the English philosopher Edmund Burke, caught Newman's heroic imagination. The existential and intellectual dilemmas of midcentury American culture, those crises of faith characteristic of the condition of the so-called "modern man," found in the concept of the sublime a framework for the fundamentally tragic approach to the human condition. Individual identity and aloneness were inextricably linked in Newman's conception. The force of his large canvases was intended to increase the self-awareness of that individual condition. Social consequences might follow. Newman's activist anarchist inclinations were as central to his idea of the artist's role in culture as his intellectual leanings were to the creation of his aesthetic position. "The only moral act is the useless one and the only useless act is the aesthetic one. The artist is the only man who performs an act for no useful

purpose, he is, indeed, opposed to its usefulness. His behavior is completely, unalterably and profoundly futile."[12] This statement reflects the direct influence of Kant's philosophy.

Newman's approach to visual form likewise shows this influence. He grappled with the difficulty of finding a visual language appropriate to the presentation of the sublime, the experience of unbounded and infinite terror. A metaphysical condition rather than an image that lent itself to iconographic representation, the sublime had to be created as a space or aporia for experience rather than as an image. Newman hoped that the scale and structure of his paintings would bring a viewer "face to face with the mystery of life" in the most metaphysically profound sense of the phrase.[13] The monumental scale of Newman's paintings is the direct result of this impetus. He seeks to create a space, *espace*, abyss, and place in which a viewer may be absorbed, immersed, taken out of the ordinary and into the extraordinary experience of wonder.

Gary Simmons's *Boom* has an irreverent but significant relation to this historical invocation of the sublime. Like Adolph Gottlieb, Newman, Mark Rothko, and other major figures of abstract expressionist painting, Simmons uses scale to make a material claim for the importance of his work. The wall-sized *Boom* and *Tumble* make explicit reference to the stylistic and thematic tropes that characterized the heroic period of midcentury abstraction. The longer history of mural paintings links Simmons's work to the tradition of historical narratives and grand memorials of state events, as well as to the postexpressionist generation of abstract work in which procedural approaches, such as those of Morris Louis, dominated the fine art mainstream. Simmons's choice to make use of such a large scale for his work takes it out of the realm of cartoon. *Boom* is as much a statement of the sublime as Newman's *Vir Heroicus Sublimis* of 1950–51.

The ephemeral delicacy of Simmons's wall drawing, done in place with chalk on paint in 1996 to the full 156" × 312" size, makes it a compelling statement of vulnerability. The title, *Boom*, suggests the potential for instant annihilation.[14] Simmons is acutely aware of history. He deliberately invokes many dimensions of the African American experience in his work, allowing that cultural frame to shape the readings of his pieces. The streaking stars of *When You Wish* have a nostalgic poignancy to them, even a faint sentimentality. "I like how subconscious memory plays into our understanding of the present," Simmons has said.[15] But the memories are not subcon-

scious; rather, they are peripheral, those trailings off into the network of historical and social forces at the edges of our own blurred boundaries of identity. Situated and circumstantial, Simmons's works can't help but invoke a chain of references.

In his recent skywriting works, with titles like Not Fade Away, Simmons brings the ephemeral traces of his erasure approach into a new scale. What could be more sublime than to write upon the sky? To etch a transient symbol of humanity against the deep blue of an infinite universe? Newman would never have imagined such a gesture nor entertained it in reality. The act is too ephemeral, for one thing. The apparatus of skywriting carries associations of popular amusement and advertising pranks, for another. The new sublime is thus enframed, located in a set of very specific circumstances. The heroic struggle is recast as a specific and particular one in which current conditions can't be transcended. In fact, Simmons's is a nontranscendent sublime, a call to reorder the universe as a social realm in which the metaphysical implications are related to particular human circumstances. Hardly ridiculous, Simmons shows the viability of heroic concepts, not as a means of escape but as a site of engagement of visual imagination. The embedded work, unable to escape its temporal location and conditions of production, expresses the profound tension between spiritual and sentimental longings. Simmons's artful play makes productive use of the space between these two, admitting the spiritual dimension while expressing it in a visual language appropriate to these times. The cartoon lines of Boom are as intimately connected to animation and cartoons as they are to pop art, just as the explosion depicted echoes the fictive world of comic events at the same time that it can't help evoking recent and profoundly terrifying and tragic events.

The upshot of this art is that it shows the necessity of conceiving current life in symbolic terms that draw on current idiom. All the idioms. The popular and vernacular are as essential to the core belief system by which we depict the tragic and heroic as are the legacy of aesthetic gestures from a fine art tradition. We live in that interwoven field of visual references, and Simmons expresses the interpenetration of the realms of popular and fine art cultures in the specific iconography he traces.

The "now" sublime is rooted in reference, tied to social and historical conditions. And the line of people marching across the sands in Lima, Peru, in Francis Alÿs's When Faith Moves Mountains has the overwhelming immen-

10 Francis Alÿs, *When Faith Moves Mountains*, photograph of performance in collaboration with Cuauhtémoc Medina y Rafael Ortega, April 11, 2002 Lima, Peru. Five hundred fifty volunteers were equipped with shovels and asked to form a single line in order to displace a 10 cm by 500 m long sand dune from its original position.

sity of the sublime, even as it is grounded (literally) in a material spot and moment (fig. 10). The transformation these aligned participants bring about on the land is only possible through their absorption into an action that dwarfs their individual scale even as it depends upon their participation. The effects will be of only minimal duration. How could the displacement of a few inches of dirt, shoved across a mountain by the coordinated action of the feet of several hundred people, even register as a significant blip on the surface of the earth? The photographs that document the performance of this work, in April 2002, show the small hill over which the group marched in synchronized movement. The dust that rises around their feet obscures the lower portion of their bodies. The earth is dry, brown, parched-looking, as far as the eye can stretch. Beyond, a verdant valley of irrigated or at least cultivated land lies like a patch of promised relief. But the hard labor of marching, up and over the hill, is tracked by the marks of the feet of the row of volunteers, working in the service of art to render this remarkable change on the land.

When they were finished, several inches of dirt had migrated from one

side to the other of the hill. This is an earthwork of the scale of Michael Heizer's motorcycle-inscribed line drawings on the desert, or his remarkable *Double Negative* echoing two volumes of sculpted absence in walls that face across a canyon, or Robert Smithson's deeply romantic *Asphalt Rundown*. The work that Alÿs has undertaken engages directly with the earth as its material. The invocation of nature and the scale of the natural landscape as a site of sublime experience are countered here by the force of culturally located work. Aesthetic work is a labor without purpose, in the Kantian sense. The scale of volunteer effort reinforces the monumentality of the project, since the mass of coordinated human movement becomes a writing instrument across the face of the hill. The idea that one moves a mountain, that spiritual yearning can achieve a minor miracle, is wonderfully cast into concrete relief by the image of actualization. The miracle is a direct result of effort. The sublime effect is a product of aesthetic vision, but again, Alÿs's project is a far cry from the transcendent imagery of South American landscapes created by Frederick Church and others in the early nineteenth-century as images of the exotic, paradisiacal sublime. In the present, Alÿs reminds us, we must access these experiences through particulars, specific circumstances, located events.

Alÿs uses no icons, no specific, representational images. No references to past forms and no specific relation to historic reference show in these works. They are sculptural performances, site-specific. By their monstrous scale and monumental quality they result in heroic achievements. Heroic? The term still serves. Each of these works expresses the romantic longing to accomplish the impossible—Rubins's hefty works suspended in space, Simmons's images of explosion delicately held in the chalk for these brief moments, Alÿs's Sisyphean tasks. To conceive of such projects is to imagine that an immensity may open within the present, an abyss that rends the ordinary fabric of existence to show its capacity for transcendence within the structures of the lived. But Alÿs's moving of mountains reads against the claims of public and civic monuments. The participatory and even futile gestures Alÿs conceives comment, by contrast, on the image of solid, somber tributes to memorialized historical events. Anticommemorative, his are gestures that, however grand, are destined to vanish—and vanish quickly. The shifting sands of the mountain are far more vulnerable to dispersal than even the whims of discourse and changeable opinion. The very ephemerality of the traces of Alÿs's activities, however, shows the difficulty of attempt-

ing to defy such changes, no matter how large an investment of material or apparent claim on attention is made. Monumentality and ephemerality, in other words, are part of a continuum, not opposite terms.

An annihilating impulse is present in these works. A gesture of self-extinction and destructive force can be detected in both by virtue of the sheer scale of the works and their capacity to dwarf any individual artist, or in the thematic content of these works.[16] They are also engaged in affirming the way the humanistic spirit registers its significance in the social sphere.

The material trace of human subjectivity, so crucial to the distinction between absorption and critical play, works very differently in the photographs of Andreas Gursky. Humans are present but only en masse, and the tension between abstraction and reference has been keyed up by the additional connection he makes between high-end production and diminished presence of any individual sign of the artist's hand. Simply by their scale, his large photographs engage in their own commentary on modern monumentality. But production values become another among the scales that being pushed to the limit and that must be read as part of the aesthetic meaning and effect of these works. Whether the images have any relation to the notion of the sublime depends on whether one may tremble at the spectacle of contemporary culture that forms their subject matter to the same degree as nineteenth-century romantics were wont to look upon the face of nature.

Gursky might seem an odd figure on whom to comment after Rubins, Simmons, and Alÿs. But his photographs of the enormous social spaces of modern life reflect on another facet of monumental work in the current context. Wall-sized, the photographs appear with the flat starkness of modern abstract paintings. At first glance, many of the images seem to be color-field or grid works, geometric and empty of human references. No perspectival distortion or lens curvature disturbs the absolutely parallel relation of object under photographic investigation and the picture plane of the final image. A deadly flattening occurs, as if whatever camera eye he is using were a flatbed scanner of immense proportions, capable of skimming the skin of the surface of the world. Whether he is photographing a natural landscape or an elaborate structure in an urban environment like *Paris, Montparnasse* (1993), Gursky stresses the capacity of the image to be fully abstract and literally referential at the same time. An old trick of the photographer's art, the act of framing observed reality so that it becomes a geometric abstraction forms the basis of these mural-sized color prints. The sheer technical virtuosity of the works takes one's breath away.

11 Andreas Gursky, *May Day IV*, 2000, C-print. Courtesy of the artist and ARS, New York.

Peter Galassi, writing in a catalog essay that accompanied the Museum of Modern Art (MoMA) exhibition of Gurksy's work, described these photographs' relation to "our omnivorous image industry."[17] The photographs participate actively in that industry. Elaborate productions of industrial photographic technology, Gursky's images are not about commercial advertising worlds but are produced entirely within their methods and venues. The camera format, printing devices, color calibrator, and use of presentation materials and structures are all of an industrial scale. Trained in commercial work, Gursky doesn't have to lust after the unobtainable technologies of the culture industry. He works through them and with them. But he is also citing all the formalisms of high modernism, calling the abstract forms back into being by means of the photographic index so that they appear repeopled, relocated within highly specific contexts. The division separating one band of color from another becomes legible as a line of grass along a dyke or the edge where horizon and land meet. The overall composition of a gridded abstraction reveals the apartment house structure on a Paris suburb. The scattered particulate elements of a massive pattern painting turn out, in *May Day IV* (2000), to be peoples' faces (fig. 11). And yet, a grave inhumanity attaches to these works, as if the flattening effect of surface rules out the possibility of human presence or intervention. The worst effects of foreclosure are formally evident in the terrifying scale and absolute finish of the images.

A paradox obtains in Gursky's visual commentary. He returns to visual abstraction all the banished references that had been rendered taboo in the search for universal languages of form. He succeeds in revealing the lie of that abstract language. He shows that it was always, in a profound and Bakhtinian sense, part of the dialogic structure of meaning. Material indices and

thematic threads are as inherent in the language of abstraction as they were in realist and figurative modes of image making. By tying his abstract but highly referential images to the precedents of modern high formalism, he reworks the visual argument of those abstract canvases of Mondrian and Newman. Abstraction is dialogic, and the dialogue was with figurative reference, networked connections to the real context of meaning production. Modernism's transcendent and universal language of forms was as historical and specific as any move made in the history of visuality.

Because of their scale, all of these images are heroic gestures. They are aesthetic products, terrifyingly closed and yet critically engaged in demonstrating the connection of the spaces of representation with the lived circumstances from which they are produced. In their huge flat spaces Gursky's photographs leave no place for individual subjectivity. The "personal" point of view is gone. The fabrication of the works renders them remote from handwork or individual expression. Cold, formal, processed. The terror they induce is accompanied by wonder, awe at the capacity of images to be so large, replete, complex, complete. Terrifying because of their ability to show the human world and yet close off any space for human presence. They read with all the mind-deadening and spirit-crushing formal splendor of large machines, spinning their inhuman wheels with utter disregard for the role of human subjectivity in the production or reception of images. Powerful and profound, these, too, are the image of the "now" sublime.

4. After Visual Un-pleasure or Monsters and Flesh

The critical reception of painting in recent decades has been characterized by a curious perversity in which it sometimes seems that all of painting's virtues are destined to be construed as vices. When other media snuck out from the repressive strictures of modernism, managing to mark its passing with increasing ease and no loss of status, painting continued to suffer all manner of attacks designed to police its behavior. The postmodern attitude toward painting, the most recent in a long line, is symptomatic of the ways painting kept being forced to serve one agenda after another. By contrast, in its actuality as a practice, painting is a field in which all kinds of "unacceptable" works are defining a realm of crucial vitality in which impurity has come to be the norm.

In Mira Schor's *Oops* (plate 6), the monosyllabic outburst fairly drips on

the canvas. Painted with lavish impasto care, the apologetic expletive is caught in the thick substance of painterly tradition even as it trips across the threshold of perception. *Oops* and its companion *ish* have much to say about the traditions of oil painting and the condition of fine art and popular culture. For these are painterly paintings, steeped in the arcane approaches that draw the legendary knowledge of gloss and glaze into the present through the trained attention of skilled practitioners. This painter's art is an artisanal craft, and Schor is more deeply tied to the guild tradition of specialized professional knowledge than to the later twentieth-century engagement with industrial media. No spilling, pouring, burning of enamel and hardware store lacquers or leftovers here. Instead, the exquisite surfaces are elaborately, lovingly made in full engagement with the fetishistic thrills of tactile sensuality.

Few painters have been more outspoken than Schor about the issues of visual pleasure, its gendered rhetorics, and its complicated history in the modern and postmodern critical frames. And the production of these syllabic paintings provides an ironic point through which to consider the ways the apologies and innuendoes in these works introduce historical axes into the current dialogue of painting and mass culture. For few painters could be farther from the realm of pop art's cartoon language than Schor. Her language isn't quoting the graphic styles of comics, nor of their fine art counterparts. *Oops* is not late Roy Lichtenstein or recycled Ed Ruscha. If anything, her linguistic tendencies are closer to the bald statements of conceptual artists, like John Baldessari, whose perpetually intriguing work, *Pure Beauty*, consisted of precisely those two words painted in block letters on an otherwise blank canvas. Schor means to invoke these conceptual realms, their intellectual complexity and play between idea and form, in order to focus the viewer again and again on the material surface through which the idea comes into view. But she also, deliberately, rides the edge of the slang line, pulling the rug out from under the self-serious stance of high fine art. If *Oops* announces itself as a mistake, one that won't be covered up but instead proclaimed quite exuberantly to the world, then *ish* is the sly aside, the we-all-know-this-game encoded statement of insider smarts. The title *ish* suggests we already know the antecedent to which the suffix gives qualification, the noun whose substantive identity is extended like a smear of paint drawn out across a surface so the full range of its values can be traced from dense to thin application.

By the quality of their *facture*, these works are deliberate descendants of the traditions of oil painting that return to altarpieces, to religious works in which the quality of paint is meant to capture a divine illumination. Glazes were developed to make the luminous surface glow, uncannily, by refracting the light that hit the surface through layer after layer of thin material in which pigment was suspended. The effect is magical. Light does seem to rise from the wings of angels, the glowing crowns, and sweet downcast eyes of Virgins of those renown Renaissance masters. Painting in this vein is antiquated, almost obscure, its traditions much lost in the studios of the new academies where anything goes and where no material is too banal for use inside a frame. The long tradition of oil painting carries its own baggage. The few practitioners whose painting demonstrates a vivid link to the studio practices of the past tend toward conservative iconography or its citation for manipulated transformation (Odd Nerdrum's dark surrealism or Komar and Melamid's perverse socialist realist imitations). But Schor's works are almost linguistic commentaries on the condition of painting as a conceptual and theoretical art. Her work is linked to the struggles of feminist theory. Her enthusiasms are for the possible ways painting can continue its existence as a rarified practice. And yet here she makes statements so evidently snatched from the vocabulary of contemporary life that they pose another issue altogether. What is painting doing in the service of these statements? The answer, of course, is that the statements are in the service of painting. When you make the image of a dollar sign in chocolate, you are calling attention to the chocolate, not just to the sign. "Look at painting," Schor's *Oops* demands, "look at what it does to current idiom." Painting's long tradition, put in the service of slang, states an apology that is actually the opposite, an aggressive affirmation. This is the same *Oops* uttered by the person cutting too large a piece of pie or heaping too much honey on their cereal—an expression of enthusiastic chagrin in anticipation of an indulgent outcome. *Oops*, this is *painting*, and all its attendant delights.

But this condition is heavily taxed in the current critical environment.

Schor has referred to the process of painting as "an endless deferral of pleasure and closure." She is clearly asserting a feminist trope of sexuality and production, the feminine erotics of continual play—tactile, sensual, unbounded, developed within the intellectual horizon of feminist critics Luce Irigaray, Hélène Cixous, and Alice Jardine. But she puts this approach at the service of theoretical and linguistic meanings embodied in the so-

matic physicality of paint.[18] *Semicolon in Flesh* (1993) is painted as thickly, lushly, and romantically as if it were made of cream cheese or icing. And the association with such comestibles is irresistible, especially since such an obvious image of gratification goes against the grain of what is supposed to be "serious" criticism of "serious" work. Schor is painting her way through the contradictions of recent critical attitudes in which "opticality" (serious, formal, self-evident work) was pitted against "visuality" (figurative and representational). Such approaches were, literally, blind to the realities of painting. Schor's work is driven by the conviction that pleasure can be theorized on canvas as well as in print.

In the 1980s a hostile discrepancy arose between those artists who still believed that a studio practice could engage with tradition and innovation within a politics of representation and those who saw politics and painting's sensual gratification as necessarily opposed. In an essay written in 1989, "Figure/Ground," Schor wrestled with Benjamin Buchloh's denigration of painting as "atavistic" and "vestigial"—characterizations he made in the same context in which he was trying to provide a critical justification for the painted work of Gerhard Richter as "political."[19] According to Schor, in this curious (moralizing) morality the "pleasure" coefficient must be eliminated from the "political" consciousness, left unacknowledged or aggressively denied. "Visual pleasure emerging out of the materiality of paint is viewed to be politically incorrect."[20] Schor points out that for a Marxist art historian, "sensual pleasure is at best a secret vice or an unfortunate relic of connoisseurship." The perversity of this point of view, Schor makes clear throughout her argument and her paintings, is that it is *because* of the scopophilic gratification that painting (and other visual art) provides that it can be effective in political ways.[21]

Schor's engagement with these issues is uncompromisingly feminist, and she has carefully mapped the gendered discourses of critical vocabulary and attitudes toward painting.[22] The very associations with bodily fluids and messy flow, unboundedness and soaked surfaces traditionally coded as "feminine," were only given a positive valence when safely transferred to male artists.[23] And then they became hallmarks of virtuousity. As this very critical discourse became gendered through works like Laura Mulvey's influential essay "Visual Pleasure and Narrative Cinema," it tended to separate women from self-representation in any figurative or somatic trace.[24] Evidence of this taboo is everywhere evident in the choices made by women

artists prominent in the 1980s (e.g., Sherrie Levine, Barbara Kruger, Mary Kelly).[25]

Schor's commitment to the critical capacity of fine art keeps her engaged with painting as a sensual means of expressing her arguments. And for the most part, she is far from the realms of media culture, looking to traditional past masters and making her arguments within a more recent modern art, feminist theory, and postmodern context. By contrast, the younger painter, Julia Jacquette, with her luscious canvases of foodstuffs, is securely and delightfully and irrepressibly playful in her transformation of visual culture materials into icons of new fine art. Jacquette's works have the finish of sign paintings. They sit on the gallery wall with the brightly inviting character of goodies in a pastry case. Reminiscent of the eye-pleasing and ever-popular images of California painter Wayne Thiebaud, these canvases are unabashedly good-looking. They practically wear "eat me" tags. Pop, cute, smart, funny, the images all are gendered reflections on dating and relationships. With girl-magazine aplomb they dish up good and bad ratings of guys whose characters find their expressive analogy in the painted images. Pleasurable? Absolutely, but far from the strict regimes of feminism's orthodoxies and equally remote from the traumas of modern and even postmodern representational politics. No struggle has to accompany the making of these works. Jacquette isn't buying her satisfactions at a critical price; she doesn't have to. Her relation to imagery seems as fraught as that of the happy shopper at the dairy case but with a savvy upscale sophisticated air. Jacquette is not naïve, nor is she innocent. Her work has all the conspicuous features of imagery made in full recognition of the devilish bargain fine art makes with media culture by—literally—buying into its superior production/consumption modes.

But if Jacquette's work exhibits one approach to gratification in its consumable iconography and seductive formal surfaces, then the comparison to the painting of flesh and of the pleasures of the flesh, two very distinct activities, provides another study in contrasts. The critical differences between the work of the high, late modern Philip Pearlstein and the indisputably contemporary Cecily Brown bring these contrasts into dramatic focus.

Pearlstein might seem out of place in a discussion of current painting. But a detail from his *Sepik River Triptych*, used as an advertisement for a 1997 exhibition of his work at Robert Miller Gallery in New York City, raises some

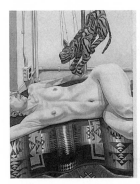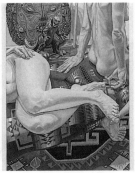

12 Philip Pearlstein, *Sepik River Triptych*, 1995, oil on canvas (full image 48″ × 116″).
© Philip Pearlstein. Courtesy Robert Miller Gallery, New York.

interesting questions (fig. 12).[26] Pearlstein is an unusual figure. His long-standing capacity to bridge the abstract and the figurative within painterly traditions has manage to secure him popular appeal and critical credibility during a period in which many other artists engaged in similar synthesis have been ignored or marginalized.[27] Pearlstein has endured and succeeded through successive waves of art world movements and styles without ever compromising his secure commitment to the idiom and medium of painting. If anything, his acceptance of the traditional identity of painting seems to exempt his work from the demands and expectations of more recent critical concerns. Common wisdom has it that painting is always about painting in some sense (while sculpture, for instance, can be made of anything). Painting is always linked to its medium and generally to its various material supports (wood, stretchers, canvas, Masonite, and so on).

Pearlstein is certainly no exception to this rule. Though figurative, his work also clearly acknowledges its own historical self-consciousness and modern origins. Pearlstein has always played out the tensions necessary (between surface and illusion, abstraction and reference, pattern and form) to place himself within a contemporary extension of classic modern concerns. In this lineage, painting has been a singular site of contestation within the history of twentieth-century art and the claims made for the status of art as a cultural practice. Painting, after all, was the sign, symbol, and embodiment of all that modern art stood for since its inception within the salon tradition of work produced on spec as a market-oriented commodity. Painting

reifies the commodity status of fine art as a product with all the distin-
guishing features of originality and artisanal production. Pearlstein's work
exists in an unbroken continuation of this tradition—the status quo.

The published detail of *Sepik River Triptych* (1995) features the trademark
symbols of Pearlstein's style. A fleshy nude leg poised on a chair is depicted
with unflinching clinical descriptiveness in the middle ground before an Af-
rican mask. The diffuse light falls on the thick, muscled, somewhat ungainly
lower leg and thigh, cropped so to remain a form, not a person. As usual in
Pearlstein's work, the flesh is an object, a form with texture, color, qualities
of touch, and brushstroke, bearing all the conspicuous signs of being
"painterly" according to the traditional codes. Such *facture* signals the hand-
made object with consistency and repetitive complicity to normative expec-
tations about what a painting should be. The signs of painting-as-painting
abound and fulfill their expected roles within the work. Pearlstein also
makes habitual use of bits of background wall and furnishings to offer con-
trast of texture and pattern. The light reflected off the polished wood of the
chair and dull clay of the flesh have a soulless, fluorescent-light sort of
brightness, bland and washed out. Still, the setting has a reassuringly fa-
miliar quality. The image is grounded in the real of a nonspecific domestic
environment. The spaces are as lived in as the bodies, and all show the signs
of use and wear that no doubt find much resonance with his comfortable
bourgeois audience.

But the clunky plastic dinosaur in the foreground of *Sepik* is the crucial de-
tail. The monster becomes by far the dominant element. It is the only full
"icon" in the image, the only form given complete recognizability and read-
ability. Its presence is striking. Awkward. Uncouth. Inelegant. By its intro-
duction, Pearlstein has made a grotesque gesture of contemporaneity—an
attempt at seeming to have grasped the current interest in things popular,
commercial, and non-aesthetic as components of a contemporary art vo-
cabulary. The dinosaur isn't fragmented, isn't simply pattern and motif; it
lunges in stiff plastic posture across the front lefthand corner of the paint-
ing, an absolute little monster.

How can Pearlstein manage to make this awkward move and yet not
break from his established mode—or can he? He remains well within the es-
tablished idiom of painting as it is known and as he is known within it. But
this work is also uncomfortably inappropriate to his generational identity
and the traditional aesthetic positions he has come to represent. The di-

nosaur's "not fitting" with our expectations reveals something very telling about the constructed image of Pearlstein in critical rhetoric. Were this the painting of an unknown or a young painter, it would hardly register—the conception is banal and the execution too conventional. Pearlstein seemed obliged or felt allowed to put this little monster into one of his works. The gratuitousness of the gesture reads against the established career of the painter. But it is not simply his stature that permits his little transgression to be indulged. Pearlstein's position serves to maintain a particular painterly idiom and set of traditions (nude, interior, still life). He and his work are almost a sign of the endurance of traditional painting. Pearlstein never sets his work up in any way as a critique of painting but rather as an ongoing and uncritical exploration of it.[28] His work remains aloof from any pointed analysis of historicity, commodity status, crises of originality and authorship, representation, thematics, or gender politics. If anything, Pearlstein seems to be the living demonstration of the invulnerability of painting to these (passing) critical trends.

But of course nothing is that simple. The painting detail verges on travesty. The lurching dinosaur might well represent the dying breed of middle-of-the-road mainstream painting itself, shown up to be a dully kitsch item in the cultural landscape. If Pearlstein's intention was to put the aesthetics of fine art into contrast with the plastic monster, then the monster has perversely triumphed. The dinosaur defines the visual terms of this work, staking a clear claim on the aesthetic territory of the work and making it over in its own image. Pearlstein's work and the place it occupies might just be that awkward dinosaur relic of form.

Pearlstein's work and career sit at the stable center of the art industry. No dialogue with popular mass culture is required for such work because it is the popular arm of the painting culture industry. This assessment isn't meant to belittle his work. But by being exactly what it is, Pearlstein's work functions as an example of the way the dialogue between mainstream painting and culture industry is staged as if the culture industry were other, as if the mass culture industry were the little monster tramping through the work. In actuality, Pearlstein's work is the consumable, commodified cultural form. Pearlstein can "get away" with the monster because his work is like the gold standard that serves to sustain everything that might have and has been brought into question in the continual interrogation of painting's identity and status over the last decades.

But where did that interrogation take place? And how was it staged? The history of painting's fate within high modernism is a tale told infinite times and always to the same, Greenbergian end. The early twentieth-century tenets of this belief are highly familiar. Abstract visual language was capable of transcending historical and cultural circumstances (Kandinsky). Or it was to signify modernity and the fragmentation of subjectivity through the social field of the sign (Picasso, Balla). Or it should be a self-sufficient formal language of differential play (Mondrian). Or it could constitute a truth within painterly means in a "real" that was anti- and nonillusionistic (Malevich). All these many earnest attempts at finding means by which painting could enact a modern aesthetic were subsumed within Greenberg's teleological critical machine into a search for purity. We all know this story, all the objections to it, all the arguments in its favor and its justifications, its philosophical usefulness, its critical weakness and historical importance—and its legacy of damage.

But the recovery of what was repressed in that process is still incomplete. The exigencies to which painting was subjected concealed much of the reality of what painting was and what it was doing: its heterogeneity, its variety, its populisms and realisms as well as its traditional ongoing and never-ceasing engagement with figuration and portraiture and landscape and interiors. A historical distortion was imposed by the point of view associated with Greenberg—painting had rarely been so pure, so self-reflexive, as he wanted to imagine. Wrong, inaccurate, misconceived, the forceful paradigm was extremely powerful (partially, no doubt, on account of being it so simplistic). So much so that for Brian Wallis, Hal Foster, Martha Rosler, Mary Kelly, Douglas Crimp, and Craig Owens, to name the foremost few among a prominent many, the refutation of modernism became focused as an attack on Greenberg's version of it.[29] This has been noted and stated frequently and hardly needs repetition here. But what has been less evident is the extent to which the reactive stance of much postmodern criticism solidified Greenberg's position, turning many of his attitudes into dogma. That legacy continues to have an effect. The term "Greenbergian" may be more perverse in its thrust than the original source. Thus the critical fate of painting was curiously dealt with in the process of the definition of postmodernism through these writings.

Few defenders of painting appeared within the postmodern critical camp. In the early 1980s only a few painters were granted, from the very outset, it

seemed, critical acclaim: David Salle, Eric Fischl, and Ross Bleckner in a first wave and within the New York scene. Critical attention also turned to the full spectrum of painters of the new figurative movement from Germany and Italy—Keifer, Immendorf, Baselitz, Clemente, Paladino, Cucci, Penck, and so forth. The "new figuration" concept seems to have been largely used to marginalize (older) figurative work, particularly that of feminist artists and artists of color for whom figuration had signified a political assertion of identity and issues. The very rhetoric of bringing figuration "back," of reviving it "from" external sources, tended to write figurative activity closer to home out of immediate past history.[30] The reasons for this seem painfully obvious, since the grassroots character and unrestricted aesthetics of first-wave 1970s feminism and activism had not played well within the chic markets of New York's upscale art publications, galleries, and museums. The bargain struck between criticism and marketing was such (de facto, not necessarily by intention) that it was convenient to manufacture a platform of "new" figuration. The result was the marketing of the work of European and American males for whom the gesture of representing something recognizable was thus made not only safe, but critically legitimate.

Painting's attractions are everywhere evident in the works of Eric Fischl. Or Julian Schnabel. Or any of the many others named explicitly or by implication above. But in the New York–based discourse of postmodernism, critical terms of appropriation and allegory introduced a requisite for critical distance and antivisuality and anti-opticality within even the painterly field. Opticality, touted by the Greenbergian paradigm,[31] stresses immediacy and self-replete presentness. Visuality invokes the wider historical and cultural domains of figurative, mass culture imagery and design, as well as the possibility of visual seductiveness and material richness outside of the bounds of the repressive flatness that once collapsed paint with its support. Opticality can be controlled—largely through the stringencies of criticism. Visuality is culturally unbounded, not delimitable, and threatens the authority of a defining critical paradigm.

But the postmodernist critical stance rejected both visuality and opticality—as if they were the same and as if both were equally tainted by suspect claims and lineages. Both were associated with the long-standing traditions of romantic modernism—the concepts of individual talent, genius, originality, and mastery. Both were linked to some extent with autonomy. In the overarching critique of these terms, the idea of the photographic impulse

gained critical ground as the most legitimate means of making images that inscribed an ironic distance *within* their production. Douglas Crimp's "The End of Painting," Craig Owens's "The Allegorical Impulse," and Thomas Lawson's "Last Exit: Painting," agreed on the suggestion that only painting that employed a photographic sensibility (of reproduction, mechanical production, and anti-authorial anti-expressive means) was acceptable within the postmodern.[32] This attitude had to be dismissed from the postmodern camp; so too did the continual pronouncement that painting was "dead" or "over" and that oil painting, in particular, because of its longstanding association with the traditions of modern self-sufficient art (again, think of Pearlstein as an example), had to be dismissed from the postmodern camp.

The irony is that the forms of painting permitted into postmodernism were themselves quite retro—the new figurative work of German and Italian painters was nostalgic and heroic, not to mention masculinist—a feature that plagued the American figurative work of Salle, Fischl, and Schnabel. These artists used photographic and recycled imagery in a "critique" of mainstream culture. But theirs was an approach that was more distant from communication with that culture than that of the dada practitioners of pastiche decades earlier for whom the mass media were the site as well as the source of work they produced. Safe within the enclave of the fine art establishment, the postmodern painters posed the most academic of "critiques"—embedded in terms and postures readable only within the codes of a specialized critical rhetoric. This is amply demonstrated by the ways in which Bleckner and Richter, for instance, were granted positive critical status. Not that they aren't good painters. But their painterliness was *qualified—even forgiven*. The critical rulings on these exceptions generally allowed that some formal element of the painter's approach signaled the requisite critical, ironic distance from painting as a traditional practice.[33] Critics intent on this selective salvage project split nuanced hairs of the formal practice of painting in order to secure their judgments on some quirky trait or idiosyncratic element. Thus Richter's work was often discussed within a critical framework—not on the basis of his virtuosity and visual richness—but on the basis of a political position he himself actually repudiated in interviews![34] Bleckner's maudlin neo-Gothic kitsch imagery has been lauded as the height of a conceptual painting intentionally pulling literal and virtual aspects of surface and illusion apart on the basis of the single (hardly unique) fact that it has a shiny surface.[35]

My point is not to denigrate these artists or their work but rather to show the perversely distorted gestures of a critical rhetoric intent on redeeming painting through this handful of select exceptions legitimated through the most peculiar arguments. Needless to say, these approaches excluded work that engaged with painting in a very different, no less self-conscious but far less repressed, exploration of visuality and painterly means.

Postmodernism as espoused by critics such as Crimp and Owens, who promoted the photographic impulse at its base, did at least as much to marginalize the heterogeneity of painting, keep it from critical examination, as high modernism had done. A quick survey of painterly practice of the last decades maps a very different topography of the field of activity than that glimpsed through the narrow lens of these critiques, which defined themselves in so narrow a response to modernism. The "politics" of that position, clinging as it did to an oppositional and negative stance for fine art, precluded the possibility of examining this wider field from the outset.

Here again, we see that mass culture and media imagery cannot be construed as the barbarians at the gate of fine art. Or that only ironic and distanced work is critically self-conscious. Or that a politics of negation is the single and sole morally virtuous basis on which to engage as an artist with the diversity, pluralism, and richness of contemporary visual life. Cecily Brown's work reintroduces elements of painterly indulgence in all its complex richness. Brown's work is all about sex. And erotics. And flesh. Freely, expressively, aggressively so. Boy Trouble (1999), like her paintings of couples in postcoital dissolution, is an image of sexual engagement. Holding his erect organ in hand, pulled out from the elastic of his briefs as they have been slipped around his thighs, the man in the image is actively engaged in an act of masturbation. His full frontal position in the painting, a stance of muscular presence, and the active energy of the paint, so clearly quoting de Kooning's nudes, are vigorous signs of a sexual energy in full force. Paint is everywhere. And the role it plays in the making of this work is to reinforce the sexual codes of the imagery, just as the iconographic explicitness puts the reading of the paint into a direct relation with autoerotic and erotic abandonment. Why not? The rumpled bed, the exhausted body, the pink-tipped blushing zones of flesh that populate the works of painters throughout the modern period are all antecedents of this work. But Brown seems to have come out from under any kind of moral judgment. No scrap of good or evil, angst or difficulty, attends to these images. In some Nietzschean abandon

she seems to have gone beyond the capacity of judgment. These erotic images are troubled only by the questions of intimacy, here placed fully within the public space of representation and display. Nothing is too intimate to be depicted, no intensity too charged for presentation. Nor is voyeurism the trope—her gaze is without prurience.

Driven to tap eros as a primal life force, Brown pushes her unrestrained investigation. Pearlstein's abstract croppings of flesh turned us away from erotic engagement with his figures, as if the very act of painting should not offer too much too easily or be too consumable. And certainly the models whose flesh was abstracted into paint were devoid of subjectivity or agency. Not so with Brown. She makes subjectivity aggressively visible everywhere even as the individuals dissolve at the edges. Brown's figures lose their boundaries in the act of being painted. In *These Foolish Things*, for example, flesh is an excuse for looking, painting, making art, as the matter through which erotic energy surfaces (plate 7). She conceives of the act of erotic abandonment outside of any critical inquiry into its means or motivations, in a manner unheard of in the moral frameworks of modern painting or of postmodern critical concerns. Brown's are the joys of a flesh-surface-painting that has never had to pay dues to un-pleasure and so bears no stigma in the expression of erotic play. This flesh has nothing monstrous about it, except the extreme of blissful exhaustion to which it aspires. Few visual works could be more life-affirming, even with all their depiction of messy lived-ness, than these images of flesh dissolving into the surface of paint in the aftermath of erotic play.

5. Painting as an Impure Medium

Suggestions of impurity surfaced in the discussion above on current painting that can be extended by examining the social and cultural dialogue in the work of Julio Galan. Galan's paintings are deliberately heretical acts. They make use of the imagery of Mexican Roman Catholicism in the service of a contemporary homo-eroticism. The intertwining of faith and fornication is hardly a new motif for art, and depicting sexuality as an act of "transgression" could be considered positively ho hum in our posteverything (postsurreal, postfunk, postliberation) condition. But the heterodoxy of Galan's work bespeaks a capacity for polymorphous diversity that displays itself with creative abandon across his canvases. Painting is never so impure as it

is in the service of this blend of faiths—in beauty and sin and fun and boys and pictures and painting and other forms of expression.

Galan's *Tardi-Sola* (2001; plate 8) combines paint and collage. Impure therefore from the start, the work is as flagrant in its disregard of categories of media as it is in its relation to visual genres. A sunny bare-buttocked beach boy, glowing with blonde health, leans on his elbows, a bright shock of hair glowing as he hangs in the canopy of foliage overarching a rustic path. Another nearly nude male stands in a posture of sexual expectation. With his socks curled around his ankles as he looks over his shoulder toward his possible seducer, he makes the sexual codes of the work quite explicit. In the center of the path an out-of-scale young man leans over a bowl, weeping in a sacramental gesture, the long trail of his milky tears collecting in the white dish. A row of antique, formal chairs lines the path. With their dark wood and red velvet seats they suggest a foregone time and a vague association with religious institutions. The empty seats seem prepared for a ceremonial witnessing of some event, as if a procession might pass where the giant, weeping figure now kneels, dwarfing chairs, landscape, and other figures. Surreal? Unreal? A fantasy image, dreamlike and personal, the image is also a legible collage where oil painting meets mass-produced icon without any apparent conflict. The tanned flesh of the beach boy, completely out of the tonal range of the rest of the work, simply gives him an attractive sybaritic glow, pitching the whole of the pictorial space into the realm of free-spirited ease.

Collage is an old modern form, perhaps the most characteristic expression of dialogues between twentieth-century fine art and mass culture. The later inventions of what Leo Steinberg characterized as the "flatbed" space of canvas, when he first created the term in response to the work of Robert Rauschenberg, have long been standard ways of working with mixed media.[36] And in the era of postmodern appropriation, with its critical love of photographic media, no combinatoric art could cause a ripple of consternation. Or could it? Galan's transgressions, and I use the term in a religious sense, are measured by the extent to which they take place against residual rules of painterly decorum and aesthetic correctness. Galan's greatest sin, if it can be called that, is that he is distinctly aware of the play of references that link his work with votive objects. And yet he refuses to take them or anything else seriously. A profound irreverence permeates this work.

Religion, even more than literature or classical mythology, was the bug-

bear of modernity, the absolutely-to-be-banished theme and referent. Secular aesthetics had no place for faith or its accoutrements, and to dabble at the edge of the sacred realm in iconographic or thematic terms is to play in forbidden waters indeed. Galan does this, cognizant of the ways his erotic imagery registers its own deliberately irreverent sensibility in relation to the Roman Catholic culture of his Mexican upbringing. The popular realm of sex ads and gay magazines, catering opportunistically to a broad audience, comes into dialogue with the ceremonial acts of ritual weeping and repentance within a religious frame. Galan's work is often explicitly involved in exploring that relation, thus this single image reads within his corpus as a whole, but even in *Tardi-Sola* the themes are indisputably clear. Painting's various purities—its once-glorious role as the instrument of religious work, its modern autonomy, its identity as a self-referential medium, then its distinction from faith-based work—almost all of these are queried by Galan's deliberate disregard for the rules of such aesthetic games. But the "I can do anything I want" sensibility is tempered in turn by the image of remorse in the center of the work, the weeping figure making amends. Here the painter admits that he is sinful, penitent, impure, engaged, expressive, and intensely self-aware of the place of his work in the midst of these interlocking networks of visual form.

Current painting could not be further from the ideal of modern purity. Eclecticism abounds. Painting's popularity is rampant, its economic viability high, its critical status unclear, its recent fortunes improved by the possibility that though painting can (fortunately!) never escape the twin demons of visual pleasure and consumability, these need not condemn it forever to aesthetic purgatory.

Susan Bee and Lari Pittman are admirable, versatile, graphically sophisticated artists whose work also segues back to the dialogue between painting/fine art and popular culture imagery. In this perilous domain painting encounters its most difficult task—trying to keep that dialogue sufficiently regulated while not subjecting itself to rules of an order not its own. This really is to say, while not subjecting itself to any a priori rules of order—since to add "not its own" is to suggest allegiance again to that ever-resuscitating aesthetic notion of each medium's unique identities. Through the threat of real impurity, fully messy, unmanageable, impossibly disordered and unorderable impurity, painting ends up falling outside the realm of critical acceptability.[37]

Untitled #32 (A Decorated Chronology of Insistence and Recognition) (1994; plate 9) is layered, complex, and dense with imagery. Pittman's work is a scathing report on the horrors of contemporary life—rampant consumerism, hypocrisy, disbalances of power, racism, sexism, homophobia, and the sacrifice of the values of humanity to the free enterprise profit motive. Impossible as it is to quarrel with any of this, the always-evident paradox is that the paintings sell and are successful participants in the market they critique. This old cliché of contradiction is itself so familiar that it is barely worth commenting on. One must allow that aesthetic expression works critically even when reified within the art market system—that symbolic work intervenes materially in the creation of discourse.

Pittman's work has enjoyed high visibility, contributing to the discourse on the AIDS epidemic, pollution, police abuse, and many other significant civil rights and humanitarian issues. In the back and forth of negation/affirmation that contemporary art engages with continually, Pittman's is a perfectly paradigmatic example of the capacity of work to function in both capacities: as consumable art commodity and as critical space of alternative expression.

Untitled #32 contains Pittman's usual eclectic range of images: a geisha wig, an announcement banner in circus type proclaiming the arrival of Halley's Comet, a MasterCard and a Visa logo, an outlined hand with polished nails, a set of diacritical arrows, a pair of jockey shorts, a dancing figure in grotesque boots, a racing, flailing Pinocchio figure with a carrot nose, a card with "R.I.P." inscribed on it, a row of blood-red tears, and other miscellaneous bits of visual information in color, pattern, and form. Painted with enamel, acrylic, and glitter on wood, the work combines media in a layered, fragmented graphic manner. At first, the image appears to be noise, an assault equivalent to a melange of channel-surfed bits assembled at random. The order of the image and the skill of its composition become apparent more slowly. As they do, they reveal their virtuosity. The work manages its complex imagery in a well-worked-out organizational regime. The painting's aggressive presence is secured by the fact that all of the areas of paint are brought to the same pitch. All are flat, graphic color—the solid, intense, pigment-dense colors of advertising, silkscreen, and design.

Pittman's work appropriates, as per the now considerable tradition of pop and postmodernism, the visual language of commercial media and transforms it into paint. This transformation is in part the key to Pittman's

success. The harmonic synthesis of his work takes place at the level of production, which treats the disparate parts in a unified aesthetic. The whole is forged in the making, which has a consistency that works in complementary counterpoint to the diverse range of iconographic elements in the work. These elements are recorded as iconographically distinct but not as materially distinct. In this regard, Pittman's work is absolutely in the pop tradition.

Graphic production, aesthetically unified, iconographically contemporary and eclectic, and politically correct (in the good, not pejorative sense of this phrase), Pittman's paintings are daring and yet safe. Safe because they conform to certain aesthetic and attitudinal paradigms. They display a unified aesthetic of transformation into paint, but paint that is not messy, material, or uneven. And they state a clear readout on the contemporary condition of the lived as interpenetrated by commerce and media at every level. Pittman's is a garish cry against the screaming sirens of the daily urban scene. A futile horror, desperate, but stylish, hip, and immersed. Pittman is very "post" in this sense—beyond all naive humanism, all old-fashioned privileging of art, all nostalgia for a supposed has-been existence. And Pittman is smart enough—visually as well as intellectually—to use that immersed condition as grist for his own position. He speaks from within the current condition of culture, not from outside it, though he speaks critically and oppositionally.

In Pittman's painting the Visa and MasterCard have a presence as signs—but they are not signs/packages for products but rather signs of identity, images that promote themselves in order to maintain possession of a share of the credit market. Questions of "truth" value can't be raised in relation to Visa—the corporate identity is simply a fact (a highly complex one, to be sure). The identity of Visa/Mastercard *is* their image and vice versa—their image is identity. As a painting the Pittman work is still a "sign" of a private voice, enclosed within the "public" domain—maintaining the fictive but real identity of that position as an element within the public sphere. But the frenzied continuum, the assaultive insanity of the image, works to contextualize those signs. The central image of the deathlike head, the contemporary version of Edvard Munch's *The Scream*, bespeaks the very nightmarish reality of a life driven by pressure to consume against the recognition of mortality. The brevity of human life is spun out in a banner announcing the

passage of Halley's Comet—whose seventy-year cycle so closely resembles a human life span.

Public space is consumer space and allows no exchanges, no comments, no dialogue of individuals with each other or in comment on the situation or circumstances. One enters the public sphere only as a consumer and only in order to distinguish among the choices offered in the rhetoric of spectacular display. Pittman's work shows the world of commercial transactions, promotions, and displays. The loss of context is like the loss of history—it conceals structures that might provide insights into the "real." Actual information, however mediated, reveals the determinative and causal relations of power in terms of material forces and their mediating influences. In Pittman's painting the figurative beauty of the sign—Visa/MasterCard—flashes brilliant in the dark night of new nightmare but pales dramatically in the toxic glare of a polluted daylight. If we care to see it that way. Or we could give in to the absorptive potential of the bright face presented to us while asking, What has happened to that discrete border, that enframing set of distinctions among rhetorics, which allowed us to distinguish one message from another, differentiate one image from the next, one aspect of the social from its integration into a synthetic, totalized, and unresponsive undialogic whole? We are certainly not "outside" of consumer culture in Pittman's work but immersed in its dense field of signs, subjects of its play.

In contrast to Lari Pittman's work, Susan Bee's paintings are riven with contradictions. She provides no stable ground on which to read the elements she combines with such playful eclecticism. An aesthetic anarchy disrupts the order of things in and on her canvases. Miss Dynamite (2001; plate 10) exemplifies this disorderly conduct, displaying an exuberantly injudicious disregard for reductive categories within which to secure this work. Misko Suvakovic, in "Painting after Painting: the Paintings of Susan Bee," describes the way the "open noncoherent compositional solutions" in Bee's canvases make for continually unstable uses of one element after another and for their resonance with "a political net of pictorial images."[38] Other painters play with some of these same issues and tropes: Jane Hammond's elaborately synthetic painted collages, for instance, or Fiona Rae's virtuoso brushwork, or Julio Galan's bedazzled canvases with their feathers and glitter and jewels. But these artists have become critically acceptable. Hammond's work has an aesthetic unity of treatment. Rae's work is clearly self-

consciously about the reinvention of painting within the tradition of its de-
mise. Galan's work engages postcolonial and homoerotic issues. Each has
some legitimating feature that has allowed it to be placed within the do-
mains of aesthetic correctness and to align with some agenda within fine
art's symbolic realm.

Not so with Bee, and perhaps the most curious aspect of her work is the
way its complexly ordered arrangements paradoxically provide evidence of
its fundamentally unruly impulses. Any systematic approach in Bee's work
is eclipsed by a profound unwillingness to submit to rules of perceivable
decorum within the terms of art world agendas. Surreal, pulp, kitsch, dec-
orative, and iconic as rebus puzzles, Bee's paintings tend to rely on the for-
mal devices of frames within the frame overlapped by trailing organic ele-
ments to organize the polyglot collections into a semblance of legible
pastiche. Miss Dynamite (2001) is typical of her Americana scrapbook col-
lage sensibility. Using stickers and decals, mass culture clichés (the pilgrim
couple providing a sweetly ironic echo to the alluring femme fatale hiding
a gun from her tuxedoed partner), Bee's work wreaks a certain joyful ha-
voc on categories of fine, high, mass, and popular art forms. Her painterly
touches turn the signature styles of Jackson Pollock's drips (used as the tex-
ture in a bouquet) or Remedios Varo's dream flowers into the equivalent of
the dime store cutouts with which they are juxtaposed. All are equally avail-
able as ways of creating visual forms and motifs within a click-art universe
of readymade icons and swatches of pattern or texture in the palette of pos-
sibilities. Level as a playing field, the surface of her canvas serves as a stag-
ing area onto which anything, apparently, can be glued or affixed. Bee is not
so much challenging the limits of fine art along the modern-postmodern
lines of collage and montage as she is making use of the permission that tra-
dition has established to create works of individual eccentricity and whim.

Nor is Bee putting herself above the mass-produced materials on which
she draws. She expresses no judgments of irony or superiority within her
frames. The quaint sense of surprise she produces from the painterly tran-
sitions between and among the collaged elements provides its glue through
a net of visual associations. Her painterly techniques (cartoonish, abstract,
flat, rendered, scumbled, patterned) finally produce an elaborate doodling
toward meaning.

Many of the appropriated images are benign, even banal. Bee never es-
chews the cute or sentimental, two categories generally considered anath-

ema even in the current art world's most permissive moods. Of these, sentimentality is the more highly stigmatized category, and the way Bee uses her found materials suggests that she actually likes the tacky, glitzy, sloppily pretty things she has put into these canvases. They don't affront our good taste, they shock our bad taste into a moment of recognition. Sentiment has been out of favor longer than lockets and pinafores and has no pedigree with which to reenter the current art world. But Bee is indulgent toward these little-loved orphans of the aesthetic universe, and her work suggests that this playing around might be more fun than didacticism. Her attitude with its implication that seriousness of intention could benefit from a little lightening up and that a touch of the ludic might provide an alternative to self-serious political critiques, threatens the status quo.

But the most compelling aspect of Bee's work is its refusal to give in to the rules of either political or aesthetic correctness. Her wayward attitude has a perverse edge to it simply because it doesn't subscribe to the commonly held belief that the "real" work of art is to serve some formulaic agenda subjugating fine art to the role of instrument within an ends-oriented trajectory. The escape valve of creative play has its own function, and the impure condition of Bee's attitude calls the self-seriousness of much artistic activity into question. Her work is not so much chaotic in its formal means as in its fundamental assumptions about the continually shifting ground on which to make judgments. And that is a profound instability indeed in a world in which fine art often professes its moral precepts with great certainty.

So when Bee does something like use those drips of enamel paint to form the bouquet of flowers in an obvious quotation of the clichés of high modernism, she deviates from the correct posture of citation and appropriation. She doesn't use the drips to indicate Pollock's historical precedent as a "sign" in an intellectually critical way but just uses them as part of the vocabulary of painting, as if they don't have to be identified as a citation. This obviating of historical lineage and the strict patriarchal line of the high modernist legacy sidesteps the usual, critically sanctioned gestures of reappropriation. Even if everything is available for use and reuse, painting is still an ongoing activity of invention. The protests and sputters of critics are practically audible in the background here—but painting is dead, painting is over, painting is painting after the end of painting, after its exhaustion and annihilation. Says who?[39]

The requirement in the present that painting be in some sense always

accountable to the question, what can painting be, is the one question that Bee blithely brushes aside. She goes ahead and simply shows *that it can be*. In all of its inventive, polymorphous, complexity, painting is medium now wholly, exuberantly impure, capable of interacting with every other form of graphic matter and material device (anything that can be attached to the canvas). By her disregard for critical orthodoxy, her nonpolemic refusal of recognizable debate, she seems to assert that painting can be whatever it wants to be without having to answer the question in advance—if ever at all.

The strict requirement that painting was to be so focused on its identity—as if that question were the only one to be asked—was always a modernist question. This premise became the means by which the borders of art could be closed at the edges of the painting's frame, by which the meanings of works could come to reside within their formal means. Bee's frames of reference are porous, her approach unable to be contained within a "coherent meaning order"[40]—or a coherent critical order. Her painting is a place in which the residues of life come to reside in all their randomness, happily threatening the stable status quo of good and bad objects, good and bad attitudes, aesthetics, and works. If we are to allow that one might like the images in *Miss Dynamite*, that one might engage with the sentimental fantasy of the little girls, or wicked women, or experience a nostalgic moment looking at those pilgrims in all their elementary school seasonal motif familiarity, or want to get absorbed in these decorative surfaces, or abandon oneself to amusement in contemplating these works—then is that the same as slipping surreptitiously into an afternoon matinee of cartoons or an old Technicolor melodrama? What if it is? Playfulness might turn out to be the one last "subversive" activity because it cuts the ground of seriousness out from under us. Painting, and by extension, fine art, can create an independent space and register individual expression within the mainstream for whatever purpose. Galan, Pittman, and Bee, each in their own way, engage the potent energy that impurity produces in painting.

6. Hybridity and Unnaturalism

The encounter between traditional media in the fine arts and new technology has created a curious focus on the "hybrid" as an aesthetic trope while simultaneously giving rise to a host of forms that display morphological transformation as their most conspicuous feature. A certain hype attaches

to this work, attached as the culture is these days to extreme rhetorics. One can easily imagine that the anxieties that arise in considering the impact of technology upon the world as we have known it—and all that is implied for basic concepts of self, spirit, culture, and community—are represented in microcosm in these visual manifestations. Streaking ahead of the cloned image of Dolly the cow, the dystopic science-fictional imagination of British sculptor John Isaacs offers a horrific realization of nightmare fears. Even the titles of his works, *Say It Isn't So* (1994) and *In Advance of the Institution* (1994; fig. 13), reinforce the perception of a threatening condition and dreaded outcomes. But aesthetics also serves the purpose of familiarizing us with the horrific. Once imaged, the unimaginable ceases to be unknowable. The move into representation is a step toward integration across the broader culture spectrum of perception. Fine art performs this peculiar function as it experiments with hybrid forms but at the same time effects a serious reconfiguration of old boundaries of media and imagery—of what is acceptable subject matter or material for fine art aesthetics.

The works that exhibit this hybrid sensibility are not necessarily using digital or electronic media. The exploration of the phantasmatic realm of imaginary life-forms is taking place across the spectrum of oil paint and sculpture using standard, representational conventions of realism even as these are extended by digital-imaging capabilities. Imagery filled with fearful curiosity about mutation and technointervention, of metaorganisms, and psychoprostheses, machinic interfaces, and tropes of an altered somatic condition figure prominently in this work. Scarily not sci-fi, but already too true, such iconographic unnaturalism seems brought into being by the same forces that have made digital technology so pervasive, rather than being a result of that technology. For this reason, the imagery feels coincident with, rather than reflective of, a current cultural sensibility.

But the discourse of hybridity has cultural dimensions, important ones. The alignment of terminology that suggests a dual concern with the crossing of borders and the fabrication of unnatural forms has to be addressed as more than simple coincidence. In 1991, the highly experimental, risk-oriented New York art space Exit Art put together an ambitious exhibit titled *Hybrid State*.[41] In the late 1980s, Kala Press in Great Britain began publication of the important periodical *Third Text*, whose editorial stance is rooted in commitment to postcolonial theory and its aesthetic manifestations. The essentialist bases of identity politics, necessary in a first claim for attention

13 John Isaacs, *In Advance of the Institution*, 1994, wax, fiber, cloth, 185.5 × 66 × 72 cm. Courtesy: Collection Antoine de Galbert, Paris; © John Issacs; 20.21 Galerie Edition Kunsthandel GmbH.

within an establish discourse, gave way to far more nuanced and complex mestizo sensibilities for artists, their work, and the critical discussion of the premises under the rubric of hybridity. That the term was also being associated with an engineered genetic alteration of the physical condition and form of humanity raises questions about the extent to which these latter

characterizations are meant to put a negative or pejorative cast onto the "hybrid" condition in general. The subtext of the mutant morphology of unnaturalism draws on an Enlightenment distinction between natural and monstrous forms, in which deviance acquires moral and ethical baggage that didn't attend to earlier centuries' ideas of the "curiosity." The legacy of that characterization remains, and the cultural anxieties that postcolonialism addresses directly in its embrace of hybrid culture are given their negative, shadow life in the embodiment of those fears shown in some of the works that take up the hybrid condition in another frame.

While my emphasis is on the way digital technology and genetic manipulation raise fearful specters in the public imagination, the worst of which are given direct expression in the works discussed below, the images that express cultural hybridity are useful to consider as a counterpoint. Consider the striking impact of Guillermo Gomez-Pena and Coco Fusco exhibiting themselves in Madrid as *Two Undiscovered Amerindians in Spain*. The pair lived for three days in a cage, replicating the display tactics of colonial exploiters of native people in an impossible-to-miss pointed demonstration of the residual racism that permeates contemporary cultures.[42] The threat of hybridity resonates through the politics of NAFTA and the World Trade Organization and has implications for issues of labor and wages, immigration policy, social welfare, and all the many aspects of social and cultural life that are premised on assessments of national borders and identity at individual and collective levels. In this context, the term *authenticity* and all its attendant assumptions about *purity* (with all the racial implications) are what is being put into contrast with hybridity. And it is this theme of pollution and mixing that links the cultural spheres and scientific and phantasmatic ones through a linked set of associations. The anxiety about the hybrid state takes many forms, some more evidently optimistic, some more overtly dark, but all demonstrate the potent role of image making as a way to render charged discourse visible within the public sphere.

JOHN ISAACS'S SCULPTURES ARE grotesque, no question about it. And the grotesque can be a gratuitous category, one that uses cheap effects to predictably high-impact ends without any significant substance. But Isaacs's work brings certain liminal issues to the fore. His figures are almost but not quite human, and their nonhumanity reinforces the attention they bring to the qualities that constitute humanness (vulnerability, individuality,

mortality). One of his figures has weird simian features it its resinous face, another has a vegetable in place of a head. Both wear white coats, indicating their lab technician or medical professional status. Theirs is a world of hygiene and monsters, of official regimes of discipline over the unnatural body. And yet, these are the figures in charge, figures whose authority over their own condition suggests that a new order has come into being. *Say It Isn't So* is the title of the potatohead figure, perched with casual posture so as to address an audience. The taboo being invoked is countered by the admission of disbelief. The actuality has already been manifest by the appearance of this awful organism. The request is a statement of horror, of recoil and protest. But it indicates that the monstrous has already occurred. Nothing can undo this situation by undoing the existence of the creature—certainly not removing this new term by wrenching it from the symbolic into which it has intervened. The order of things is forever changed. Such is the full force of unnaturalism.

Similar themes emerge from the title of the simian-featured figure, *In Advance of the Institutions*. But here the appearance of grotesquerie is identified as a harbinger of something whose character may or may not be beneficial but most definitely as an instance of the exceptional. The institutional frameworks aren't identified. They might be construed broadly, as cultural parameters, or understood more narrowly as specific institutions—the medical or other conventional organizations that order the social universe through their standards and practices. Something has gotten away from them here and may or may not be able to be accommodated into those existing orders. In any case, they will have to change, extend their current parameters, if such a thing is to be reconciled to normative systems. By the same standards, these are hardly works of fine art. Their forms enact the transgressions they announce and protest in their titles. For after all, the protest of the first title is an echo of an oft-heard refrain in response to contemporary art—that it isn't art at all. And the second title may as well apply to fine art as an institution as any other. The conventional character of art practice is hardly reaffirmed by these mannequin figures with their special-effects faces and cliché costumes. Art? How can it be? A mere figment of ephemeral imagination, conjured for the sake of causing a ripple of shock in the unsuspecting viewer? Not only are traditional notions of formal beauty or artisanal virtuosity about as far from these works as they are from Toys-R-Us purchases, but the critical scaffolding that kept fine art from being con-

fused with popular culture is also missing. The institution that is most hybridized as an effect of these works is that of fine art. No reassuring difference can be guaranteed by these figures. The careful policing of those ever-sacred boundaries has lapsed if a potatohead and a one-liner mannequin can be celebrated as a sculptural works.

Because his work exists at the opposite end of the aesthetic spectrum and is exemplary in its display of virtuoso skill, Alexis Rockman's hyper-realist paintings embody unnatural attitudes in a radically different aesthetic mode (plate 11). *Embryo* and *The Beach*, two paintings from 1996, target an area of dispute and a liminal zone. The theme of embryo immediately references genetics and experimentation, the sanctity and integrity of human life, and the violations of propriety that extend from intervention. Hyper-realist painting has never enjoyed serious status in the context of twentieth-century critical perception. The work of the 1960s and 1970s that pushed photographic codes of representation to the fore as a basis for painterly production are still perceived as a sidetrack, rather than a part of the mainstream of contemporary art. The paintings of Richard Estes, for instance, or the many California photo-realists, Robert Bechtle, Ralph Goings, and Mary Snowden, among them, have been excluded from serious consideration. Alexis Rockman's use of the hyper-real approach would seem to put his work into a similarly marginal position. But the continued disregard, or underappreciation, of this photographically based representation-in-paint has to be factored into the perspective brought to bear on Rockman.

The tightly finished and exquisitely rendered hyper-realist surfaces of Rockman's work align him with illustrational, rather than fine art, sensibilities. At least that is the standard line. The self-conscious attention to media that was one of the hallmarks of modernism, the cliché of the laying bare of devices and methods combined with a "purity" of nonillusion cherished as the distinguishing feature of abstraction. Exiling representation merely replayed, again, philosophical biases that have long traditions within Western thought. The modernist version of this prohibition mapped onto a cultural context in which the consumable forms of visual expression were denigrated through association with the lower classes, for whom the elite and esoteric terms of abstract or conceptual work were, "naturally," inaccessible. The mere fact of visual consumability, as well as legibility within compositional and representational conventions of realism, was enough to condemn a work to a critical purgatory from which there was no redemption.

How could there be? The only critical recourse was a reading of the content, or even an implied referent, of the iconographic imagery. Much of the work of socialist and social realism finds itself condemned under these statutes.

Realist techniques are not the only feature of realism, which struggles to apprehend some imagined actuality and capture it in visual form. The realistic effects achieved by Rockman don't point toward a "real" but rather toward a dark imaginary world, one in which the forms of nature have been perverted. Processes of organic growth are accelerated to produce mutant organisms whose decay is already prefigured in the distorted pattern of their design. Nature's own capability has been twisted into monstrous activity, the results of which entwine in the sensuous finish of the brushstrokes whose insinuating tendrils have wrought the terrifying image before our eyes. Un-naturalism is the dark side of hybridity, the experiment gone astray and escaped from the petri dish to enact its potent destruction on the world. Rockman's apocalyptic vision self-consciously refers to that tradition of Edenic landscapes, whose own ideological efficacy served the forces that colonized the once-natural world. Rockman's echo of nineteenth-century works in the tradition of Frederick Church or Thomas Moran links his imagery to the performance of Gomez-Pena and Fusco mentioned above, since the two attitudes are equally engaged in showing the condition of a "fall" to which the course of empire was destined by its unacknowledged imperatives with regard to the natural and cultural worlds exploited in its sweep. Here, as in almost every instance under discussion, the cultural and techno-dystopic versions of hybridity are connected in subtle, but substantial, ways.

But Rockman's legible imagery is not a modern-style contribution to the realm of political activism. His relation to visual pleasure creates an unacceptable—and also unnatural—condition. His dystopic renderings are highly visually seductive. The coy turns of excellent atmospheric mood and descriptive accuracy of imagined worlds are not the stuff of good hardworking poster art. No, Rockman's work exhales a flagrant decadence. The fetid landscapes fairly reek with the sweetness of rotting life, the perverse pleasures of a dark, even necrophilic, imagination. Such decadence has experienced precious little critical popularity in the twentieth century, which eschews the nihilistic turn. We may read Rockman's work as a cautionary tale within a humanistic frame. But we may also read it as an expression of antihumanist philosophy, profoundly and wickedly aware of the indiffer-

ence of the natural world to preservation of the conditions of human exis-
tence within its continually changing systems.

Rockman's work challenges the received critical tradition in all its prej-
udices against realism—and even more, the hyper-real and photo-real—
and against decadent indulgence in sensual visuality. Rockman's skill can't
be dismissed as incidental. The viewer's jaw-dropping response to the
sleight of hand performance of deft illusion trumps even the most skep-
tical reserve. No matter how disdainfully an intellectual judgment is pro-
nounced upon these works ("hyper-realism" doesn't carry the cachet of
"abject" in the rarified realms of art theory), immunity to their effectiveness
is difficult to sustain. The hyper-real has different premises than photo-
realism. The latter takes its point of departure from a conviction that pho-
tographic codes have come to posit a particular, culturally normalized, mode
of visual representation. As a signifying system, the arbitrary features of the
photographic appear transparent to the naïve viewer. Analog and indexical,
appearing to be a mere mirror of the real, these features come to circulate
within a cultural context as a set of normative conventions. We come to be-
lieve that the photographic is the visual premise of the real, and that our per-
ceptual apparatus has come into line with this (supposedly) mechanistic
method of image production. As a natural evolution this process accords a
congruence between the cultural prevalence of photographic imaging for
production and reproduction and a general conviction that photographic
representation replicates human visual perception. In fact, it replicates a
specific cultural encoding of that perception. And thus the photo-realist
work of the 1970s in many ways was a conspicuous, self-conscious exposing
of a cultural device much in keeping with the modernist sensibility from
which it appeared to be so remote.

Hyper-real art, such as Rockman's, has a different lineage. It is much
closer to two critically debased forms—academic realism and illustrational
rendering. Utterly unacceptable within the modern canon, these modes pos-
itively flaunt their audience-pleasing capabilities. Norman Rockwell, Max-
field Parrish, the work of Bougereau and Cot, or many forgotten, unnamed
and unstylish, almost unmentionable figures belong to this tradition. These
artists were much beloved by audiences and much disdained by modern (let
alone postmodern) critics. Popularity has always been a suspect trait. The
amazing Thomas Hart Benton remains an unsung figure within the history

of modern visual art, his formal contribution to modernism almost invisible behind the glare of his successes. Rockman's work oozes popular consumability in the exquisitely obsessive rendering that brings his negative imagery into being. Why should "mere virtuosity" be disdained by high critics and beloved of wide audiences? The need to reinforce the gap between elite and popular modes goes farther toward an explanation than any aesthetic precepts, with the single caveat referred to above: simulacral realism has always had a suspect history within the philosophical frames of Western thought. A primal, fundamental sinfulness attends to illusion carried to extreme—in this case, not even as a critique of cultural modes (photorealism's single redeeming feature), but as an indulgence in seduction.

To assert that pleasure is a negative virtue is too simplistic. Rather, *easy* pleasure is what constitutes the pejorative charge against this work. Easiness undermines criticality. Consumability is counter to the tenets of radical negativity. So be it. Meanwhile, Rockman's imagery contains explicit metaphoric explorations of the hideous consequences of human folly. The hybridization he explores merits more than a passing mention, fraught as it is with a reinscription of that other anxiety—about the hybrid forms of contemporary art and popular culture artifacts running rampant, with utter disregard for the decorum of boundaries and well-policed distinctions on which to maintain aesthetic order.

As the term *hybridity* came into popular currency in the 1990s, therefore, it carried a number of values. It signaled the shift from essentialist, community-based political identity to a synthetic concept of identity contested in the symbolic realm. This explains and justifies the emphasis on cultural activism as opposed to political organization. As mentioned above, the term functioned as a rubric for a landmark exhibition at Exit Art in 1992 whose title, Hybrid States, suggested conditions as well as locations for activity at borders that are geographic as well as conceptual and aesthetic. The resonance with biological sciences was made evident in that exhibit through reference to genetics, breeding, livestock, and crops. The use of the term "hybrid" in those realms suggests a positive-outcome experiment, one in which purported improvement of genetic strains is the objective, if not the actual result. Hybridization, unlike mutation, carries no negative stigma. But this is not to say that hybridization is without a measure of anxiety. Rockman's *Embryo* might be a site for manipulation toward production of a hybrid strain, but the very image of an embryo suggests a highly charged site of cul-

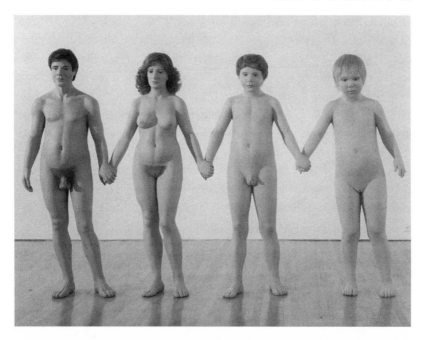

14 Charles Ray, *Family Romance*, 1992–93, mixed media, 54″ × 96″ × 24″. Courtesy Regen Projects, Los Angeles.

tural anxiety. A symptomatic anxiety about reproductive integrity is concentrated within that imagery. The threat of a mutant hybridization of the flesh, a topical theme, takes shape in the physical manifestation of form.

The image of a physical body, potential and in formation, is one site of transformation through technological intervention. As Isaacs's figures are already mutated, so Rockman's represent mutation as a process, ongoing, and all the more terrifying for being yet unfinished. Other hybrid sensibilities emerge from the same cultural climate of anxiety, such as reducing body to machine and the terror of having physical identity entirely uploaded into code.[43] But the mecano-morphs of early twentieth-century art long ago consolidated that aesthetic sensibility into a secure system of social management. The function of art, then as now, was to familiarize and normalize the lived condition. Against such a background, *Male Mannequin* (1990) and *Family Romance* (1992–93; fig. 14) by Charles Ray have a wonderful nonmechanical quality in their mutant forms. Both have immediate impact. The visual shock value of *Mannequin* depends on the realistic quality of the

genitalia attached to the standard department-store display figure. That of *Family Romance* is more complex, having to do with the uncertainties introduced by the odd scale relations of each of these figures to the other. None can be right, and yet, how can they all be wrong? The uncanny, unnatural quality of the four-figure family group, and all its humorous if slightly irreverent references to Freud and psychoanalysis, trades less on our sense of commercial versus fine art imagery than *Mannequin*. But both works are blatant in their appropriation of mass-produced imagery put toward a transformed end. Old news, to put it mildly, such acts of transformation go back to other early twentieth-century acts of similar transformation such as Picasso's handlebar bull's horns. What's different? Ray doesn't aspire to have his mannequin pass into mass production, nor for his chillingly outsized baby figure in the family group come to life as a Hollywood comedy or horror movie character. No indeed, Ray is not engaging in research and development for the culture industry in the production of this work but instead is mining the already-extant industry for those points where intervention and response can get purchase. The hybrid condition of *Mannequin* combines a cross-pollination of fine/mass culture and manifestation of anxiety about the condition of sexuality identity and desirability in commodified culture.

No technology is evident in Ray's or Isaacs's work. Rather, there is a sense of effects that must be accounted for, and in that accounting, a conviction that something has gone astray. That points back toward the Rockman *Embryo* as a source for the distorted alternatives to the evolutionary continuum that are showing up all over the place in these sculptural figures. After exposure to these works, the grounds on which mutation can be distinguished from the norm, or hybridization from the original source, disintegrate. No standard remains as a point of reference any more than a clear boundary between fine and commercial realms of imagery.

Digital manipulations of image add their own contribution to eroding these boundaries, among others. In two-dimensional illusions, the slippages between defined and undefined zones, internal organs, orifices, and exterior surfaces are all part of an uncomfortable continuum. The traditional binarisms of nature and culture, organic and artificial, biological and mechanical, are irrelevant in images where morphed forms and flesh can't be identified as any known organism and yet have all the specificity of a living, breathing creature. Isaacs and Rockman give us transformations that can be

read against a familiar point of origin, but many artists have gone quite beyond those conventional frames of reference just by playing around with filters in photo-manipulation programs that manifest techno-effects nonstop. The digital mode presents a completely synthetic imagery of new flesh and grotesquerie, almost without effort. Hot storage, cool whisper in the dark corridors of culture, this rhetoric, persuasive as it may be, is separated from the tangible physicality of what used to pass for the real. Image seduces, as always, through a stylistic capacity to fascinate and absorb, thus overcoming any initial response of repulsion with an intensified identification and interest.

Clearly the technology inspires fantasies—nightmarish and not so nightmarish ones. Likewise, the cultural condition raises often unacknowledged fears. Artists express anxiety about causes and effects, about the development of new hybrid conditions for experience, sensation, and form and the extent to which unnatural conditions have transformed the ground on which we conceive of our physical and social identity. But another anxiety shadows the fantasy of transformation of corporal and social conditions— an anxiety about production and consumption and boundaries of subject and object along traditional lines. In an era of intensified consumerism, such boundaries are blurred at the level of the body in realms of hygiene, medicine, health care, and physical culture. Whose body is made of these parts? And what is the source, the brand? What is the role of art? To make a comment? Or to produce an aesthetics of the new techno-body and the rampant forms of mass material culture? If aesthetics has a function, is it only to render seductive and consumable the totalizing images and texts of the new unreal?

Are these cultural forms totally foreign to the old humancentric models? Should a conventional humanism and fine art of individual expression be revived and fought for in response to these new forms—or through them? Only the fact that we are human allows us to make the distinction between ourselves and the hybrid technology, but no simple binarism applies in an age of mutant somatic existence. We are techno-hybrids, subject to forces outside our understanding and control. We are used and consumed. The vulnerable flesh is capable of being extended. The mutable forms of fine art are able to stretch a long way toward popular forms before they lose all defining features of their identity. In the face of the seductive potential of electronic form we have to decide, according to our own disposition and digi-

tal orientation, whether to give in to enthrallment as consumers of illusion or become skeptics testing that illusory reality in order to "unconceal" the terms of its production. No amount of nostalgia can return us to a "natural" condition, simply to another, equally altered, cultural one.

Parallels can be drawn between the anxieties produced by images of mutant organisms and artistic practices that render conventional boundaries meaningless or uncertain. Alexis Rockman's hyper-realist paintings of mutant and polluted landscapes refer to the long tradition of picturing the natural sublime but now within a corrupted ecosystem and even more polluted cultural frame. Mutation has become a way of life, as it always was, but the new adaptations transgress the old aesthetics. Can an aesthetics of this new mutation transcend the rabid prejudice against representational realism, which poses a supposed threat to fine art purity? Can the aestheticization of mestizo identity allay fears about miscegenation by familiarizing its appearance? Anxiety about hybridization already admits to these changed parameters of human identity, somatic integrity, and the line between elite fine art and more popular visual modes of image production and viewer seduction. The unnatural state of fine art is as much a matter of hybrid practices as of images of newly hatched forms. But the two reinforce each other in a thematics of mutual fascination that continually extends the fall from modern autonomy and postmodern critical distance into a hothouse of fertile mutation.

7. Thingness and Objecthood

In the 1990s, sculpture engaged in a highly charged dialogue with the themes, imagery, and "stuff" of material mass culture. This dialogue extends the long-standing questions at the core of modern sculpture: How does an art object distinguish itself from other objects in material culture? What are the formal and critical characteristics of those objects that not only define sculpture but also determine what constitutes its identity at any particular moment? No matter how engaged it is with thematic or illusionary iconography, sculpture has always been first and foremost a *thing* in an irrefutable and fundamental way. This simple fact is crucial to its artistic identity.

Challenges to this condition and to the delimitation of the boundaries distinguishing art from nonart objects arose with concentrated vigor in the

1960s and 1970s when pop, minimalism, and conceptualism dominated the mainstream. The critical reformulations that arose in this period restructured sculpture's conceptual parameters in a process that extends to the present. This transformation begins with pop/minimalist "objecthood" and arrives at the contemporary condition of "thingness"—a recent reconfiguring of sculptural identity.[44] The term "objecthood" in Michael Fried's well-known 1965, "Art and Objecthood," arose in response to the sculpture and critical position taken by a number of artists for whom sculptor Donald Judd's 1963 essay "Specific Objects" served as a defining moment.

In contrast with minimalism's "objecthood," the concept of "thingness" links sculpture to objects in and of the world in a combination of traditional arts, conceptualized contemporary art, and mass culture production. Thingness embraces the specificity and allusional properties of material in combination with conceptual and minimal approaches. The category depends on the intersection between the world of things that are irrefutably and indisputably a part of material culture and those that are in the world of art. Rather than preserving the thin dividing line that minimalism relied on to separate these domains, these new works aggressively blur those boundaries. In capitulating to material culture, they embody its most phantasmatic properties: continually deferred possession, seductive contemplation, and endlessly displaced signification.

With whimsy and terror, this work manages to reify the strategies of consumer desire as well as to celebrate the material richness—resonant, redolent, replete with associative meanings of that material culture. This work is always deferring to and yet mimetically aspiring to the condition of mass culture. The material properties in these works have meaning within these highly mediated domains. Part of what makes them so effective is their capacity to activate these associations. Play-Doh, pipe cleaners, or colored cloth used by Daniel Wiener draws more directly on personal associations than do raw chunks of wood or quarried marble. Such familiar materials have a special effectiveness in the marketplace of aesthetic material art and culture. They contain a charged tension. They flaunt the "individuated" experience of art production through the very objects whose mass production sources seem to be utterly at odds with the distinctions on which fine art depends. The two modes of identity (fine art/consumer material) are sustained simultaneously in a single object.

As sculptural objects have undergone a transformation from the au-

tonomous, self-sufficient works of bygone formal modernism to referentially rich, materially suggestive, things, a vivid conceptual logic seems to be emerging from these works.

Daniel Wiener's work is an example of this new "thingness." Wiener's recent *Tree* is created from a combination of hydrocal, Sculpey, dyed muslin, and wire. The work bears the distinctive hallmarks of this artist's work in the last decade. It is whimsically fantastical, defying spatial and attitudinal gravity, stretching its quasi limbs of wire, chair-stuffing, and Play-Doh through space to sketch an informal form.[45] *Chorus*, a multiarmed, capillary-filament structured work arches across space like a many-thonged leash controlling the activity of a brand-new generation of young offspring of an indeterminate but very vivid species. *Angel* is a tangled intersection of soft cloth forms wrestling with each other in small-scale but large-scope struggle of matter and matter. Wiener's work is as hard to digest as it is to characterize. The pieces have just a bit too much of a preschoolers' playgroup feeling to allow serious critical discussion to recuperate them in purely formal terms. Contrasting textures? Delicacy versus stability? The piece itself would appear to mock such academic discussions with a knowing sci-fi creature's indulgent nod. A genetic experiment cloning a bit of Judy Pfaff with old dada classics—Jean Tinguely and Hans Arp at their most mechano-morphic and anthropo-organic—by way of Dr. Seuss?[46] The pieces investigate sculptural principles (space articulated through physical means) too seriously for them to be reduced to mere material associations. Their bright, almost day-glow primary colors reinforce a connection to kids' activities and play materials, and there's nothing sharp, apparently dangerous, or threatening in either the form or the substance of the piece. The polypodia base elements of another work, *Ball* (plate 12), rise like some mutant pajama-clad octopus from the floor to support a hairy-armed something whose tentacles are raised in exploratory alien greeting.

At every level of production and execution this work is resolutely non–fine art, its pedigree unlocatable within any historical aesthetic. It refuses to be classed as a simple, sculptural "object" in the terms once so clearly articulated by Donald Judd for the condition of minimalist sculpture, and yet it is in clear dialogue with the aesthetic terms of minimalism's challenge to the fine art object.

Wiener's work has much in common with Jean Tinguely's kinetic whimsical works and the baroness Freytag-Loringhoven's American dada bird-

cage headdresses, but it also draws on an irreverent engagement with Toys-R-Us and Mr. Potatohead. The work manages to do this in formal terms—by means of the "stuff" it uses and the way it uses it. Playful, eclectic, appropriative with respect to materials, this sculpture displays a self-consciousness about the trajectory of twentieth-century sculpture. Most particularly, it calls attention to the crucial way minimalist sculpture pushed art objects toward the limit of aesthetic identity, eliminating both the antiart humor of collage/assemblage and the self-evident autonomy of the abstract formalist tradition.

If minimalism provided the definitive break between modern sculptural investigation and whatever comes after, then the current wave of imaginative reworkings takes minimalism's premises into a curious and sophisticated conversation with both its notions of "specificity" and "objecthood" and with the traditions against which minimalism itself gained its own identification. The "specificity" that Donald Judd strove to embody in his work was invested in a rejection of the conventional compositional dynamics of internal formal relations in favor of a unified, single object—one that could only "minimally" be distinguished from an ordinary object.

The iconic suggestiveness of Wiener's work creates a forthright association of these sculptural objects with a popular culture context. The "ordinary" object from which sculpture has to be distinguished—or with which it is in dialogue—is no longer the bland, uniform, repetitive (and let's face it, boring) stuff of industrial material—but rather the eye-seducing, visually distracting stuff of playgrounds, garden supply outlets, and party goods stores. Consumables, all vying for shelf space in the public imagination, are as much a source of inspiration for artists as are the inherited terms of modern sculpture or even the longer tradition of figurative work that preceded. If one thin edge of this associative wedge was inserted into sculpture through those artists from the 1970s who allowed iconic suggestions of some meaning beyond the formal in their work, then another source for this activity comes from the media-fascinated art activity of the 1980s. Popular culture is no longer the "other" of fine art—it is rather a shadow double, a nurturing twin, or a rival sibling from which the best stuff—as well as the best opportunities—have to be snatched.

This new "thingness" can't be read as a replay of pop art, nor as a repeat of 1980s appropriation in the spirit of Mike Kelly or Robert Gober, but instead as a highly transformed and synthetic production in which a visual

vocabulary has been absorbed, digested, and reused to a new conceptual and formal end. The materials and surfaces are absorbing, fascinatingly so, while the forms of the work exploit the potential of material to produce both meaning and effect in works that are delimited, sculptural pieces whose referential field vibrates within a matrix of associations.

No purity to materials inheres in Weiner's work. Materials turn out, in fact, to be the very Trojan horse of meaning. In this case, the particularity of materials forges a link between stuff and social meaning. The cultural associations suggest any of a number of other possibilities. Each of these is a meaning, not any meaning, but a meaning that is irrevocably embedded in the network of lived experience, not abstract vocabularies of aesthetic form.

The immediate precedents for Weiner's work are themselves wide-ranging—from feminist critical commentaries on minimalist form (Polly Apfelbaum, Maureen Connor, Janine Antoni) to other conceptual reworkings of the received formalist tradition (from Charles Ray and David Hammons to Rachel Lachowitz). Still other antecedents can be found within the longer history of contemporary art, for example, the tradition of funk sculpture in the work of Bruce Conner, Ed and Nancy Reddin Kienholz, for instance, or the suggestive materiality central to arte povera, with its use of humble materials and replete invocation of meaning through visual/formal knowledge. More recently, the work of any number of artists for whom sculptural materials are used to communicate an ethnic or cultural identity—such as Jimmie Durham, David Hammons, or Renée Stout—has reintroduced the potential of materiality to produced meaning within the sculptural arena.

Wiener pushes the pop culture envelope into a complex network of suggested references and explicit formal tropes. Its *objecthood* (the delimited, bounded condition of the sculptural objects) is in direct but complementary contradiction to its *thingness* (the necessity of locating its meaning outside circumscribed formal terms). Thus these works lead the eye into the cultural field, forging meaning through a process of interconnections among the visual domains from which fine art distinguishes itself rhetorically. The quality of theatricality—calling attention to the presence of the viewer, the temporal dimension, and the situation of viewing—becomes something far more connected to and complicit with the cultural world. This new theatri-

cality invokes the quality of image-mediated sociality, of shared exposure to the cartoon/televisual/graphics—dense realm of visual and material culture.

In an important sense, the fears of Greenberg and Fried have been confirmed by this recent work. The citadel of rarified aesthetic values, which Greenberg hoped fine art could be (in counterdistinction to kitsch culture), can't be clearly demarcated in material terms in this work. The autonomous object granting the possibility of transcendence through aesthetic experience has been embedded, as Fried worried it would, within a complex matrix of signifying systems that bind it to the here and now of contemporary experience. "Things" provoke complex associations through their material properties.

The impulses that in the 1990s motivated dialogues with material mass culture are very different from those that spurred the recovery of traditional, ethnic, gendered practices in the sculptural work of the 1970s. Iconographic forms and traditional materials brought aesthetic dimensions into play that had long been marginalized within modernism. But they share the basic premise that a work's identity is not separable from the specific contexts and conditions of its production. The link between the art of identity politics of the 1970s and the 1990s leapfrog the paradigm dominant in the 1980s, with its focus on media and critical theory.

Postmodern strategies of appropriation—for which Jeff Koons and Haim Steinbach serve as exemplary models—divorced commodity objects from their commercial context in order to call attention to the interpenetration of media culture into nearly every aspect of contemporary experience. Such work engaged with commodity culture in a material way but stopped short of any transformative gestures. The emphatic critical stance of anti-authorial originality, the poststructuralist interrogation of the mythic character of artistic subjectivity, which was a key feature of 1980s postmodern theory, condemned the artist to strategies of appropriation, reproduction, and display. The poststudio concept of art practice took its impetus from a rejection of modernism's privileging of visual opticality and its repression of traditional pleasure in making, artisanal skill, or basic disciplines. The "critical" sculptural object was indistinguishable from its pure commodity form. This supposedly implied a critique of the commodity structure of the art system as well, though, paradoxically, posed in a highly

consumable form (as opposed, for instance, to the earlier conceptual, site-specific critiques or anti-object performances of Happenings and Fluxus artists).[47] Studio practices in the 1990s reasserted subjective inflection, signs of personal creation. Traces of making are evident in the material as a way of showing off the presence of the artist. Individual subjectivity can still be made to matter, to exhibit a presence, even in the face of mass material culture and its store-bought symbolic.

Nancy Davidson's *Buttress* (1997; fig. 15) exemplifies another way these historical trajectories are currently reconfigured. Grounded in feminist practice, Davidson's work has its conceptual roots in the 1970s assertion of gendered identity in the face of modern art's transcendent forms. In its 1990s manifestation, Davidson's work combines the elegant formalism of a modern sculptural vocabulary with a gendered commentary on its neutrality. Her use of material objects and iconography calls attention to their situatedness within contemporary mass culture. The five-tiered structure of *Buttress* consists of pairs of pink, globed, latex forms at once the epitome of modern formalism and its distinct opposite. The forms are buttock-like, fleshy, coded as feminine by their color and shape. The addition of silver girdles resembling women's erotic undergarments—the only other element in the piece—fixes the iconography of the work in a frame of irrepressible references. The work is profoundly simple. Its repetitive structure is reminiscent of and clearly quotes minimalist sculpture. Its vivid color and humor reference pop art—the Nanas of Nikki de Saint-Phalle, the cartoon drawings of R. Crumb's exaggeratedly curved women, or closer to the present, the distorted figures of John Currin and Lisa Yuskavage. But the air-filled, taut latex forms suggest buoyancy, sensuality, and lightness as well as bondage and the sex industry. Feminist critiques of the supposed neutrality of modern sculptural forms have become an established category, but they initiated an interpenetration of the formal and the associative properties of material, shape, and gestural vocabulary, and the erosion of autonomy through a suggestive contingency of form and complicity with the iconography of spectacular culture.[48]

Davidson's work, like that of Wiener, poses a new paradigm for artistic practice. Eschewing the romantic art as alternative to the deadening effects of material culture, she also moves beyond the defeated 1980s poststudio abdication of any possibility of authorial originality. Davidson's gestures affirm precisely this potential of "art" to participate in material contemporary

15 Nancy Davidson, *Buttress*, 1997, latex, fabric, 180″ × 53″ × 33″. Courtesy Edwin Aldrich Museum of Art. Photo: Nancy Davidson.

culture while embodying an individual inflection. The possibility for such a gesture grants to art practice a genuine affirmative role—that of, the making over of absent values into form, a point of individual reference made to register in the culture of spectacle. Davidson reworks material forms so that they convey meanings at odds with and yet still continuing the association of their mass-produced origins as material and image. Neither artistic identity nor material culture are denied or repressed as she emphasizes a critical opposition; the artistic gesture reads as a related displacement, rather than a negation, of the culture in which it is situated and with which it is in dialogue. The identity of art as a cultural practice is not "other" than that of mainstream culture; rather, it is an aspect of it and unashamedly engaged. Davidson takes full advantage of the suggestive potential that this condition of embeddedness or situatedness provides, so that the minimal voluptuousness of *Buttress* vibrates with associative values. The piece never aspires to function as "pure form"—rather, it belies that possibility as well as its desirability, forcing the formal language to act again and again in and on the cultural milieu from which it draws its significance.

The specificity of "thingness" is not anti-lyrical and anti-expressive, nor is it anti-compositional. Instead, it risks the self-conscious flirtation with and awareness of cultural meaning and value through work, which evidences personal terms of determining reading through a shared (or at least, available) set of contemporary cultural references. While clearly demarcating the "art" object from the "ordinary" objects of material culture, the work of an artist like Wiener or Davidson also makes a counter-gesture. These objects are emphatically to be read as "things" among "things"—that is, of, rather than apart from, the world of contemporary material culture. They gain their identity in that dialogue rather than in refusing or repressing it.

8. *Affectivity and Entropy*

A tension exists in contemporary sculpture between work that possesses seductive production values and work that aggressively disregards these values.[49] For instance: Sarah Whipple's *Glow Worm* (fig. 16) looks so good, its cast-resin, high-polish, fabricated form is so obviously well made that it has the degree of fine finish worthy of a showroom floor model. By contrast, Elizabeth McGrath's *Pose* (fig. 17) looks like cast-off debris beneath the level of roadside junk, a mere accident of laundry lint in a chance

16 Sarah Whipple, *Glow Worm*, 1997, sculpture of foam, epoxy, and phosphorescent paint. Courtesy of the artist.

17 Elizabeth McGrath, *Pose*, 1997, sculpture of lint and filament. Courtesy of the artist and Eugene Binder Gallery.

encounter with mono-filament. In both cases, the sculptors are struggling to make their attitude toward production so conspicuous that it differentiates their work from other consumable objects of mainstream material culture on formal as well as conceptual terms. Whether making a show of attending not at all to formal, material, values or attending too much to these values, contemporary sculptors seem united in their efforts to use this self-consciousness to make clear that theirs is an art product. No matter what a sculptor's work is about thematically, the values of production and the production of values juggle for balance. A struggle is played out through the formal properties of sculptural objects. Standards of making have to be kept from becoming values that simply reinforce and reiterate the prevalent standards of market culture. Sculpture can't simply engage with the same techniques or materials of fabrication that characterizes mainstream consumables. At the same time, the object has to have enough value not to be dismissed from all aesthetic or critical notice.

Work like McGrath's and Whipple's puts aside the shadow of negation that has been so central to contemporary art and its critical reception as a legacy of the classic avant-garde. Neither artist is alienated from their objects, nor are the objects alienated from their social context. Something else is going on that looks suspiciously like affirmation—if that term can be used to indicate a positive affect, a certain longing for some of the sense of connectedness and participation in the mainstream, an unequivocal engagement with the delight of making an object for enjoyment—a curious but viable premise on which to continue the romantic project of art as that which allows us to imagine otherwise? Making use of the qualities that are attractive in material culture rather than eschewing them in favor of dreary esotericism, Whipple and McGrath dispense with making a virtue out of difficulty for its own sake wherein the only reward was the resistance offered to consumption.

A skeptic's quick response to this might be that if sculpture were to become too consumable, it might run the risk of simply passing for any other object. Might not these objects be absorbed without causing the least ripple in the surface of consciousness? Certainly some of these objects depend heavily on the gallery or museum setting to have their effect. Even as they seduce the eye with their vividly imaginative shapes, they exhibit their ability to vie with racks of plastic barrettes or new running shoes for our attention through somewhat similar means. Upping the formal ante for fine art so

that it competes with the visual qualities of the massmade object is an expression of enthusiasm for the material culture world, a complicity with its pleasures combined with an imaginative response to them.

The exploration of nonorthodox materials that has been part of modern art and, in particular, twentieth-century sculpture, persists in this new work. The underlying anxiety in the current climate of art production is how to make art count, how to make it show up on the culture screen. For a solution many artists have gone straight to the source of their anxiety and pleasure. They shop for their materials at Waldbaums, Stop & Shop, Home Depot, and Toys-R-Us, selecting the stuff of their production from the aisles of bright, vividly colored plastics, paints, and other already (usually cheaply) made things. No fine cherry wood, no Carrera marble, no bronze, no gold. The point of departure for production is mass-produced and mass-processed stuff, generally plastic, synthetic, indestructible-seeming artifacts. By the mid-1990s, sculptor Jessica Stockholder was using plastic laundry baskets, vivid latex paint, and other hardware and general merchandise material as the basis of a formal approach to installation-scale sculpture.

McGrath's *Pose* has an animate quality that derives from the gesture implied by its shape. Whipple's *Glow Worm* has the shape of a highly defined formlessness. McGrath's upholstery stuffing and monofilament line and the soft moldable substances of Whipple's pieces are closer to the "raw" material of clay and its traditional identity as a material waiting for form to shape it into "art." The unconventional nature of the materials contradicts their conventional nature (pliant, supple, and potential) as art-making stuff. But in both cases the act of transformation is a dramatic one, radical in its capacity to shift the material out of its raw condition and into the category of distinctive and animate form. *Pose* and *Glow Worm* exhibit particular qualities of animation verging on the anthropomorphic through the gestures they strike—a clear investment in the material to make it active. In *Glow Worm* this function is served by the pseudo–life force that suffuses the waxy substance with a glow in the dark paint substance, a New Age élan vital that produces a hybrid simulation of a life force. Even this kitschy touch resonates with a pleasure in the special effects approach to sculpture, putting it into a popular culture frame of reference. Whipple's work has a made-from-Sculpey material-for-kids quality to its figurative forms, as if their claim to meaning and identity as beings came from cartoon culture or the Gumby museum.

The work of Stockholder demonstrates affectivity as a formal transformation that renders these store-bought materials significant, powerful, beautiful, seductive, and suggestive (plate 13). Stockholder is so far from the tradition of the ready-made that there should be no reason to even address the comparison, but the inevitable association of Duchamp arises as an automatic response to almost any sculptural work that makes use of recognizable mass-produced items. Stockholder uses plastic, synthetic, and cheap massmade items the way traditional painters used their tubes of cadmium, ultramarine, and umber—as colors capable of building form through conscious manipulation and arrangement. The colors retain the imprint of their original form completely; they function as things as well as materials. This emphasizes the extent to which she is organizing elements from the sphere of material production into new meaning (even new systems or structures of meaning, since they are shifted out of functional or conventional use systems entirely and into aesthetic and semiotic roles).

The affectivity that Stockholder infuses into her repurposed objects lets them function as referential—they are meant to be legible as what they are—while also working within a compositional ensemble as elements whose visual properties prompt their placement and produce their effect. Stockholder's work has nothing cutely anthropomorphic or theatrical in it. Rather, she integrates mass-produced materials into the visual catalog of elements that function as part of sculpture right where it meets the production capabilities of mass culture. Such formalism argues against a sphere of purity or autonomy, where form is supposedly self-sufficient and self-contained. Instead, all the formal properties participate in layering meaning into the work as a set of connections to various spheres of activity. This referential function is suggestive but not specific. A laundry basket clearly indicates domestic sites, but its generic nature keeps it from any strictly overdetermined gender tag, cultural location, or class association. Any literal reading of these objects as a statement of class relations or identity issues would be misguided, although reading them without recognizing their indexical relation to mass production would also ignore their effect since their literalness in terms of the history of modes of production and consumption patterns goes far beyond trivial information.[50]

Stockholder's work clearly demonstrates the principle of affectivity as an organizing gesture that recognizes referential and formal values simulta-

neously in making aesthetic work out of objects of the material world. She performs an act of displacement that adds a value to the objects, an additional quality of meaning so that they function formally and referentially on account of her organizing gesture. In certain ways, all painterly or sculptural work of assemblage is clearly affective in this sense, but the blatant retention of recognizable objects and the aggressive assertion of the aesthetic properties of disposable culture confronts the critics of material culture with a playful and enthusiastic engagement that is aesthetic in nature. She is not dismissing the plastic forms nor suggesting that these objects contain a "critique" of consumerist hype and production values. Quite the contrary: Stockholder's gestures express genuine pleasure in the colors, shapes, and forms of these items even as they are appropriated to new (aesthetic) use.

A significant divide separates the work of Whipple, McGrath, and Stockholder from that of their immediate 1980s predecessors. Their work also distances itself from that of early modern artists for whom a quality of abstraction and biomorphism found happy concert in sculptural and painterly works that became source material for a whole generation of interior decorators enamored of the kidney-and-liver–shaped forms codified in the work of Miro, Arp, and Gorky. McGrath's *Pose* is a universe away from Arp's biomorphic abstract sculptures, with their lyrical animation and smooth perfection. McGrath's *Pose* is wrested from an impossibility, achieved against the odds of its happening, as a triumph over the fundamental inertness of the material it uses. Remaking meaning through formal reconfiguration, McGrath corsets the massive lump of stuffing with transparent filament and fishing line and lets its shining network catch the eye. The overwhelming dumpy shape of the form itself attempts a gesture of movement, its nipped waist and bent torso all too easily dismissed as mere lumps rather than explicit body forms. The somatic reference is reinforced by the title, which by its nature confers animate value to the shape. McGrath's struggle has nothing nostalgic about it. *Pose* is as capable of a heroic interpretation as a Michelangelo slave emerging from the marble except that there is no foregone conviction of its presence. This is not life released as spirit from a condition of capture in base material; this is a constitutive process of life coming into material through transformation and human intervention, a cloned and manipulated animation, a gentle Frankenstein's monster of upholstery stuffing blundering toward life. Even more fundamentally, it is the gesture

of making over mere material into form through that act of affectivity that confers value through transformation. From stuff into form, from stuffing into animate gesture, from mere stuff into something more.

Anthropomorphic identification, humor and bubblegum heads, and the potential of synthetic fantasy to figure forth an idea from disposable detritus are also features of this work. The possibilities extend into a fantasy realm, reinforcing the potential of the New Age assemblage sensibility to create aesthetic value by transforming the materials of mass-produced culture. But the work of Bill Davenport goes further into the entropic mode than the work of his counterparts here. *Pair of Lint Sculptures* (1998; plate 14) is about as formless as work can be and still be identified as an object. Davenport's piece has the undone, to-the-limit-of-formal quality of some of Richard Tuttle's works (though by contrast, Tuttle comes off looking like a hard-edged modernist, so extreme is Davenport's approach). The lint sculptures are just that, works made of dryer lint. Unlike McGrath's upholstery-stuffing form, these have no affective gestures at all. They exist on a level of inanimateness and unreadability. No sense can be made of them. They have no form in their lack of form, they are inert pads of lint, the most ephemeral detritus of the domestic world, the leftover residue of a useful process from which they are produced as a useless by-product. Nothing can be done with it. This work achieves this nothing, the no-thing, absence of the possibility of being-a-thing, so successfully with its cavalier-seeming gesture. The *Pair of Lint Sculptures* is resolutely aesthetic, which is to say, it identifies itself as art in the act of showing how far the art-identity game can be played. There is of course no further limit in such a game, and artists will continually trump each other in attempts to push the entropic extreme of what is a definable object. Davenport underscores his blurring-of-the-lines sensibility on his Web site where photographs documenting his (usually) whimsical work occupy a space one click away from his collection of found-object macramé owls. A kind of slacker entrepreneurialism permeates this universe (Davenport has a "store" on his site, reminding us of Claes Oldenburg's Ray Gun days), with its grunge humor and disregard for the critical nuances of higher aesthetic judgment.

The entropic gesture is one that moves the material of the work out of any stable system of usable production. The lint sculptures might be falling apart or coming together or be on their way to being something, or disintegrating from a higher level of organization. The confusion this induces at

a cognitive level effectively short-circuits any possibility of use. The "stuff" of the piece can't really be turned back into anything, nor is it likely to evolve as an object. It exists in a state of suspended identity, not quite formed and not quite not a form. But this is not the *informe* of the dissident surrealists and European post-1945 abstractionists with its negative assault upon a decorous bourgeois sensibility—it is playful, apparently harmless, even whimsical, and doesn't have the self-serious critical edge of the work of Wols or Jean Fautrier.

Another of Davenport's pieces, *Seafoam Pen Holder*, is equally entropic, though perhaps in less purely aesthetic terms. A piece of unsavory, soiled Styrofoam serves as the base for eight pens and pencils and a single seashell, all upended into it without either care or lack of care. They all tilt a bit, but not quite at the same angle. They've been stuck there as an interim move, as in a makeshift office furnishing. But the sea foam/Styrofoam is so dirty and unattractive that it would never find a happy home on a desktop. The supposed order it introduces into a presumably messy workspace by assisting the pens and pencils to stand upright is pretty well undermined by the ugly addition it makes with its unsightly edges and indeterminate shape. But this isn't a piece of Staples equipment; it is a work of art. Its form, texture, color patterns are all formally determined. The contrast of each bit of the whole has the de facto (regardless of intention) effect of a compositional arrangement. But the composition is entropic in its foundation, and its every move goes against the kinds of rules of good design in the universal language of art mode that was characteristic of early twentieth-century formalist investigations. Its entropic quality resides precisely in the fact that the recognizability of its components is subsumed to the dysfunctionality of the whole. Their potential for usability might remain, but to function within the almost formal but absolutely not formal character of the final work the pens and pencils, humble instruments of practical value, have to be kept out of circulation. They become as much "mere" decoration as the clam shell, whose organic surface betrays wear in a manner that could be read as authentic and aesthetic, except that shoved into the moldy, mangy, sea foam, it deteriorates aesthetically. The sea foam doesn't rise to the level of the mass-produced finish of the pens, nor does it acquire the attractive distressed quality of the shell. Rather, it pulls all them into its grubby ambiance. Entropy is effected as a negative gesture in which the normal functionality of these objects is obviated by their being absorbed into a sculptural

work. They mean *less* in that context, rather than more, and yet they engage this dysfunctionality with a wanton, sensual abandon. We are not left repulsed by the *Pair of Lint Sculptures* or *Pen Holder*, but offered another insight into the pleasures of material. This distinction is crucial and keeps the entropic gesture from merely repeating the spit-and-body-spume tropes of the *informe*. *Pen Holder* is not an instance of abject physicality, reductive and throbbing, but a work that has come apart and disintegrated as an aesthetic effect.

Writing about this work and others in the catalog essay accompanying her exhibition, curator Courtenay Smith used the phrase "latent entropy" to describe the condition presented by several of the pieces. She was referring to an evident material contradiction in the works. Some gave the appearance of solidity though in many cases they were highly fragile. Or else they gave the appearance of being tremendously ephemeral and delicate objects while in fact they were virtually indestructible pieces—made using technological processes whose longevity can be measured against the half-life of current landfills. The challenge she identified is fundamental to contemporary artists. How is it possible for an art object to compete with the production values of an automobile, an appliance, or any of a host of other mass-produced objects—from plastic forks to computer disks—in their own terms?

Whipple's *Glow Worm* and McGrath's *Pose* show off their production values in a manner that differentiates them from the broader cultural field of objects. By making the simple claim that *I am not the same as other things*, sculptural objects put into play the significant terms of contrast that are the core of aesthetic experience and value.

Such strategies of differentiation gravitate toward two poles—that of "entropy" and the counterpole of "affectivity."[51] To understand the way these are defined, it is useful to invoke the classical Aristotelian distinction between form (as organization and structure) and matter (as that which is possessed of qualities even without having form).[52] Matter is never outside a cultural (economic and historical) system of production but always inscribed within it as well as providing the substantive foundation of that system. Form constitutes a signifying configuration and matter the inherently valuable stuff. Form configures and thus pulls material into a system of meaning, but material provides a basis with intrinsic properties that can be worked upon. Linking this discussion back to the investigation of contem-

porary art and Smith's curatorial project, the dualism of form and matter become identified as two variables that are always working in some specific (but distinct) relation to each other.

The terms *affectivity* and *entropy* echo the title of Wilhelm Worringer's famous essay of 1907, "Abstraction and Empathy." The parallel is not mere parody. Worringer sketched out these two opposing poles of form to align with geometric and organic styles. He suggested the first was created out of a response of fear of the natural world, the second as an expression of harmony with it. The first enacts an aesthetic of distance and control, the second a synchronous ease of relations. Worringer had derived his analysis from the study of motifs and patterns of decoration and device in early human cultures. His insights belong to a phase of art historical scholarship intent upon finding meaning in style, while mine align with a contemporary attention to use and process.

Thus, defining affectivity and entropy, my interest is not in providing a key to the meaning of forms, but rather a way to understand how it is that a use of material can effectively show up—that is, register as significant— within the overwhelming field of other things. The affective gesture puts material objects (or stuff—that is, cloth, string, things that are often shaped by use after they are purchased in bulk) into an organized construction. In so doing, the affective gesture brings the inert to life, it rehumanizes material, not in the romantic sense but in a production sense. Affectivity gives material a sense of intention and form, of sentience and action, it shifts it out of the mere material while engaging with it, tweaking the stuff, making it active. Affectivity takes what looked like matter already formed and uses it as simple matter to give rise to another level of organization and structure. Thus a laundry basket or a soap dish transforms into the marble of the new sculpture and becomes organized into another level of form. Meanwhile, the associations invoked by the functional identity of these objects-as-material are also part of the final communicative whole of the piece.

Entropy, on the other hand, is a deconstruction of normative identity through material means. It demonstrates the effect of removing things from the system of production and consumption in which they normally circulate. By rendering objects nonuseful, the entropic gesture forces attention back onto its "mere" materiality as an object, as a thing, so that it can't be pulled back into the form of the usual "commodified" (and readily consumable) object.

The affective gesture is active. It is the positive dynamic of doing, action on the processes and materials of consumption. The entropic gesture is passive. It is constituted by the dynamic of undoing and the taking apart of the processes and materials of consumption to make them available to a renewed sense of formal pleasure in the stuff itself.

The structural underpinnings of Worringer's approach were organized around the interpretation of form as a specific cultural response to a *natural* environment. Contemporary sculptural works like *Pose, Glow Worm*, and *Pair of Lint Sculptures* are specific responses to a *cultural* environment, each working symbolically to describe a relationship to its "natural"-seeming systems of consumption and production.

9. Dubious Documents

The entertainment industry, amateur photography, and documentary photojournalism are the three realms of photographic activity from which fine art used to take great pains to distinguish itself. Now all these seem perilously present in work by artists in the mainstream of contemporary art: Anna Gaskell, Dana Hoey, and Jeff Wall. And they are not exceptions.[53] What is going on?

Childhood, sexuality, hints of sadism, and dark shadows lurk at the edges of every frame in Anna Gaskell's photographic series entitled override (plate 15). The richly suggestive look is the stuff of titillating fantasy. Icons of girl worlds abound. White stocking-clad legs and blue dresses, secrets, whispers, and naughty intimacies echo in late-night corridors of what might be a huge estate or a very exclusive private school. Gaskell uses the seductive vocabulary of historical costume dramas and saturates her imagery with color. Lush and suggestive, the images are richly fantastic and utterly consumable fictions. Gaskell is one of several younger women photographers producing images that satisfy, rather than reject, the desiring gaze. She is also one among several who create dubious documents, works whose fictional identity is sometimes made evident, and at other times, simply passes within the more conventional narrative frames. Gaskell's override series from 1997 was comprised of set pieces. Each image clearly was worked out well in advance of the photographic record. Their stagey quality is marked, and every bit of prephotographic effort shows in the creation of a final product in which as little as possible is left to chance. We're a long way from life

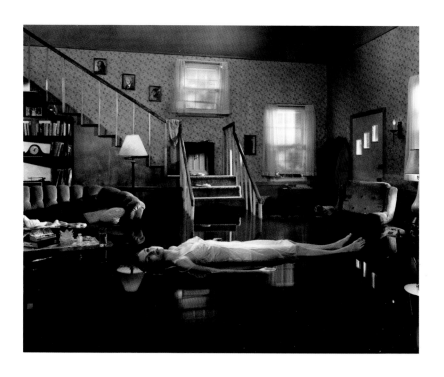

PLATE 1 Gregory Crewdson, *Untitled (Ophelia)*, 2001, from Twilight series, digital C-print, edition of 10 with 3 artist's proofs, 50″ × 60″. Courtesy of the artist and Luhring Augustine Gallery.

PLATE 2 Robert Colescott, *Tastess Lik Chickens*, 2001, acrylic on canvas, 75″ × 85 ″. Courtesy of the artist and Phyllis Kind Gallery.

PLATE 3 Catherine Howe, *Yellow with Mushroom*, 1999, paint on canvas. Courtesy of the artist.

PLATE 4 Llyn Foulkes, *But I Thought Art Was Special*, 1995, mixed media, 42″ × 31 1/2″ × 2 1/4″. Courtesy of Patricia Faure Gallery and the artist.

PLATE 5 Lisa Yuskavage, *Big Little Laura*, 1997–98, oil on linen, 76″ × 96″. Courtesy Marianne Boesky Gallery.

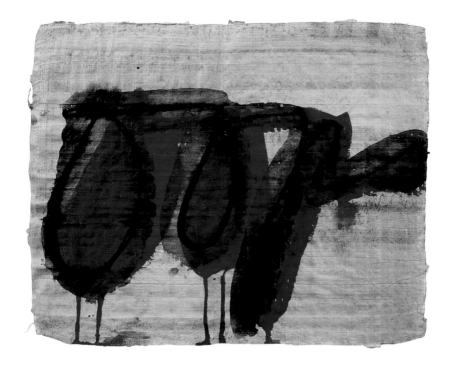

PLATE 6 Mira Schor, *Oops*, 1997, ink and mixed media on papyrus, 12″ × 16″. Courtesy of the artist. Photo: Bert Gossen.

PLATE 7 Cecily Brown, *These Foolish Things*, 2002, oil on linen, 90″ × 78″. Courtesy of the artist and Gagosian Gallery.

PLATE 8 Julio Galan, *Tardi-Sola*, 2001, oil on canvas, 51″ × 74 1/4″. © Julio Galan. Courtesy Robert Miller Gallery, New York.

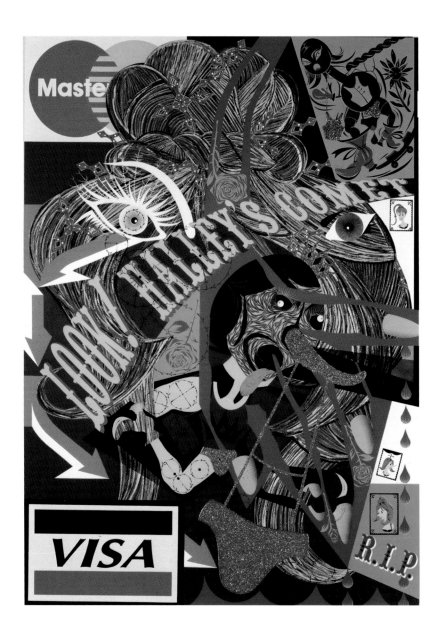

PLATE 9 Lari Pittman, *Untitled #32 (A Decorated Chronology of Insistence and Resignation)*, 1994. © 1994 Lari Pittman. Courtesy of Barbara Gladstone.

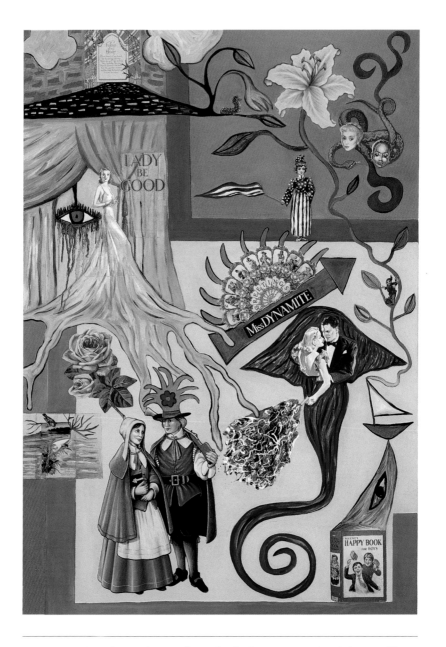

PLATE 10 Susan Bee, *Miss Dynamite*, 2001, oil, enamel, and collage on canvas, 50″ × 34″. Courtesy of the artist.

PLATE 11 Alexis Rockman, *Biosphere Primates*, 1993, oil on wood, 64″ × 96″. © Alexis Rockman, 1993. Courtesy of Gorney, Bravin + Lee, New York.

PLATE 12 Daniel Weiner, *Ball*, 1993, fabric, etc. Courtesy Gorney, Bravin + Lee, New York.

PLATE 13 Jessica Stockholder, eight suitcases, stepstool, snapshots, plastic vases, tables, wood, linoleum tile, shower curtains, birdcage, sandals, yarn, hardware, nylon webbing, carpet, chain, Velcro, extension cord, light fixture, bulb, pie plate, acrylic, and oil paint (inv. no. 343), 59″ × 90″ × 163″. © Jessica Stockholder. Courtesy of Gorney, Bravin + Lee Gallery, New York.

PLATE 14 Bill Davenport, *Pair of Lint Sculptures*, 1998, dryer lint, 2″ × 4″ × 4″. Courtesy of the artist.

PLATE 15 Anna Gaskell, *Untitled #27*, 1998, from override series, C-print, 50″ × 60″. Courtesy of the artist and Casey Kaplan, New York.

PLATE 16 Yasumasa Morimura, *Daughter of Art History (Theater B)*, 1990, color photograph mounted on canvas. Courtesy of the artist and Luhring Augustine Gallery.

caught unawares here and deep into the territory of mainstream fiction. Still, these are photographs, and their relation to a lived event, even if a staged one, is one of indexical directness. Something happened and showed up on a piece of film as a result of the exposure of light.

How far do we have to go to move from our acceptance of Gaskell's fictions as photographic records of staged works to the questioning of what a photograph records in the pseudo-snapshots of Dana Hoey?

In Hoey's piece *Timeless*, for instance, a 1996 print shows two teenagers involved in a struggle, one pushing the other (mouth taped, hands bound) into the front seat of a car. Such dramatic work might be reminiscent of Cindy Sherman's film stills, a captured image from a nonexistent movie in the mood of Larry Clark's *Kids* instead of the film noir genre Sherman so admired. But this doesn't make sense if we look at Hoey's work more broadly. She ranges from utter banality, creating toned-down emptied-out versions of Tina Barney's mordant observations of white, upper-middle-class family life to pseudo-ethnographic photos to images that could pass for vacation snapshots were it not for the production values in the final prints. Hoey's pseudo-amateurishness sits in an oddly ambiguous place, neither documentary nor fictional nor incidental nor real. She isn't following any of the established, identifiable protocols of photography. If anything, her slipperiness calls the identity of known genres into question, but in an offhand, unrigorous, uncritical way. Slacker aesthetics revisited. An image like *Disaster Relief* (1998; fig. 18) shows us a glimpse of a scene in which a large Saint Bernard, held in check by a chic woman in heeled sandals, looks at a foot sticking out from under a large coil of flexible black pipe leaning against a concrete form. Though deliberately banal, the image was produced at a large (50″ × 40″) scale. Why? How is the incidentalness of the photographic record manipulated as a result? The answers are disturbing; since the work can't hold up to serious critical scrutiny, it has to be read in a self-referential play of photographic history. The rhetoric of these images comments on the history of amateur framing, presentation, and the artifice of unselfconscious picture taking. Whatever we may think of the work, it challenges the received traditions of photography by disregarding the rules of many games.

Culture industry images and amateur productions have had their own critical history, but documentary photography has been the subject of longstanding debates about the nature of fine art and the aesthetic status of images produced in the service of news, journalism, exploration, science, and

18 Dana Hoey, *Disaster Relief*, 1998, C-print, 50″ × 40″, edition of six. Friedrich Petzel Gallery

a host of other fields. The photographs of Jeff Wall are self-consciously and carefully composed to have the look of documentary work. Though Wall's compositions conform to all the known codes of photojournalism, the images are set-up shots, carefully staged and then recorded. These are truly dubious documents.

Gaskell's gothic works have clear fine art credentials, even if they quote

the culture industry without any reservation. They could easily be part of a dark fantasy from a mini-series production of kitsch-y historical costume dramas. Hoey's framing, treatment, and approach sally off toward the world of amateur snapshots. If encountered outside of a gallery setting, they would be difficult to distinguish from the millions of photographs that pass through the developer's trays of mass-market processing on a daily basis. And Wall's work, if glimpsed only as an image of something, could pass itself off for a wire-service photo without anyone ever noticing. All are dubious documents.

The fact that each of these photographers is the object of serious critical attention shows the extent to which the foundation of fine art photography has shifted. Each suggests that the esoteric aesthetics that refined photography into a recognized medium for personal, individual, subjective expression that could be recognizably marked in the forms of its imagery, have given way to an even more rarified aesthetics. Now the connoisseur must rely on a metadistinction that embeds the works in a complicated discourse of criticism, not merely in a rhetoric of the image in itself. Photographic aesthetics, self-consciously debated, are making compelling arguments in this moment. But the question of what constitutes fine art photography is being eclipsed by another challenge in which the notion of the "real" as an indexically linked referent is being called into serious question in a new way.

Current theories of photographic realism provide a readout on the ever-so-subtle nuancing of the definition of fine art imagery and its distinction from other forms of photography. The discussion has received an influx of critical attention since the proliferation of digitally produced photographic work has become commonplace. The capability to produce photographic fiction on any and every desktop computer has softened any residual attachment to the concept of photographic truth. The properties of verisimilitude that dominate the photographic codes have no necessary relation to a referent. The ultimate effect of this activity is to show up the fact that photographs were never about the "real"—and digital images only make absolutely clear what was the case all along. The concept of the photographic index—as a link between the world and the image through an exposure of light on a receptive surface—is significantly eroded in a digital environment. No connection to any external source is required to produce the most believable of photographic truths.

All this is now pure banality, well-known among the teeming masses—

for whom photographic imagery gets most of its power from its falsity, not its accuracy. The wise public knowingly nods at the special effects of the daily news, fully aware of its production as an artifact. But if daily consumers and high-end users of digitally manipulated imagery are all as savvy as can be, a curious divide exists between the rhetoric of the digital and that of fine art photography. Though digitally produced work has become common currency in the gallery realm, the critical discussions of contemporary photography that flirts with conventions of the document and theoretical interrogation of digital work remain resolutely separated from each other. Yet both focus on the *untruthfulness* of the document.[54]

A crucial aside is in order here. Current discussions about photographic truth align along a single theme: that the fictional nature of photographic illusion is revealed and confirmed by digital photography. But none of these conversations turn the argument around to reflect back, not on photography, but on the sense of the "real" that is supposed to be represented or misrepresented by photographic instruments. My concern, in fact, is *not* only with photography, but with the way critical discussions about this medium in its historical range from traditional to digital modes calls attention to current cultural beliefs about the *real*.

The critical discussion of "the document" informs and influences a belief system about what constitutes the real as term and concept whose existence is taken for granted within the discussion of photographic representation. An image might distort or lie about the "real" but that doesn't change the dynamic in which photographic representation is defined in relation to the presumed existence of a world capable of being truthfully presented in photographic media. The net effect of all three of the dubious approaches to fine art photography sketched above is to show how complicit the photographic artifice is in reinforcing the myth of the real—by incorporating the high artifice, amateur aesthetic, and false document into the realms of fine art. By expanding the critical authority of these approaches, fine art photography takes to itself ever more territory of representation, ever more ways of creating symbolic constructions, that can be discussed and refuted as if they stood in relation to a world that went on outside their frame. As if the real existed, as it were, in prephotographic condition, ready to be photographed if only photography would continue to follow the rules. Violating those rules—through artifice, amateurism, and false documents—only reinforces the dynamic in which art and "real" continually redefine each other in

a codependent relation. Is that relation false if it is conceived that the photographic art constructs an encoded image of what is otherwise real? Not at all. The photographic medium creates artifacts in its own codes that are themselves real. Simply that. The statement "This is" in any discussion of a photographic image does not have a referent outside the symbolic form of the image, at least, not a referent equal to the photographic image. "This is my cat," I say of the photo of the old red tabby. Wrong—not because the two terms are not equivalent (Magritte's drawing and statement are not equivalent to the pipe, as this famous canvas *This Is Not a Pipe* brings home dramatically), but because the relation of equivalence suggests the possibility of a relationship of identicality established by means of representation. And that is where the myth enters.

The asymmetry of the relationship of image to real is not the same as the destruction of illusions of truth. You can see this most when there is the greatest effort to close the gap of image and real—in photographic images produced from scanned objects. But to get to that point, we need to look briefly at photography's current critical life.

In his essay on Jeff Wall, "The Social Pathology of Everyday Life," John Roberts traces attitudes toward realism as a critical practice in visual art, with particular emphasis on theories of realism from Soviet and Russian avant-garde practice through to the present.[55] By contrast, current theoretical discussion of digital photography emphasizes the longer tradition in which "wet" photography is part of a continuum with digital manipulation. The crux of the latter conversation is the essentially fictive, or at least, manipulated, nature of the photographic image. Early discussions of digital photography, particularly those of William Mitchell and Fred Ritchin, stressed the rupture between digital and traditional photographic production. Their attention focused on the absence of a referent for the photographically coded image. Programs like Adobe Photoshop could produce the codes of realism from data, and thus they concealed the absence of a source for that photograph within an actual event (especially without a "light" event, a moment of recorded exposure). So the story went. For Mitchell and Ritchin, the capacity to produce such effects without a moment of origin represented a major change.

But as other critics have pointed out recently, the capacity to use photographic methods to create images of "nonevents" or unreal and unrecorded objects that pass for photographically documented ones, is intrinsic to pho-

tographic processes.[56] Multiple negatives, manipulations within traditional darkroom techniques, and the creation of prephotographic fictions provide ample evidence for this argument. A particularly sweet example is the series of fairy photographs produced by Elise Wright and Frances Griffiths in the early twentieth century. Their paper cutout sprites were photographed in the garden alongside the innocent dears themselves striking winning poses. Who could imagine these were not the absolute truthful documentation of the existence of magic creatures? The belief system within which the "real" referent functioned made it impossible to imagine adolescent girls engaged in elaborate deceit. The believability of the images derived from that cultural attitude and the perceptual frame within which the photographs were received. The nature of the photographic image might have been suspect. Spirit photographs and other artifices of deception had already enjoyed popularity and skeptical public reception by this time. Photographic images always encode a specific cultural norm of visual perception.

The image of what is real is based on highly debatable, and mutable, visual assumptions. These manifest themselves as codes of believability. This, a photograph presumes to say, is what the real *really* looks like. From black-and-white glass negatives to Polaroids to low-resolution digital files? Quite a range of "reals"—and yet they all pass because the image has sufficient analogue to perception experience that we can make it align. We can go even farther. Our perceptual apparatus, which evolves and refines its capabilities as we develop, gets reinforcing cues for its cognitive tasks from the codes of visual images in the culture context in which we function. Not surprisingly, given the prevalence of photographic material in our contemporary lives, we imagine that the world actually looks the way photographs tell us it looks. We've made the transition from taking the representation as real to taking the real as conforming to expectations trained into us from looking at images. I come back to the particular importance of the way the older boundaries of fine art photography have fallen to the power of culture industrylike images, amateurish ones, and fake documentary approaches. All are ways of pushing our sense of what the world is into conformity with their codes.

Nothing is taken more for granted than that the "real" has a common form, standard, a priori, passively accessible to the camera. No matter how much the mediating function of photography is subject to the scrutiny of critical study, the "real" escapes debate. Why should it? The discussion of

photographic untruth isn't significant because it reveals codes in these images. The real impact is the insight that we create the real, that it is a *lived and perceived construction*, rather than mere matter existing in an a priori condition waiting to be uploaded into image.

The hybrid nature of the high art artifact resides in its premises as much as its forms. An artist like Jeff Wall plays an acutely self-conscious game of hide-and-seek with terms of reference while contributing to a myth of the "real" as itself conceived within photographic terms. Likewise, Gaskell's fictions wreak havoc on the legitimating terms of fine art taste and unclouded judgment, while Hoey's absurd snapshots push this argument into the realms of banal imagery. If we reflect on the nature of the photograph as a document, the dubiousness of its current condition becomes all the more striking.

One of the durable characteristics of documentary photography has been its association with socially progressive causes. The link between reform movements and documentary images, however contrived they might be to serve agendas on all sides of an ideological issue, gives the documentary photograph credentials the fine art photograph has never had within the political community. The working-class struggle, the plight of the poor, children abused by labor conditions, migrant workers displaced by the consequences of drought and economic forces—documentary photography defined its role as champion. Always subject to question, the "realism" of documentary photography can be critiqued from all the same perspectives as literary modes of realism. Does the photograph reify the real, giving it the appearance of wholeness by virtue of the image codes? This is a question far from the "truth" questions about staged or set-up images. The question goes deeper: do photographs have any capacity to reveal contradictions within the totality of social and visual relations? If the documentary photograph is the common currency of a certain realism, then realism is in turn the frame in which the document is enclosed.

But realism lost its political identity and edge as art activism retreated into conceptualism in the 1960s in an effort to avoid the bad faith of exhausted utopian beliefs. Direct instrumentality, the naïve notion that representing the politically disenfranchised was a move toward empowerment, lost its credibility. Any attempt to find a critical edge for photographic documentation was rendered very difficult by the critical deconstruction of documentary photography's hegemonic presumptions (by Martha Rosler and

others). Critics who remain attached to avant-garde agendas continue to see a platform for photographic efficacy beyond the utopianism of the early avant-garde.[57] For such critics, the large-scale "documents" of Jeff Wall provide the right combination of elements. They are neutral and contrived simultaneously. They are incidental documents, not heroic ones, and they appear to undercut the tropes of monumental documentation as well as the tenets of fine art photographic protocol. These are fundamentally insincere works, on some level, participating in a belief that honest relations —or at least, honest representations—are impossible. In Wall's play with documentary codes, the game of the "real" plays out as a set of conventions meant to be read through *as* conventions.

In Mimic (fig. 19), Wall orchestrates every aspect as much as Gaskell organizes hers. The characters (not people, but role-playing individuals) in Mimic have been given directions on how and where to act and move. The result is a staged photograph that intends to communicate the incidentalness of a documentary found photograph. The title announces the conceit.

Futility of social purpose pervades Wall's work with a cynical nihilism.[58] Wall uses the tropes and formats of the documentary tradition to make large-scale fictional images with a high level of consumability.[59] Indeed, these images are so consumable that they slip readily into the domains of high art from which the document was so long (and in some cases, is still) barred. The intention to produce a document—usability, a service function, a record for purposes other than the aesthetic—became the criterion on which exclusion from the always useless realm of fine art could be determined. But Wall coyly nods toward such intention as a set of conspicuous formal features while displacing the functionality of these means into aesthetic brackets. Clever fellow. Much as the work of Jason Rhoades calls the value of labor into querying focus, Wall puts a frame around the very concept of documentary efficacy.

Roberts reads this work quite differently. And Wall has gotten precisely the kind of attention that Roberts generates so expertly. According to this critical line, Wall is to be read as an artist struggling to rehabilitate the strategic power of avant-garde traditions through creation of a form of "dialogic" realism. The referential assumptions communicated in photographic codes supposedly force the viewer into an awareness, through Wall's odd use of convention, of the peculiar disjunction between what appears to be real and

19 Jeff Wall, *Mimic*, 1991, photograph. Marian Goodman Gallery.

what could or might actually have been a real moment captured in documentary form.

All this is fine as far as it goes. But a problem remains. How, for instance, might Wall's *Mimic* be distinguished from any other photograph found within a daily news or documentary context? Compare his images with almost any wire-service photograph from the *New York Times* or other daily paper and the point comes sharply into focus. How are the forms of Wall's "self-consciousness" communicated? The specialized discourses of fine art criticism do not acknowledge their own mediating function in this situation.[60] Not at all. Why not? The esoteric, self-conscious distinction of Wall's image from a "normal" documentary photograph cannot and never would arise from the images themselves. My argument is not for an innocent eye, nor for a retroformalism of immanence and transparency. Quite the con-

trary. I am suggesting that the sociological condition of fine art criticism has to be factored into the production of the discourse that serves to frames this work, to make it seem different from the work it rather too aptly imitates (Mimic indeed).[61] Wall's work doesn't make any clear distinction from the sources he is quoting—except that his prints are large in scale and exhibited in a gallery setting. The point is obvious: sociological or anthropological criteria, not aesthetics, are required to describe the identity of Wall's work as artistic artifacts.

The fundamental (always suspect) "fact" of photographic realism has of course evaporated in the face of digital technology. Not even the naïve continue to believe. The capacity for manipulation may have set the watchdogs of duplicity in place in even the dullest of gate-keeping minds. But the codes of documentary photography continue to play with the hinge point of that belief system: the idea that a photograph is an image of something that is. The link between the photograph's "is-ness" and that of some existing object, event, person, artifact, or scene's "is-ness" is the persistent myth of photographic representation. Data files undercut this mythology to some degree, but fine-art play with the codes of documents sets up a very different productive tension with this long tradition of belief and its foundation in the idea of the predicate. How dubious has that predicate become? How up for question is the "is" of photography's claimed visual relation to an actual event?

To come back to the point made above, the common phrase "This is" appears in the presentation of photographs in the vernacular context. "This is my mother," one says, holding out a snapshot. "This is us in France." "This is where I used to live." The construction hides a complex assumption of equivalence that is the essence of photographic truth claims. Translated into an equation, real life = this is and this is = the photographic image. But when the object on the other side of the equation—the "this" that "is"—has no existence at all except as a data set—then what happens? The data set, sure enough, has as much claim to "be" as any other entity. The faces in the early experiments of digital artist Nancy Burson, for instance, suggest a fictive reality that is qualitatively different from that of the multiple-negative image or airbrushed print. Why? Because the photographic face given to a set of data allows its informational content to be manifest as an image that uses the codes of the real. In essence, this is not different from the use of photorealist techniques to draw dinosaurs or alien landscapes—the codes enact

20 Tom Patton, *Chicken Leg*, 1995–2003, archival ink-jet print, from the series Icons and Artifacts. Courtesy of the artist.

a convincing fiction. And more to the point, the break with traditional, wet photography should not be seen, we are cautioned by the new digital critics, as a reconfiguring of the relation of referent and image. Rather, the digital image is what shows up the lie of realism and indexical relations. All photography is fictional, manipulated, constructed.[62]

At another extreme, however, digital imagery calls attention to the full force of reification that occurs within processes of its encoding. Tom Patton works with the scanner as his primary photographic input device. He puts substances such as rocks and sliced lunchmeat onto the flatbed and scans them. Then he creates large black and white prints of the visual input, such as *Chicken Leg* (1996; fig. 20). The effect is uncanny. Stripping photography to its essence as a document—closing the indexical gap between light, lens, and object in the world—the scanning technique collapses any distinction between surface of image and skin of the world. The result is a reification of that which we have always known. The image is more real than the real, because the conviction on which our perception depends derives from the way photographic codes mediate their visual information. A scanned image of a slice of sausage laid flat upon the surface becomes its image. No rela-

tionship of self-identity can be produced, even when the gap between image and object is reduced to a sheet of transparent glass.

Why relate this discussion of digital art to the work of Jeff Wall, Anna Gaskell, and Dana Hoey? For two reasons. The status of the document as a fictive construction does not reside in the nature of the image but in the assumption of what lies beyond. If Wall's work is a fiction, it is only because of the assumption that "real" conditions have escaped it. But our lessons in the simulacral hyperreal have long established the futility of such binarisms. The role of representation within the image-saturated mediated condition has replaced the distinctions on which real and image were opposed. But categories of photographic realism, quaintly enough, continued their own dependence on such oppositions, and genre distinctions such as documentary or fiction indicate that persistent belief.

Thus many claims have been made for granting Wall's work privileged status as "other" than the stuff of daily culture industry production on the grounds that his work shows the fiction of the real in documentary form. But does it? Here the digitally scanned images erode the lines on which such an argument holds its boundaries intact. For digital files and displays undermine the very point of opposition—fictive/actual—on which Wall depends for his distinction. That opposition was always grounded in a belief in some absolute basis on which a dubious and authentic document could be distinguished. That basis no longer exists, if it ever did. And Wall shows that fact through the mimicry of "actuality." In so doing, the very gesture he thinks guarantees his art distinction collapses the dividing line of fine and other images. For if Wall's are dubious documents, they are never so much so as those that circulate under the masque of elaborate fictions (commercial, entertainment images) and authentic truths (news, etc.).

So how are we to imagine, even for an instant, that the fine art image has a special status?

Walls's work depended on reifying a concept of the real outside of representation against which his fictions could register as art. Patton demonstrates that even when the "real" comes flat up against the very face of its own image, the work of art is practically a Lucretian skin peeled off the very object itself, very very close, but still, a surrogate. A reassessment of the assumed positivist underpinnings of photography have been reinforced in discussion of digital artifacts. Photography might still have a capacity to reify the concept of the real on terms that correspond with its particular proper-

ties of representation. But such attitudes recognize the artifact, not revealed social relations, as the central fact of the images. Wall's preexisting social relations aren't any more of a pure presence available for truthful or fictive representation than sausage on a scanner. And the languages of simulation, for all their self-conscious admission of the absence of reference within the field of the real, were never as effective in breaking that relation of visual identity as the blunt effect of scanning digital files has been in undercutting photographic truth values right at the point of production. The document, any document, always stands in dubious relation to that assumption.

The photographic document contributes to an ongoing mythic system of belief through which the notion of real is itself continually reified. But such attention distracts from the fact that these are created works, mere (or sheer) artifice. Thus one level of "dubiousness" feeds on the crossover from fine art's engagement with the critical theory of realism to that of digital imagery and the issues it brings into the discussion. Another doubtful aspect calls attention to the way imagery crosses the lines from commercial and industry photographs to that of fine art and to the impossibility of sustaining a distinct line between them as image. Other dubious documents—Hoey's and Gaskell's—call into question distinctions between amateur, entertainment, and fine art images. The critical claims asserted for high art serve their own mediating function. The belief systems within which images circulate constitute their value as much as their optical or visual information. The myths these discourses produce vary according to the interests they serve. Even the "naturalized" condition in which we accept the distinction between fine art and other images has its source in such constructions.

10. New Aestheticism and Media Culture

Warren Neidich's photographs comment on media events. They expose the way experience is mediated through the complex apparatus of contemporary culture industries. In addition, they engage self-consciously with the history of photographic precepts that come from fine art, conceptual, and documentary traditions. These images argue for a formal dialogue with culture and art history and for a new aestheticism as a basis on which to discuss the relation of fine art images to mainstream culture. But the only way to understand the assertion of a "new" aestheticism is to place it in the context of older precedents. In Neidich's case, that requires attention to the specifics

of photographic traditions as well as to the features of engagement and affirmation that position his work within artistic practices in the late 1990s and 2000s.

Neidich sees his work in a postmodern frame, following the historical lineage laid out by Hal Foster and others.[63] That sequence describes a first wave of postmodernism that broke with high modernism's focus on formal properties of media, a second wave that occurred with theoretically inspired work of the 1980s, and a third, more recent, wave in which the artist functions as cultural critic or "anthropologist."[64] Neidich sees himself in this final role. But is this accurate? The cultural critic posited by Foster retains the distanced stance of modern and postmodern aesthetic negativity. However, Neidich's work suggest a complicity—not so much with the values of mainstream culture and the entertainment and media industries as instead with the *enjoyment* these provide. Such observations return us to question the way a new formalism raises issues of reflective engagement through its manifestations. This apparent contradiction between an attitude of critical disjunction and one of positive interaction with mass culture is sustained in Neidich's work. His visual approach argues for a subjectivity that distances itself from mainstream values and provides a point of view rooted in the real and mythic idea of individual artistic perspective. But he also makes use of the complicit pleasure that saturates media production values. The powerfully present tension between these two elements (disjunction and engagement) in Neidich's photographs foregrounds visual form as aesthetic argument in contemporary art. This extends the arguments I'm making for sculptural work, painting, hybrid media artifacts, installation and video work, and digital art and the way these work out an admitted, self-conscious relation to the culture industry through similar reinvestments in aesthetics.

Center stage in the discussion of aesthetics in the last few years was an argument put forth ardently by Dave Hickey. At the beginning of the 1990s, Hickey's pronouncement that "beauty" was to be the overriding concern of the decade resonated through an art world that took up his charge with varied agendas. To the visually starved, theory-weary audiences for whom the 1980s had been a decade of mixed difficulties, the very idea of "beauty" was a welcome, if insidious, relief. The critically overdetermined new conceptualisms of Barbara Kruger, Sherrie Levine, Richard Prince, and other artists

had prepared the ground for this backlash. Receptivity to Hickey's notion was accompanied with a certain smugness and satisfaction at seeing the theory cart overturned in the name of something reassuringly old-fashioned and familiar.

But the very familiarity of the term "beauty" belied the complexity of concepts—and art political agendas—that it concealed. For whose beauty were we to take as the standard? Whose aesthetic investment was to be used as a measure against which new forms might be assessed? In *The Invisible Dragon*, Hickey dismissed this question as irrelevant, intent as he was on resurrecting the potency of visual persuasion.[65] Hickey succeeded by elegant argument. He made comparisons, for example, between images by Mapplethorpe and Caravaggio, using the seductive idea of a regime of aesthetic submission that carries sexual as well as artistic overtones. By selecting such canonical and highly aesthetic works to demonstrate the power of images to engage the viewer in a ritual surrounding the "arrested moment" enacted therein, Hickey was able to campaign for the salvific capacity of "beauty" to resurrect the old notion of the "transcendent" value of fine art. Beauty was not an index to circumstances of cultural production, in Hickey's argument, but a way out of context in the name of aesthetic form. A clever approach to theory-bashing, Hickey's work undercut political correctness through indirect means, never mentioning identity politics agendas but sidestepping them entirely with a retro-conservative position that appealed by appearing to be above the fray of art world culture wars. The aesthetic sensibility that Hickey prescribes is strictly formalist, a stripped-bare closing of the circle of art into itself as a field of reference.

But the aestheticism that we find in Neidich is quite at odds with the "beauty" promoted by Hickey. Neidich's aestheticism can't be cast into an old-fashioned formalism. His is not a retro-gesture, a claim to ideal beauty through the purity of form or out of history through a transcendent image. In this regard he joins those artists of recent years for whom formal properties have become again an invested instrument of communicative efficacy. I would hesitate to cast all of 1980s postmodernism into a completely unaesthetic category, though the "anti-aesthetic" announced in Hal Foster's anthology of that title of 1983 indicates the attitudes of New York–style postmodernism that were birthed under its shadow.[66] Emphatically true, however, is that in the critical climate of the 1980s and culminating in debates

around the 1993 Biennial, appreciation was never articulated as a formally based enterprise, thus supporting the sense that artists' work led with issues and ideas rather than through a materially based rhetoric.

A substantive change occurred through the course of the 1990s. Formal values were given a serious charge to carry meaning through the capacity of material to communicate semiotically *and sensually*. The new aestheticism is a formalism informed by conceptual art, critical theory, identity politics, and the satisfactions of studio practice in dialogue with media culture. In other words, this is not a revival of modernist formalism with its belief in the inherent properties or purity of media. Neidich's work exemplifies the hybrid integration of these once utterly distinct, even antithetical lineages, an integration that prevails across the broader field of art production in recent years.

Placing Neidich properly within the history of contemporary art requires a sketch of photographic practice fraught with historically charged concerns, each of which has its own relation to aesthetic properties. The Camp O.J. series produced at the end of his cross-country, Kerouac-inspired, mythically heroic journey (according to the narrative supplied by the artist), is composed of large-scale color images of the media camp struck up around the O.J. Simpson trial (fig. 21).[67] The title of the series alludes to the central reason for the existence of the site and its appurtenances, but nothing in the images refers to the trial or its issues in any significant way. This could be a media encampment for a presidential race, a royal wedding, or any of the other incidents that are daily fodder for the broadcast industry. Since the mediation apparatus, not the event, is Neidich's subject, this is part of the point. O.J. is very far off camera in the series, which makes sense.

The thematic obliqueness is matched in formal characteristics of the photographs whose aesthetic precepts violate the standard conventions of fine photography. Such systematic violations are very old news, of course. The lack of focal emphasis, absence of hierarchical distinctions, fragmentation of the scene, use of framing that is neither snapshot incidental nor fine art fetishized, disregard for the protocols of photographic production with no absolutely clear undermining of them, a sense of the documentary impulse but without any statement of principles or editorial position—the list of traits could go on. But they are used in Neidich's situation with a very self-conscious sense of their history (and their cognitive effect—Neidich's interest in vision and brain function is a developed part of his approach to

21 Warren Neidich, *Vanishing Point*, part of the series Camp O.J., 2000, photograph. Courtesy of the artist.

image production).[68] Yes, he seems to be saying, all of this has been done and will be done. In doing it himself he is not claiming invention or transgressive violation of the terms of aesthetics. Rather, he acknowledges that since those transgressions are now part of the stock-in-trade of photographic practice, they are themselves highly coded aesthetic gestures. From the moment of its invention in the early nineteenth century, fine art photography's bid to "art" status depended on the elaboration of a set of legitimizing aesthetic conventions (a capacity to demonstrate its formal and expressive values). But the history of photography *since* its acceptance as fine art in the twentieth century was characterized by the same kind of medium-specific self-consciousness that occupied other "modern" art. The elaborate taking apart of these conventions derives from a dialogue within that tradition of the "composed" versus the "found." Just as the fate of narrative within high modernism improves in the postmodern condition, so the implied narratives of Neidich's images engage the combined character of found and contrived work. Their allegiance to the "found" gives them their

documentary credentials. Their engaged contrivance allows them to self-consciously play with the frames and devices of postmodern artifice, made conspicuously, visibly, present. Even the use of the fish-eye lens, with its distorting gaze, calls attention to the fact that these are contrived photographs, not mere "documents" pretending to transparent record.

Many of Neidich's apparently anti-aesthetic features can be traced to conceptual art, which gave photography another kind of legitimacy as "document" of the "immaterial" acts and objects central to its rhetoric. The aesthetic force of conceptual art, its striking distinction between idea and artifact, became the basis on which fine art could presumably eliminate production values. The emphasis on "non-aesthetic" properties gave conceptual photography distinction. Three decades later, this position has been reintegrated with the suite of production tools available to an artist.[69] The necessity for an anti-aesthetic is not as stringently defended—or defensible—within the current cultural climate. We are weary of the empty, unconstructed image that pretends not to care about its visual appearance. Neidich's images contain that disregard as a posture, seeming not to give in to requirements of careful composition or traditional aesthetics—but at the same time they make every effort to fascinate through visual means.

The editorial point of view in these images demonstrates Neidich's participation in mediated culture. Neidich doesn't position himself outside or above the life he observes. His depiction of persons, for instance, the newscasters, camera crews, other technical and editorial members of media teams, is clearly without malice or grotesquerie. Neidich is not cynical, but he is critically concerned with how media fascination is produced. At the same time, he is careful to make use of those principles to attract and keep his viewers' attention. A photograph of a woman broadcaster, preparing herself for the camera, shows her at the moment of taking on the persona she projects through the media. Her body is awkward, almost not her own. Her costume is vivid, mall-bright, and her face and hair perfectly cosmeticized to read into the technological feed. Yet she is vitally present as an individual person whose job is to perform a role. Her presence splits between self and image, between embodied consciousness of the role she performs and the role itself, hanging on her like her outfit, and yet, less separable from her than those professionally coded clothes. A certain tragic tone attaches to this image, and the mood casts its pall through the series as a whole, showing that the process of producing "fascination" is a complex activity of

sleights and feints and duplicities performed with earnestness and distance, professionalism and ironic recognition in active, simultaneous contradiction.

Neidich cannot be simply pigeonholed within a single historical tradition, which also speaks to the contemporary condition of his aestheticism as a new formation rather than as a retrogressive gesture. His work makes use of the full history of effects, in a highly self-conscious manner, producing in the viewer an awareness of critical concerns as well as perceptual ones, all through properties of the images. For instance, the obvious "unconstructedness" of these images, the fragmented, ordered-disordered, apparently uncomposed and yet elaborately selected, produces a visual field that has to be pieced back together through a combination of looking and reading. Legible but not immediately apparent, the structured bits have a random "life captured unawares" aspect that is actually as artificially constructed as any tableau vivant.[70] The prints are saturated, rich with embedded color. But for all their large scale, they are not fetishized, deep-focus detailed works, and they flaunt their allegiance to a fast-moving, on-the-fly, journalistic mode with a deliberate disregard for either fine art quality or documentary craft. Taken in sum, the aesthetic characteristics of these photos are a series of sidesteps that jump off and away from quite recognizable points of tradition.

The notion of laying bare *any* device whatsoever carries with it the echoes of early twentieth-century avant-garde practices whose earnest naiveté was suffused with belief in the possibility of revealing the mechanisms of illusion in order to raise political consciousness through aesthetic means. The current condition of media saturation, of image glut and visual overstimulation, denies us the luxury of such easy critical operations. We cannot simply "take apart" an image, any image, or work of art to show that its conceits are merely a means of deception. The structures of engagement are too complex in current (or indeed, in any) culture. The means of elaborate production involve us through already internalized spectacular experience. We are so inhabited by the images of media life and so complicit with their fascination that taking them apart would serve very little function. How does one undo the image according to which the very terms of self and culture are constructed? An impossible task, like perceiving oneself as whole from within the embodied mind. We are fully interpolated subjects. The deconstruction of the spectacle in many ways just reinforces our subjective and

complicated relation to its many layered, interlocking systems. In it, and of it, we are mediated creatures in our early millennial lives. Neidich's images show this, claiming along the way in his particular vocabulary of scientific, neurobiological critical parlance, that this is a feature of the cultured brain in its specific historical moment. Rather than ignore the potency of mediation, Neidich intends to engage its affirmative capacity, its ability to seduce us through consumable sensation.

Thus the avant-garde, with its resolutely critical stance and distancing mechanisms of image production and execution, is only a residual specter as it appears in Neidich's lens. This is a quoted avant-garde, a citation and reference, not a living, pulsing presence in real form. As a quotation, it marks our distance from the historical moment of its appearance on the artistic stage and to give us purchase on the distance from that point of origin. Neidich's rhetoric embraces Foster's reinvented version of the avant-garde artist, that savvy cultural critic. But the addictive capacity of media productions translates into his own visual work. A fascination in looking at the process of production permeates his photographs, and though the production values they embody are far from those of mainstream media, they are not antithetical to it. Quite the contrary, if Neidich quotes the avant-garde and its stance of critical interrogation, he also quotes and participates in the look of trendy publications whose photographs are produced for entertainment value within the mainstream zones of spectacular consumption. The glitz and celebritization, the exploitative voyeurism and journalistic assertion into realms usually left invisible, unrecorded, are all present. Neidich is playing paparazzi freelancer, professional with bulbs flashing and an entrepreneurial instinct, seeking out events on which to feed his appetite for anything that can be transformed into a photograph for sale. The images are not "life taken unawares" but rather life made aware in order to participate in the world of media and mediated images. Living to be image, the media subjects of Camp O.J. are well suited to such an approach.

Neidich's Camp O.J. series also shows us the world in which "image" is always being produced and put into circulation, but the angle through which Neidich looks at that world inflects his images with a gratification that wasn't allowed within a postmodern photographic canon. Neidich knows that his images are framed by the voyeuristic obsessions that the media produced and fostered around the O.J. incident. By not showing the chief protagonists of the tale and focusing instead on the mediating structures

through which the event of the trial is produced for spectacular consumption, Neidich participates obliquely in the same system that he is slightly to the side of. These images could be (and have been) published in a photo-essay in a mainstream lifestyles magazine. They could be—and are—also shown in galleries and museums. In this era of fine art fashion, the slick products of a Richard Avedon have claimed space on the museum and gallery walls. The glamour industry's inroads into the citadel of fine art may stir protests in certain quarters, but Neidich doesn't shy away from this compromise. His "art" production, occurs in a variety of sites. This distinguishes him from those photographers who do commercial work as a "day job" but preserve their "own" creativity for fine art. His work also moves away from the affectless stance of canonical postmodernism (Levine, Prince, Kruger) emblematic of the "already produced" image-in-circulation sensibility. Like these postmodern artists, Neidich clearly has a sense of mission. Art has something to do, something it can do, and that only it can do. What has changed is that this mission may no longer be fulfilled by opposition. Quite the contrary. The most subversive act that fine art can currently perform may well be to show its own complicity with mainstream culture.

Fine art photographs provide a specifically *aesthetic* form of mediation. To do this, of course, they must be aesthetic objects. They demonstrate that subjective affectivity can be inscribed within an image. By showing that possibility they appear to preserve the last vestige of a romantic sensibility in which the artist is the lone voice, the individual talent. After all, Neidich chose that quintessential late-romantic on-the-road outsider Jack Kerouac as his mythologized model. Doesn't that put Neidich right back into the stereotype of the artist-hero, alienated in his own individualism?

Yes and no. Neidich's series positions itself not simply in relation to fine art but also in relation to media and the experience of existence mediated through images. The struggle the fine art artist faces is to find a formal vocabulary through which to be distinct from mass culture while competing with it. How does one engage the viewer outside of mass media while acknowledging the fully colonized condition of all imagery? Perhaps very simply, by making artifacts out of that experience, ephemeral testimonials to its having passed through us. Contemporary existence is fully mediated, and through all the systems described by critical opponents of the culture industry. Fine art imagery, such as Neidich's, occupies only a tiny, rarified, endangered zone in visual culture. Any functionality that attends to such

imagery, besides the immediate insight to the viewer, comes through the set-aside to-be-seen aspect of its identity so that it can—as it does here—show us something. That it shows us the backstage of the culture industry is hardly a surprise. What else is there to deconstruct? To interrogate? To take apart and put before an audience? These gestures are not simply an imitation of the visual culture production system, they are also part of the culture's self-conscious reflection upon itself.

Mediation as a social process is crucial to the artist's work, an object of fascination not only as an image, but as a process of image production. Media trump fine art, they overwhelm it. The aesthetic force of these images is not what they depict, but their demonstration of the way mediation can itself be captured as an image and then cast back into the culture as a momentarily reflective frame. These photographs affirm the seductions of mass-produced imagery and spectacle. They acknowledge the mutual dialogue of fine art and the rest of visual culture. The aesthetic of fine art is not "other" than that of mainstream culture but exists as a space within it.

11. Techno-bodies and Art Culture

Contemporary artworks give evidence of an increasingly anxious discourse played out in displacements, extensions, or relations to a supposedly "real" body.[71] The anxiety expressed in such works exposes contemporary concerns in a telling way. To get a purchase on this work, a glance at the technologized body in popular culture provides a useful foil. The images of the techno-body in art are in many ways responses to these popular notions.

For instance, contrast the body implied by the space suit and the one implicated in the virtual reality device. A space suit embodies the older technology of modern rationality, while the virtual reality machine is a disembodiment that represents the new technology of the so-called postmodern hyperreal. The space suit—like its counterparts, the diving bell and aqualung—is a Jules Verne-esque piece of ancient, cumbersome, technological hardware designed to preserve all too vulnerable flesh in a hostile or foreign environment. By externalizing all of the body's functions—breathing, eating, elimination of waste—and encapsulating the organism in a sealed, self-sufficient mechanism, the suit sustains life through isolation and enclosure. As an image, the space suit is encumbered with history, resonating with old, industrial technology that extends human experience through

clumsy, physical means. But it also foreshadows a terrifying future, one in which only economic privilege will provide access to survival technology.

In striking counterpoint, the virtual reality machine—with its masks, gloves, in some cases even a genital sheath—is a "dis"-embodying apparatus that produces an experience of space, time, and place without the actual involvement of the flesh. The virtual experience bypasses the actual condition of the flesh, tricks the surface sensors, providing a perceptual deception through the very means the organism normally makes use of for survival. The body is reduced to its capacity to process simulacral stimuli through the neural networks in order to create sensation in the brain—rather than to assess the threats, dangers, or conditions present in its environment. The body becomes a site for artificial production and consumption of sensation for its own sake.

In both cases a body is implied rather than explicitly represented. The empty suit and the unoccupied machine both echo the morphological form of the body. Even more, they describe a site for its disciplined existence, its restraint, and its subjugation to controls that limit movement, access, and contact with the world. The body completes these machines and the machines complete the body—preserving, stimulating, satisfying its real and phantasmatic needs. This imagined body is not linked to a unique identity nor to a specific individual or particular body. This body is "next" to the real body, a space that a real body—any real body—may inhabit. They have highly specified parameters of scale, size, and functional relations to a real body but have nothing whatsoever to do with individual identity in any sense. In addition, because of their futuristic morphology, many of these artworks—like the image of the space suit and virtual reality apparatus—also suggest a body that may come "next" in the order of things, a body whose flesh is inadequate for survival or sensation without the prosthetic or protection devices of this elaborate technology.

The morphology of Daniella Dooling's Breathing Space: Outerwear is that of protective survival gear (fig. 22). The suits bear the marks of disaster as an event that has already occurred, melting, staining, disfiguring the pristine apparatus with the slime, muck, ooze of a future apocalypse. Dooling's work invokes those dark environments forecasted for some imminent yet still deferred future in which the body, a body—one that is not a specific, identified, or even necessarily real body—is imagined to exist at the center of the piece.

By contrast, the work of Roxy Paine does not, literally, make a site for the

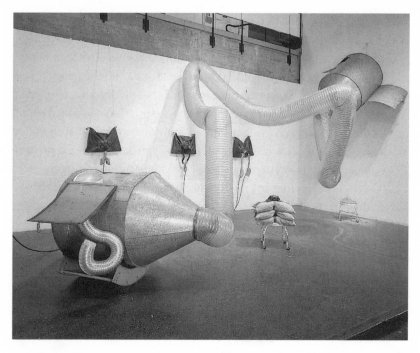

22 Daniella Dooling, *Outerwear* (*Breathing Space*, detail), 1991, installation in mixed media. Courtesy of the artist.

body, but extends it into the familiar realm of machinic metaphor. In a piece titled *Lusts* (fig. 23), a machine, an apparatus, exists in unbalanced tension between fluids, pumps, and equipment all struggling for an unachievable equilibrium in the emotional life of the machine, the mechanical reproduction of libidinal drives. Here the "figure" of the body is indeed a corporal trope, a transformation into other terms, in this case, objects that represent the body only by extensions—or by displacement. In Paine's work the body has become a machine, fully displaced, replaced, but without even the satisfying image of the robotic form, the android, or the cyborg to mirror the human form from which it took its original inspiration. This machine is very explicitly what Gilles Deleuze and Félix Guattari termed a "desiring machine"—a machine that cathects libidinal energy—though here functioning only in a grotesque appropriation of this energy, dispersing it into the apparatus of capital, not returning it to any experience of love, pleasure, or even human pain.[72] *Lusts* is an image of the fulfillment of an antihumanist

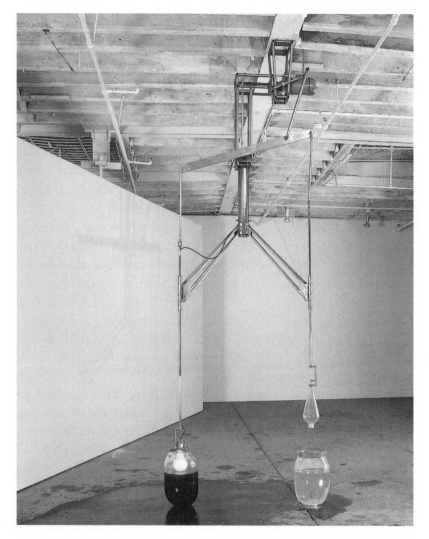

23 Roxy Paine, *Lusts*, 1992, glass, water, light bulb, steel, motor oil, 120″ × 84″ × 30″. Courtesy James Cohan Gallery.

agenda, one in which the fantasy of individual life has been fully replaced by an efficient function.

This piece suggests a laboratory of new sensation, the licensed arena of invention (and I mean the commercial implication of the term "licensed" to be felt here), unfettered and unchecked—in which the nightmarish lurks but need not be overt or even inevitable or forthcoming. Its systematicity is

not functional. Rather, it elaborates in fetishistic form the varieties of means for the organization of sensation, life support, into a traffic of flows, controls, regulations, and devices. To quote Marshall McLuhan from his *Understanding Media* (1964), "Emergent technologies suggest compelling reasons for the flow of goods and services to be directed elsewhere in a continuing series of diversionary tactics."[73] And each transaction enters the economic as well as libidinal flow.

The elaborateness of Paine's apparatus suggests a purpose to the continual diversions that, in turn, permit the very elaboration itself to be justified in a manner that suggests an excessive administration or bureaucracy for the managing of resources. In its hybrid intersection of industrialized apparatus and the human form, the machine renders human functions efficient, playing with the sexualized energy of the efficient pistons and parts, interlocking in ineluctable movements of repetition and reproduction. The result is not an eroticization of the machine, rather, an interpenetration of the technological and erotic into a new synthesis of mutual definition and seductive engagement. The acts of erotic play suggest a correspondence between supposedly human operations (emotions such as "lust") and repetitive actions associated with the mechanical domain. Here they are made equivalent and interchangeable.

These contemporary images invoke a simulated body in a theatrical scenario (a threatened body), and a metaphoric displacement of the body into the structure and operations of an apparatus. The "next" body has little or nothing to do with the body—or bodies—of modernism—though it is already present within modernism as a phantom, a flicker, a glimmer, hinting at what will come "next."

Within modernism "the body" functioned as an instrument of authorship, site of subjectivity, and sign of authentic experience. The preservation of the notion of "touch" as a legitimating distinction between artistic and industrial modes of production allowed for the "art" object to differentiate itself on a fundamental level of "making" from that of mass-produced object.[74] The concept of artistic work was of course also linked to the myths of special (as well as specialized) skill, as in the notions of the masterly "touch" or the "marks" of genius—the infallible eye of Matisse, hand of Picasso, or signature strokes of van Gogh. Such mythology was self-consciously critiqued as part of the modern project as well, most conspicuously in the work of Duchamp, but also in such hyperbolic gestures as

Robert Motherwell's painting of his last name scrawled as a signature across a large, otherwise blank, canvas.[75] From the moment at which Jackson Pollock distanced himself spatially from the canvas, moving beyond the limits of touch and reach, the notion of somatic trace expanded to include the gestural signs of a body's movement. Yves Klein's anthropometric manipulations of "other" bodies marked the canvas as "his" painting. Helen Frankenthaler's so-called "feminine" stains extend this somatic authenticity to metaphor.

But all of these are gestures implying the authorial body as the "origin" of the marks, whether they were produced as a direct result of the artist's hand or simply as a manifestation of "artistic vision." Even a contemporary work like Janine Antoni's gnawed blocks of chocolate are sculptural extensions of this kind of somatically authentic "artistic" production. "Touch" is now much bracketed, much qualified and self-conscious as a quotation of the conventions of an early modern tradition of artistry. But gestures like Antoni's assert, almost defiantly—as if in opposition to the nostalgic stigma they bear—the desire to preserve a certain notion of lyrical subjectivity in the face of the postmodern deconstruction of the old humanist concept.[76] And the techno-body that comes under aesthetic scrutiny perhaps reflects anxieties circulating elsewhere in a culture in which organ replacement, mechanical parts, and somatic boundaries are elements in a discourse intimately bound to media and its possibilities. Clearly the connections between human and artistic, body and creativity, technology and media, are all elements in this aesthetic zone.

Of course twentieth-century art is filled with work that dismissed or called into question the whole notion of the "genius touch" in artistic work from the readymade to the fabricated piece to the appropriated object. Minimalist artists fully, successfully repressed the signs and traces of the body within that same historical moment (the late 1960s and early 1970s) that the performed body of the artist came increasingly to the fore. The work of Carolee Schneeman, Robert Morris, Ana Mendieta, Vito Acconci, the Viennese Action Theater, and others asserted physical and somatic presence as the object and instrument of art. Mary Kelly pointed out that this concept of "the body" transformed the idea of the somatic trace by shrinking the extended hand, arm, eye, back into the literal skin of the artist, making the artist's own body both the site and the subject of the work of art.[77] In such practices the artist uses his or her body as indisputably authentic—whether

as locus of pain or pleasure; instrument of display; object of repulsion, abuse, or contest and struggle; or as the ultimate referent in the construction and play of gendered, ethnic, or cultural identity (for example, in the performances of Gina Pane or James Luna).

In these practices the body is granted a very different status from that granted to the psyche. The body is considered an intact, autonomous referent, one whose identity is guaranteeable *outside* of the strategies of construction. By contrast, the basic perception of self-identity in psychic terms is staged as a continual process of *misrecognition*. This artificial separation between the two—body and psyche—and the attribution of distinct, even opposed, notions of identity to them is one of the more perverse fictions of modernism's (and postmodernism's) visual rhetoric. After all, bodies are no more "real" or "authentic" or self-identical than any other symbolic construction.[78]

The contemporary notion of the "next" body has little in common with these two mainstream modern bodies. It is neither the authenticating body of the artist, nor is it the performed, performing, performative body visibly, literally present. As in the distinctions between the work of Daniella Dooling and that of Roxy Paine, this "next" body is a body produced through processes of displacement or extension, discourses that suggest a "body" at their center, without making use of a visible or literal body. Their pieces challenge the pursuit of the ever-intensifying search for "authenticity" as it is staged in a return to the "real" body. Because they invoke a "discourse of the body" through objects, situations, and devices—displacements, relations, and extensions—they demonstrate that though the body itself may be "real" its claims to an indisputable authenticity are not: an important distinction. Rather than repeat the desperate attempt to guarantee authenticity through the reduction of artistic expression to a genuine body, these works do away with any essentializing claims to individuated identity that could be supported by recourse to a physical site of origin.

In these peculiar techno-bodies, a space is made. Into this opening a specific person/body could enter. But because this is always a surrogate, equally replaceable by another body, it is emphatically not authenticated by the work. And more importantly, the work is not authenticated by the body. Instead, in a piece like *Lusts*, objects serve a constitutive function, providing an illusion of the body in a displaced, extended, or relational way. A "body" is produced as a mirror effect of display or consumption, as a cultural pro-

duction, an object among objects. All the parts of Paine's Lusts machine refer and relate to human bodies through metaphor or mimicry (of action). But "real" bodies remain an absent locus of experience. The "next" body reintegrates the original somatic uncertainty of identity into the psychic operations of subject production. Because it is imagined, the techno-body can't be contrasted with a "real" or "authentic" somatic point of origin for art production or lived experience. Instead, it seems to conjure a threat of fear, a concern for physical safety, or other conspicuous anxiety. Even the title of Daniella Dooling's elaborate Breathing Space suggests the body as a "space" to be controlled, manipulated, engineered, rather than as a single site to be preserved and contained. Markedly dystopic, her installation consisted of a series of survival stations, places where someone could hook into a network of tubing linked to a huge externalized lung machine. More cumbersome even than the old portable apparatuses of aqualung and space suit, the breathing space creates a sinister condition of constraint and dependency. This technologized body raises the specter of dystopic conditions. Breathing Space is a negative vision of either an imminent future or an already present condition in which survival depends on the machine. The overtly dystopic anxiety played out in Breathing Space displays fears in a manageable fantasy, that is, a fantasy that leads to managerial solutions, something administered.

Work extending the motor apparatuses of the body or making a prophylatic extension through mechanical or technical means has a long history in mechanical devices, and these show up regularly within the aesthetics of modernism. A more recent development is the extension of the sensory tools of the body through a technological device. For instance, in Alan Rath's Hound (fig. 24) a small, mobile cart reminiscent of children's playthings is attached to two monitors by means of two long, flexible, fantastic, and whimsical tubes.[79] The monitors display noses—human noses—that embody the keen sense of smell for which the "hound" is renowned. The duplication of this smelling function by the use of two monitors emphasizes their hopeless inability to perform the function they visually represent. The sensory body is replaced by its image, extended through a simulation that cannot perform "real" functions—this is a "simulacral" "next" body—one whose specialized sense organs have been replaced, rechanneled, redirected through a technological mediation that negates all possibility of the sensory reality of the lived body. Rath's work is funny, but darkly so, characterized by

24 Alan Rath, *Hound*, 1990, mixed media video sculpture. Courtesy of the artist.

an ironic futility. If the "next" body relies on such technological enhancements, Rath suggests, it may defeat its own purposes and functional operation. Anthropomorphism is not humanity, nor is it quite its other; it is the "almost" other, deformed, transformed, just beyond exact recognition.

The conclusions to be drawn from contemporary work like Paine's *Lust* machine, Dooling's breathing apparatus, and Rath's *Hound* are historical and critical. In historical terms, a strong contrast can be drawn between this work and part of the modern "machine" aesthetic. Picabia's mecanomorphs or the mechanized bodies of Leger fragmented human forms as a reflection of either enchantment or disenchantment with industrial production and its physical, social, and cultural effects. The techno-body does not suggest an intact, original "whole" fractured through its encounter with the mechanics of industry. Instead, this recognition of an a priori fragmentation realizes that the "next" body is one constituted only across the dispersed discourses of objects, commodities, apparatuses, or spaces as an aspect of subjectivity. This fragmentation cannot be refuted by a return to some original, essential, or authenticating "real" body—because it is a frag-

mentation of subjectivity, not a fragmentation of form. As a consequence, no authentic, intact, "identity" can emerge as the legitimate identity against which the fiction of the "next" is challenged. And here, the critical point of historical distinction lies in the contrast between the modern bodies of signed, indexical, or performed authenticity, and the contemporary works that compose, delimit an absent body as an aspect of subject production.

The contemporary works that articulate the implied body, stripped of identity, whose fragile physical survival is threatened, often contain a scenario of repressive terror. Dooling contributes a vague image of apocalypse in which a fantasy of a body whose capacities are transformed is mutated through technology. This work displays a profound anxiety about the intersection of desire, fear, and flesh. But this technophobia is not the only form of anxiety on display here. Another anxiety exists about the location of the body within a network of objects. Such work suggests that the sustainable fiction of identity is produced in a discourse of objects (clothes, accessories, theatrical situations staged through things). A relation between the technophobic anxiety on the one hand and an anxious production of identity through consumption on the other is manifest in these works, all of which participate in this elaboration of the "next" body.

This relation is to be found in the way the mythic identity of the artist as individual, unique, highly differentiated, autonomous, and apart from the norm/conventions of her/his culture still functions as one of the fundamental myths of our current culture. Many contemporary works offer a challenge to the entrenched concept of artistic authenticity as it is interwoven through the various trajectories of modern art. But much of this work is farther and farther from providing the reassuring fiction of identity as such. If anything, it shows that the mythic fetishization of identity cannot be authenticated by the assertion of the body as an essential, irrefutable site of truth, pain, or pleasure.

Looking for a face, one is confronted with a machine. Looking for a body, one is offered an apparatus. Looking for a sex, one finds only a device. These are indeed all "desiring machines." Libidinal urges and erotic drives are subjected to technological operations industrial to electronic, productive to informational. But in no case is a graven image of a self, a uniquely identified self, providing the reassuring fiction of identity. Instead, a continual displacement moves from position to position, from space to space, always to the "next" body in an attempt to find one's own—which appears only as an

absent site, space, position charged with threats of mutation, mutilation, or transformation. Identity becomes an impossible fiction—replaced by a process of consumption and exhaustion, disposal and waste, distribution and exchange, and the body, rather than offering a reassuring counterpoint to the disturbing elusiveness of subject production, participates in its sleights, feints, and processes of continual misrecognition.

What looms on the horizon is a fantasy/anxiety dream of the body transformed by technology and consumption, one in which the very physical locus of sensation is reconceptualized as dispersed, rhizomatic, extensive, displaced from its containment within the literal boundaries of the skin.[80] This is not to say that the flesh dissolves, melts, or disappears. But the constitutive function of flesh as the material support of the myth of wholeness and identity transforms as sight, hearing, touch, and eventually also, perhaps, smell and taste, become functions of the neural processing center rather than physically located receptors. Sensate perceptors extend the physiological soma through technological means transcending the geographical limitations of the actual body. That somatic wholeness as an identity was always mythic hardly matters as its dissolution becomes intensified and increasingly evident.

To cite McLuhan again: "In the electric age we wear all humankind as our skin."[81] We can now paraphrase this as, in the polluted age all human skin is worn as an electric apparatus, or surgically replaced as diversionary entertainment. A communicative surface, sensitized to receive and transmit the broadcast messages of an infinite entertainment network. The fragmented body as a ganglia, a nexus/clump in a global matrix getting its illusion fix. Another recurring theme in *Understanding Media* is the idea of technology as an extension of the human nervous system. McLuhan perceived many implosions of the time/space continuum brought about by technological changes in communication so that new patterns of mechanized repetition and standardization colonized the interior life as well as determined social form. But then, at one moment, he suggests that quite possibly human beings are merely "the reproductive organ of the technological world."[82] Terrifying? Maybe. But maybe just a useful insight. DNA makes and uses us, not the other way around. Code dominates. Code storage in hot media. The flesh is a useful vehicle. Is it necessary or expendable? No moral arbitration, only use, takes place at the level of the somatic. Fears are the fears of an egocentric subjectivity. But this plays out in stress and violence in

a societal hierarchy in which control of resources and power are conflictually determined and limited.

What, then, is the connection among all these things, and what are the cultural implications of such artistic activity? In whose interests is such work produced? To what ends? The simplest of questions. The hardest of answers. The very concept of the authentic body was and is an essential component of the myths of individualism, autonomy, romantic love, and the nuclear family—all of which are central features of modern life. Works like Lusts, Breathing Space, and Hound obfuscate, to some extent, what is real about those bodies in the name of some mythic idea of authenticity.

Current representations of anxiety about the body in relation to new technology have surfaced in the work of visual artists, only some of whom are using digital or electronic media. These artists are exploring what we might call a phantasmatic imaginary realm filled with fearful curiosity about hybridity, mutation, technointervention, metaorganisms, psycho-prostheses, machinic interfaces, and tropes of an altered somatic condition.

As motifs for this argument, two other popular culture images come to mind: one of a brain kept alive in the chemical bath through attachment to an elaborate electrical/technological apparatus, and the other of a chip attached to the cockroach brain stem, using the motor capability of the insect to ambulate according to a program directed by remote control. Powerless human intelligence, sentient, and trapped, versus a mobile unit with no sense of its mission or use (the machinic mind attached to a somatic lifeform). These are classic grade-B sci-fi film images, as familiar as Frankenstein's monster with its patched flesh coming to life in an electric storm in which the forces of nature hybridize with the whims/intentions/agendas of culture.

The "truth" of the body, like other "truths," it turns out, can best be understood through the elaborations of the fictions of production according to which it functions. What these works of the techno-body demonstrate is the extent to which the various discourses of identity, eroticization, sociality, and power make themselves evident in and through objects. The image of the body in these works becomes more and more fractured and fragmented—as in the senses of Rath or the clothing of Dooling. Bodies are produced, not given. This work suggests ever clearer realizations of the ways the body is produced through technological means: between the exoskeletal flesh–preserving mechanism of the space suit (in which the body

is objectified, reified, in its productive functions) and the interior-oriented, flesh-denying technology of the virtual (in which the body functions as consumer of sensations). Whether or not the "next" generation of bodies is the last generation of lived bodies, the techno-body will be produced in and through images and objects to assure the individual identity of subject. As such, this work promotes and legitimates consumption—both as an instrument of self-definition and as a tool of self-preservation where the physical "body" being preserved is perceived as "authentic" in defiant denial of the knowledge that its authenticity is a fictive production. We can no longer support the delusional identity of subjectivity through reference to a "real" body. Instead, we are now experiencing the "next" body, a body constructed through various displacements, extensions, and relations.

12. Commodified and Mediated Identities

The machinic fantasies of techno-extension reach an ad absurdum extreme in Alan Rath's Hound (1990; fig. 24 above). But beyond the evident irony of replacing the sensitive organ of smell with the insensitive monitor, another lurking threat is made evident in the replacement of organic body parts with electronic equipment: the merchandizing aspect. Areas of life that were once merely lived now come increasingly to be available for a service fee—looking, listening, sexual activity, and touch are now able to be extended over distance and into the virtual as image, text, sound, and telepresence, paid for as experiences available for consumption. Marshall McLuhan wrote that if Archimedes were alive and looking for a fulcrum point of power, he would say: "I will stand on your eyes, your ears, your nerves, and your brain and the world will move in any tempo or pattern I chose."[83] McLuhan went on to note that we have leased all of these "places to stand" to private corporations. These days we can well imagine that a "nose" is lent by the Turner network, a nervous system is a franchise offered by Rupert Murdoch, and the brain is brought to you by Disney. With every step of increased techno-production comes a corollary increase, complicity, and dependence on the corporate supply system and sponsorship extortion network that will, inevitably, come to lease us our dependence. The artists dealing with the replacement or modification of the physical form of flesh, are raising questions relevant to the ways identity, privacy, and traditional boundaries of private body and marketable zones are being challenged by medicine and

cosmetology. The limits of the possible may or may not define the limits of what is necessary, desirable, elective, required, mandated, or controlled in the short and long term future.

McLuhan remarked that "[s]tyle is the working arm of the aesthetics industry, its applied arts." Clearly the technology inspires fantasies—nightmarish and not so nightmarish. Art expresses its anxiety about causes and effects, about the development of new hybrid conditions for experience, sensation, and form. But there is another anxiety that shadows the fantasy of corporeal transformation, an anxiety about production and consumption. Or maybe it would be more accurate to say, consumerism. Whose body is made of these parts? And what is the source, the brand? What is the role of art—to make a comment? or to produce an aesthetics of the new techno-body? If aesthetics has a function, is it only to render seductive and consumable the totalizing images and texts of the new unreal?

What is the structure of new culture? Is it totally foreign to the old humanistically centered models? Or should they be revived and fought for in some new form? No simple binarism applies in an age of mutant somatic existence. We are techno-instruments, and technology, like capital, has its own will and force. We are used and consumed. Without question. Need it be without limit? The desire for fantasy is a desire for power. The vulnerable flesh is capable of being extended. Can it be transcended? In the face of the seductive potential of electronic form we have to decide, according to our own disposition and digital orientation, whether to give in to enthrallment as consumers of illusion or become skeptics testing that illusory reality in order to "unconceal" the terms of its production—or live with both simultaneously and the subsequent contradictions. The continual need to reconstitute a somatic locus of subjective identity compels our oscillation between belief in the authentic integrity of the *soma* and the equally seductive desire for an ever-renewed techno-produced illusion of mutating simulacra. The extent to which these ideas now intersect with new product lines in the marketplace of new illusions is another essential aspect of the rapidly emerging story.

Orlan and Stelarc are both highly entrepreneurial artists who use their bodies as a means of manipulating the public media spectacle. Their work is anathema to many fine artists, who consider the gratuitous acts of self-mutilation to which Orlan subjects herself or the mechanistic boy-with-toy machismo of Stelarc's extensions of his body to be mere novelty distractions

engineered precisely to garner attention. Whatever dismissive criticisms one wants to levy against the work of these two, they have achieved recognition and attention in the mainstream realm of contemporary art. Why this should be the case? What does the justification of the transformation of self into product for consumption and the fantasy extension of body into machine as art indicate about the current identity of art as a cultural practice?

The contrast between these two artists is curiously (but not surprisingly) coded along conventional gendered lines—woman and appearance, man and machine function. In each case, these are artists working through the publicity apparatus of mass culture as a part of their work—Stelarc in more esoteric electronic machinery, Orlan in the recording-to-transmission mode of video/television industry. Stelarc's evolution from endurance performer to robotic interface actor has always depended upon mediated representation. Thus media activity and effects are key to what he does, rather than secondary, surplus, considerations. But the work parallels or echoes the modes of mainstream spectacle activity—it is recorded, processed, and in some cases, actually produced through electronic media. But it is not produced only or directly for broadcast transmission.

Orlan's work is simulacral spectacle—it imitates the production apparatus and attitudes of mainstream media activity. The work is conceived with broadcast transmission in mind, and her self-narrated screenplay scenario of the operations she undergoes has a television talk-show quality. This is not "real" media—it is self-production as media making use in parodic (though serious) fashion of the means of mass culture.

The work of Cindy Sherman adds a third dimension to these two since her work has mutated through the specific media machinery of the art world, rather than using, echoing, or paralleling mainstream culture industry activity. Sherman's work demonstrates, yet again, the extent to which the art world *is* a culture industry, capable of similar effects and operations with respect to the distortion of individual identity into celebrity image and product.

Each of these figures (and many others whose work shares common features) demonstrates the interrelation of fine art and mass culture modes—not just media, but conceptualizations of identity as self-production at the level of bodily fantasy. The media culture aspect can't be separated from the fine art aspect, nor can one suggest that one is determining the other in a unidirectional drive for research, development, or appropriation.

"The body now performs best as its image," Stelarc writes in "Fractal Flesh."[84] One distinctive feature of his work is the interest in making an image of the interior of his body—from the nonvisible spaces of body cavities—stomach, esophagus, into which an optic probe can be inserted. Beginning in the 1970s, Stelarc produced a series of works that includes performances, some of which were major demonstrations of a certain machismo endurance. In such exercises, his work was consistent with certain body/performance works pushed toward a scientific, technological, machine-dependent (or device-dependent) sensibility. His robotic devices, most particularly the third arm, are part of his overall project to push the body's capabilities through the use of technological means. Stelarc's arena of activity has chiefly been international festivals of electronic art, and his work has a light-show, special-effects, road-warrior–meets–art-performance quality. As spectacle it is low-tech, in spite of the fact that as robotic transformation, takeover, and adaptation of human function, it is high-end. The means of the spectacle are not so much put to the production of images in imitation of the media mainstream as they are to extending the boundaries of image into domains of bodily activity hitherto unrepresented. This conjures the notion of spectacle as colonizing force, continually searching for new material to turn into consumable image. While the ostensible subject of Stelarc's work is robotics, one of its actual products is imagery that feeds the insatiable appetite of spectacle. In addition, the work glamorizes the idea of the prosthesis, removing the older, much-outmoded but uncomfortably persistent, stereotype of prosthetic devices as means of compensation for inadequate or damaged conditions. Stelarc's Third Hand conjures those images of braces and mechanical devices replacing lost limbs, but the aesthetic function confers an operational grace on the extended capability provided.

Though banal in iconography and formal values, Stelarc's photographs are high in novelty value, which endows them with greater interest than if they had been produced as images in their own right. The photographs of Hollow Body, for instance, are floodlit tunnels of red flesh spiraling off into interior darkness.[85] Read as images of a visual probe in Stelarc's living body, they become situated within a network of social negotiations of the body's boundaries. They are images that blur the reassuring distinctions of interior/exterior identification. The somatic fragmentation, which is surpassed by the original mirror-stage imago, has here regressed. The body has no "image" as a gestalt, as a fictive whole; rather, it is seen to be that partial,

sensate, and unimage-able, nonwhole *as an image*. This contradicts the entire developmental and psychological function of the image—as that which provides the subject its fictive identity as a discrete being. An image that only returns the "picture" of fragmentation and somatic self-identification with its sensory or functional operations subverts the social rule by which the subject is produced by images in an endless series of fictive roles. The *Hollow Body* images are thus particularly perverse as images for consumption, while the *Third Hand* images, which document the use of the hand as a prosthetic, seem to serve as product advertisements in the guise of techno-art performance. Stelarc's body serves as a vehicle for the promotion of the device, rather than vice versa, though of course it is the fact of an artist's identification with the device that allows it legitimacy within the spectacular arena. A privileged image, rather than a technical/medical one, the art image of Stelarc's *Third Hand* resonates with all the added value of its art coefficient. The leveraging function of "art" within the spectacle is pressed into service to push the product placement through the sanctification of aesthetics.

One could say that life with the machine need not mean life in the machine or as the machine. But setting a humanist-romantic nostalgia for a nonexistent past against a techno-futurist vision of a totally electronic future is clearly a false opposition. Stelarc's pieces, such as his early *Third Hand* (1981), in which a robotic arm duplicates and then performs the functions of a "natural" limb, or *Hollow Body/Host Space* in the 1990s, in which a microcamera enters the body cavity through the digestive system to project the image outward, stretch the limits of such easy binarism (fig. 25). Machines no longer bruise the flesh—they *are* the flesh. From surrogate extension to technology turned inward—rather than as an outward extension—this colonization of interior and exterior spaces turns the interior into a new virtuality. Will Stelarc approach the central nervous system so that his next "ride" will be into the optical nerve fibers so that it can project directly back through various technological media as an image of its own self-observation?

Orlan is far less subtle than Stelarc. Her aim from the outset is to produce herself as an art image through the means of media spectacle—video, broadcast, and guerilla journalism extremes as recorded in the documentary *Carnal Art* (fig. 26). Her early work as a performance artist contained the usual components of exhibitionism and narcissistic self-involvement, but

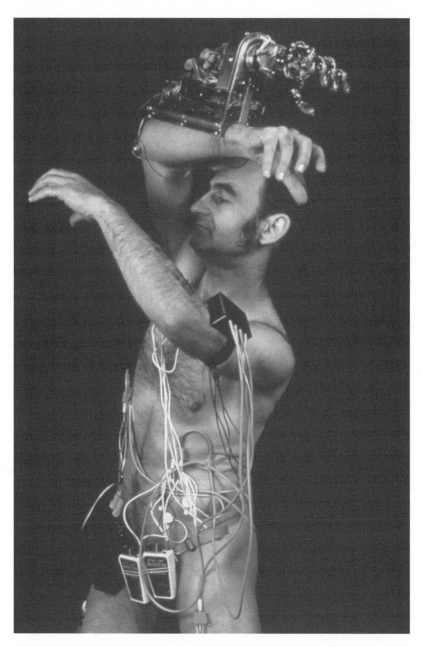

25 Stelarc, *Third Hand*, 1990s. Courtesy of the artist.

26 Orlan, still from *Carnal Art* (performance, "The Mouth of Europa, the Figure of Venus"), Dec. 8, 1990. Courtesy the artist, and ARS, New York.

the explicit engagement with media as a site for self-production is aligned with a long series of transformative operations begun in 1990. As Barbara Rose succinctly puts it, "Her new medium would be her own flesh." But more to the point, as Rose goes on to say, "Orlan's medium, finally, is media."[86] Orlan's surgical operations are recorded, and in most cases, narrated by her in real-time (rather than being rendered unconscious, she had a spinal block, a procedure that adds medical risk to the operation, creating real conditions of danger). The intended goal of the seven transformations is to resculpt her body into a composite ideal—each element taken from a model within art historical beauty. Thus the titles of the operations: "The Mouth of Europa and the Figure of Venus" (Dec. 8, 1990). In a billboard-style schematic diagram, Orlan pictured her ideal finished form in the center of its several sources, each pointing an arrow toward the projected image of the completed project.

The idea of such transformation is sufficiently banal. It is the stuff of fashion industry and television/Hollywood makeovers. It is the story of Elizabeth Taylor, Bo Derek, Michael Jackson, the innumerable rank-and-file of the image industry bit players all the way up to the most renowned celebrities. As such it hardly bears the considerable attention it has garnered. Again, what distinguishes Orlan, like Stelarc, is the capacity of each individual to stage the work as "art." Is Orlan suggesting a political commentary on the image industry? Critiquing its grotesque extremes and the internalization of the fashion image in women's psyches in a collective sense? Not in the least, and any attempt to read the work in that way seems specious and gratuitous. But Orlan's self-conscious enactment of a self-produced image as product is uniquely complicit with the image industry and its dependence

upon being cycled through the media. Orlan is producing her own self-production as spectacle, and the end result, the new identity, will be sold off to the highest bidder. Her face/self/image will be given a new name, new trademark identity, and used to promote whatever product, idea, or service is in the new owner's interest.

Without media, the entire production would remain invisible, part of that discrete behind-the-scenes transformation that is supposed to be barely noticeable in the star's image. Celebrity perfection, equally produced for media consumption, does not make a product out of its transformation into consumable condition. Orlan makes spectacle consume itself as it participates in the construction of a new consumable image. The accoutrements, costumes, various strategies of taping, directing, and so forth are all props that contribute to the whole. Paco Rabanne costumes for surgeons and patient alike, the citations of classical imagery, the unholy alliance of medicine and exploitation—are all merely so many familiar elements of the spectacle. Orlan's work is not interesting for the specifics of its imagery or for the particulars of her conception of art—or for the rather tedious posing of the "is it art" nonquestion. Rather, it is the way it forces to the fore the hitherto unmentionable fact that artists need, court, and desire production of their own identity through the same celebrity-making apparatus as other stars of the entertainment/culture industry.

Orlan performs within the terms of that mainstream culture industry—and can therefore be more readily contained by critics and skeptics eager to push her into the far side of the "art/nonart" boundary lines. But Cindy Sherman is so squarely placed within the art arena that what goes unmentioned in the extensive literature on her activity is the curious alignment it has with the work of Orlan on this particular point: self as image produced through media activity, in this case, the specific media vehicles of the art world.

A peculiar denial of media as an essential feature of the art world is part of this phenomenon, as if art, necessarily in the old and still lingering modern conception, takes place outside of media culture. Pure, unsullied, and yet, mysteriously, manipulated into the eye of that particular public that confers value—art objects and personalities are assumed to exist independent of the system through which they are, in effect, produced. Sherman is as surely, utterly, and perversely remade through the art world publicity apparatus as Michael Jackson is through the celebrity machines of popular culture.

Critical attention to Sherman's thematic interest in media production of self-image in the first series entitled Untitled Film Stills of the late 1970s has tended to focus on the quotation of media tropes and their relation to gendered identity. At the outset, her work fell directly in line with Douglas Crimp's formulations of a postmodernism using photographic means of distancing and appropriation to critique the terms of originality, authorship, and creativity that had dominated modern art since romanticism.[87] As Rosalind Krauss succinctly points out in her discussion of Sherman's work, the next round of critical assessment stressed the identity-as-masquerade aspect of the images—"manifesting the fact that, within patriarchal culture, woman is nothing but 'image.'"[88] Krauss asserts the formal properties by which effects are constructed in Sherman through manipulation of signs but stops short of asking how these images transform over time—formally and/or thematically. Sherman's early, significant success promoted her into an art world limelight—along with a cohort, which included Robert Longo, Barbara Kruger, and Sherry Levine, among others. But Sherman's concerns and her self-consuming mode of production distinguished her immediately from the other artists of the initial postmodern generation. While they commented on traditional art and media culture through strategies of appropriation, Sherman continued to use her "self" as the medium of interrogation. That "self" goes through considerable mutation in the process. The mutation is, arguably, an effect of mediation. The very acts by which her image was continually cycled back to her through the production apparatus, which she (and other artists) had taken as transparent and insignificant, produced the media spectacle of their own celebrity.

No particular revelation accompanies the statement that the model of the "rock star" served as a paradigm of media-mediated success for a current generation of artists. The possibility of acting out the dual role of on-stage, name-in-lights, glamour type while simultaneously reaping the credit/rewards of intense creative individuality had its origin within the 1960s with the transformation of the status of art as a cultural practice in its capitulation to media culture. But the artists who achieved celebrity in the late 1970s early 1980s were well steeped in this paradigm, and they were the first generation of visual artist to have meteoric rise-to-fame careers in their early twenties. The actual unformedness of their career identities at that moment meant that they were largely extruded through the crucible of public attention, with every stage of artistic development taking place in the bright lime-

light. Sherman, more than perhaps any other artist of her generation, internalized that attention as a feature of her own development. She moved rapidly through phases of narcissistic self-celebration to self-loathing, from enthusiasm to anger, from construction to destruction. All of these phases are marked in the thematics and formal properties of her work.

The Untitled Film Stills (1978–79) and the Centerfolds (1981) series, with their evident mimicry, announce the theme of mediation thematically and structurally in ways that have been discussed repeatedly in the critical literature around Sherman so that they hardly need rehearsing here. By the 1980s, Sherman's self-self-consciousness began to reveal itself in interviews and to manifest a radically altered aesthetic sensibility in the destructive visual imagery of new work—such as the beaten face of Fashion #137 (1984). This abusive self-image and self-construction intensified in the 1988–89 Disasters. In an Aperture interview with Larry Frascella, Sherman responded to the interviewer's suggestion that that recent work—with its images of vomit, violence, abjection, and self-destruction—was "angry."[89] Sherman's response is interesting in its blend of admission and denial: "I'm trying to thumb my nose at the art world, at all those people wandering into a gallery and wondering, 'What's she gonna do now? How's she gonna keep this up?'"[90]

The specific content and form of Sherman's work show her desire to transform her self as a mediated image. Initially this takes place within the bounded frame of the images. But they quickly move into the mediated realm of art world publications and reception. The production of self became caught in a cycle of perceptions mirrored from personal image to public image and back to be reworked. An extreme abjection characterized Sherman's work in the mid-1980s that seems fraught with the frustrations of the cycle of interpenetration of public and private identities. Being consumed in the media through images of a "private," even phantasmatic, "self" revealed in elaborate self-constructions seemed to have led to an exhaustion, anger, and desire to fight the consuming public gaze with defilement. The gestures of self-loathing begin with the vomit/corpse sequence, its deathly cool-blue lights, filth-besmeared face, and running scenes of body fluid-garbage-waste. The sex-toy, horror-toy sequences that follow, with their dismembered torsos, outsized genitalia, and grotesque presentations of intimate selfhood in monstrous form are further extensions of this abjection. My point is not to trace a thematics of self-destruction but to point out the extent to which "image" in Sherman participates in the medi-

ating cycle of publicity, reproduction, and consumption in the elaborate apparatus of art world media industry. Since she took as her subject matter the construction of self as image, the transformation is marked. Other artists transform their oeuvre toward greater sensationalism, upping the ante of attention-getting shock value to interest an ever more jaded audience. But Sherman internalizes the process of self-as-image in her work so that the mediating effect manifests itself.

As a consequence, Sherman's work makes explicit what most art careers keep implicit, the relation of artist to art world publicity machine. Orlan and Stelarc have no qualms about making this connection overt. Their relation with that machine is no better, worse, or different from that of any other artist, and no moral judgment is meant in this assessment. The description available from assessing the trajectory of their careers is merely the obvious but never mentioned one of art as a culture industry, not an activity independent or apart from its machinations. Heresy this may be, but as a point of fact, it seems indisputable. And thus the artists' body, in the final analysis, becomes a fulcrum point for the leveraging of the cultural status of art from mode of production to conceptualization in and through the very means which it also so self-consciously critiques. The complicity does not moot the efficacy of the process—and pointing it out is merely a means of clearly articulating one fundamental apparatus of art's instrumentality as a cultural practice. In an age of media culture, fine art couldn't possible function outside, in opposition to, or without those effective means. Denying their relation to artistic endeavor is simply the mythic obfuscation that proves the point.

13. Image Branding and Art Product Design

Molly Blieden's installations of her office furniture product line raises questions about how delicate the line is between real production design and design as a critical commentary. Andrea Zittel's compact units are fully equipped living spaces, quite beautifully made objects that might be prototypes under development. Nam June Paik's recent works make use of materials indistinguishable from the banks of electronic displays used in high-end trade shows. The synthesis of mainstream culture industry production and fine art production makes it nearly impossible to distinguish these items from works in showcases, corporate lobbies, and professional design

fairs. All of them suggest scenes of unreal, even inhuman lives—though perhaps the better term here is *lifestyles*—with all that it implies about image rather than actuality.

Blieden deliberately adopts an identity almost indistinguishable from that of a corporate designer. She works under the name of the Transparent Image Design Studio. She collaborates with professional business consultants and industrial designers in the conception and production of office furnishings with names like *The Streamliner* (fig. 27), *The Servo Stall*, and *The Distinctive Companion Desk* (1993). These are workstation elements, designed and promoted through slick brochures mimicking the promotional literature of any sales office. The texts in the brochures reveal Blieden's critical irony and commentary. The streamliner desk, made of recycled office paper, promotes itself: "the first in our new line of recycled office furnishings for the downsized office environment. Why slash your payroll to reduce costs when you can save just by making mistakes?"[91] The studio's slogan, "If you know your place, we know your desk," is printed on the back of every brochure, under the Transparent Image Design logo.

Blieden's pointed attitude vis-à-vis the antilabor policies of corporate capitalism may be evident, but the objects themselves are less clearly distinct from those we find in the environments that they propose to critique, and addressing this confusion is crucial to understanding her work. *The Distinctive Companion Desk*, consists of a workstation constructed from fully mirrored surfaces. A small Apple monitor placed on the hygienically pristine surface carries a single message on the screen, "I am a positive reflection on our work." The collective noun and the first-person singular hang in uncertain relation to the environment. No work is in evidence, just a completely impersonal, cold, glass-hard, desk that has the features of "transparency" that Blieden's pseudocorporate identity bespeaks. This "transparency" is evidently the naturalized appearance of fully integrated ideological positions—the disappeared-into-the-familiar quality of hegemonic manipulation, asserting as fact what is actually a condition of power relations. Again: "If you know your place, we know your desk."

But the desk is "real" in every sense—stylish, as well made as a floor model, and utterly seductive. As a product, it could well find its audience in precisely the world it criticizes. This collapse of critical distance and cooperation is what gives Blieden's work its interest and its edge. This work has potential to flip over into real production and succeed in the corporate world

27 The Transparent Image Design Studio (Molly Blieden), *The Streamliner*, 1996. © 1996 Molly Blieden. Courtesy of the artist.

of high style, where the irony would be completely lost. This art is at risk because it comes so close to participating in mainstream culture, production design, and the use of aesthetics to satisfy corporate interests. The *Desk of Visual Splendor*, another Blieden "Transparent Design," "breaks down the barriers between you and your employee." The obfuscating rhetoric of power works through such truisms as surely as through the sleek fashions embodied in Transparent Design's projects. Aesthetics, Bleiden seems to be telling us, function to conceal power relations under style choices. The contract between consumer and product is insidious. Blieden is overtly critical of the voluntary participation involved in consumption, but her work also promotes the game of style choices and consumer products in which relations of power are embodied.

In an exhibition environment, Blieden's work is difficult to spot. It fits into the decor as if it were part of the gallery workspace. The "art" coefficient is unmarked, undeclared. Part of the work's impact is that it "passes" successfully as real business furnishings. The critical dimensions are only gradually revealed—if at all. The stealth operation may be so subtle it escapes detection. The peril of critical mimicry is that it risks being missed or misread. Objects have difficulty preserving ironic distance when they present themselves so clearly for consumption.

Andrea Zittel's work faces some of these same issues. Zittel's elaborately crafted pieces, such as the *A to Z Management and Maintenance Unit, Model 003*, have the same high production values as Blieden's furnishings (fig. 28). Zittel's pieces, whether furnishings or the more complex self-contained modules, look like trade show items that have been delivered to the gallery by mistake. Highly fabricated units, Zittel's various modules *are* industrial products. They don't merely pretend to be custom units for fully self-sufficient living or activities, they *are* these units. Zittel's pieces from the mid-1990s look like tiny trailers or mobile homes, large enough to house a single person. Depending on the unit, they are designed for a specific function or for a supposedly "complete" existence. The cleverly constructed units accommodate multiple tasks in a small space of variable configuration. Chair, table, bed, stove, entertainment and/or disposal unit all have the compact cunning shape of elements in a railway sleeper. They speak of a world in which space is at a premium and self-sufficient efficiency is maximized through design. They communicate a terrifying sense of the regime of economic discipline for an individual as a social organism whose needs

28 Andrea Zittel, *A to Z Management and Maintenance Unit, Model 003*, 1992. Andrea Rosen Gallery.

are to be met with the least amount of expenditure. Human, individual function is reduced to its essence, constrained to the minimal components needed to supply basic functionality.

Zittel's independent bathing, sound, or sleep units could easily be mass-produced and manufactured. Nothing prevents these works from being put into mainstream production, thus the trade show atmosphere of the gallery. Zittel, like Bleiden, promotes her work with brochures. Her AZ trademark employs the slick language of product advertising. The critical edge is more elusive in Zittel's work than in Blieden's, and the question is whether this work needs to be read as critical at all. Zittel's complicity is apparent in the easy slippage between art prototype and mass-produced reality. The first time I encountered a Zittel piece, in an exhibition at New York's Museum of Modern Art, a woman who had been circling the work over and over again with a predatory hunger in her manner turned to me and asked if I knew

where she could buy one. Not as art—she wasn't thinking of it as a sculpture, but rather as a unit she could install in her apartment to use as an escape or isolation unit. The work communicated no critical distance whatsoever. The piece fit into a consumer aesthetic without any resistance. Nor is resistance part of Zittel's rhetoric—the work is an actual exploration of the possibility of efficient living units and function-specific modules. Affirmation shows its face again here. This work embodies an alternative, rather than critical, vision. Zittel's units beg to be contrasted with that of Kryzstof Wodiczko, whose designs for homeless vehicles have many of the same features as Zittel's high-end, elite consumer items. Wodiczko's work is intended to solve a genuine dilemma. They provide a practical solution for individuals living on the street—while publicizing that dilemma as a social problem. Zittel's work fetishizes elite consumer taste in a designed-for-consumption product. Wodiczko uses a related form to publicize the inequities in American class structures, to give an identifiable form to the invisible homeless population as a way of making them visible within the public sphere. But Wodiczko's solution is also a positive gesture, promoting concrete assistance to meet the daily needs of a disenfranchised segment of the real population.

In both cases, the works are prototypes for mass production, intentionally crossing a line between fine art production and industrial/commercial production, crossing a line that has always remained distinct.

A work from the mid-1990s by Nam June Paik was indistinguishable from installations of the commercial entertainment and communication industry. Paik, long a respected member of the new media avant-garde, is a figure whose credentials as proponent of critical intervention in electronic media have an established track record. But over the course of a career spanning more than four decades, Paik's work has gained visibility and corporate sponsorship that has pushed his capitalized production base to unprecedented heights. Paik originally used recycled or modest electronic equipment in a practice intently engaged in self-consciously calling attention to its place and properties in a culture beginning its love affair with technological media. Now his work is so heavily funded that he can command huge banks of high-definition monitors to make work that looks just like a trade show display.

Paik's piece from the 1996 Mediascape exhibition at the Guggenheim Museum Soho in New York consisted of a wall of monitors coordinated as

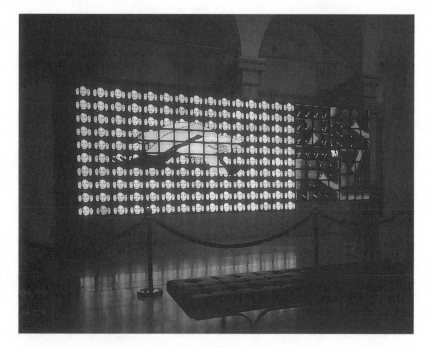

29 Nam June Paik, *Megatron*, 1996, Smithsonian American Art Museum. Museum purchase made possible by Mr. and Mrs. Barney A. Ebsworth, Nelson C. White, and the Luisita L. and Franz H. Denghausen Endowment.

a mosaic to make an enormous single screen (fig. 29). The discrete spaces of each monitor are unified into that integrated whole where pattern and image recombine in continuous, time-based display. The format of this work might preclude any capacity to produce a critical dialogue with the viewer. The images are seamless. The sheer virtuosity of production skills and the overwhelming size and impact of the monitor wall dwarfs the viewer. Like a Circuit City wet dream of high-wattage entertainment power, this work seems impervious to any interaction. No viewer response could register in this environment, given the assaultive force of the technology being engaged. The scale of the project positions a viewer outside its machinations, without even the satisfying instrument of a remote to alter the looping cycle of display. Any medium, whether video, street signs, traditional painting, conventional or electronic imagery has the possibility for a rhetoric of disjunction and defamiliarization. But the aggressive character of the Paik

piece precludes any space for viewer interaction. The seamless totalized rhetoric of commercial media and/or the info-tainment industry dominates.

In addition, the format turns every image in the Paik piece into a logo. The size and scale of image display reinforces the sense that Paik is providing aesthetic legitimation for the corporate sponsor and supplier of the equipment. The monitors frame their imagery so relentlessly, the boxes are so absolutely the container of the work, that no frame of reference seems to exist outside of these monitors. The integration of smaller monitors into a single display suggests a coordinated system of great force. One has the sense that the wall could commodify an ever-increasing range of our experience and sell it back through a visual rhetoric of autonomous signs and consumable images. The display is mysteriously networked; its elaborate inner connections operate out of sight. Like the mythic corporate entertainment world whose structures it depends on, it shows us only a glittering, shining illusion to which we attach more value for knowing less, having limited access to its actual operation.

One question raised by all of these works is what dialogues, disjunctions, and contradictions they manage to inscribe in their actual imagery and in their form and presentation as objects. Efficient function, the old goal of an earlier age, returns transformed into an integrated circuit in Paik's piece. A new set of signs of equivalence, baffling in their seamlessness, overwhelms with its capacity to seduce and numb the eye and mind. The face of the monitor seems invulnerable, inaccessible to interaction or dialogue—even as the hype of interactivity comes to dominate the promotions for the product line of which it is the front runner. Paik's work is also a "gallerina"—an art world beauty aspiring to meet the standards of the fashion industry in order to prove the competitive adequacy of once-marginal resistance so that it can operate at the same standard of conformity and consumability as that of the repressive mainstream. Why?

Why should fine art aspire to such a condition? Paik's work feels bankrupt in this regard, empty of any value beyond that of monumental display. It integrates too completely into the world from which its forms derive. The fine line of art, the aesthetic coefficient by which the discourse of art distinguishes itself is lost. The issue is not merely one of content, nor one of form and production values, but of the capacity of the work to leverage the distinction between familiar formulae and that momentary epistemic dis-

junction that results in awareness and insight. To what end? Here we must pause and refuse the easy answers drilled into us as automatic responses by the old avant-garde. No singular end, no pseudo-political agenda, satisfies as answer to this query. Rather, the point is to recognize the function of fine art as a realm of artifactual production in which forms speak of and to their time, as material expressions of thought. Beyond this, their fate is as the rest of ours, to be determined according to context and circumstance, reception and the elaborate machinations of cultural discourse and its histories.

Thus it behooves us to be attentive to the implications of the ways new forms, by their very specificity, have an impact on the configuration of various dialogues: between graphic design and fine art, between commercial interests and the public interest, between individual perception and formulaic production. The features of these various rhetorics both may and may not contribute to making such dialogues possible. In the dialogues among people and through the media of art, design, and conventional or electronic technology, public debate remains alive. Such dialogue is a process, not a product—it can't be packaged, commodified, experienced as a standard "brand" or sign—and in an image-saturated culture one of the functions of fine art is to keep opening spaces of such dialogue within the integrated circuitry of signs. Bleiden and Zittel make objects that pass as products. Their semiotic condition is fraught with the perils of mistaken identity, of product branding. Within the consumer system of fine art, artists have long depended on the development of a brand identity for their own products. Harold Rosenberg remarked on this phenomenon half a century ago, saying that the art market had come to depend on trademark standards for an artist's work. One buys "a Pollock" or "a Paik" with assurance about its authenticity and identity. The play between this product assurance and the creation of works that pass as commercial products is complicated. The systems of art production and industrial production don't mirror each other. But they do define each other at some level as practices meaningfully differentiated by the distinction between art products and those of the commercial world. Bleiden and Zittel call attention to the line that keeps these worlds distinct. Paik may well have crossed it.

For the 2001 Armory Show, Alex Bag created *Van*, a performance work that commented on the celebrity culture character of the current art scene.[92] The van contained a video showing interviews with three aspiring female

artists. All describe their idea of successful career trajectories in terms that have the profundity an episode of *Friends*. Bag is unabashedly interested in media imagery and culture. Her generational identifications are with MTV and *America's Funniest Home Videos*. No conflict at all exists between these sources of influence and her work as an artist. As surely as Picasso reworked Velázquez, Bag is reworking Oprah and Donahue. Perversely heretical as that might seem, the reality is that media culture holds far more weight with younger artists than the Janson's *History of Art* inventory. Working in video and multimedia formats, Bag aspires to television productions. She doesn't even look to the precedents of film or theater, which seem like high art, esoteric and remote adult culture.

Bag described *Van* as "a mobile video viewing unit."[93] When she parked it in proximity to the Armory show, the video interviews produced a poignant, funny commentary on the activities of the art world. The young artists had the quality of starlets hoping for a seat at the Oscars, hoping their talent would be recognized by the quality of their makeup and accessories. The sheer superficiality of the way they defined themselves and their work had a tragic feel to it. These young women actually seem to believe in scenarios of success consisting of magical moments in which Charles Saatchi buys all of what is in one's studio, or one gets picked up as the artist deemed worthy of decorating a high fashion showroom, or is written about by an established critic. Such conceptions are outside of work in the traditional sense. No corpus of aesthetic production exists on which the aspiration could even be fulfilled. The idea of "being an artist" displaces the creation of work. Bag, making these videos, thus capitalizes on the image of mythic art world success, turning its fairy tales into a story to be reified in the telling. Bag makes art world capital out of this mythology and thus realizes the perverse reality of the way the system functions. The culture industry of art is itself available to be represented as a work that turns the artist who performs it into a celebrity. Circular? And apt. Superficial and ephemeral as Bag's work may prove to be, the mythology of art world success she plays with is far from false, even if her superficial representation reflects only on the surface of a more complicated system. Serious work? The very question is misconceived since it suggests that the art world is somehow immune to the corruptions for which it points so supercilious a finger at the rest of the culture industry.

14. Flagrant Complicity

The visually striking immediacy of Yasumasa Morimura's *Daughter of Art History (Theater B)* (1989; plate 16) plays with art historical references, transforming Manet's *A Bar at the Folies-Bergère* in what at first sight is a clever comment from a postcolonial other on the legacy of Western art. Morimura's photographic mural-sized piece appeared on the cusp of the 1990s. With a combination of sophisticated immediacy and mediation, the monumental work is remediated from an outside perspective, in this case, that of a young, gay male. But the usual postcolonial reading of this tradition as imperialist and exclusionary gets turned inside out through Morimura's literal insertion of his own body into the reworked image. The binarisms of self and other, mainstream and margins, Western and non-Western, become difficult to believe in or sustain in the face of Morimura's play with Manet's painting as an icon of popular culture rather than simply an artifact of high culture. By the time we finish looking at this work, we realize that the relation of modern art to popular spectacle has been recast as one of complicit interrelations rather than oppositions.

Morimura's image is striking and seductive. Such a formally engaging sensibility as Morimura's came to characterize work of the 1990s with renewed vigor. But the theoretical concerns therein embodied are equally sophisticated. Postcolonial and gay subjectivity could not be better articulated in all their complicated relation to mainstream Western art and criticism than through this particular game of mimicry and substitution. Nor could any critical gloss manage to exhaust or even replicate the visual impact of the piece. Visual fascination gives this work its rhetorical pull on the viewer who is caught in a peculiar tension of familiar and unfamiliar imagery. We know the Manet work so well that seeing it remade registers its changes with shock effect, tempered by the wry humor of Morimura's ironic posture. The expectations about what we should see in the Manet work have been formed through the widespread reproduction and discussion of the *Bar* in many contexts—academic writings, blockbuster exhibitions, gift shop productions. In effect, Manet's image functions with its own currency in the economies of contemporary art's elaborate industry.

Morimura's work finds an echo and (perhaps perverse) counterpoint at the end of the 1990s in the work of Mariko Mori (fig. 30). Her large-scale installations and performance works are highly capitalized works with state-

30 Mariko Mori, detail from *Nirvana* 1996, courtesy of the artist and Deitch Projects.

of-the-entertainment-art values. Both Japanese artists function in an international global art scene. Both are members of a generation for whom local identity has become one sign among others in the accessorized trade of art personae, one of the outfits they wear in defiance of any limiting sense of essentialism. Celebrity politics and mass media culture dominate the world

in which Mori moves. She is no more stigmatized by the local point of her origins than are the Sony television sets produced by her industry sponsors. She takes off from the platform of that global corporate wealth, fashioning her own self and its commodification without a single flinch or hesitation. The balance of aesthetic trade has shifted. The concept of the global (with its overtones of synthetic movement across borders through an integrated system of fast-paced exchange) has replaced that of the international (with its associations of outmoded nation-states with indigenous customs, identities, and trade agreements). A parallel transformation has taken place in the shift from a commerce of traditional fine art to one in which a flagrant exchange of values between fine art and popular culture produces endless hybridization.

Mori's style is the daily stuff of music videos and girl fashions—an endless whirl of cute culture focused on a teen dream of playful stardom against a background of what was once tradition. A consummate self-promoter, she turns everything and anything from the traditional, commercial, pop, and sacred worlds into motifs for the sake of set decoration and entertainment. As long as it works, she'll use it. Her work promotes a New Age spiritual salvation of an utterly uncritical variety, a no-holds-barred hyperbolically synthetic amalgamation of representational forms. Unified, synthetic, and uncritical, her work exists in an amoral universe, one in which critical judgments have far less authority than ratings or sales figures.

Morimura's work is clearly created in relation to tradition. His carefully embodied insertion put him inside the Manet painting, replacing the object of our modern gaze with a contemporary subject. By contrast to Mori's almost nihilistic disregard for the very categories of tradition in which such deviations might even register, Morimura's work looks careful and classical. Who cares for such earnestness? Mori seems to declare, twirling by in her skating skirts and outrageous costumes amid the primary-color and pastel-fantasy decors of her performances and installations. When nothing is sacred, there is no possibility of "transgression." When nothing is beyond the reach of fine art nor exclusive to its domain, then there is no ground for critical opposition. No shock to be had. Flagrant complicity, with all its cheerful dismissal of any actual consequence and enthusiastic participation in consumer culture, is the very core this work.

Manet's original painting is usually considered to have participated in a different game, one in which fine art still struggled to redeem values from

popular culture. That game has been played and lost, and Morimura's work suggests that a nuanced but striking visual potency can still register within the frames of that fine art world because its own, original terms of conception were based on a belief that fine art had a superior relation to mass-media culture. The waitress in the Bar is a fallen woman, that working-class angel exploited by the world that consumes her, and offered to us as a kind of martyr, her youth destined to be spent through the corruption around her. Fine art, saving her through capturing her image, cannot change the structure of public entertainment palaces in which she will be exchanged and used. But Morimura puts himself into that place. Fine art is among the worldly creatures, not separate from them, and Manet's original painting, by extension, is perhaps not so distant from the spectacle it records as we have been led to believe. Mori, by contrast, is not merely worldly but flirtatiously commercial and consumable. She makes no pretense at all that her work or its existence guarantees a set of values apart from those of the corrupt world. Instead, its very existence depends upon, contributes to, and is sustained by that world.

Morimura's visual means are elaborate, his images dense with seductive visual properties, rich in color and form, and thematically resonant. If his work has a "political" agenda, it succeeds by virtue of the seductive force of the image, not the moral force of lesson to be learned. By the way it embodies its insights, Daughter of Art History (Theater B) synthesizes critical issues. There is no doubt at all that this work contains a "postcolonial insight into the hegemonic exclusions of Euro-centric culture," as we might say in academic crit-speak. Just as surely, the body of Morimura, gender-ambiguous, sexually "deviant," culturally marked as "other," serves to call the work of early French modernism embodied in Manet's A Bar at the Folies-Bergère, into critical focus through visual means. And that image is perfectly situated within the trajectory of modernism and its many academic and critical debates to provide the ideal site for such a gesture. He inserts his body in such a way that it complicates the space of representation (we can't quite tell how he has put himself into the image—through a prephotographic tableau or a manipulation of pictorial means). At the same time, he complicates the perception of his identity—we struggle to figure out Morimura's gendered, ethnic, and historical identity. These formal destablizations make close discussion of the image difficult since the image doesn't unify into a work from a single place, author, or point of view. The work

is fractured, of course, by what Morimura is doing within it. And this, of course, is that point. After all, the original Manet painting has figured prominently in social, feminist, Marxist, and aesthetic discussions—but always as the object of critical analysis, not as a site to occupy, a place to get into and inside of, a place from which to make us see it anew. The striking originality of Morimura's gesture is that he addresses us from within the canon rather than pointing to his confinement to a place outside it. Mori, by contrast, is remaking canonical imagery with high-end commercial means and entrepreneurial enthusiasm for producing consumable experience.

Morimura's *Daughter of Art History (Theater B)* is steeped in rhetorical gestures of fine art's self-consciousness about its identity. But he extends this awareness of identity into a cultural dimension while appearing to make an image concerned with lineages and the genealogy of artistic identity. Manet's interest in the subject of the *Bar* and other distractions and delights was not merely critical but forthrightly attuned to the changing circumstances of visual culture. But if Manet figures at all in this image, he is only a ghostlike figure in reflection, possibly that top-hatted male who is someone on "our" side of the bar. A customer. An outsider by class and disposition who is nonetheless essential to the workings of the scene. Not so with Morimura. He's right there in the image, reconfiguring our assumptions about the personal identity of the artist. "This is me, here I am," he announces, even as his cosmetic treatment has disguised his face, covered his head with a wig, tied his neck with a ribbon, and then, left his body bare.

If ever the much-contested "body" of the "postcolonial other" was put into the center of a work to introduce confusion, it is here. The "body" is one of the clichés of the field of postcolonial theory in which theoretical writings cycle back to the absent referent of the "bodies of women and people of color."[94] Morimura centers his photographs on visual images of himself, often nude or nearly so, and yet, making it teasingly unclear what is gender is. All but explicit, these works are quite definitely narcissistic. Perversely, unabashedly, Morimura underscores the self-involved quality of identity politics. The pleasure he takes in decentering our expectations, offering a curious play with gender categories and cultural history through the use of his own slim, androgynous, and costumed form is no doubt well matched by the pleasure he takes in presenting himself as the object of attention. Such work goes beyond any simplistic agenda of postcolonial or identity politics. Here art starts to bid for attention for itself, as Morimura bids for attention

for himself. The two intertwine, shamelessly engaged in acts of visual se-
duction that were only coyly hinted at in, for instance, Cindy Sherman's self-
portraits. And we know that the moral price she paid for such early acts was
to turn her image into one of abjection, heaped with refuse and befouled,
as if in acknowledgment of the wickedness of giving in to the pleasures of
self-centered visuality.

Morimura's work has been the object of considerable critical attention.[95]
But to characterize Morimura's work as political because it introduces per-
sonal subjectivity into the project of destabilizing the cultural hegemony
of Western art's historical self-descriptions misses the point. *Daughter of Art
History (Theater B)* is unequivocally narcissistic. Certainly its visually sophis-
ticated and seductive means make a point. And this already contrasts it with
many of the (frequently) visually repressive works of canonical postmod-
ernists, who deliberately eschewed (and mistrusted) the visual "opticality"
associated with high modernism.[96] The theoretical puritanism that gov-
erned 1980s postmodern visual production is not belied in the work of Mori-
mura. He begins to call into question an ethos that hides the fact that fine art
is not about purity of moral purpose.[97] Morimura's work is about Morimura,
and his desire to be an object of aesthetic pleasure, to be the object of that
naughty but popular attention that has so long accrued to the bored but
charming barmaid.

Of course, *Daughter of Art History (Theater B)* is not only about that but also
about the assumptions we carry with us with respect to traditions of modern
art. For one thing, the photograph disorients us by suggesting that mod-
ernism is not finished, is in fact unraveling and being continually remade,
even in its most canonical form. Morimura appears in three places in the
photgraph: as the maid at the bar, in her reflection, and the reflection of her
customer. Morimura is made up to be art, an image, not a real barmaid, and
he emphasizes this resemblance to the original by the garish painterliness
of his makeup. He is meant to look like a painting, and he succeeds so well
that at first we can't quite tell that a substitution has taken place. But that is
where the resemblance stops. The barmaid's dress had a lace collar, and but-
toned, dark bodice, but below his black choker Morimura is naked. His arms
are crossed over his chest, demarcating the painted portion of his body from
the rest, his naked torso and thighs. Elements from Manet's painting have
been replicated on the physical bar behind which Morimura stands. And
among the painted champagne bottles and tangerines in a cut glass bowl,

Morimura has placed a glass filled with roses that conceal his genitals. In Manet's original painting these roses established a subtle counterpoint with the corsage tucked into the barmaid's bodice so that the associations of femininity and floral bouquet, of flowers proffered and services offered, were aspects of the meaning conveyed. In Morimura's case, the flowers take on an explicitly sexual connotation, in fact, a homosexual one. Their placement calls attention to the mixed codes of gender with which Morimura is playing throughout. Partially cross-dressed, partially revealed, Morimura's is a hybrid identity, but one that must be read against the background of this classic image. The intricacy of the game of what is and is not "real" within the play of painterly and photographic codes becomes the basis of an elaborate act of visual seduction. Morimura is the painting (now canonical fine art) and the barmaid (modern popular culture), the subject and object and artist of this work.

From such an "inside" position, Morimura plays with his position as an "outsider." Does Manet's work stand for a Western tradition? A modern tradition? Canonical art history? A history from which Morimura is excluded? That seems too simple, since he is so clearly placing himself within the work. As a young, contemporary artist, however, he sees the full range of the historical materials as available. Obviously, such an attitude violates expectations: the viewer is made aware of the ways the work of a Japanese artist both is and is not the logical extension of Western modernism. But also, Morimura shows the extent to which modernism already had a complex and complicit relation to the popular culture from which it was distinguishing itself. Manet's formal innovations differentiated him from his academic peers whose works dominated the Salons of mid-nineteenth-century France. Manet's attention to surface and mark-making called attention to painting rather than putting it only at the service of representation. But he took popular entertainment as a subject matter, he didn't create Cot-like works whose own popularity would consume them. But in our era, impressionist works such as the Bar are the most popular of paintings. Manet's images (and many impressionist canvases) have become almost debased by their reproduction in posters and framed reprints used to adorn the walls of dorm rooms and suburban homes, figure on umbrellas and tote bags, calendars and greeting cards. Within the modern canon, impressionism was meant to stand severe guard against the supposed horrors of academic and salon painting whose virtuoso technical achievements are considered the

worst in vulgar bad taste. Morimura challenges these beliefs. By rephotographing this painting, Morimura unifies that brushstroked canvas back into an "image"—the very condition from which the tradition of modern art history has tried desperately to save it by making it a canonical work of social criticism and artistically radical innovation. We, however, must reconcile ourselves to what Morimura shows us—that Manet's painting is and simultaneously is not that single canonical work.

Much has been made of the way Manet's original treatment of the barmaid's forearms reveal their physical development and the way her exposed flesh betrays her working-class (available) status. In Morimura's image the arms have been modeled out of plaster. They break just above the bare forearms to reveal grotesquely bent and twisted wire armatures. These arms add yet another dimension to Morimura's image, the evidence that his tableau has been staged spatially, in a physically fabricated set, and not produced merely through photographic manipulation. What was artistic fabrication has been remade as "real" so that it can be used to provide a foil for Morimura to pose the question of how authenticity (of self, identity, fine art) is determined. We could take Morimura's to be the authentic image of a Japanese homosexual male, and Manet's image as fine art. But how are we to know that this is Morimura's actual identity—any more than we are to trust our ability to understand the difficult terms of the transaction between the original Manet and its recycled, grotesque remaking as an icon of once-radical modern art, now used to call attention to its painterly qualities? The nineteenth-century painting, which depicted an ambiguous space of social relations, resonates with historical self-consciousness, but it was also very self-consciously an image of that sensibility. Morimura's late twentieth-century reworking seems to suggest that the work had certain contradictions in it that later critical art history puts aside.

Morimura inverts the various categories by which the Manet work achieves its canonical status. The working-class barmaid—so renowned in art historical criticism for her physicality, her brazenness, her combined vital, muscular femininity, and ennui—has been replaced with a slightly built, delicately featured, cross-dressed Asian male. Every category of identity—gender, race, class, and sexual orientation—is called into question by the presence of a body, which ruptures the framed image—revealing its armature (that is, the structure on which its aesthetic and art historical identity is based). On what foundation can Morimura be the "daughter" of this

art history? In what way is a young gay male Japanese artist to enter into a dialogue with the tradition of Western modernism except through it popular history? The canon of impressionism is a pop canon, not only a high art, academic one.

The opportunity modernism seemed to offer—that of a free space in which to innovate through painterly, artistic means—is brought up short and fast. Morimura insists on the popular production of modern art. Morimura makes the Manet personal, but also seems to put the high art status of the work into a broader history of visual culture and of the reception of impressionist work. Morimura doesn't want the "Daughter" to be read without recalling the Manet *Bar*. Clearly, he wants to reference and reinvent the Manet, to change its historical site/ meaning so as to serve as the punchline to his own work. But he also knows that the link among the two images happens in popular culture, in the systems of visual image circulation that guarantee the familiarity of Manet's *Bar*. The meaning of the Manet is changed as well, since not only is its imagery called into a new visual focus, but its place as canonical work is reaffirmed even as isolation of the high art canon is called into question in the process.[98]

Morimura's image, and the claims its title makes to a complex lineage, depends on the scaffolding effects of the historical references. In what way was Manet's painting about modern life? What features of its artifice betray their own complicity even as they advance the aesthetic investigation of form giving as a means of cultural knowledge? Morimura's work is utterly embedded within the play of historical information at the level of reference and discourse, but also at the level of artifice and production. *Daughter* returns many repressed elements to the visual fore, but it does so according to the terms of a politically correct postcolonialism that serves the more subversive assertions of vulgar representation and mass culture imagery in which Morimura reclaims the Manet as a piece of popular history. Our understanding of modernity as a cultural phenomenon still comes to us largely through the legacy of visual modernism and its interpretation. Morimura reinserts the present into that past canon in a dramatic act of rereading and invention. Look again, he suggests, at the received tradition from within rather than from outside. The transformation of perspective is remarkable, undoing the objective history with a subjective turn. The outrageousness of Morimura's work resides in the extent to which he succeeds in inserting a new fulcrum point to leverage our understanding of that history, not only

in the way his presence forces content issues and historical lineages to the fore.

Mariko Mori's installations and performances use their elaborate technological means and strikingly immodest strategies to put her (also) into uninhibited narcissistic focus as an image that is created whole cloth from the synthetic realm of entertainment culture. Fine art? No, artifice is what abounds in this work, though it finds its audience in museum and gallery sites.

Mori draws on Buddhist texts and imagery to produce a form of techno-pop. Her stated goal is spiritual enlightenment. Her means of achieving it is to produce futuristic visions with titles like *Nirvana* (1996–98), *Enlightenment Capsule* (1998), and *Dream Temple* (1999), in which she portrays herself as a cybergirl shaman. *Nirvana* consists of four large photographs, each extravagant in scale. Their backgrounds are natural landscapes of significant dimension: the Painted Desert, the Gobi Desert, the Cave Massif, and the Dead Sea. Each serves as set for a piece depicting one of the four elements: air, fire, water, earth. The images bear suggestive titles, like "Burning Desire" to characterize fire, and they are peopled by odd little creatures with a hybrid Pokemon cartoon quality unsurpassed outside of Japanese pop culture. The image of the lotus appears in the installation as an acrylic object activated by optical fibers, a motif that becomes the central theme of *Enlightenment Capsule*. That piece draws natural light into the lotus blossom form and segments it into the ultraviolet and infrared divisions of the spectrum. The sci-fi fantasy aspects combine with traditional spiritual iconography—the Buddhist imagery follows conventional lines but is remade in a plastic artificial scheme that goes over the top of kitsch.

Tradition and religion combine with kitsch-and-pop culture. Mori's experience as a model, her photogenic features and consumable persona mocked-up in costumes and makeup that give her an adorable cyborg presence make her utterly one with the realm of mass culture. No critical distance separates Mori from her sources, either spiritual or commercial. She achieves a seamless integration of two realms, both anathema to the secular radicalism of the avant-garde and the academic keepers of its flame. It is impossible to cast Mori as a critic of the worlds she so adores that she makes them anew in her own fantasy image so as to inhabit them more completely. The high production values of her work, available to her as a privileged daughter of the entertainment industry (a sharp contrast to

Morimura's stated lineage), allow her work to compete with media culture on its own terms. This is not amateur work. Mori is a professional of the highest order, a producer of spectacle aspiring to play in the same league as Madonna or Michael Jackson, Las Vegas night clubs and Disney theme parks. If her motif is a Buddhist sci-fi spiritual land, her method is calculated according to the highest standards of kitsch consumerism.

Internal contradictions exist in this work as well if we believe that the crass materialism of manifest installations is at odds with a Buddhist spiritual quest for enlightenment. But there are no art contradictions. The work neither claims nor performs any pretense of critique or opposition to the culture whose image-producing apparatus it so successfully appropriates to its own ends. The pop-celebrity cuteness of Mori has been vetted. She has credentials as a real model, not pseudomodel or simulacral model. She sings pop songs as a real performer. She put herself into a special-effects video, The Birth of a Star, without irony, flaunting her perfect smile from a head artificially joined to a long-legged body in bright tights and red skirt. A party girl on her way to the heaven of higher consciousness and headlines. Full artifice, fully realized.

So, how is it that this highly produced, kitsch-pop, techno-culture, consumer-girl stuff passes for art? How is it that it finds its way into the world of museums and galleries? What concessions have been made on any/all sides for this work to be situated so centrally within the sacred gates of high culture?

The contrast with Morimura's work is useful. Morimura's outrageous-seeming visual play with Western modernism looks positively intellectual in contrast to the over-the-top pop of Mori's work. A decade of distance, a world traversed. What role does the aesthetic play in a narcotic universe of stylish cute-girl fantasy? Mori's success affirms the flagrant complicity of fine art with its cultural context. An unconflicted, frictionless alignment between the interests of industry and the affirmative role of the aesthetic makes itself fully apparent in Mori's work. It shows not the end of fine art as we know it, but the recognition of one long-denied aspect of its fundamental identity as an instrument of that same hegemony so long taken to be its other. Mori's work takes individual expression out of the picture. She subsumes the artist's identity within the motifs of a product universe. She puts choice into mere style brackets and reintegrates secular and sacred motifs in a single hybrid of consumable iconography.

All the devil's bargains are made here and made evident. Where is the course to salvation now through this lotus land of commercialized dreams? The mediating function of fine art must be reconciled to its relation to mainstream modes of media production as Morimura reconciles us to Manet's relation to popular culture, rather than reinforcing the usual reading of its distance from it. The earnest purities of high modernism (never really present in the early avant-garde) have lost all power to preserve those once-sacred boundaries between the culture industry and fine art. But how much enriched are our vocabularies as a result? What purpose, then, did those lines serve? The shifting discourse of art will always be marked by its apartness, by its capacity to be self-consciously, archly aware—and to make us aware—of the way it is not simply another instance of replicated thought in predictable form. Mori's work, challenging so many of the sacred beliefs on which fine art loves to go about unquestioned, forces new premises into relief. The task of continually remaking a belief system in response to these forms may prove the shallowness of their premises. But such activity may also demonstrate—to our great surprise—the almost infinite capacity of artistic transformation. Complicity is not the dead end of art but, rather, the condition of its self-conscious reinvention.

15. Mediation of Modern Life

Jim Campbell uses digital and electronic technology to dialogue with the longer history of modernism. Raymond Pettibon is an artist whose entire oeuvre demonstrates the effects of media imagery on the interior life of an artist. Both make compelling arguments for the nature of contemporary aesthetic space as the filtered effect of a subjective sensibility within the complex networks of visual culture.

Campbell's work marks the distance from the nineteenth-century representations of modern life in visual art by marking continuities and breaks within that tradition. Evident concerns such as the iconography of urban experience and passing fashion provide a superficial, surface continuity. And insofar as modernism is profoundly bound up with surface effects (formal values, consumable images, spectacle), this obvious continuity is an important one. But less obvious connections exist as well in the formation of the conception of modern aesthetics as an activity of mediation, a rhetorical mode of transformation and comment through the act of form giving.

Campbell's work brings back to the fore an often-repressed connection between mass media and visual culture within the modern tradition. This relation has its own historical dimension while also providing the means to assess historical perspectives and varying modes of subjectivity within the field of modern visual forms. Campbell's work resonates with this longer history, showing that the contemporary condition is an extension of modern life, not a new one, and that the fate of modern art is contemporary art, which is to say, that modernism is much with us—alive and vibrant, but constantly reinvented.

Campbell's *5th Avenue Cutaway #1* (2001; fig. 31) displays slow-motion images captured by video and processed through a panel composed of a technologically sophisticated grid of red lights. The images are further modified by the presence of Plexiglass, set at an angle to create a pixel effect on the left side of each image that gradually fades from digital to analog across each panel.[99] While drawing our attention to the information-based and processed character of visual media and the mutable effect of mediation of electronic technology, Campbell produces a continual stream of images of figures walking in the city.

In these fleeting images, the grid of information code continually refreshes itself. The illuminated spots range like halftone dots in a mechanical reproduction filtered through a mediating screen. The effect fascinates, holding our attention as a play of pattern across a surface and as a legible illusion. The pattern seems to create images more nuanced and more detailed than the grid that displays them, as if the granularity of vision and that of the display device were in a dialogue of continual selection and exchange. The ephemerality of the banal image of figures passing on the street resonates with the memory of a Baudelarian flâneur.

Campbell's screen snatches at modern life with full cognizance of the futility of the attempt, that the image is always already gone, mutated and morphed through movement in an illusory continuum. The hypnotic repetition of the work is seductive. The red light tapestry effects suggest the lost presence of a past nostalgic for this particular future. Modernity, a modern past, self-consciously remembers its peculiar relation to temporality and imagery. Digital technology. Beautiful imagery. The modern scene, still with us, elusive and passing. Old theory, new art? Maybe. Charles Baudelaire's definition of the painting of modern life became a framework for understanding modern visual art. But the emphasis he placed on the representation of

31 Jim Campbell, *5th Avenue Cutaway #1*, 2001.

modernity carries another emphasis that links his thought to Campbell's work. For the condition of modern visual culture as Baudelaire encounters it is already bound up in the apparatuses of mass media as much as in the forms of fine art. Baudelaire's essay is shot through with flickers of insight into the dialogue between forms of modernity and media of representation. How are we to know how we know what we know of the world? And what is it we ask fine art to tell us?

The artist referred to by Baudelaire as "the painter of modern life" was Constantin Guys, an illustrator and commercial artist much of whose creative output had been tied to his career as a journalist. His work was quick and sketchy, indicating a fleeting scene in a brief outline created with a few strokes. The images are indications, rather than replete works, and rendered all the more "mediated" by the standard convention of being engraved by someone other than Guys. Contrast with the more detailed and finished lithographic drawings of Daumier, his contemporary, makes this vividly clear. Daumier's caricatured observations of the follies and realities of modern life seem more apt as the images that would fulfill Baudelaire's prescription. Daumier's style and high-art credentials suggest he is the artist to whom Baudelaire's arguments should attach. The later use of Baudelaire's famous phrase within the canons of art history generally call up the work of Édouard Manet, Edgar Degas, and other masters of modernism. Their formal reworkings of painterly mode seem appropriately matched by their supposed interest in the social and cultural transformations of, particularly, Paris as

it was radically remade in the politically charged climate of the second half of the nineteenth century. So be it.

But after all, Guys was crucial to the original discussion precisely on account of those very characteristics that cause him to be shunted aside later. He was involved in the commercial world and made images destined for communication in print mass media. The illustrated press was in its first generation of full-blown operation in the late 1830s and 1840s, and the new market for imagery created a novel brand of artist-correspondent. Guys traveled widely, recording such incidents at the "Memorial Service for Greek Independence in Athens" or "The Appearance of the Sultan at a Bairam Festival in Constantinople."[100] Guys personified the tension between the transitory and eternal that was central to Baudelaire's aesthetic: the role of art was to provide possibilities of "stability and the constant possibility of renewal" in relation to the "perpetual flux of modern life."[101] These were images that were destined to be consumed with the same ephemerality as the rest of the illustrated news that comprised the mass media of its day.

This crucial, definitive text of modern fine art takes its inspiration, therefore, from the work of a journalist who made his living working for the media. The hierarchy of fine and commercial work barely had grounds on which to exist at that point in time, even though earlier distinctions of artisanal craft and beaux arts were well established. Guys is most emphatically not an academic artist, and Baudelaire's embrace of the journalistic grasp of ephemeral phenomena shows his own conflict in seeking a balance between classical forms that are universal and transcendent and the romantic sensibility of subjective, affective expression whose future he troubled over. But Baudelaire was keenly aware of history. The axis that measures the flux of time is a historical one, and the cultural condition of modern life is defined by awareness of that progression. Guys's work is never outside of history. Quite the contrary. His formal means are conspicuously marked by ephemerality. The images call attention at every point to their dependence on historical knowledge and subjective insight. They can barely be read without returning to a historical moment, they are so sketchily dependent on the context from which they are lifted, conceived so entirely from within that historical condition rather than from outside of it.

Perhaps for this very reason, the specific properties of Guy's style tend to disappoint the late-twentieth-century and millennial eye, familiar with photographic reportage even though Baudelaire understood Guys's capac-

ity to "wring from contemporary life its epic aspect." Did he also understand the extent to which the pressures of deadlines and reporting schedules affected the artist's production? Or the way the technological limitations of mid-nineteenth-century reproduction imposed their requirements on the artist? Dazzled as he was by Delacroix's rich surfaces and brilliant brush-work, Baudelaire must have found Guys's sketchy linework anemic by con-trast. But industrial print production was limited to those tonal ranges that could be achieved using black ink on cheap paper. Dissemination of images through mass circulation created a new perception of modern life. A con-sensual image, the reified world, made and presented in visual form, be-came the adjunct to language as an instrument in the social construction of reality. We take so much for granted the presence of visual imagery that the novelty of image-based print media is difficult to recapture. That the painter of modern life arises within this sphere and that mass media are contem-porary with the emergence of self-conscious modernity in fine art is hardly news. But the branch of visual production that comes into being through the machines and apparatus of the media industry is quickly denigrated to a sta-tus of otherness in the history of modern art. Eclipsed and ignored, the prac-titioners of commercial visual culture sink from canonical view.

Maybe the way to think about Guys is as the mediator of modern life rather than as its painter. Visual modernism gains its impetus from the mass production and circulation of images, from the creation of new idioms within the print realm, from the creation of a public for whom visual refer-ences come to have a value because they exist in a domain of other images. These specific qualities are the result of media that extend the boundaries of visual culture beyond the province of fine art. The mediating function, that act of transformation into record through reproducible means of mass production, is a key feature of modernity. The presumption that images can be circulated widely changes their cultural role and broadens their stylistic vocabulary. Journalism serves a wide range of interests in the secular realm. Guys's images are consumer items that in many cases focus on consumption in the form of men's and women's fashions. And fashion is the guiding trope for ephemeral production in material culture.

Campbell's work gives Baudelaire's argument its contemporary form. He invokes art history, modernism's history, and an attitude toward image pro-duction that has been long present but much ignored: that modernity is visually coded through the productions of mass media as much as through

its fine art artifacts. Campbell's work, sitting as it does in a museum setting, creates a resonant link between the technological and cultural histories of modern visual form in both fine art and mass media realms. The wall of the museum has been turned into a screen that, like a new millennial window, gives us a glimpse of a world we want to believe still exists, the ordinary everyday life of the urban street. We can't rely on Campbell's screens as any guarantee of the ongoing existence of that world, only of its record and re-circulation as image. The faith that keeps us fascinated by the ghostly tran-sit of figures through his panels is the same faith that makes us believe, for a moment, that we are being given a live feed of contemporary existence. Live feed, an oxymoron, is one lie that Campbell exposes. The image is al-ready a reification, a record, at the point where it enters the video eye of the analog device that feeds the digital system its signal. The prosthetic effect differs only by degrees of technological intervention from the process by which the eye receives information processed by the retina and optic system to become a signal reencoded by the hand in a trace of graphite or ink. Im-agery is always mediating and mediated. The explicit condition of moder-nity remarked on by Baudelaire calls our attention to the ephemeral as well as the permanent quality of that record. Campbell is our Guys, a neutral journalistic eye, turning reportage into image through the filter of a specific subjectivity. The difference between a mechanical mediation (pencil, ink, printing plate and automated press) and a digital one is minimal. Both artists make use of the materials of mass media communication, giving us a glimpse of contemporary life through a medium specific to it.

Campbell's window/site produces a remote relation to the city of mod-ern life. Its method of display is both too crude and too refined for our per-ceptual apparatus, alien and seductive. In the aesthetics of its display a di-alogue between media and culture and traditions of fine art—the red and the black, print modes and reproductive technology, the readout and print-out frame of a realistic illusion—are all in play. From autonomy to contin-gency to complicity, we confront the embedded, entangled condition of all knowledge production visual or other. Campbell's work is not a window on the world, nor a mirror, but a produced mediation of the symbolic image of the once real. Integration and streaming virtuality create a Virilian vision machine whose subject production is without humanity. Or they create a ni-hilistic humanism, striving to recover a purpose for works of significa-tion—or to cover the aporia of "meaning" with a continual stream of in-

formation passing into aesthetic form as the pattern of bits through a compromising filter.

If Campbell's work reminds us that our sensibilities still draw on their modern origins, then it also demonstrates that new media and modes of production bring their own set of material possibilities into play. The mediated subjectivity of Campbell's work locates it at the intersection of individual and social experience. This recognition differentiates it from that of his predecessors in the nineteenth and early twentieth centuries. But he makes the mediating subject clear. And the result is that it demonstrates the capacity of visual art to perform an aesthetic act that marks itself as distinct from other discursive forms within the culture at large. He also shows how much we are still working through the theoretical frameworks on which modernism was founded.

By contrast, Raymond Pettibon's work has the raw edge of 'zine culture all over it.[102] In every stroke of graphic scratchiness or blotted line, the deliberately rough pen drawings evidence their break with academic drawing and realist traditions. Artful to the nth degree, his work speaks volumes on the capacity of individual subjectivity to register the lived experience of mediated culture. Few artists in our time have been so extensive in their capture and reinscription of the tropes and themes of visual media. Nothing escapes his unflinching eye. Murder, criminality, erotic violence, banality—all are of equal import, capable of serving as subject matter. Teen nudes, Gumby, a solider with a machine gun, a grinning woman in a terrible wig, naked figures proclaiming their sexual relations with the bland ennui of news commentators—Pettibon's vocabulary is as limitless as the range of materials encountered in newsstand browsing and channel surfing. But unlike the appropriating artists of two decades ago, Pettibon *draws* his images. His hand filters and transforms the vast catalog of found materials into a personal vision of the hellish life in which we all exist, hellish not by its systematic violence or perpetrated ills but by the chaotic randomness of events and irrational circumstances. Dark humor and the headlines of the daily news combine in his work, which consists of single panels, each a drawing, usually with text commentary or caption. Nothing is sacred. Nothing is out of reach. No material is taboo. No topic is to be avoided, censored, modified, or made easier to digest by his presentation. Raw aesthetics, uncompromising to an extreme, Pettibon's are the attitudes of flayed subjectivity throwing itself open to receive stimuli from the mass mediated world.

If Campbell sets up the window through which a mediated process registers, then Pettibon is the content provider extraordinaire. Limitless and abundant, his imagination grabs hold of any and every iconographic figure that crosses his retinal path. Streaming art, produced without compunction, Pettibon's may turn out to be the great inventory of our age. Black ink on white paper, an image of a lightbulb hanging bare, "Swung from the ceiling, the last light bulb. It made death brighter." Eyeballs, hands, dismemberment, sadism, surfing, playing guitar, and making it with groupies. The destructive nihilism of the content is countered by the vital drive of the pen and brush. Pettibon has a striking capacity to make image over into image, to transform into fresh statements experience made in relation to the mediated condition of existence. His work continually traces—literally, in the work of his hand—the place of subjective experience within that process. He is the artist qua remediator of the richly mediated material of contemporary visual culture.[103] His nihilism eschews a position of judgment. He sees, he draws, he writes, he makes, and in so doing, returns an image of contemporary experience through the realm of fine art.

CONCLUSION

Topics worth considering abound in the contemporary sphere of art production. Many touch on the changed relation with mass media culture or with the inventory of images and attitudes from the history of art. Others include the range of visual and material artifacts with which the act of art making exists in productive dialogue. The argument I have tried to make arises from these many observations and is simply that the critical frameworks inherited from the avant-garde and passed through the academic discourses of current art history are constrained by the expectation of negativity. Fine art should not have to bear the burden of criticality nor can it assume superiority as if operating outside of the ideologies it has long presumed to critique. Fine art, artists, and critics exist in a condition of complicity with the institutions and values of contemporary culture.

But not by accident did the final discussion here emphasize links between current works of art and the nineteenth-century formulation of modernism. Jim Campbell's mediations of the passing street scene in his work 5th *Avenue Cutaway #1* immediately suggest a contrast with the work of Baudelaire and Guys, whose intersecting sensibilities provided a touchstone in the history of visual modernity. The mediation of modern life into image shapes the world by providing a record, sketching what it is we are to know, provoking us to recollection in our social and personal memory. Like the observations of Baudelaire's flâneur, Campbell's images—mute, looped, and mediated—provide no hint of judgment. Moral grounds are absent. The mere fact of observation is the instigation for production. An impulse to see, look, and transform perception into image drives the work. Like his nineteenth-century predecessors, however, Campbell exploits the aesthetic properties of material form. His seductive use of the red lights of the digital screen engages our eyes with a hypnotic repetition of display. The work is alluring. Compelling. Artifice is everything in the instantiation of art. Where do we go from here?

Where we go is backward into the history of modernism. The zones of habitual exclusion are a good place to start: clearly marked as off-limits, evil territory, only to be approached wearing protective intellectual garb that render the susceptible spirit immune to temptations of so-called bad art. But what is meant by the "bad" objects of modernism? Figurative work, derivative abstraction, spiritually inspired imagery (whether abstract or representative), and works in a formulaic, illustrational style? For the history of visual (and literary) modernity is dominated by the attempt to render form in a condition of "purity" that eschews reference. The avant-garde, insofar as it has a formal language to aid its enterprise, borrows from the abstract, collaged, and formally esoteric vocabularies that mark the distance, now so differently observed, between zones of fine and commercial—or, alternatively, *consumable*—work. But the more insidious effect of this purification was the internal division within fine art and the condemnatory character that attached to its internal hierarchy.

Perhaps we should look again at those objects that are ill-suited to the critical tenets on which the "good" modern object has been long valued, to discover how and why they failed. For the legacy by which the characterization of good and bad faith comes to be constituted within the history of modern art is very much with us. Why is Gustave Moreau and the work

of decadent art in the late nineteenth century so clearly condemned, marked as interesting only because his pupils were so significant within the history of modernism? Other "unacceptable" objects litter the realms of decadence and symbolism: the figurative works of the Pre-Raphaelites, many of the most popular academic works or most *academic* popular works, and of course, realist work in the later nineteenth and early twentieth century in American, Russian/Soviet, British, and other contexts have been condemned to a critical limbo *as visual artifacts*—though the once-absolute stricture against serious consideration of their *modern* character has begun to relax.[1] That most successful twentieth-century figurative painter, Balthus, is persona non grata in the critical writings of academe or treated as a curiosity. Thomas Hart Benton is more often considered a figure for sociological study than an artist whose visual engagements with form define a modern aesthetic.[2] Examples abound. The principles of exclusion only need a few examples to be themselves laid as bare as modernism's other devices.

To take one example, the struggle to keep Winslow Homer's modern heroic paintings free from any taint of his illustrational past, to see the composition of the figure groupings in his watercolors as if they had no relation to the highly popular images he produced as illustrations, is perverse. Too often, a canonical artist's work is often divided into objects of good and bad faith, then, prescriptively, given aesthetic valuation in accord with this division. Thus, Homer's paintings of the sea, made late, in isolation, are read in accord with the quintessence of the heroic figure wrestling with the sublime and human fate in the face of nature, art, and problems of representation that verge on abstraction. This "real" Homer is projected as a frame in which we are to read the Caribbean watercolors and croquet paintings not as diversions, observations, artifice, or "mere artistry" but as tales of courage, struggle ("man" and nature), class, and colonialism. Obviously, the works are what we make of them. Mutable, complex, outside of Homer's own control, even in their making. What if, in fact, much of Homer's oeuvre is interesting precisely because it does not fit the frames of modernity as we have so often conceived it, but because of the ways it can extend our definition of what and how modern art looked and thus what it did as a means of cultural expression?

The red herring of debates about commercial and fine art used to police a boundary between work for hire and unpaid labor ring hollow in our world, rife as it is with commissions and prize money, calculated market

strategies and fine art venture capitalization. Still, the undirected invention of fine art has its own imperatives, distinct from the controls that pressure commercially driven undertakings. Moral integrity remains linked to the aesthetic virtues of an image as good faith remains linked to a noncommercial condition of creation, no matter how successful the outcome. Bad faith is conceived of as a compromised aesthetic from the outset. We know better, of course. On aesthetic, moral, and economic grounds, these lines of distinction are crisscrossed with contradiction.

For these tenets may be reordered dramatically when conceived not in terms of commerce but in the light of a program of aesthetic features. One might well produce, as William Morris did, works whose aesthetic credentials exhibited at every turn the peculiar features of a misconceived practice. For Morris's objects, in spite of his intentions to the contrary, are fraught with bad faith. Their visual forms are meant to embody and signal an attitude toward labor as craft that is undermined by every element of the production circumstances—use of photographic technology, creation of goods for a luxury market, a pseudo-medievalism that is as grotesquely anachronistic as a costume drama, the indulgent play of a private gentleman squire–socialist commanding resources for his own distracted ends. No one would dream of calling Morris a bad-faith artist. Rather, he is deemed a paradigm of correctness, but one whose work, for some reason, is simply "not interesting" as a formal contribution to our current sensibility. Nothing could be more wrongheaded. The work is precisely what is interesting and precisely because of the flaws it embodies and the challenges it poses.

Morris is no monster. Wickedness is not his mode. His spirit was engaged in full earnest. But it is not the less corrupt for that. Good intentions are not the wellspring of good art or even, sadly, of moral integrity in aesthetic objects. But the specific form of Morris's work has much to offer us once we let go of those judgments and look squarely at the assumptions on which they are based. And that is the point on which this discussion pivots.

Why invoke Morris in a discussion of late twentieth-century and early twenty-first-century art? The issues of good and bad faith, of the connections between aesthetic and moral integrity, of complicity—knowing and/ or unacknowledged, self-aware or self-deceptive—are intertwined with the entire history of modernity. The struggles of art to claim a higher purpose, and maintain a sacred precinct of secular activity "above" and "free from" the ideologies of commercial culture create endless complexities in our un-

derstanding of the positions from which we work now to understand that historical trajectory as part of and underlying our own condition.

The burden of current history resides in the charge to fine art to perform a task for which it is ill-suited: a moral function. Whether it can, should, would, may, might, or will—coercive expectations all in these various auxiliaries—depends not on the work but on the effects wrought in its reception, after the fact of production. Creativity conceived in didacticism rarely survives the dulling force of its own prescription. Art made to serve an agenda—moral, religious, critical, political, therapeutic—suffers from the limitations of those framing religiosities. Creative imagination must outstrip the program of its initial impulse, for that is where imagination lies— in a dynamic process of reimagining whose outcome is unknown in advance of the act.

With this stated, we can see that the conditions of contemporary art do not present a fall from an earlier state of modern purity. The history of modernism contains every feature of complicity described in the works that have received enthusiastic attention in this study.

Modernism, as I said earlier in this work, is not what the academy has made of it. Every instance of playful engagement, of serious exchange, of complex attraction and adoration and longing through which symbolic forms circulate in the social cultural world today, can be linked to antecedents. The creation of cultural capital for its own sake, the idea of art as idea, the notions of conceits and artifice, of figuring forth the world as an expression of insight or even of misunderstanding, the sense of inadequacy in the face of celebrity culture or the engines of new mass media and its spectacular capacity to enthrall through its bright vivid lights and tabloid intensity—these and many other tropes and tendencies all have their own past within the long history of modernism. The reification of value, the production of commodities, the idea of branding, the pyramid schemes of belief that create an economic structure of exchange, the cultivation of fame, the deliberate flaunting of immoral behavior, the self-styled "transgressive" activities, and also, submission to conformity, adherence to tenets of faith, virtue—instances of these, too, exist as precedents to their enactment in a current frame.

My project with contemporary art has been to shift the fulcrum on which the critical assessment of current practice is balanced. Here I show that the legacy of oppositional criticism, of a negative position claiming moral

superiority and distance from those ideologies in which fine art participates, can't be sustained any more. Mythic though they were, these belief systems do not accurately describe either our current condition or our past history. Modernism has yet to be fully understood and described, and visual modernism, of which fine art is but a part, not the whole, not even the dominating force, will be rethought for decades to come. The unblindered gaze, willing to inquire into the complicit relation between art and its ideological condition (of production, reception, evaluation, effect, even formal composition and conception), will find a rich and fertile field.

As I finish this final note, events around me reconfirm, again, the persistence of mythology. Successful bad-boy artists claim to have no interest in money and are scornful of success, while reaping the benefits of highly capitalized endeavors. Who pays? The sponsorship of art remains a matter of money and success, a matter of the whims of a complex market of ideas and trends and consumable positions embodied in objects of a rarified trade. No one is fooled or surprised by this. But the posturing continues. And it continues to be promoted as the nth degree of originality.

Pierre Huyghe, licensing the rights to a bit of intellectual property created by a Japanese animation company, turns the image of the little wide-eyed wire-frame girl image that he's purchased over to a selection of individual artists, each of whom helps contribute to her "liberation" from that original condition as proprietary matter. And then in a final conflagration, they set her image free. Incidental content? Or specific? What kind of symbolic gesture? Neither art nor capital are set free. The terms on which property relations are contracted can't be so easily dissolved.

Yves Klein, flinging gold into the Seine while he burned the signed contract for a zone of immaterial pictorial sensibility, already touched the essence of this arrangement half a century ago. Pointing out the contractual arrangement between art objects, their institutional and social scaffolding, and the economic values of art only reveals a structure. It does not reveal the substance, which, as I said at the very opening of this project, is *the art*.

We respond to work because of its aesthetic affect. Good, bad, repulsive, attractive, even indifferent—perception is not only structural, nor even only cultural, however situated and specific its circumstances. The processes of cognition stimulated through perception are linked to the very core of the way we imagine ourselves and the world. The contract to be investigated in its specificity is the dynamic relation between that symbolic figuring forth of

images and the conceptual understanding according to which we come to structure the very basis of perception. The purpose of the image is not to mean but to be, and in so being, to show the way we think we understand our lives and culture.

The work of criticism and historical study is to engage with the principles of art's conceits, to show its machinations, the how of its structuring dynamic, the nature of its artifices. For that constructedness is the artfulness, the art and the work of art, by which we are brought into engagement and awareness. The force of art is as Blake said it was, to open the doors of perception, not to herd thought and spirit into adherence to a campaign program or prescribed agenda.

I could end here with a sketch toward a new beginning. I could list many amazing and wonderful contemporary artists about whose inspiring work I have not had time or space to write here. The list would be a long one. Equally tempting is the desire to point toward major works within the history of modern art, beginning with the advent of romanticism, as works through which to rethink and recast our understanding of artistic forms and their purport in the modern period. Topics worth considering abound in both spheres. Many touch on reconceptualizing the relation between fine art and visual culture. Much has shifted and changed, but the function of art remains bound to the capacity of artists to make imaginative artifacts. Contemporary work is in active dialogue with the history of those symbolic forms through which we struggle to understand our individual and cultural condition. And it is also engaged in a complicated relation with the visual forms of media culture, art history, ethnic traditions, and technological invention. Aesthetic objects mark the differentiating line between individuality and a subsumed alignment with the status quo machines of cultural life—whether these come from the culture industry, the academy, the marketplace, or the marginal remnants of an outmoded avant-garde.

What is art? Now? We have only to open our critical eyes to find abundant opportunity to engage with the insights of ongoing artistic invention.

NOTES

PREFACE

1. Such a statement is so broad as to be nearly meaningless, but, to make my case, consider the vast literature of modernism outlined by conspicuous high-profile figures from Clive Bell, Roger Fry, Clement Greenberg, etc., through Rosalind Krauss, Michael Fried, Hal Foster, Benjamin Buchloh, et al. The very image of any of such persons confronted with Paul McCarthy's copulating Chuckee-Cheese-like characters may be amusing, but the notion of a critical tract as the outcome of such an encounter seems improbable, at best.

2. See Norman Bryson, *Calligram* (Cambridge and London: Cambridge University Press, 1988); Peter Brunette and David Willis, editors, *Deconstruction and the Visual Arts: Art, Media, Architecture* (Cambridge and New York: Cambridge University Press, 1994); Victor Burgin, *The End of Art Theory* (Atlantic Highlands, NJ: Humanities Press, 1986), for the late twentieth-century extension of formalist methods derived from Russian formalist sensibilities transmuted through the

lens of French theory, semiotics, and poststructuralism in the 1980s and early 1990s.

3. Abigail Solomon-Godeau, *Photography at the Dock: Essays on Photographic History, Institutions, and Practices* (Minneapolis: Minnesota University Press, 1991) provides numerous uses of the term "contingent" as a concept distinguishing postmodernism from modernism on the basis of these assumptions about the embedded nature of meaning production.

CHAPTER ONE

1. Edward Lucie-Smith, *Symbolist Art* (London: Thames and Hudson, 1972), 38.
2. Douglas Crimp, "Pictures," in Brian Wallis, ed., *Art after Modernism: Rethinking Representation* (New York and Boston: New Museum and David Godine, Publisher, Inc., 1984), 175–88.
3. Lynne Cooke, *Gerhard Richter's Atlas*. Available at http://www.diachelsea.org/exhibs/richter/atlas/essay.html.
4. Ibid.
5. Edgar Allen Poe, "The Philosophy of Composition," *Graham's Magazine* (1846): 163–67. See also Elizabeth Nelson, "Pictorial Interpretations of the Lady of Shalott," *Ladies of Shalott*, ed. George P. Landow (Providence, RI: Brown University Press, 1979).
6. Max Horkheimer and Theodor Adorno, *The Dialectic of Enlightenment* (New York: Continuum, 1994).
7. Pierre Huyge's acquisition and re-working of the Japanese anime figure is a good example of a piece that has been read as critical but seems to reinforce the economic value of trademark and brand image identity.
8. I went to art school in the years in which Newman, Pollock, and Nevelson were gods in a pantheon whose loftiest heights were occupied by the school of Paris and whose foothills were being peopled by the figures of Stella, Olitski, Serra, and company while Judy Chicago, Faith Ringgold, and Miriam Schapiro were banging on the doors and everyone, including the gatekeepers of criticism, were pretending they weren't there.
9. T. J. Clark, *The Image of the People: Gustave Courbet* (London: Thames and Hudson, 1973), and *The Absolute Bourgeois* (London: Thames and Hudson, 1973).
10. T. J. Clark, *The Painting of Modern Life* (New York: Knopf, 1985).
11. "If I can't have the proletariat as my chosen people anymore, at least capitalism remains my Satan." From a Web site review, at http://www.notbored.org/farewell.html. For introductory texts, see Tony Bennett, *Formalism and Marxism* (London and New York: Routledge, 1979); Eugene Lunn, *Marxism and Modernism*

(Berkeley, London, and LA: University of California Press, 1982); and Maynard Solomon, ed., *Marxism in Art* (Detroit: Wayne State University Press, 1979).

12. See Ernst Fischer, *The Necessity of Art: A Marxist Approach* (Baltimore: Penguin Books, 1963); Fredric Jameson, *Marxism and Form: Twentieth-Century Dialectical Theories of Literature* (Princeton: Princeton University Press, 1971); and Martin Jay, *The Dialectical Imagination: A History of the Frankfurt School and the Institute of Social Research, 1923–1950* (New York: Little, Brown, 1973) for critical overviews of this position in historical perspective.

13. Joseph Beuys is a striking example of an artist whose rhetoric (as a self-proclaimed "shaman" and the shockingly unified authority structure this invokes) is at odds with the critical spin applied by critics who see his "social sculpture" as a contribution to left-oriented "politics" in aesthetic terms. Heiner Stachelhaus, *Joseph Beuys* (New York: Abbeville, 1991).

14. For an account of the nineteenth century in this regard, see Stephen Eisenman, ed., *Nineteenth Century Art: A Critical History* (London: Thames and Hudson, 1994).

15. Clement Greenberg, "Avant-Garde and Kitsch," *Art and Culture* (Boston: Beacon Press, 1961), 8.

16. Peter Burger makes this point the core of his argument in *Theory of the Avant-Garde*, trans. Michael Shaw (Minneapolis: University of Minnesota Press, 1984).

17. *October*'s centennial issue roundtable discussion of the state of art criticism, the bemoaning of the perception that artists don't seem to "need" these critics, is a good example of the impasse to which I'm pointing.

CHAPTER TWO

1. "I always try to avoid individuality." Beecroft cited from http://www.clients.nyws .com/smock2/vanessa.htm (accessed July 2003). See also Roberta Smith for a summary of positions at http://www.yvonneforceinc.com/yfinew/smith.htm (accessed July 2003).

2. Sara Adams, "Vanessa Beecroft," at http://www.bbc.co.uk/arts/news_comment/ artistsinprofile/beecroft2.shtml

3. Foundacion Web site, exhibition curated by Julian Zugazagoitia, at http://www .proa.org/exhibicion/futuras.html.

4. See http://artnetweb.com/gesture.html for documentation.

5. *Aesthetics and Politics*, afterword by Fredric Jameson (London: Verso, 1977).

6. In "Modernism and Mass Culture," Thomas Crow summarizes the history of this argument. *Modern Art and the Common Culture* (New Haven: Yale University Press, 1996), 3–38.

7. Adams, "Vanessa Beecroft."

8. Abigail Solomon-Godeau, "Photography after Art Photography," in Brian Wallis, ed., *Art after Modernism: Rethinking Representation* (New York and Boston: New Museum and David Godine, Inc., 1984), 75–85.

9. I am referring here to Louis Althusser's "ideological state apparatuses" but modified to include cultural formations, discursive formations, and symbolic activity, which isn't linked directly to institutions of state/corporate power. The concept of "art" floats far more freely than does "church" in terms of an institutional base. Louis Althusser, *Lenin and Philosophy* (New York: Monthly Review Press, 1991).

10. It is a long-held tenet of Marxist art history that fine art is political even (and even *especially*) when it seems to be least political. I not only support this position but extend its inverse as a complementary premise: that the stated ideological position of art as a cultural formation can never be taken at face value, especially if it proclaims its own "political" value.

11. See Jean Baudrillard, *Simulations*, trans. Paul Foss, Paul Patton, and Philip Beitchman (New York: Foreign Agents Series, Semiotext[e], 1983).

12. This phrase comes from Victor Shklovsky's "Art as Technique" in *Russian Formalist Criticism: Four Essays*, ed. and trans. by Lee T. Lemon and Marian J. Reis (Lincoln: University of Nebraska Press, 1965), 4.

13. Even "immaterial" art ties itself to the object in some residual sense in order to guarantee a "value" through use of a placeholder of some kind. Yves Klein's "zones" of "immaterial pictorial sensitivity," in which collectors were given title to a zone of the immaterial, are the paradigmatic instances of this principle in action.

14. See Rick Bolton, *Culture Wars: Documents from the Recent Controversies in the Arts* (New York: New Press, 1992); Nina Felshin, *But Is It Art? The Spirit of Art as Activism* (Seattle: Bay Press, 1995); Carol Becker, *Zones of Contention: Essays on Art, Institutions, Gender, and Anxiety* (Albany: SUNY Press, 1996); and Camilla Gray, *The Russian Experiment in Art* (New York and London: Thames and Hudson, 1962) for a brief treatment of the Soviet period. For some important milestones in the reassessment of modernism and politics, see Francis Frascina, *Modern Art and Modernism: A Critical Anthology*, ed. Francis Frascina and Charles Harrison, with the help of Deirdre Paul (New York: Harper & Row, 1982); and Benjamin Buchloh, Serge Guilbaut, and David Solkin, eds., *Modernism and Modernity: The Vancouver Conference Papers* (Halifax: Press of the Nova Scotia College of Art and Design, 1983).

15. Bolton, *Culture Wars*; Becker, *Zones of Contention*; and Alan Wallach, *Exhibiting Contradiction: Essays on the Art Museum in the United States* (Boston: University of Massachusetts Press, 1998).

16. My point is not to denigrate the commitment to political change, to social trans-

formation through any and every possible means. My argument is with the attachment of a "political" valuation to an aesthetic activity like "informel," a concept that originated in a wave of post-WWII European abstraction before it was developed as a critical concept in which gestures of abjection were discussed in terms only comprehensible to a limited elite audience and largely supported by an obscure academic critical discourse. For whom is such work "political"—and even more, *how* is it political? What instrumentality does it have in the realm of power relations structured into the social and cultural domain?

17. Crow, "Modernism and Mass Culture," ends on this note.

18. Chris Jenks, "The Centrality of the Eye in Western Culture: An Introduction," in *Visual Culture*, ed. Chris Jenks (London and New York: Routledge, 1995), 1–25.

19. Raymond Williams, *The Politics of Modernism: Against the New Conformists* (London: Verso, 1989).

20. Not that this precludes or forecloses the possibility of progressive or radical politics, but it reconfigures the mythic description of the position of the artist.

21. Jean Fisher, ed., *Global Visions: Towards a New Internationalism in the Visual Arts* (London: Kala Press, 1994).

22. Kobena Mercer, "Black Art and the Burden of Representation," *Third Text* (spring 1990): 61–78.

23. Thanks to Kristine Stiles, in her reading of this manuscript, for this thought.

24. Though they expressed enthusiasm for the text I sent them from this section, Kilimnik's gallerists refused to allow me to reproduce the image for reasons best know to themselves or the artist. Their decision works to confirm, rather than undermine, my argument. See *Artforum* (December 1998).

25. Richard Prince informed me that Cameron Diaz's lawyers filed a suit against him for this ad, and so he said he didn't think it prudent to reproduce this image again. Given the argument that follows in my text, all this is quite wonderfully apt, and I refer the reader to the original ad in *Artforum* (December 1998).

26. Solomon-Godeau, "Photography after Art Photography," described Prince's work thusly: "a shared propensity to contest notions of subjectivity, originality and, most programmatically in the work of Levine and Prince, authorship" (80).

27. Writing about the cult of Diana and the publication edited by Mandy Merck from which this image is taken (*After Diana: Irreverent Elegies* [New York and London: Verso, 1998]), Emily Nussbaum counters this received critical radical attitude (embodied for her in the negative cynicism of Christopher Hitchens) characterizes Di's mythic image as a demonstration of false consciousness by celebrating the production and perpetration of this icon of martyred royal innocence.

28. Emily Nussbaum, "Jaundiced Di's," *Artforum* 37, no. 34 (December 1998): 20.

29. Clement Greenberg, "Avant-Garde and Kitsch" (1939), is the founding text, of course. See *Art and Culture* (Boston: Beacon Press, 1961). For a contrasting attitude, see Brenda Jo Bright and Liza Bakewell, eds., *Looking High and Low: Art and Cultural Identity* (Tucson: Arizona University Press, 1995).

30. Robert Hughes's comments on Andy Warhol are an excellent example of this. Located in "The Rise of Andy Warhol," in *Pop Art*, ed. Steven Henry Madoff (Berkeley and Los Angeles: University of California Press, 1997), 375–384, Hughes discusses the ways Andy Warhol criticism has created a mythically "political" figure are to the point here: "especially in Germany, where, by one of those exquisite contortions of social logic in which the Bundesrepublik seems to specialize, Warhol's status as a blue chip was largely underwritten by Marxists praising his 'radical' and 'subversive' credentials" (380).

31. I tend to refer to this as the "October" position, but *Critical Inquiry, Representations, Documents,* and any number of other publications that are the venue for academic critical writing continually rehash this stance in their endless reconsiderations of Walter Benjamin, Theodor Adorno, and the Frankfurt School, which in its latter day interpreted condition is a mainstay of academic self-justification. My objection isn't to the original authors or their texts but to the institutionalization of a supposed avant-garde oppositional discourse within a highly academic one.

32. Atlanta: Contemporary Art Center, exhibition catalog, May 5–June 17, 2000.

33. Roger Fry, *Vision and Design* (London: 1920); and see sections from Fry's "An Essay in Aesthetics" (1909) in Charles Harrison and Paul Wood, eds., *Art in Theory, 1900–1990* (Oxford, Cambridge, MA: Blackwell, 1992), 78–95. Like the work of Clive Bell, this was highly influential, with a parallel in literature in new criticism.

34. For an introductory overview, see Bennett, *Formalism and Marxism;* Jameson, *Marxism and Form;* and Victor Erlich, *Russian Formalism: History, Doctrine* (New Haven: Yale University Press, 1981).

35. Discussions of Sherrie Levine's work provide a good example. The critical discussion of her appropriated "re-photographings" and of her "neo-geo" images were disconnected from the experience provided by the work. Specialized knowledge had to be provided in copious amounts before the import of those works was clear.

36. Recent calls, particularly those of Dave Hickey, for a return to "beauty," only reduce this issue to a grotesque misperception of what is at stake. By contrast, David Summers's focus on the term "facture" as a fundamental point of departure for interpretation of any work of art in any context is precisely the move I have in mind. Where Hickey uses beauty as a partisan bludgeon against the conceptual infidels, Summers invokes facture as a touchstone to the complex of

forces and social and historical conditions of production and reception that are always embodied in a material artifact.

37. Nina Felshin, ed., *But Is It Art? The Spirit of Art as Activism* (Seattle: Bay Press, 1995), anthologizes work in an activist vein that extends conceptual investigations of the institutions borders and boundaries of fine art.

38. Douglas Crimp, *On the Museum's Ruins* (Cambridge: MIT Press, 1993) is a collaboration with Louise Lawler; Barbara Bloom, *The Reign of Narcissism: Guide Book, Fuhrer* (Stuttgart: Württembergischer Kunstverein, 1990); Trudy Wilner Stack, *Art Museum: Sophie Calle, Louise Lawler, Richard Misrach, Diane Neumaier, Richard Ross, Thomas Struth* (Tucson: Center for Creative Photography, 1995); Kerri Sakamoto, *James Luna: Indian Legends*, 1 (Banff, CA: Walter Phillips Gallery, 1993); Patterson Sims, *The Museum: Mixed Metaphors, Fred Wilson* (Seattle: Seattle Art Museum, 1993); Lynne Cooke and Karen Kelly, eds., *Ann Hamilton: Tropos* (New York: DIA Center for the Arts, 1995).

39. For an example, see Miwon Kwon, "For Hamburg: Public Art and Urban Identities" (http://www.art-omma.org/issue6/text/kwon.htm/). Her comments on the project curated by Mary Jane Jacob, "Places with a Past," and on the Sculpture Projects in Muster in 1997 are insightful with respect to the usefulness of aesthetics to the tourist industries. The implication is that somehow another responsibility *should* be borne: "considerable urgency in distinguishing between the cultivation of art and places and their appropriation for the promotion of cities as cultural commodities." Why should this be so? Many assumptions about consumption, the health of cities, and role of fine art underlie her position.

40. Louis Althusser, *Lenin and Philosophy* (New York: Monthly Review Press, 1971), 133.

41. The appearance and success of the periodical *Third Text* is indicative.

42. The critical reception of Benjamin Buchloh's "Figures of Authority, Ciphers of Regression," *October* 16 (spring 1981): 36–68, is a striking example of the influence of this attitude and of the peculiar blindness of its approach. The status and influence of this essay are in part due to its inclusion in the Brian Wallis anthology, which established many crucial critical positions: *Art after Modernism: Rethinking Representation* (New York: New Museum of Contemporary Art, 1984), 106–107.

43. The very first paragraph of Tom Crow's much cited and anthologized essay, "Modernism and Mass Culture," betrays the prejudice of fine art against the objects of mass production in his use of terms like "seductive and nauseating," "cheap," and "low," to describe popular images. Thomas Crow, "Modernism and Mass Culture in the Visual Arts," in *Modern Art in the Common Culture* (New Haven and London: Yale University Press, 1996), 3–39. As a contrast to this tra-

dition, see Jenks, *Visual Culture*; and also my "Who's Afraid of Visual Culture?" *Art Journal* 58, no. 4 (winter 1999): 36–47, quotations on 3, 26, and 28.

44. Catherine Gudis, ed., *Forest of Signs: Art in the Crisis of Representation* (Cambridge, MA: MIT Press, 1989), provides one useful catalog of what had become the canon of 1980s postmodernism.

CHAPTER THREE

1. For three useful reviews, see Stephen David Ross, ed., *Art and Its Significance: An Anthology of Aesthetic Theory* (Albany: SUNY Press, 1984); Monroe Beardsley, *Aesthetics from Classical Greece to the Present: A Short History* (NY: Macmillan, 1966); and Bertrand Russell, *A History of Western Philosophy* (NY: Simon and Schuster, 1945).

2. Beardsley, 89–98.

3. Paul Guyer, *Encyclopedia of Aesthetics* (Oxford and New York: Oxford University Press, 1998), s.v. "Baumgarten, Alexander Gottlieb."

4. H. B. Nisbet, *Encyclopedia of Aesthetics*, s.v. "Gotthold Lessing."

5. Margaret A. Rose, *Marx's Lost Aesthetic: Karl Marx and the Visual Arts* (Cambridge: Cambridge University Press, 1984), 5–23.

6. Rose, *Marx's Lost Aesthetic*.

7. "Has not imitation been shown by us to be concerned with that which is thrice removed from truth?" Plato, *Republic*, book 10, quoted in Ross, *Art and Its Significance*, 39.

8. Rensselaear Lee, *Ut Pictura Poesis: The Humanistic Theory of Painting* (NY: W. W. Norton, 1967).

9. "The avant-garde poet or artist tries in effect to imitate God by creating something valid solely on its own terms, in the way nature itself is valid." Greenberg, "Avant-Grade and Kitsch," 6.

10. Wassily Kandinsky, *Concerning the Spiritual in Art*, trans. M. T. H. Sadler (New York: Dover Press, 1977).

11. See Terry Eagleton, *The Ideology of the Aesthetic* (Oxford and Cambridge, MA: Blackwell, 1990), 70–101.

12. G. W. F. Hegel, *Esthetics*, vol.1, translated by T. M. Knox (Oxford: Clarendon Press, 1975), 518, cited in Peter Bürger, *Theory of the Avant-Garde* (Minneapolis: University of Minnesota Press, 1984), 92.

13. See Arthur Danto's suggestions for reading Hegel's pronouncement in philosophical versus cultural terms in *After the End of Art: Contemporary Art and the Pale of History*, Bollingen series, 35, no. 44 (Princeton: Princeton University Press, 1997), especially "Three Decades after the End of Art," 21–39.

14. The autobiographical voice of Samuel Taylor Coleridge, *Biographia Literaria; or, Biographical Sketches of My Literary Life and Opinions* (1817), is a landmark, as is the

important anthology edited by Coleridge and William Wordsworth, *Lyrical Ballads* (Bristol: Biggs and Cottle, 1798), which initiated the Romantic movement in British poetry.

15. William Blake, *Jerusalem: The Emanation of the Giant Albion*, ed. Morton Paley (1827; Princeton: Princeton University Press, 1991), chapter 1, plate 5.

16. Konrad Fiedler, *Über der Ursprung der Kunstlerischen Tatigkeit* (1887).

17. Maurice Denis, "Definition of Neo-traditionism" (1890), in Herschel B. Chipp, comp., *Theories of Modern Art: A Source Book by Artists and Critics* (Berkeley: University of California Press, 1968), 94.

18. Michel Seuphor, *Abstract Painting: Fifty Years of Accomplishment, from Kandinsky to the Present*, trans. Haakon Chevalier (NY: Abrams, 1962), cover copy.

19. Seuphor, *Abstract Painting*, 33.

20. Seuphor, *Abstract Painting*, 15.

21. See Victor Burgin, *The End of Art Theory: Criticism and Postmodernity* (Atlantic Highlands, NJ: Humanistics Press International, 1986); Serge Guilbaut, *How New York Stole the Idea of Modernity* (Chicago: University of Chicago Press, 1983); Yve-Alain Bois, *Painting as Model* (Cambridge, MA: MIT Press, 1993); and Briony Fer, *On Abstract Art* (New Haven and London: Yale University Press, 1997).

22. Jerome McGann, *Dante Gabriel Rossetti and the Game That Must Be Lost* (London and New Haven: Yale University Press, 2000), 32.

23. Clive Bell, *Art* (1913; reprint, New York: G. P. Putnam's Sons, 1958).

24. Clement Greenberg, "Modernist Painting," in Francis Frascina and Charles Harrison, eds., *Modern Art and Modernism: A Critical Anthology* (NY: Harper & Row, 1982), 5–10.

25. Greenberg, "Avant-Garde and Kitsch."

26. William Camfield, "Marcel Duchamp's *Fountain*," in Rudolf Kuenzli and Francis M. Naumann, *Marcel Duchamp: Artist of the Century* (Cambridge, MA: MIT Press, 1989), 66–94.

27. The phrase served as the title of Joseph Kosuth's 1966–67 series, Art as Idea as Idea. See Kosuth, *Art after Philosophy: Collected Writings, 1966–90*, ed. Gabriele Guerico (Cambridge, MA: MIT Press).

28. Writing with respect to Picasso and Braque nudes, Seuphor says they made "no effort to be recognizable as such. These works ask the viewer to consider only the elements of painting as painting" (*Abstract Painting*, 10).

29. The lines between these two positions are not always clearly drawn—as in the case of Kandinsky, for example, while in other cases partisans align strictly on one side or another.

30. Renato Poggioli, *The Theory of the Avant-Garde* (Cambridge, MA: Belknap Press, 1968); and Bürger, *Theory of the Avant-Garde*.

31. Bürger, *Theory of the Avant-Garde*, 90.

32. Some examples: Aleksandr Rodchenko, Bertolt Brecht, communist surrealism, in the first instance; Walter Benjamin, Max Weber, and Ben Shahn, as instances of the second; and Greenberg in the late 1930s as the third.

33. Theodor Adorno, *Aesthetic Theory*, trans. Robert Hullot-Kentor (Minneapolis: University of Minnesota Press, 1997); and Lambert Zuidervaart, *Adorno's Aesthetic Theory: The Redemption of Illusion* (Cambridge, MA: MIT Press, 1994), 35–36.

34. Zuidervaart, *Adorno's Aesthetic Theory*, 40.

35. Zuidervaart, *Adorno's Aesthetic Theory*, 42.

36. Raymond Williams, *Marxism and Literature* (Oxford: Oxford University Press, 1977).

37. The distinction between "totalized" and "whole" is that the former implies a logical systemic unity locking all elements of culture into a single hierarchical set of relations according to the configuration of power set by the material base, while the latter, "whole," is a cumulative effect of disparate and interrelated but separately functioning arenas or components, each of which is capable of generating and working from its own material base—some of which may, in fact, be generated symbolically.

38. Solomon-Godeau, *Photography at the Dock* or the implied position of Craig Owens, Douglas Crimp, and even Rosalind Krauss, as much as she is able to actually engage with postmodernism given her modern, formalist orthodoxy.

39. For crucial reflections on modernism and its relation to mass culture and industrial models of production, see Yve-Alain Bois, "Painting the Task of Mourning," in idem, *Endgame: Reference and simulation in recent painting and sculpture; September 25–November 30, 1986* (Boston: Institute of Contemporary Art; and Cambridge, MA: MIT Press, 1987), 29–49; Thomas Crow, "Modernism and Mass Culture in the Visual Arts," *Modernism and Modernity: The Vancouver Conference Papers*, ed. B. H. D. Buchloh, S. Guilbaut, and D. H. Solkin (Halifax: Press of the Nova Scotia College of Art and Design, 1983); Meyer Schapiro, "Abstract Painting," *Modern Art: Nineteenth and Twentieth Century (Collected Papers)* (New York: Braziller, 1978), 185–232.

40. Ellen Wiley Todd's fine study, *The "New Woman" Revised: Painting and Gender Politics on Fourteenth Street* (Berkeley and LA: University of California Press, 1993) is a good example of the social history orientation Americanists often bring to their work. Adele Heller and Lois Palken Rudnick, eds., *1915: The Cultural Moment: The New Politics, the New Woman, the New Psychology, the New Art and the New Theatre in America* (New Brunswick: Rutgers University Press, 1991) is another. No argument for the formal contribution of American realism to the modern idiom of visual art is made in these pages in spite of extensive discussion of the artworks—which are treated as documents.

41. Kirk Varnedoe, *High and Low: Modern Art and Popular Culture* (NY: Museum of Modern Art, 1990) is the caricature of this sensibility. All works of "fine art" were displayed in this exhibit on walls across from works of "low" culture, no doubt to prevent pollution. Lines were rarely more tightly drawn.

42. I'm parodying Thomas Crow's lines in "Modernism and Mass Culture."

43. Benjamin Buchloh, in a roundtable in *October* 100 (2002), bemoans the passing of "the traditional assumption that artistic practices supposedly generate a critical, if not utopian, dimension of experience." Cited by David Rimanelli in *Artforum* XL, no.10 (summer 2002): 29. An anecdote to support this: Buchloh once told a studio artist she couldn't use collage as a formal method because it was a political method.

44. My use of the term "modern" in this context is meant to invoke the academic critical paradigm, not the broader cultural or artistic realm much eclipsed by the mainstream discourse.

45. Danto, *After the End of Art* , 24.

46. Nothing is ever this simple, and it is the generalized perception of this canonical domination rather than the reality to which I am referring.

47. Sohnya Sayres et al., *6os without Apology* (Minneapolis: University of Minnesota Press in cooperation with Social Text, 1984).

48. Lucy Lippard, *A Different War: Vietnam in Art* (Seattle: Real Comet Press, 1990), provides some insight into the dissatisfactions of fine artists with the received tradition of modern abstraction.

49. See Frascina and Harrison, *Modern Art and Modernism*; also Beth Handler's work in progress; and Amy Ingrid Schlegel, "Codex Spero: Feminist Art and Activist Practices in New York since the Late 1960s" (Ph.d. diss., Columbia University, 1997).

50. Norma Broude and Mary Garrard, *The Power of Feminist Art: The American Movement of the 1970s; History and Impact* (NY: Abrams, 1994) for essays giving an account of this period.

51. Corinne Robins, *The Pluralist Era: American art, 1968–1981* (NY: Harper & Row, 1984).

52. Lucy Lippard, *Mixed Blessings: New Art in a Multicultural America* (NY: Pantheon, 1990) details a contemporary sweep of diverse practices.

53. Amelia Jones, *Postmodernism and the En-gendering of Marcel Duchamp* (Cambridge: Cambridge University Press, 1994), and *Sexual Politics: Judy Chicago's Dinner Party in Feminist Art History* (Los Angeles and Berkeley: UCLA, and Armand Hammer Museum of Art and Cultural Center in association with University of California Press, Berkeley, 1996).

54. This includes most art historians trained in current academic programs. As for

Danto, he gives himself away when, in trying to analyze the general pluralism of which he speaks, he leaves out feminism and the women's art movement. An astonishing move with respect to the 1970s!

55. Danto, *After the End of Art*, 13.

56. Erika Doss, *Twentieth-Century American Art* (Oxford and New York: Oxford University Press, 2002), and Benton, *Pollock, and the Politics of Modernism: From Regionalism to Abstract Expressionism* (Chicago: University of Chicago Press, 1991).

57. The reference is to Thierry de Duve, *Pictorial Nominalism on Marcel Duchamp's Passage from Painting to the Readymade* (Minneapolis and Oxford: University of Minnesota Press, 1991).

58. Jean Baudrillard, *For a Critique of the Political Economy of the Sign* (St. Louis: Telos Press, 1981).

59. Hal Foster, "For a Concept of the Political in Art," in *Recodings: Art, Spectacle, Cultural Politics*, ed. Hal Foster (Seattle: Bay Press, 1985), 139–56. Foster struggled to preserve some notion of political efficacy without relying on outmoded models of culture and art practice which came from the classic avant-garde (in its oppositional/instrumental or its resistant/preservative forms).

60. Foster, *Recodings*, 147

61. Hal Foster, *The Return of the Real: the Avant-Garde at the End of the Century* (Cambridge, MA: MIT University Press, 1996).

62. Francesco Bonami, ed., *Echoes: Contemporary Art at the Age of Endless Conclusions* (NY: Monacelli Press, 1996), in particular, Jeffrey Rian's "The Generation Game," 24–83, provides one landmark.

CHAPTER FOUR

1. Michael Duncan, "A Better Mouse Trap," *Art in America* (January 1997): 82–87, quotation on 82.

2. John Miller, "Jason Rhoades," *Artforum* (January 1994): 86.

3. Miller, "Jason Rhoades," 86.

4. Adorno, *Aesthetic Theory*; Crow, "Modernism and Mass Culture," and sources therein, particularly Meyer Schapiro and Clement Greenberg. The Crow article was originally published in *Modernism and Modernity: The Vancouver Conference Papers*, ed. Benjamin Buchloh, Serge Guilbaut, and David Solkin (Halifax: Press of the Nova Scotia College of Art and Design, 1983), 215–64 and then reprinted in Francis Frascina, ed., *Pollock and After* (New York: Harper & Row, 1985), 233–66.

5. At a point in which the need for labor was particularly high—as in various moments of nineteenth-century industrialization on the mass scale—such an opposition of course works in favor of the capitalist since it establishes a low premium for individual laborers (whose work is granted value as generic by its

opposition to the skilled, rarified, fetishized labor of an artist—with "artisan" as the absent, other term in this complex dynamic).

6. Intentionality hardly matters. The issue is not whether Rhoades was intuitively able to perceive these issues or simply, through artistic gifts, was able to reify a current issue—such ideas would assume the work is inherently significant. What is significant is that Rhoades's work gained critical currency, thus showing its viability and use as a term of aesthetic signification.

7. Obviously this paraphrases the work of Adorno in its analysis of the "autonomous" object of art as ideological—and of autonomy as the condition that allows art, by not seeming to be ideological, to in fact serve an ideological function that much more effectively. Theodor Adorno, *Aesthetic Theory*, trans. C. Lenhardt (London: Routledge and Kegan Paul, 1984), 1; and Lambert Zuidervaart, *Adorno's Aesthetic Theory* (Cambridge, MA: MIT Press, 1994), 28–43. But there is a crucial difference in my point of view—as much the result of a historical change as of a critical one. Very simply, my conviction that art is a culture industry, rather than being opposed to it. This uncomfortable but incontrovertible conviction informs every section of my discussion.

8. Roxana Marcoci, "The Anti-Historicist Approach: Brancusi, 'Our Contemporary,'" *Art Journal* 59, no. 2 (summer 2000): 18–35, see particularly the exchange with Rhoades (34).

9. See Jonathon Fireberg, *Art Since 1945: Strategies of Being* (Englewood Cliffs: Prentice Hall, 2000), which has as the premise of its approach the celebration of individuals. Deconstruction notwithstanding, such is the usual approach.

10. Arthur Danto, "Dislocationary Art," *Nation* 254, no. 1 (January 6/13, 1992): 29–32. The entire citation reads, "Her alternation is what Alex, in *A Clockwork Orange*, calls 'The old in-and-out'" (21).

11. Barnett Newman, "The Sublime Is Now," *Tiger's Eye* 6 (December 1948): 51–53.

12. Barnett Newman, *Selected Writings and Interviews*, ed. John P. O'Neill, texts, notes, and commentaries by Mollie McNickle, introduction by Richard Schiff (Berkeley and Los Angeles: University of California Press, 1992), 112. I have drawn on the work of J. Edgar Baeur, "Barnett Newman: Iconoclasm, *Heilsgeschichte* and the 'Modern Mythology,'" paper presented at the Center for Studies on New Religions 2001 Conference, London School of Economics, available at http://www.cesnur.org/2001/london2001/bauer.htm.

13. Newman, *Selected Writings and Interviews*, 154

14. Merrily Kerr, "Gary Simmons: If These Walls Could Talk," *Flash Art* 228 (January–February 2003), traces Simmons's work from installations of the early 1990s to his current "erasure" mode in relation to the shifting attention to discourses of multiculturalism and identity politics in the period. Simmons's earlier work made explicit reference to African American issues. Kerr suggests the acts of

"erasure" in the current pieces enact their own critical commentary about the fate of these concerns in the fashion trend of art world attention.

15. Gary Simmons, interview with Franklin Sirmans for a press release for the Chicago Museum of Contemporary Art survey of his works. Available at http://www.mcachicago.org/MCA/About/Press/releases/gary_simmons.html.

16. Jerome McGann punningly termed this impulse "subtract expressionism," personal communication, August 2003.

17. Peter Galassi, "Andreas Gursky," http://www.moma.org/exhibitions/2001/gursky/gursky2.html.

18. Johanna Drucker, "Area of Denial" *Provincetown Arts* 10 (1994): 96–97.

19. Mira Schor, "Figure/Ground," in *Wet: On Painting, Feminism, and Art Culture* (Durham: Duke University Press, 1997), 144–45. On Richter, see Benjamin Buchloh, "Interview with Gerhard Richter," trans. Stephen P. Duffy, in Roald Nasgaard, *Gerhard Richter Paintings*, ed. Terry A. Neff (London and New York: Thames and Hudson, 1988), 21–29.

20. Schor, *Wet*, 154.

21. "I want to engage with the metaphorically expressive possibilities of the materiality of painting, trusting in the complexity of visual language, in order to reinvest painting with the energy of different politics, a politics of difference, and a different eroticism than that of the monocular penis." Schor, *Wet*, 154.

22. She finds it "almost sinister" that women artists would align themselves unquestioningly with a wholesale rejection of visual pleasure because "continued assertions *by* men of painting as the sole domain *of* men because of its connection to male eroticism or because of the *nature* of male eroticism."

23. Drawing on the work of Klaus Theweleit, *Male Fantasies*, trans. Stephen Conway, 2 vols. (Minneapolis: University of Minnesota Press, 1987–89), which achieved a certain popularity in the late 1980s and early 1990s, Schor articulates the masculine "fear of fluidity and bodily materiality."

24. Laura Mulvey, "Visual Pleasure and Narrative Cinema," in *Screen* 16, no. 3 (fall 1975): 6–18.

25. Schor, *Wet*, 66.

26. *Art in America* (January 1997): inside front cover.

27. Pearlstein's career could be usefully contrasted with that of any number of feminist painters, for instance, Joyce Kozloff, Susan Rothenberg, and Miriam Schapiro, all of whom have engaged in a similar tension between figuration and abstraction.

28. Not every critic would agree with my statement about Pearlstein on this point.

29. Other areas in which critical paradigms of postmodernism emerged exist, of course, but the widespread influence of the anthologies edited by Brian Wallis and Hal Foster, *Art after Modernism* (Boston and NY: David Godine and New Mu-

seum, 1984), and *The Anti-Aesthetic* (Seattle: Bay Press, 1983), respectively, fostered a particular critical formation.

30. Benjamin Buchloh, "Figures of Authority, Ciphers of Regression" (1981), reprinted in *Art after Modernism: Rethinking Representation*, ed. Brian Wallis (New York, New Museum, 1984), 120.

31. A position completely endorsed by Rosalind Krauss and other members of the *October* group as a way to characterize the highly privileged—but highly circumscribed and rule bound—concept of the visual within modern art.

32. Douglas Crimp, "The End of Painting," *October* 16 (spring 1981): 69–86; Craig Owens, "The Allegorical Impulse," *October* 12 (spring 1980): 67–86 and 13 (summer 1980): 59–80; and Thomas Lawson, "Last Exit: Painting," *Artforum* 20, no. 2 (October 1981): 40–47.

33. As David Carrier so aptly put it in a recent review, in this critical approach art is divided into "good" objects and "bad." The former category is reserved for those pieces that conform to the political critique and the other for those that are either oblivious or complicit or that have other agendas.

34. Buchloh, "Interview with Gerhard Richter."

35. Thomas Crow, "Ross Bleckner, or the Conditions of Painting's Reincarnation," *Modern Art in the Common Culture* (New Haven: Yale University Press, 1996), 111–130.

36. Leo Steinberg, "Other Criteria," in *Other Criteria: Confrontations with Twentieth-Century Art* (New York: Oxford University Press, 1972), 55–91.

37. This isn't the only unacceptable form of painting—the other, addressed below, is unacceptable for other reasons and is what I refer to as painting as a "conceptual medium."

38. Misko Suvakovic, "Painting after Painting: The Paintings of Susan Bee," *M/E/A/N/I/N/G: An Anthology of Artists' Writings, Theory, and Criticism*, ed. Susan Bee and Mira Schor (Durham: Duke University Press, 2000), 46–53, quotation on 52.

39. Other painters play with some of the same issues and tropes: Jane Hammond's elaborately synthetic painted collages, for instance, or Fiona Rae's virtuoso brushwork.

40. Suvakovic, "Painting after Painting," 52.

41. Curated by Jeanette Ingberman and Papa Colo, November 2–January 25 1991, the exhibit included, among others, Jimmie Durham, Ida Applebroog, Luis Camnitzer Juan Downey, Ming Fay, Jerry Kearns, Guillermo Gomez-Pena, David Hammons, Juan Sanchez, Cecilia Vicuna, Martin Wong, Ida Applebroog, Ursula von Rydingsvard, and Krzysztof Wodiczko.

42. Stacy Alaimo, "Multiculturalism and Epistemic Rupture: The Vanishing Acts of Guillermo Gomez-Pena and Alfredo Vea Jr. (Critical Essay)" *MELUS* (summer 2000). The docents invited viewers to ask for an 'authentic dance,' a 'story in Guatinaui,' or a Polaroid photo, thus encouraging the audience to act out their

racist and colonialist desires. As it turned out, the audience needed little encouragement. Few audience members were actually self-conscious about their own reactions. In fact, as Fusco explains, a 'substantial portion of the public believed that our fictional identities were real ones' (37). Some spectators, to the horror of others, happily paid for a dance or a story, fed the male a banana through the bars of the cage, and had their picture taken with the natives." At http://www.findarticles.com/cf_dls/m2278/2_25/67532180/p9/article.jhtml.

43. See section entitled "Techno-Bodies and Art Culture" below.

44. The term "objecthood" refers to Michael Fried's essay of 1965, written in response to the sculpture and critical position taken by a number of artists for whom Donald Judd's 1963 "Specific Objects" served as a defining moment.

45. See an image of this at http://www.danielwiener.com/sculpture/50tree.html.

46. This description in partially paraphrased from remarks made by dealer Deven Golden, whose gallery exhibition Thing in September 1996 partially inspired my interest in this work.

47. See Johanna Drucker, "Collaboration without Object(s) in the Early Happenings," Art Journal 52, no. 4 (winter 1993): 51–58.

48. Sense and Sensibility: Women Artists and Minimalism in the 90s, curated by Lynn Zelavansky at the Museum of Modern Art, New York, June–September, 1994.

49. Courtenay Smith, "Blunt Object," in Blunt Object, 11 September–25 October 1998 exhibition catalog (Chicago: David and Alfred Smart Museum of Art, 1998).

50. In the first version of this argument, given as a talk at the Smart Museum in October 1998, it was suggested by an audience member that such literal interpretation might map an interesting demographic reading of the work. I disagree, since it seems clear that these objects are being used for their cheapness, generic-ness, and ready availablity rather than for some critically pointed or didactic purpose.

51. Smith, "Blunt Object."

52. Bertrand Russell's summary of Aristotle's positions is succinctly cited: "We may start with a marble statue; here marble is the matter, while the shape conferred by the sculptor is the form." He goes on to emphasize, however, that "'form' does not mean 'shape'" in a reductive or literal sense, but in the sense of defining border and delimited identity." Bertrand Russell, A History of Western Philosophy (NY: Simon and Schuster, 1945), 165–66. Russell summarizes Aristotle thusly: Form is "more real than matter"—and a form can exist, as per Plato's notion of idea, outside of matter (166).

53. Thomas Demand, Richard Billingham, Gregory Crewdson, Sophie Calle, Urs Lüthi, and Deborah Mesa-Pelly come to mind, among others, in a very long list.

54. See Kevin Robins, Into the Landscape: Culture and Politics in the Field of Vision (London

and New York: Routledge, 1996); William J. Mitchell, *The Reconfigured Eye: Visual Truth in the Post-Photographic Era* (Cambridge, MA: MIT Press, 1992); and Fred Ritchin, *In Our Own Image: The Coming Revolution in Photography* (New York: Aperture, 1990). Struck by how far apart these discussions have remained, I was interested to see what kind of result can be produced by putting the work of Florian Rötzer, Humbertus Amelunxen, Martin Lister, and/or Kevin Robins—all theorists of the digital—next to that of John Roberts, an orthodox practitioner of photographic criticism. Roberts's credentials are within the British late Marxist critical realm, his specific interests focus on conceptual work. His work has helped redefine the historical parameters—and theoretical premises—for an understanding of photography as a conceptual medium. Thus informed, he seems particularly apt as a figure through whom to forge the connection I am suggesting.

55. John Roberts, *The Art of the Interruption: Realism, Photography, and the Everday* (Manchester: Manchester University Press, 1998).

56. Hubertus v. Amelunxen, Stefan Iglhaut, and Florian Rötzer, in collaboration with Alexis Cassel and Nikolaus G. Schneider, *Photography after Photography: Memory and Reproduction in the Digital Age* (Amsterdam: G & B Arts, 1996); and Martin Lister, ed., *The Photographic Image in Digitial Culture* (London and New York: Routledge, 1995).

57. Roberts goes on to say, and in so doing escaping the defeatism of the post-1968 political climate, that the solution is to take knowledge to those who can use it—specifically, the middle-class professionals who constitute an organized political block. Whatever the flaws and virtues of this argument, Roberts's conclusion stops short of criticizing the conceptual limits of the photographic document within the aesthetics of high art—where it occupies the extreme position on a spectrum privileging positivist opticality. His account leaves out the photorealist work of the 1960s, with its claims to encoding a visual mode as a cultural norm, and the more esoterically "un"-photographic works of conceptualists meant to show off the "invisible" within visual terms (the work of Robert Barry, for instance). These don't serve his purpose—to identify a critical tradition and reinvent its premises.

58. Roberts refers to Wall's work as a reinvention of dialogic realism in the vein of Althusser and Bakhtin that also self-consciously poses a critical dialogue with the terms of documentary photography. The work is to be read as knowingly engaged with the history of the disillusionment with the avant-garde faith in the social efficacy of documentary photography.

59. Quite at odds with the attitude of Warren Neidich, for instance, the discussion of whose work follows these readings.

60. The assumptions that Roberts makes are typical of fine art critics within the

terms of a persistent new academicism: namely, that Wall's images, to take the case at hand, are read through the lens of critical self-consciousness to begin with. Roberts comes to them predisposed to this reading.

61. Within the critical mainstream, Wall's work is read as an extension of an older avant-garde project, one in which his photographic imitations and nuanced commentaries on the nature of the document supposedly have a capacity to create social change. A bizarre notion—that Wall's images are "radically transformative." Roberts asserts that the "dialogic" realism of Wall's work redeems his photographic aesthetic through a capacity to create social change, but he never explains the magic mechanism whereby this change is to be enacted, what systematic transformations of social or political structures are to be effected by Wall's photographs.

62. Vik Muniz makes photorealist images using chocolate syrup, dirt, sugar, and other materials. Then he photographs these images, making photographs that have the look and codes of realism. But these artful sleights trick the eye while they undermine the once invincible authority of the photographic document. Thomas Demand's artful prephotographic set pieces make their convincing arguments through the construction of a photographic record. His cardboard and paper models, carefully lit and photographed, enact a terrifying deceit, making us believe in them as evidence. More real than real, the interiors have a reified iconic character, as if the very essence of our historical expectations has been distilled and then returned to the imagery. Here, constructed, is our most dreadfully imagined and precisely figured image of Hitler's bunker, Bill Gates's dorm room, and other locations in our historical past. Now brought into sharp photogenic focus, they are made present as images of a reality that is supposed to appear as if once lived. The profound falsity of these images belongs to their toying with cultural myths. They provide visible images for us of icons we have barely glimpsed in photographic form. What was history? Where was it? The photographic sleights of his productions lead us to confront our belief system.

By contrast, Muniz's ephemeral beauties try to do the impossible, to wrest a permanent image from impermanent materials that are transient except for the photographic record by which their imagery is represented. Muniz's materials draw on the vernacular with selective, but eclectic, deliberateness. The Sugar Children depict children in the cane fields of the Caribbean, and the Portraits in Chocolate show revolutionary heroes, political figures, rendered in highly consumable tonal values. Muniz's belief in transformation makes him, in his own words, a "twisted realist" (http://www.bombsite.com/muniz/muniz7.html) His interest in Ovid's Metamorphoses shows in his clever trickery, his capacity to use a form of image making as a hinge between one order of representation (photographic) and another (hand-drawn and comestible). The graphic originals pass for pho-

tographs but were never made from light, simply in accord with the codes of illusion that photography has etched into our collective social mind. Both are artists who call attention to the idea of the photographic "real."

63. In a panel discussion about his work *Camp O.J.* held at the Bayly Museum at the University of Virginia, November 2000.

64. Hal Foster, *The Return of the Real* (Cambridge, MA: MIT Press, 1996), especially "The Artist as Ethnographer," 171–204.

65. Dave Hickey, *The Invisible Dragon: Four Essays on Beauty* (Los Angeles: Art Issues Press, 1995), 35.

66. Hal Foster, *The Anti-Aesthetic: Essays on Postmodern Culture* (Port Townsend: Bay Press, 1983); Ann Goldstein and Mary Jane Jacob, *A Forest of Signs: Art in the Crisis of Representation*, ed. Catherine Gudis (Cambridge: MIT Press, 1989).

67. Warren Neidich, *Camp O.J.*, intro. by Stephen Margulies, essays by David Hunt and Charles Stainback (Charlottesville: The Museum, 2000).

68. Warren Niedich, *Blow-Up: Photography, Cinema and the Brain* (NY: Distributed Art Publishers, 2003).

68. Lucy Souter's dissertation addresses this relation in detail, comparing the work of fine art photographers and conceptual art photography and assessing their formal and ideological connections within shared lineages/traditions and shared contemporary concerns. See Souter, "The Visual Idea: Photography in Conceptual Art" (Ph.D. diss., Yale University, 2001).

70. The phrase is, of course, from Soviet filmmaker Dziga Vertov. See Annette Michelson, ed., *Kino Eye: The Writings of Dziga Vertov*, trans. Kevin O'Brien (Berkeley: University of California Press, 1994).

71. The concept of the "body" as a topic for contemporary art and exhibitions has received so much attention in the last few years that any attempt at an exhaustive listing of all the catalogs, articles, publications, and so forth would be futile. Sigrid Schade, "Different Bodies," in *Andere Körpe*, exhibition catalog (Linz: Offenes Kulturhaus, 1994), contains a good preliminary bibliography (10–25).

72. Gilles Deleuze and Félix Guattari, *L'Anti-Oedipe* (Paris: Éditions de Minuit, 1972).

73. Marshall McLuhan, *Understanding Media: The Extensions of Man* (New York: McGraw Hill, 1964).

74. Tom Crow's argument, presented in his well-known and oft-cited "Modernism and Mass Culture in the Visual Arts," in *Modernism and Modernity*, 215–64.

75. Critiques of the notion of authorial genius and signature mark making were of course a major feature of 1980s postmodern theory and artistic practice, most conspicuously in the work of Sherrie Levine and other artists involved with appropriation, although Marcel Duchamp's systematic examination of the terms of artistic authority are the founding instances of such artistic critique; see the work of Thierry de Duve, *Pictorial Nominalism on Marcel Duchamp's Passage from*

Painting to the Readymade (Minneapolis: University of Minnesota Press, 1991); and also that of Amelia Jones, *Postmodernism and the En-gendering of Marcel Duchamp* (Cambridge and New York: Cambridge University Press, 1994).

76. Again, one can think of canonical postmodern artists such as Eric Fischl, Ellen Phelan, or Ross Bleckner in this regard, as well as the artists of appropriation techniques.

77. Mary Kelly, "Re-Viewing Modernist Criticism," *Screen* 22, no. 3 (fall 1981): 41–62.

78. The positing of identity may be subject to any and all kinds of critical evaluation when considered in terms of the interior life of the artist as a construction. But the body is somehow granted the power to refute, legitimate, or assure an identity as authentic by the supposed authenticity it is itself accorded. This is contrary to the very fundamentals of social and critical theory. It is also in direct contradiction to the fundamentals of psychoanalysis in which it was the realization of the uncertain identity of the body, with its desire for and belief in a *myth* of somatic wholeness, which instigates the production of equally fictive psychic images of subjectivity as a compensation for this condition.

79. See *1993 Biennial Exhibition* (New York: Whitney Museum of American Art in association with Harry N. Abrams, 1993).

80. I have also discussed work in which an artist performs his or her body without necessarily returning to this basic notion of authenticity—in other words, an artist may present a real body without having it serve as the sign of an essential identity, but this is not the way most performed bodies are read or perceived; see "Spectacle/Simulation," *Third Text* 22 (spring 1993): 3–16, which appears as part of this chapter.

81. McLuhan, *Understanding Media*, 47.

82. McLuhan, *Understanding Media*, 116.

83. McLuhan, *Understanding Media*, 68.

84. Cited in Don Collins, "Digital Somatics: Getting Jack Out of the Box," *New Art Examiner* 32, no. 10 (summer 1996): 24–29.

85. Stelarc, "Prosthetics, Robotics, and Remote Existence: Postevolutionary Strategies," *Leonardo* 24, no. 5 (1991): 591–95.

86. Barbara Rose, "Orlan: Is It Art?" *Art in America* (February 1993): 83–87, 125; quotation from 84 and 125, respectively.

87. Douglas Crimp, "Pictures," *October* 8 (spring 1979): 75–88.

88. Rosalind E. Krauss, "Cindy Sherman's Gravity: A Critical Fable," *Artforum* (September 1993): 163–64.

89. Larry Frascella, "Cindy Sherman's Tales of Terror" *Aperture* 103 (summer 1986): 48–53.

90. Frascella, ibid.

91. Molly Blieden, "The Streamliner," Transparent Design Studio, 1990s.

92. David Rimanelli, "Best of 2001," *Artforum* (December 2001): 110, s.v. "Alex Bag."

93. Artists and exhibition archives, 97.3, http://www.artpace.org/whatsnew/PR
 .jhtml?ID=23&Previous=/artists/artist.jhtml*ID~33.

94. See the pages of *Third Text* throughout the 1990s, Lucy Lippard's *Mixed Blessings*,
 and responses to Thelma Golden's Black Male exhibit.

95. Jan Avgikos, "Yasumasa Morimura," *Artforum* 35 (April 1997): 91; Lynn Gumpert,
 "Glamour Girls," *Art in America* 84 (July 1996): 62–65; Norman Bryson, "Mori-
 mura: Three Readings," Art & Text (September 1995): 74–78; Norman Bryson,
 "Yasumasa Morimura: Mother (Judith II)," Artforum 32 (January 1994): 70–71;
 and Francesco Bonami, "Yasumasa Morimura," *Flash Art* 42 (March/April, 1992):
 82–83. See also Drucker, "Simulation/Spectacle, *Third Text* 22 (spring 1993): 3–
 16, which appears as part of this chapter.

96. The very term "optical" is a remnant of high modernist sensibility; the intellec-
 tualized distance between visuality/materiality and surface is inscribed in its
 assumptions. Rosalind Krauss, *The Optical Unconscious* (Cambridge: MIT, 1993).

97. Such a generalization as this is impossible to sustain, of course, and immedi-
 ately all kinds of contradictions come to mind, notably Cindy Sherman, and a
 host of others motivated by visual pleasure. But the antivisual precepts of the
 postmodern were strongly felt throughout the 1980s, and the values of theoret-
 ically rigorous work were frequently held up as being bought at the price of (and
 necessarily so) the visual pleasures that had been invoked as modernism's very
 essence.

98. It is interesting to contrast this piece with the Rhoades piece, *My Brother Brancusi*,
 discussed in chapter 4, which also claims a familial relation to tradition, but
 Brancusi is no more Rhoades's brother than Morimura is anyone's daughter.
 And by shifting the relation from one of parentage to one of fraternal relations,
 Rhoades sets in place something other than the familiar oedipal struggle in his
 bid for his own artistic identity. Both are posing the question, Who am I as an
 artist, and both are attempting to find a place for themselves within art's his-
 tory. The insertion of self as image emphasizes the ego-identified inward nar-
 cissism of Morimura as it does the egocentric assertive outward-moving expan-
 sive gesture of Rhoades. The "outsider" and the "insider" experience anxiety
 differently: one tries to insert/position/make a space literally for that body/self,
 and the other makes a non-Oedipal but still patriarchal/genealogical connection
 for the sake of validation. Morimura seeks validation through disruption and
 subversion within the symbolic while Rhoades seeks validation through conti-
 nuity and appropriation of references and connections. One works within a
 frame; the other is unable to be contained within a frame and yet chooses to be
 "framed" within tropes of history/continuity/artistic legacy. In both cases, the
 "work" is done through the relation with the historical field.

99. See *2002 Biennial Exhibition*, exhibition catalog (New York: Whitney Museum of American Art in association with Harry N. Abrams, 2002), 48.

100. At http://www.aspireauctions.com/auctioncat11/auctionlots98.html (accessed Sept. 20, 2004).

101. Cited in Nicole Savy, "Baudelaire, Charles (-Pierre)," *The Grove Dictionary of Art Online* (Oxford University Press; accessed September 20, 2004), http://www .groveart.com.

102. Raymond Pettibon, *Plots Laid Thick* (Barcelona: Museu d'Art Contemporani de Barcelona, 2002).

103. J. David Bolter and Richard Grusin, *Remediation: Understanding New Media* (Cambridge: MIT Press, 1999), contains a thorough discussion of this concept.

CONCLUSION

1. Erika Doss, *Twentieth Century American Art* (Oxford: Oxford University Press, 2002).

2. Erika Doss, *Benton, Pollock, and the Politics of Modernism: From Regionalism to Abstract Expressionism* (Chicago: University of Chicago Press, 1991).

INDEX